CAMERA

A HISTORY OF PHOTOGRAPHY
FROM DAGUERREOTYPE TO DIGITAL

Sterling Signature
NEW YORK

An Imprint of Sterling Publishing
387 Park Avenue South
New York, NY 10016

ISBN 978-1-4027-5656-6 (hardcover)
ISBN 978-1-4549-0002-3 (paperback)

Library of Congress Cataloging-in-Publication Data
Gustavson, Todd.
 Camera : a history of photography from daguerreotype to digital / Todd Gustavson.
 p. cm.
 Includes index.
 ISBN 978-1-4027-5656-6
 1. Photography—History. I. Title.
 TR15.G88 2009
 770.9—dc22

2008045851

Distributed in Canada by Sterling Publishing
c/o Canadian Manda Group, 165 Dufferin Street
Toronto, Ontario, Canada M6K 3H6
Distributed in the United Kingdom by GMC Distribution Services
Castle Place, 166 High Street, Lewes, East Sussex, England BN7 1XU
Distributed in Australia by Capricorn Link (Australia) Pty. Ltd.
P.O. Box 704, Windsor, NSW 2756, Australia

All camera photos by Barbara Puorro Galasso
Photo research by Todd Gustavson, Susan Oyama

Cover credits:
Cover, front and back: Camera images by Barbara Puorro Galasso.
Flaps, front and back: Historical images are courtesy of the George Eastman House Collections,
Rochester, NY. Camera images by Barbara Puorro Galasso.

All cameras are from the George Eastman House Technology Collection. Unless noted otherwise,
all historical images are also from the George Eastman House collections.

Information has been gleaned, when possible, first from the actual artifacts, then from technical
files/primary sources, and third from research books/secondary sources.

Camera IDs contain the item's introduction dates; dates for many are preceded by "circa" as most
cameras have a production range. When the museum's collection does not contain the first model,
a later date is established by serial number or by research in secondary sources.

Some of the historical images shown here were given no titles by their makers. In such instances,
a descriptive title is given in brackets.

Facing page: American style daguerreotype camera, ca. 1848. See page 16.

For information about custom editions, special sales, and premium and corporate purchases, please contact Sterling Special Sales at
800-805-5489 or specialsales@sterlingpublishing.com.

Manufactured in China

2 4 6 8 10 9 7 5 3 1

www.sterlingpublishing.com

GEORGE EASTMAN HOUSE

CAMERA

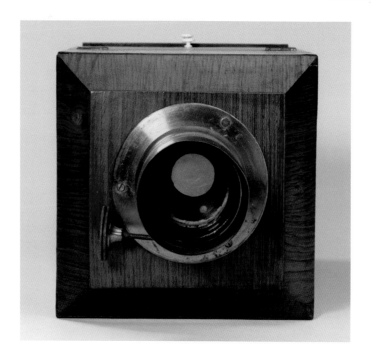

A HISTORY OF PHOTOGRAPHY
FROM DAGUERREOTYPE TO DIGITAL

TODD GUSTAVSON

Sterling Signature
NEW YORK

TABLE OF CONTENTS

FOREWORD

A CHILD KICKS A BALL into the air. You click a ten-dollar camera. That ball will never hit the ground.

It will, of course, a second later. The child will pursue it, a moment older. If you like how that picture comes out, it is not too sentimental an indulgence to imagine her one day showing that twenty-cent print to her own daughter at the same age.

That experience—locking the present into the past and stashing it away for the future—drives people to take an estimated 3,000 pictures every second.

Snapshots let us taste the flavors of memories, from nuanced joys to the fragile isolation of grief. They show us who we were and, in many ways, who we will always be. They report and provoke subtle forms of wonder. Some comments raised over one 3 x 5 print from 1980:

Did I really look like that? Wow, you were beautiful, even at twelve! What was the name of that girl in the green sweater—she was my best friend for about a week or so—if I could remember, I'd call her.

Nothing we own does what pictures can do. We all know why people grab their snapshots when disasters hit homes—why a picture of a three-year-old still sits by the phone thirty years later.

We know that "photography" means "writing with light," but it's not quite that simple. We are the authors of our photographs, but a camera—a little dark room with one window—does the writing. A shutter (it might as well be called an opener) shears off a slice of light in less than a blink. This light paints itself onto the surface of a film or a pixel array.

This book is about that process; it draws upon a collection of some the most ingenious and elegant physical devices, machines really, ever invented. Its text—and especially its photographs and captions—describes a trail of ingenuity, a sequence of events that could be said to have begun with a man in ancient China who became intrigued while watching shadows.

To work at George Eastman House offers a singular reward. The history of photography parallels the history of the modern world. Photographs write that history in light, but they do much more. They show us the other side of the official record we are tempted to regard as a deeper form of meaning. The bodies at the Battle of Hastings or Bunker Hill could not have looked that different from those at Gettysburg or Normandy or Cua Viet. But because of Mathew Brady and Robert Capa and David Douglas Duncan, we can detect a whiff of what it was like to die there in a way that only photography can provide.

Photographs can be passports. The contours of Greta Garbo's face—like the lines in Lincoln's—speak of zones our minds can inhabit if we want, separate states the ancients likened to planets. It may be cleverly argued that photography always lies, that its reports are circumstantial, provisional, and so susceptible to manipulation (especially in a digital age) that we should not believe our eyes or trust our reactions.

This is plausible enough, but finally sophistry. Photographs can be falsified—after all, they are nothing more than patterns on paper. And of course they only show one among the millions of perspectives available at any time. But that's always been the case.

The pictures we treasure tell the stories we value. And as anyone who tacks up a picture of a ball hung in the air demonstrates, the camera has proved to be the most common cultural recorder in our lives. It cannot displace music or language or painting. But as this collection shows, cameras *trans-scribe*. They take the light of the day and with effortless ease, if not always eloquence, *co-memorate* those moments we come to treasure as time, as it will, goes by.

Anthony Bannon
Director
George Eastman House
International Museum of
Photography and Film

INTRODUCTION

It is perhaps worth stating the obvious:
the camera is central to our
understanding of photography.

—*John Szarkowski*

To understand what a camera does, it helps to recognize that no one has ever really seen the light.

Imagine a box lined with pure black paper, flooded with light. When you peer inside, you see infinite blackness—a darkness blacker than the spaces between stars.

But suppose you drop a fresh, tasty banana into the box. Its yellows and greens would spring to light, revealing the fruit's true colors. Right?

Wrong. The first thing to understand about light, and lenses, and films, and sensors, is that much of what we might take for granted is upside down, inside out, reversed and/or backwards.

In fact, every color *but* yellow resides in the banana. There is no red in a ruby, no blue in the sky, no green in a rain forest. What we see as yellow—or any other color—is a sliver of the electromagnetic field around us everywhere that we label the visible spectrum. Our eye perceives that spectrum as a continuous field ranging from infrared to ultraviolet—waves that measure between 400 and 700 nanometers.

When light strikes the banana, all the wavelengths of light *except* yellow are absorbed in its skin. The yellow waves bounce back to your eye at the speed of light—and then into your brain. Thus light gives color and form to the external world.

Thanks to Isaac Newton and his intellectual descendants, scientists know a great deal about optics, the psychoneurology of vision, and the properties of the electromagnetic spectrum. But most of us are still as much in the dark about light as the eighteenth-century English writer Samuel Johnson. "We all *know* what light is," he noted, "but it is not easy to *tell* what it is."

Physics teachers start to explain what light is by describing its speed as the only universal constant. They go on to say that it exists as both waves and particles called light quanta or photons. That's fine as far as it goes, but most of us find the whole thing bewildering.

This book is about framing the light—*taking* pictures. A camera works pretty much the way the eye does. While there are many ways to expose photographic plates and films without a conventional camera, it is safe to say that virtually all the photographs we know have been gathered inside a light-tight box through a lens mounted on its front surface. The camera appears to be the simplest of all the machines that came out of the Industrial Revolution; but as we will see, there is much more to it than meets the eye.

Historians of photography may fuss over who did what exactly when, who stole what idea from whom,

and who was first to demonstrate this or that. None of this really matters very much. Once an innovation is demonstrated, people swarm.

As John Szarkowski pointed out in his graceful history of the medium, *Photography Until Now*, the progress of photography has been more like the history of farming, with a continual stream of small discoveries leading to bigger ones, and in turn triggering more experiments, inventions, and applications while the daily work goes along uninterrupted.

People intuitively grasped that photography was "writing with light," and you could transcribe anything you could see into a document that did not require translation. Pictures could write history as well as any scholar, report the news as well as any headline, display beauty and ugliness indifferently, and ring every emotional bell in the fickle heart.

Pictures are, like writing, potentially powerful. And anyone who owned a camera might—in theory—apply "the pencil of nature" to narrate any tale to any purpose. Of course doing anything well is seldom as easy as it looks.

Light behaves in curious ways. Each camera must obey the inflexible laws of physics (the Latin word for nature). In order to "take a picture"—an exact description—the camera must admit the right amount of light in just the right way onto a suitable surface.

The one-dollar Kodak Brownie cameras introduced in 1900 are as different from today's $5,000 high-end digital models as the Wright Brothers' aircraft invented that year differs from today's NASA space shuttle. But it's the same for light as for flight. Improving the basic equipment yields better results, brings more customers on board, and makes more money for everyone along the supply chain.

Camera collectors are engaging and discerning, and this book is in many ways for them. The George Eastman House Technology Collection is a museum of its own. Each camera represents an insight—some by a single inventor, others by a team of scientists and engineers—that there was a way to do things better. And the more you know about shutters, mirrors, focal planes, apertures, light meters, sensors, and LCD displays, the more you can appreciate the tales told through the sequence of photographs and captions you see here.

But this book is also for people who may not know an f-stop from a bus stop, but enjoy how the world works, how ideas turn into products that come to mediate human experience on a personal and historical scale. Telephones, automobiles, and radios changed the first half of the twentieth century; TVs, computers, and a hundred labor-savers changed the second. But all along the camera has been there, working harder to deliver what no other product does: something unique, personal, and permanent. No two clicks are the same, and each fresh picture kindles a slightly different story.

Familiar names like Daguerre, Eastman, Hasselblad, and Land denote inventions we recognize at once. But there are other names, too, such as Frank Brownell, Richard Leach Maddox, Josef Max Petzval, Goro Yoshida, and Steven Sasson. Their innovations mark inflection points on the nearly continuous double-digit growth in exposures that constitutes the statistical (and financial) history of photography.

The George Eastman House collection of cameras represents the past, and in an essay that concludes this book, Alexis Gerard speculates on what tomorrow's "pencils of nature" may write like. Digital technology has already combined with the Internet to utilize pictures in dozens of ways. At a time when half the people who ever lived are competing for all forms of resources, nearly all information in and about the world is becoming increasingly accessible, mostly for free, and often captured in pictures.

Most of what we call great writing was done with handheld devices that never required rebooting, recharging, or upgrading. The same holds true for photographs. The most expensive camera can do no more than tell a story. Technology is one thing. A photograph is another.

Todd Gustavson
Technology Curator
George Eastman House
International Museum of
Photography and Film

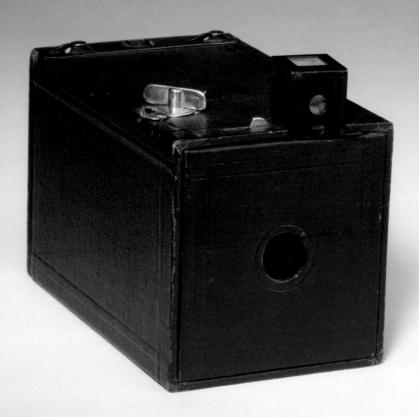

No. 1 Brownie (owned by Ansel Adams). ca. 1901. See page 146.

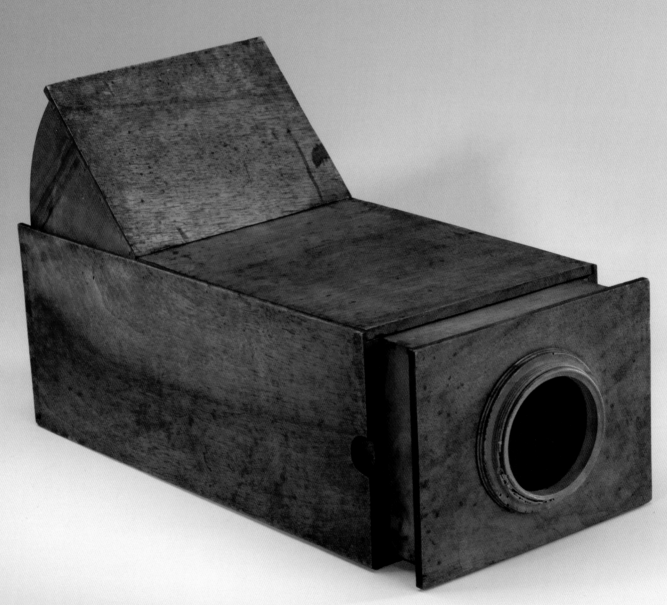

Camera obscura, ca. 1820. See page 4.

I

EUREKA MOMENTS: NIÉPCE, DAGUERRE, TALBOT

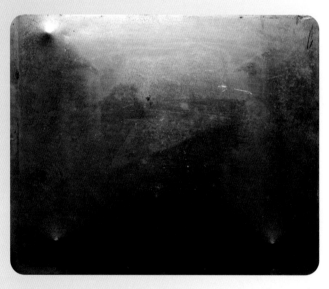

Joseph Nicéphore Niépce, *[The world's first permanent photograph from nature]*, ca. 1826. See page 5.

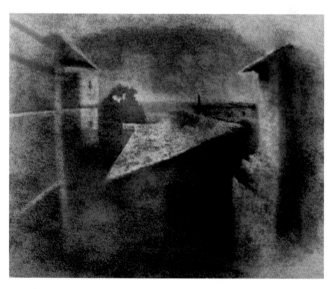

Helmut Gernsheim, *[Enhanced version of Niépce's first permanent photograph from nature]*, ca. 1952. See page 5.

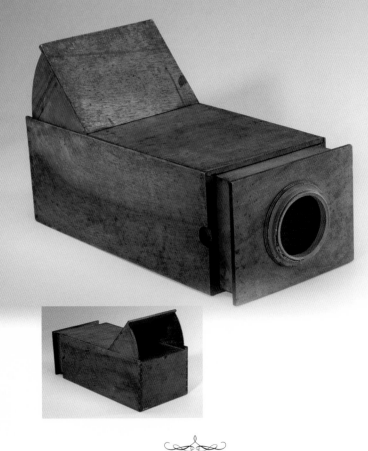

Reflex: Camera Obscura

ca. 1820

Unidentified manufacturer, France. Gift of Eastman Kodak Company, ex-collection Gabriel Cromer. 1989:1341:0001.

The camera obscura phenomenon—that light passing through a small hole into a darkened chamber projects an inverted image of the outside scene upon the opposite wall—has been known for thousands of years. In the 1500s, it was observed that simple lenses improved the resolution and sharpness of the image created by cameras obscura. Introduced in

the 1600s, portable reflex cameras obscura were used by artists as an aid to correctly render perspective. All photographic cameras descend from the camera obscura.

Illustration of artist using a portable reflex camera obscura. From: A. Ganot, *Traité élémentaire de physique* (Paris, 1855). George Eastman House collections.

N̲o one person "invented" the camera. Like most inventions, what we think of today as a camera developed slowly over time. What finally brought it into being were a few experimenters who put together the physics, chemistry, and optics—the seemingly unrelated effects of the camera obscura and darkened silver salts.

The camera obscura phenomenon has been known for thousands of years. Astute observers have long noted that light passing through a small aperture into a darkened chamber projected an inverted image of the outside scene on an opposite wall. And for thousands of years, people have been using that phenomenon of light to create images.

In the fifth century BC, the Chinese philosopher Mo Ti traced the upside-down image formed by a camera obscura, becoming the first such practitioner in recorded history. The natural phenomenon was also mentioned in the writings of Greek philosopher Aristotle (BC 384–322) and the Egyptian scientist Alhazen (965–1040), considered the father of modern optics.

It took hundreds of years for artists to begin using the camera obscura effect as a drawing aid, as the Italian scholar Giovanni Battista Della Porta did when creating the images for his 1558 publication *Magiae Naturalis.* By the 1600s, cameras obscura became more practical by being made smaller and therefore portable.

Also known for hundreds of years was the fact that certain silver salts darkened when exposed to the sun. The connection between that effect and light, not heat, was demonstrated by German physicist Johann Heinrich Schulze (1678–1744).

In the 1790s, Englishman Thomas Wedgwood (1771–1805) used Schulze's knowledge to make images by exposing leaves placed on ceramic pots coated with silver nitrate. Although he had limited success (his results weren't permanent), his publications discussed the possibility of using a camera obscura for such a purpose.

The first experimenter who put a camera obscura together with permanent images made by light—who both captured and saved an image—is where the real story of the camera begins.

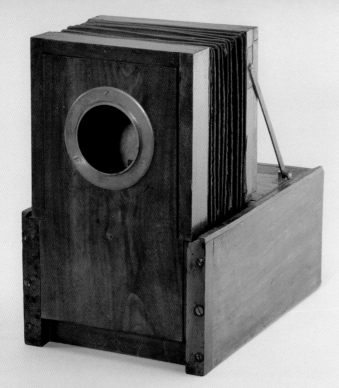

Joseph Nicéphore Niépce (French, 1765–1833). *[The world's first permanent photograph from nature]*, ca. 1826. Heliograph. Courtesy of Gernsheim collection, Harry Ransom Humanties Resource Center, The University of Texas at Austin.

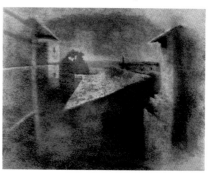

Helmut Gernsheim (Swiss, 1913–1995). *[Enhanced version of Niépce's first permanent photograph from nature]*, ca. 1952. Gelatin silver print. Courtesy of Gernsheim Collection, Harry Ransom Humanities Research Center, The University of Texas at Austin.

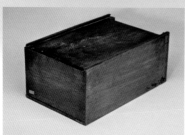

Bellows camera (owned by Isidore Niépce)
ca. 1840

Unidentified manufacturer, France. Gift of Eastman Kodak Company, ex-collection Gabriel Cromer. 1974:0037:2113.

Thought to be the first to use a bellows, this quarter-plate camera was acquired in 1933 by Gabriel Cromer from J. Batenet, a childhood friend of Isidore Niépce. Isidore's father, Joseph Nicéphore Niépce, is credited as the first to apply the bellows to photographic instruments (though not cameras). He had earlier employed a similar device to induce air into what he called the "pyréolophore," an internal combustion engine he and his brother Claude built in 1807.

According to Cromer, Isidore had this camera constructed "at the earliest time of the Daguerreotype," using a bellows in place of the more typical double-box system of focusing. An additional feature is that the camera's base also functions as its carrying case. The front standard and bellows can be detached from the bed and stowed in a compartment in the base, enabling more convenient transport.

EUREKA

JOSEPH NICÉPHORE NIÉPCE (1765–1833) defined heliography (writing with sunlight) as "spontaneously reproducing the image received in the camera obscura by the action of light with all the gradations from black to white."

Niépce is credited with making the first permanent photograph from his window in Saint-Loup-de-Varennes, in France. The exact date is unclear; many historians favor 1826, though it may have been as early as 1822 or as late as 1827.

The shadowy pattern of contrasting planes has its own pleasing abstract form. The eight-hour exposure was recorded on a pewter plate coated with a light-sensitive asphalt compound called bitumen of Judea suspended in oil of lavender. Niépce described the process as "nearly magical."

It was as much a eureka moment as Edison's invention of the phonograph fifty years later or Crick and Watson's discovery of DNA in 1953. And like many of the ingenious inventors of the Industrial Revolution, Niépce proceeded not by rigorously defined procedures but by simply keeping at it. He had been trying for years.

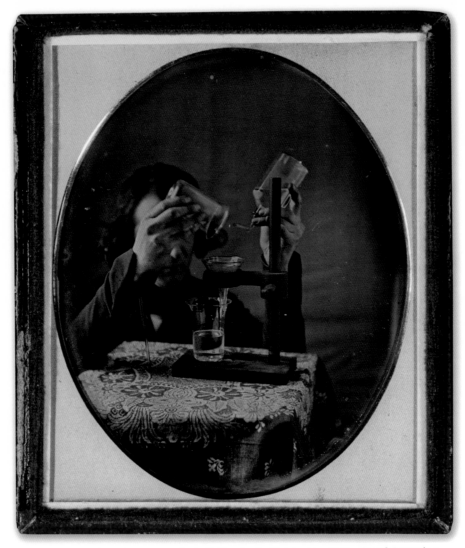

Robert Cornelius (American, 1809–1893). *[Self-portrait with laboratory instruments]*, December 1843. Daguerreotype. Gift of the 3M Company, ex-collection Louis Walton Sipley. George Eastman House collections.

Niépce's early experiments came to the attention of another ingenious investigator, Louis-Jacques-Mandé Daguerre (1787–1851). Letters were exchanged. Trust was established. They first met in 1827, and in 1829, they agreed to work together. Like many such collaborations, their history became technically and legally complex, involving, among others, the scientist and statesman François Arago. (Beaumont Newhall's *The History of Photography* contains a lucid description of these events.)

Theirs proved a brief collaboration. Niépce died in 1833. But two years later Daguerre exposed a plate coated with light-sensitive silver iodide to obtain a faint image, which he in turn exposed to mercury vapor. The two chemicals reacted in a way that enhanced the image. Daguerreotypes were extremely sharp in detail, with lovely silvery surfaces. The discovery was announced on January 13, 1839. Even today, daguerreotypes remain the photographic process with the highest resolution.

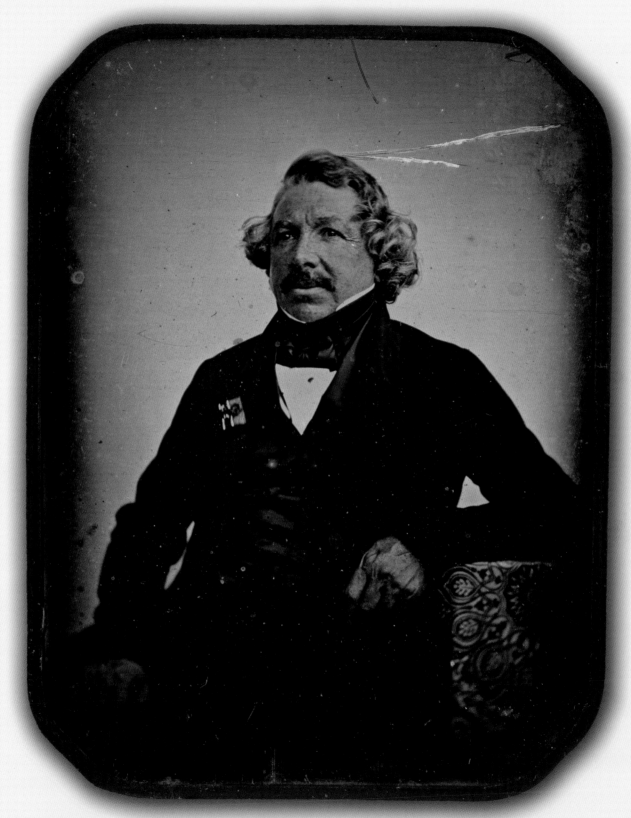

Jean Baptiste Sabatier-Blot (French, 1801–1881). *LOUIS-JACQUES-MANDÉ DAGUERRE*, 1844. Daguerreotype. Gift of Eastman Kodak Company, ex-collection Gabriel Cromer. George Eastman House collections.

Giroux daguerreotype camera

1839

Alphonse Giroux, Paris, France. Gift of Eastman Kodak Company, ex-collection Gabriel Cromer. 1978:1371:0008.

The Giroux daguerreotype apparatus is photography's first camera manufactured in quantity. On June 22, 1839, L.-J.-M. Daguerre and Isidore Niépce (the son of Daguerre's deceased partner, Joseph Nicéphore Niépce) signed a contract with Alphonse Giroux (a relative of Daguerre's wife) granting him the rights to sell the materials and equipment required to produce daguerreotype images. Scientist and politician François Arago publicly announced the new daguerreotype process in a speech to the French Academy of Art and Sciences on August 19, 1839, and the first advertisement promoting the process appeared in the August 21 issue of *La Gazette de France*. Within three short weeks, Giroux met with popular success both in and outside of France; the first export of his company's cameras arrived in Berlin, Germany, on September 6, 1839.

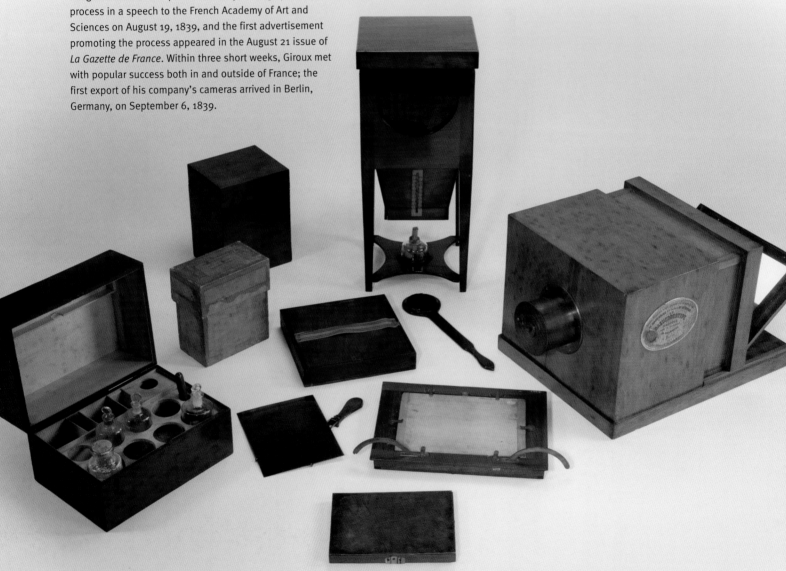

The Giroux camera was an improved version of the apparatus used by Daguerre in his groundbreaking experiments in photography, now fitted with a landscape-type lens produced by Charles Chevalier, a renowned designer of optical systems for microscopes and other viewing devices. The camera is a fixed-bed, double-box camera with an attached 15-inch f/15 lens, accompanied by a slightly smaller rear box that slides inside for picture focusing. It measures a robust 12 x 15 x 20 inches and produces an image of 6½ x 8½ inches, a size format known as a full- or whole-plate daguerreotype. It also houses a mirror held at a forty-five degree angle from the focusing glass on which an image is composed prior to loading and exposing a sensitized plate.

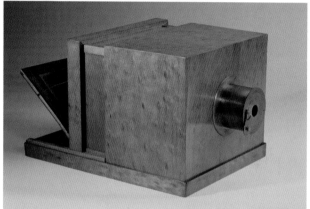

The Giroux was sold as an outfit consisting of a camera, lens, plate holder, iodine box for sensitizing daguerreotype plates, mercury box for chemical development, and an assortment of other items necessary to produce the unique, mirror-like images. In a nod to product marketing in an emergent and competitive industrial age, Giroux "branded" his outfit with trademark authority when he attached a plaque to his cameras inscribed with the statement: "No apparatus is guaranteed if it does not bear the signature of Mr. Daguerre and the seal of Mr. Giroux."

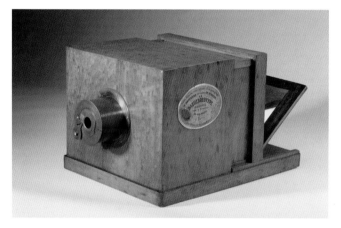
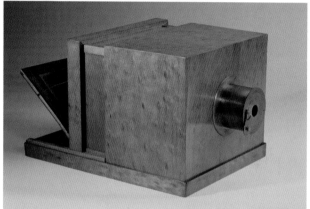
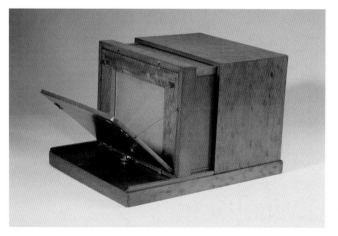
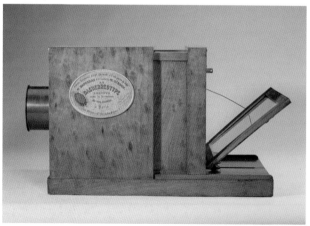

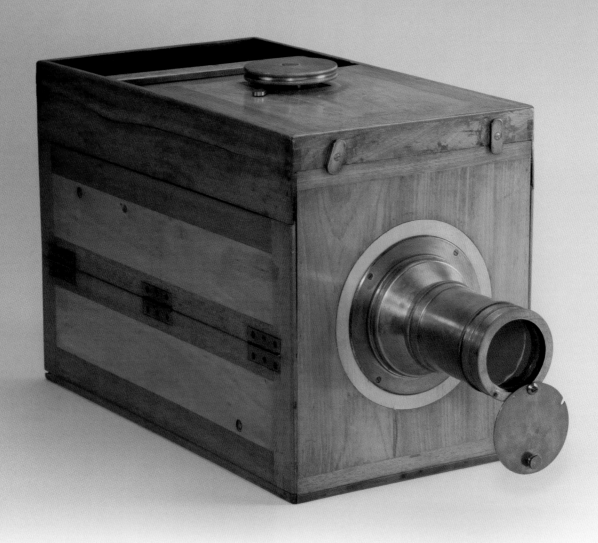

Grand Photographe
ca. 1843
Charles Chevalier, Paris, France. Gift of Eastman Kodak Company, ex-collection Gabriel Cromer. 1974:0028:3313.

About 1843, Charles Chevalier introduced a full-plate camera designed to be portable. The camera is of the double-box style, but the sides of the boxes are hinged. Removing the lens board at the front of the camera and the track for the plate holder at the rear allows the camera to collapse vertically from 11 inches to 3½ inches. The camera also features a rack-and-pinion focusing system; turning the large brass knob on the top of the camera adjusts the focus by moving the inner box toward and away from the lens.

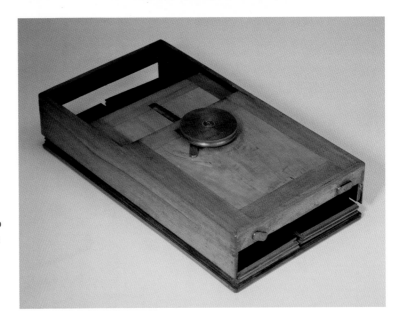

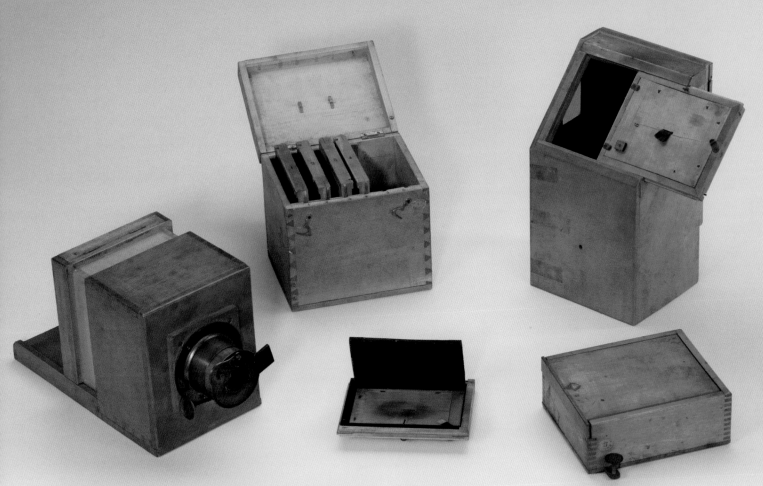

Richebourg daguerreotype outfit (quarter-plate)
ca. 1842

A. Richebourg, Paris, France. Gift of Eastman Kodak Company, ex-collection Gabriel Cromer. 1982:0237:0007.

Pierre-Ambroise Richebourg was apprenticed to optical instrument maker Vincent Chevalier, who supplied Daguerre with his experimental equipment. Following Chevalier's death in 1841, Richebourg took over the business of supplying cameras and lenses and expanded into giving lessons in daguerreotypy and producing portraits.

This quarter-plate Richebourg camera is of the fixed-bed double-box type, fitted with a landscape lens, with provision for correcting mirror. It is shown with its sensitizing and developing boxes and a box for six plate holders, all of which fit into a wooden trunk bearing the Vincent Chevalier and Richebourg label inside the lid.

Many early images show things such as still lifes, street views, and buildings. But the allure of the portrait ignited a craze in France that resulted in millions of daguerreotypes.

Their tiny format was perfect for the small leather covered cases they were often kept in, and long exposures led to tight-lipped, stern results. Still, the smooth metal surfaces often left sitters looking composed and elegant.

By the late 1840s, the daguerreotype photographers were encouraging charm. Sitters dressed up in theatrical costumes, assumed more playful faces. In portraits, feeling is content.

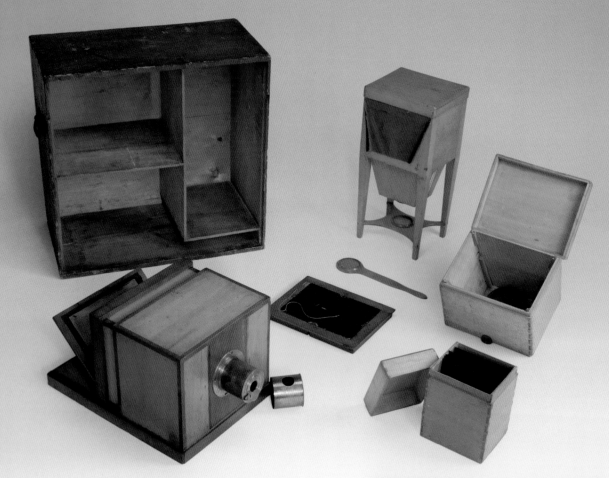

Full-plate daguerreotype camera
(owned by S. A. Bemis)
1840
Alphonse Giroux (attrib.), Paris, France. Gift of Eastman Kodak Company.
1978:1792:0001.

Samuel A. Bemis (1793–1881), a Boston dentist and amateur daguerreotypist, bought one of the first cameras sold in the United States. Fortunately, he and his heirs saved not only the camera but also its receipt. While it's likely too late to return the camera, the receipt is useful as evidence of what is probably the earliest documented sale of an American daguerrean outfit. Thanks to the dentist's pack-rat ways, we know that on April 15, 1840, he paid $76 to François Gouraud, Giroux's agent in the U.S., for a "daguerreotype apparatus," twelve whole plates at two dollars each, and a freight charge of one dollar. The apparatus, which Gouraud advertised as consisting of sixty-two items, included the camera, lens, plate holder, iodine box for sensitizing plates, mercury box for developing

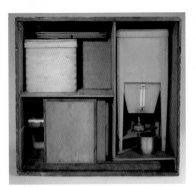

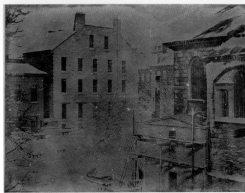

Samuel A. Bemis (American, ca. 1793–1881). *[King's Chapel Burying Ground, Tremont Street, Boston, winter]*, ca. 1840–1841. Daguerreotype. Gift of Eastman Kodak Company, ex-Eastman Historical Photographic Collection. George Eastman House collections.

plates, holding box for unused plates, and a large wooden trunk to house the entire system. Quite large, the camera weighs about thirteen pounds and can produce full-plate images, 6½ x 8½ inches in size. Bemis made his first daguerreotype on April 19, 1840, from the window of his Boston office, and during the next several years went on to expose more than three hundred images, most of them in his beloved White Mountains of New Hampshire. The George Eastman House collection also contains a second Bemis camera and nineteen of his images.

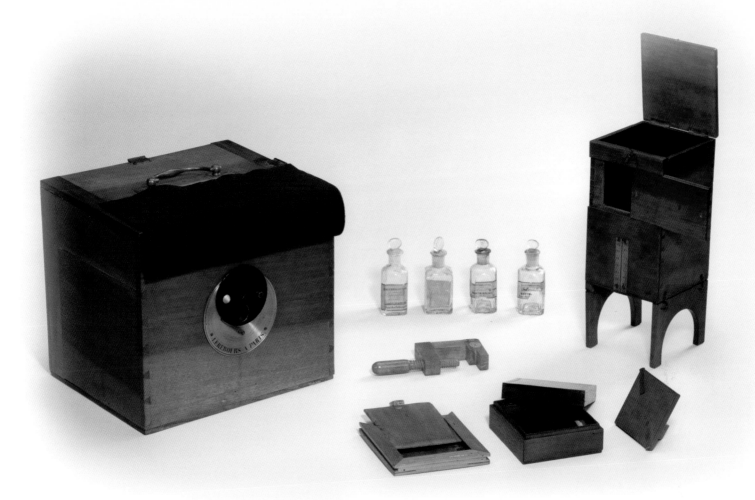

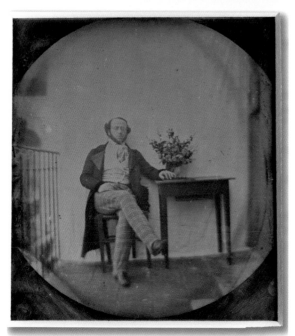

Unidentified photographer. *[Man at a table with flowers; portrait made with a Gaudin camera]*, 1840. Daguerreotype. Gift of Eastman Kodak Company, ex-collection Gabriel Cromer. George Eastman House collections.

Novel Appareil Gaudin
ca. 1841

N. P. Lerebours, Paris, France. Gift of Eastman Kodak Company, ex-collection Gabriel Cromer. 1974:0028:3543.

Another early departure from Daguerre's Giroux camera design was the Novel Appareil Gaudin. Designed by Gaudin of Paris, France, the body of this sixth-plate (8 x 7 cm) camera is made of two brass tubes that slide within each other to adjust focus. The camera is built into its carrying case, which is large enough to transport the sensitizing and developing boxes as well as the rest of the items required to make daguerreotypes. On the top of the carrying case is a piece of black cloth that was raised and lowered over the lens, acting as a very simple shutter. The f/4 doublet lens was faster than that of the Giroux, which, when combined with the sixth-plate image size, made the camera suitable for portraiture. George Eastman House owns a portrait that, according to Gabriel Cromer, was made with a Gaudin camera (see left). On front of the lens is mounted a wheel stop, a metal disc with three proportional holes used for controlling the amount of light exposing the plate.

Chevalier half-plate camera
ca. 1841

Charles Chevalier, Paris, France. Gift of Eastman Kodak Company, ex-collection Gabriel Cromer. 1974:0037:2565.

Soon after Daguerre made his photographic process public, other manufacturers began producing cameras. Parisian optician Charles Chevalier (1804–1859), who made lenses for the experiments of both Joseph Nicéphore Niépce and Daguerre and provided the link that brought the men together, introduced a double-box camera with hinges added to the bed. This improvement allowed the bed to fold and nest at the back of the rear box, making the camera less cumbersome to transport. To further improve portability, Chevalier added a hinged brass handle to the camera's top. The camera was fitted with his Photographe à Verres Combinés à Foyer Variable, an empirically designed lens, which shortened exposure times from about fifteen minutes to three. At the front of the lens is a mirror mounted at a 45 degree angle, which was used to laterally correct the otherwise reversed daguerreotype images.

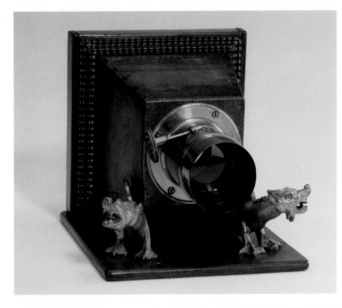

Bourquin camera
ca. 1845

Bourquin, Paris, France. Gift of Eastman Kodak Company, ex-collection Gabriel Cromer. 1977:0850:0007.

Judging from the way the ground glass and plate holder affix to the camera, the Bourquin dates from about 1845. It is a French-made single-box-style camera fitted with a Petzval-type portrait lens; the only means of focus is the lens's rack and pinion. Mounted on either side of the lens are dragons, which appear to support the lens but more likely were used to hold the attention of the subject, a sort of daguerrean-era version of "watch the birdie."

Ninth-plate sliding box camera
ca. 1850

Unidentified manufacturer, France. Gift of Eastman Kodak Company, ex-collection Gabriel Cromer. 1995:2625:0001.

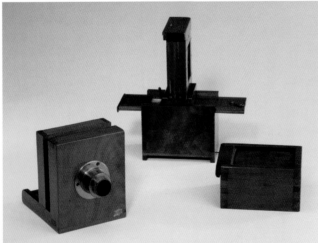

This is the smallest double-box camera in the George Eastman House collection. Fitted with a Hermagis landscape lens, it produced an unusually sized 1½ x 2-inch image. Accompanying the camera is a glass-lined iodizing box, the earliest style used to sensitize daguerreotype plates. A second accessory is a daylight magazine-loading plate box, suggesting the camera may have had a long working life, perhaps in an amateur's hands. The box would have allowed the camera to use dry plates, which appeared on the photographic scene nearly forty years after the camera was manufactured.

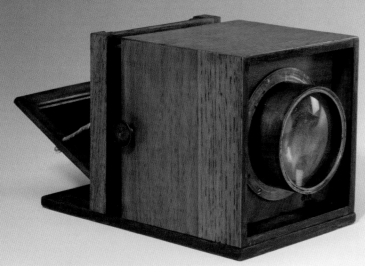

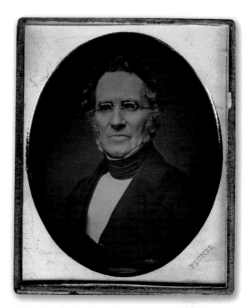

Plumbe daguerreotype camera
ca. 1842
John Plumbe Jr., Boston, Massachusetts. Gift of Eastman Kodak Company.
1974:0037:0093.

Dating from the early 1840s, the Plumbe daguerreotype camera is the oldest American-made camera in the George Eastman House collection. Of the double-box style, the Plumbe is similar in design to the Giroux camera, but it produced the smaller 3¼ x 2¾-inch images known as sixth plates. Unlike the Giroux, it was intended as a portrait camera. A label on the camera's back identifies it as a product of Plumbe's Daguerreotype Depot, United States Photographic Institute, Boston.

John Plumbe Jr. (1809–1857) was a civil engineer, early promoter of a transcontinental railroad, author, daguerreotypist, and publisher. He may have studied the daguerreotype process with François Gouraud in Boston, Massachusetts, in March 1840, though he certainly opened a studio in the city by late that fall. The next year, he established the United States Photographic Institute, also in Boston, and opened the first of branch galleries that he called "photographic depots." Plumbe continued to set up new studios and in 1843 opened one on Broadway in New York, a city that would soon be the center of his operations. The first American to create and franchise a chain of daguerreotype galleries, he had founded establishments in at least twenty-five towns and cities by the time of his bankruptcy in 1848. In addition to being a working daguerreotypist, "professor" of the process, and franchiser, Plumbe also distributed daguerrean materials and equipment bearing his name.

John Plumbe Jr. (American, 1809–1857). *[Man wearing eyeglasses]*, ca. 1850. Daguerreotype. Museum purchase, ex-collection Zelda P. Mackay. George Eastman House collections.

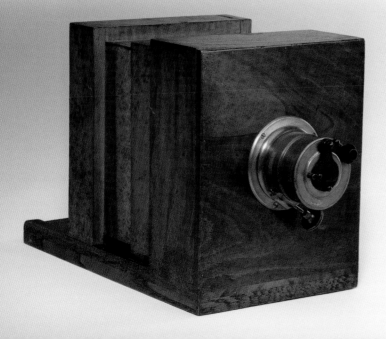

Quarter-plate French triple sliding-box camera
ca. 1845
Unidentified manufacturer, France. Gift of Eastman Kodak Company, ex-collection Gabriel Cromer. 1974:0037:2916.

This fixed-bed French quarter-plate daguerreotype camera employs an unusual three-box focusing system, instead of the traditional two-box design. The extra box allows the camera to telescope much like a bellows would, though there is no apparent technical advantage over the usual construction. Also unusual is the landscape lens, which is fitted with a pivoting aperture used to control the exposure.

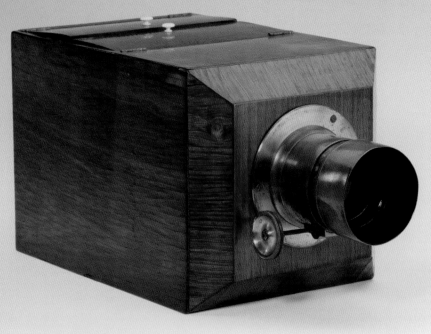

American-style daguerreotype camera
ca. 1848
Unidentified manufacturer, United States. Gift of 3M Foundation, ex-collection Louis Walton Sipley. 1977:0085:0004.

This style of simple box camera was produced by numerous U.S. manufacturers during the middle of the daguerreotype era, about 1845 to 1850, and is usually referred to as the American-style daguerreotype camera. The cameras came in three sizes for full, half, or quarter plates; this particular example is the quarter-plate size. The doors at the top of the camera allow access to the focusing glass and frame for the plate holder. Focusing is accomplished by the rack-and-pinion mechanism mounted on the lens, as there is no provision for focusing within the camera body.

The American-style cameras were most commonly used for portraiture and are usually fitted with Petzval portrait lenses. Introduced in 1841, Petzval lenses were about twenty times as fast as the landscape lens first used on the Giroux cameras and they, along with more light-sensitive plates, allowed for shorter exposure times, making portraiture feasible.

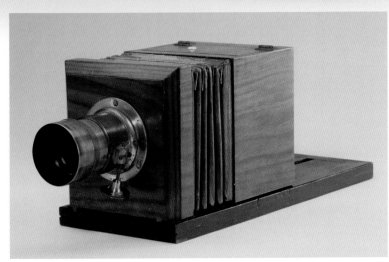

Lewis daguerreotype camera (quarter-plate)
ca. 1851
W. & W. H. Lewis, New York, New York. Gift of Robert Henry Head. 1974:0037:2887.

In 1851, W. & W. H. Lewis of New York City introduced a fixed-bed bellows camera that became one of the most popular with daguerrean studio photographers. Similar in appearance to the earlier American-style chamfered box camera, this style had the bellows inserted into the middle of the camera body. This was done to facilitate the copying of daguerreotypes, which, being unique objects, could only be duplicated as a second, in-camera copy of the original.

Initially a partnership of the father and son William and William H. Lewis, the firm changed hands several times while the basic style of its camera remained the same. Other known manufacturers of this type of camera include Gardner, Harrison & Company, Palmer & Longking, and H. J. Lewis, as well as unidentified makers. This particular camera is quarter-plate in size; others were made in half-plate and full-plate sizes.

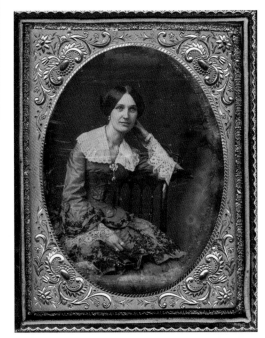

Unidentified photographer. *[Portrait of the grandmother of Wallis Warfield Simpson when a young woman]*, ca. 1850. Daguerreotype with applied color. Museum purchase, ex-collection Zelda P. Mackay. George Eastman House collections.

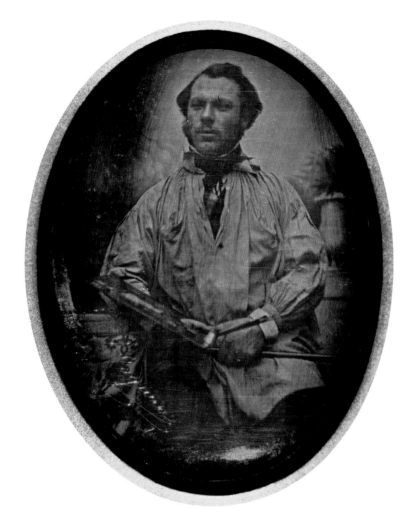

Louis-Jacques-Mandé Daguerre (French, 1787–1851).
PORTRAIT OF AN ARTIST, ca. 1843. Daguerreotype. Gift of
Eastman Kodak Company, ex-collection Gabriel Cromer.
George Eastman House collections.

SMALL FACES STILL ALIVE

THE VERY FIRST PORTRAITS of public figures are still startling today. We have Queen Victoria, abolitionists John Brown and Harriet Beecher Stowe, literary giant Edgar Allan Poe. We have Indian chiefs, U.S. senators, and English members of Parliament. The best seem taken yesterday.

We can only imagine what it must have been like for people who had never seen a photograph to encounter such notables face-to-face, made human, mortal, real. Daguerreotype studios sprang up in every major U.S. city. By 1850, there were nearly eighty in just New York City alone. Traveling vans brought the cameras to towns and villages. Demand was driven by the prospect of being not just remembered, but verified, even after death. Daguerreotypes preserved the wistful smile, the arrogant posture, the look of a warrior.

The same kinds of content mattered then as now. We have daguerreotypes of mill fires, operating rooms, battle scenes, Niagara Falls, London's Crystal Palace, the Cincinnati riverfront, Egyptian monuments, and occasional images of nude persons. Daguerreotypes confirmed human nature.

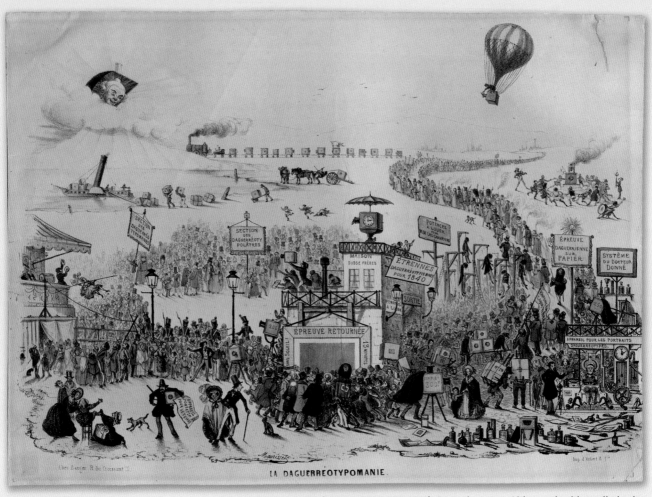

Théodore Maurisset (French, 1803–1860). *LA DAGUERREOTYPOMANIE (DAGUERREOTYPEMANIA)*, December 1839. Lithograph with applied color.
George Eastman House collections.

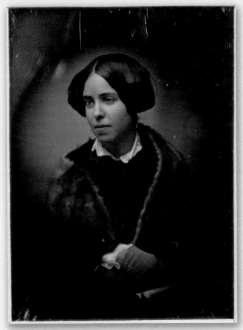

Southworth & Hawes (American, active ca.
1845–1861). *[Unidentified female]*, ca. 1850.
Daguerreotype. George Eastman House collections.

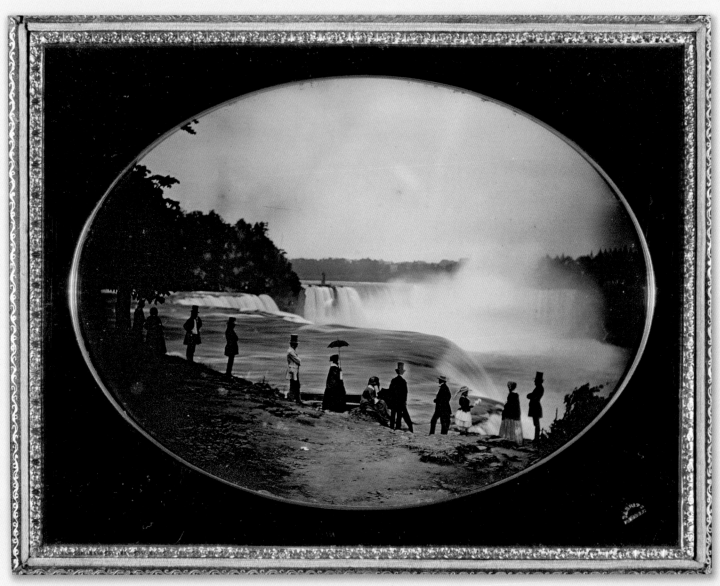

Platt D. Babbitt (American, d. 1879). *[Tourists viewing Niagara Falls from Prospect Point]*, ca. 1855. Daguerreotype with applied color. Gift of Eastman Kodak Company, ex-collection Gabriel Cromer. George Eastman House collections.

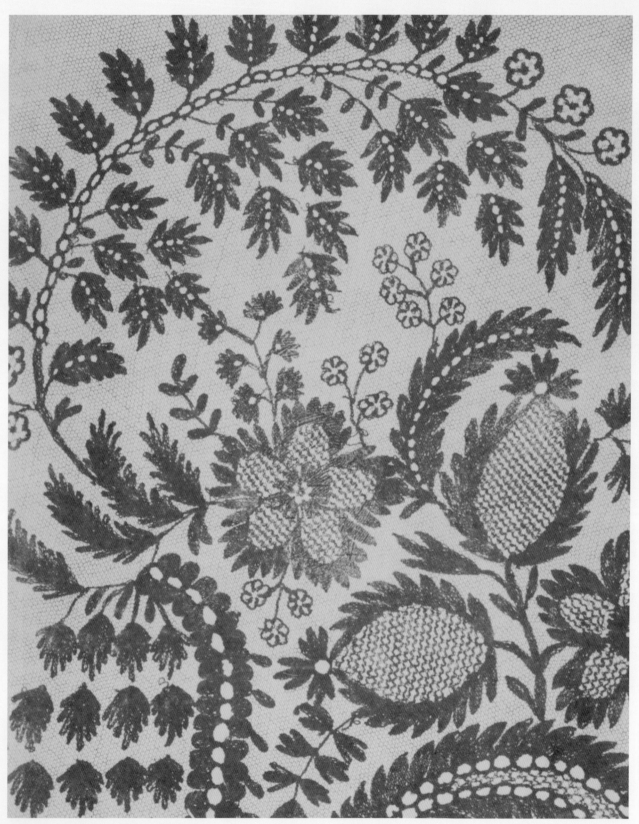

William Henry Fox Talbot (English, 1800–1877). *[Lace]*, ca. 1845. Salted paper print. Gift of Dr. Walter Clark. George Eastman House collections.

John Moffat (Scottish, 1819–1894). *[William Henry Fox Talbot]*, 1848, printed from 1865 original negative by Harold White. Carbon print. Gift of Alden Scott Boyer. George Eastman House collections.

How charming it would be

THE ENGLISHMAN WILLIAM HENRY FOX TALBOT (1800–1877), who went by Henry, invented a different way to make a picture. In the 1830s, Talbot's experiments in reproducing pictures led to an engraving process that evolved to become photogravure. It began when he became frustrated with his tracings from a camera obscura. "How charming it would be," he mused, "if it were possible to cause these natural images to imprint themselves durably and remain fixed on the paper!"

Talbot solved the problem, only to learn to his chagrin that Daguerre had beaten him to the announcement. (He did not realize their two inventions were different.) On January 31, 1839, he described his process, photogenic drawing, to the Royal Institution in England. The pamphlet titled *Some Account of the Art of Photogenic Drawing*, the first published description of photography, was the result. In 1841 Talbot applied the phenomenon of the latent image, and the calotype (from *kalo*, the Greek word for beautiful) was born.

The calotype was the opposite of the daguerreotype. It began with a negative—a document that looks useless, for it reverses all the values in the scene, leaving whites black, blacks white, and people looking ghoulish. The original negative was placed in contact with another sensitized paper material and exposed to light, producing a positive print from the original negative. This principle would be applied to all negative plates and films.--

William Henry Fox Talbot (English, 1800–1877). Cover of *The Pencil of Nature*, 1844. Lithograph. Museum purchase, ex-collection Alden Scott Boyer. Richard and Ronay Menschel Library Collection.

Calotypes were never as popular as daguerreotypes. The total number of paper negatives in the world was likely less than one year's production of daguerreotypes during the early 1850s. The negatives were neither so sharp nor sensitive. The paper fibers dulled, blurred, and mottled the final result. Waxing the paper either before sensitizing it or after fixing it helped increase the paper's transparency and sharpness somewhat. Glass offered some improvements, but Talbot found it tricky to coat. Not least, the requirement to pay Talbot patent royalties for commercial uses discouraged others.

Still, a calotype was cheap. It was easy to sensitize, easier still to expose. And best, prints could be made faster and more easily. Talbot promoted that advantage by creating the first book illustrated by photographs. *The Pencil of Nature* was published in 1844 and 1845. It was issued in six parts and contained twenty-four prints. The photographs had to be pasted in by hand (modern halftone printing techniques were yet to come). But by producing nearly 300 copies of the book, Talbot forecast the mass distribution of pictures through mechanical means.

To make prints for his book and for others, Talbot created a laboratory—in effect, the first commercial photo lab. Printmaking was done outdoors. An assistant slid the paper negative into a printing frame on top of a sheet of silver chloride paper and placed it in the sun. When the prints looked right (after ten to thirty minutes), they went into a chemical bath, a sodium hyposulfate "fixer," to stop them from further darkening. When the sun shone in England, dozens of prints from the same negative could be made in a day. On a cloudy day, each print could take an hour.

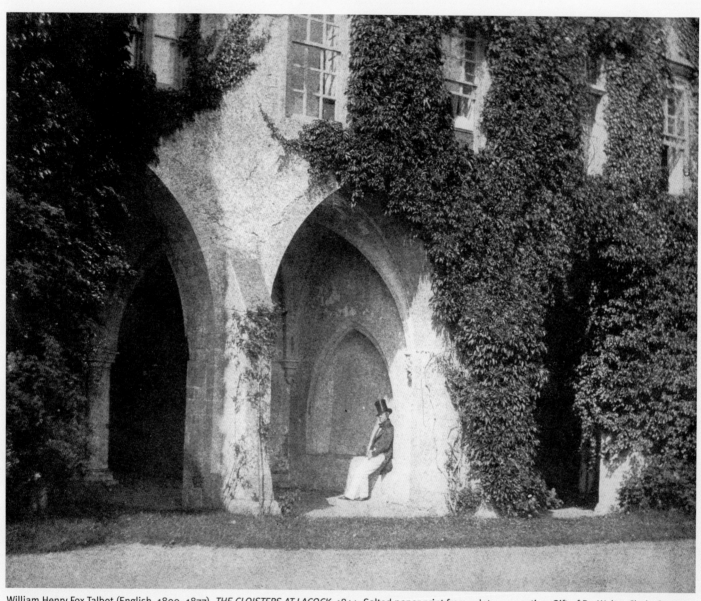

William Henry Fox Talbot (English, 1800–1877). *THE CLOISTERS AT LACOCK*, 1844. Salted paper print from calotype negative. Gift of Dr. Walter Clark. George Eastman House collections.

Chambre Automatique De Bertsch, ca. 1860. See page 35.

II

APPLYING THE CRAFT

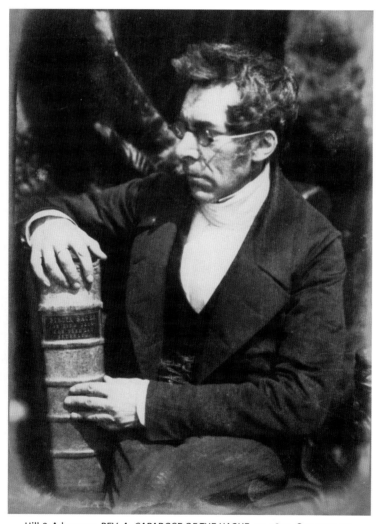

Hill & Adamson, *REV. A. CAPADOSE OF THE HAGUE*, ca. 1843. See page 27.

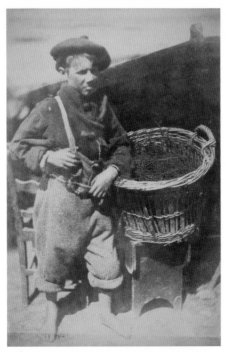

Hill & Adamson (Scottish, active 1843–1847).
[King Fisher], ca. 1843. Salted paper print. Gift
of Alvin Langdon Coburn. George Eastman
House collections.

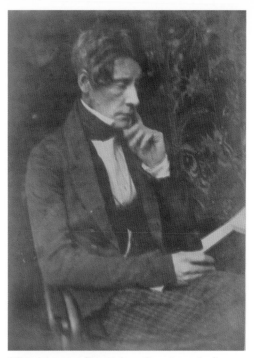

Hill & Adamson (Scottish, active 1843–1847).
[Rev. Dr. John Duncan], ca. 1845. Salted paper
print. Gift of Alvin Langdon Coburn. George
Eastman House collections.

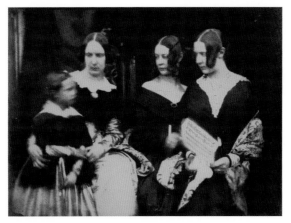

Hill & Adamson (Scottish, active 1843–1847). *[Three women
and child]*, ca. 1845. Salted paper print. George Eastman
House collections.

As technology continued to improve and costs gradually decreased, portraits continued to be the most desired type of photography, and a new business was born.

Foremost among early calotype portrait and landscape photographers was the Scottish calotype team of David Octavius Hill (1802–1870) and Robert Adamson (1821–1848). Hill, a landscape painter, knew lighting and was skilled in composition; Adamson was a sensitive photographer. Their calotypes portrayed Scottish luminaries, ordinary working people, fishwives and fishermen, soldiers and clergy.

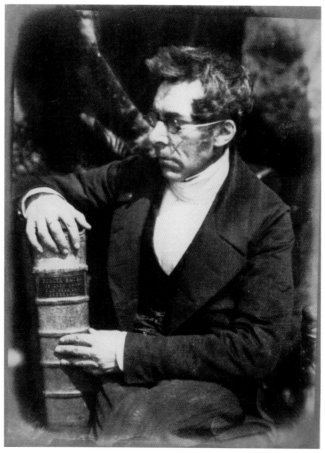

Hill & Adamson (Scottish, active 1843–1847). *REV. A. CAPADOSE OF THE HAGUE*, ca. 1843. Salted paper print. Gift of Alden Scott Boyer. George Eastman House collections.

WRITING (AND EDITING) WITH LIGHT

SOME EARLY PHOTOGRAPHERS sought to imitate paintings by combining several photographs in order to achieve seamless effects. To print a landscape with realistic sky, for example, it was necessary to combine sections of two negatives of the same scene, one exposed for the bright clouds, another for the darker terrain below.

The nineteenth century also saw the first attempts at astrophotography, photomicrography, photojournalism, war photography, medical photography, police photography, and aerial photography.

Every technology defines itself in part by its limitations. And despite the great enthusiasm for the medium, and the money that was beginning to be made, there were few practices as downright inconvenient as photography in its first few decades.

The daguerreotype camera, much like all cameras with a single lens, could only make one picture at a time. The calotype process produced pictures with less detail and a more limited tonal range than daguerreotypes but made possible an unlimited number of prints. Glass plates yielded wonderfully sharp prints, but coating them on the scene was messy and prone to accident.

Cameras were cumbersome. Exposures could seem forever. Everything associated with taking, developing, and printing a picture took time. If one thing went wrong, the effort was wasted.

A NEW USE FOR EGGS

BUT IN 1847, another inventor from the Niépce family, Abel Niépce de St. Victor (1805–1870), developed a new application for eggs.

He was Nicéphore Niépce's cousin and a chemist. He invented a process called albumen-on-glass. He showed that either starch or albumen from egg whites could be used as a binder to suspend potassium iodide. Once this solution had dried on the glass plate, the plate was sensitized in silver nitrate solution.

There were, however, a couple of problems. The coating technique required a large, perfectly level table. Since no one could make glass plates to perfectly flat tolerances, ripple effects were unavoidable. Exposures took five to fifteen minutes. This was fine for taking pictures of buildings and tranquil landscapes, but portraits were practically impossible. Plates had to be developed in hot gallic acid for as long as an hour—no fun for anybody.

Nevertheless, the albumen process became the standard for printing photographs for the next forty years. (It was also the basis for the first photographic projection slides used in magic lanterns.)

Coating paper with sodium chloride suspended in albumen solution formed a separate layer atop the paper. Because it did not soak into the paper, patterns from fiber did not distort the surface. A lustrous, almost glowing appearance resulted from the shine of the albumen layer. When the albumenized paper was floated on silver nitrate and dried, it became a perfect material for making prints from glass negatives. Though a few photographers found albumen prints too shiny for their tastes, the process succeeded. It is estimated that in Germany alone, in 1863, tens of millions of eggs were used to manufacture albumen printing paper.

Of the many people trying to improve emulsions on glass, the first to succeed was an English sculptor. Frederick Scott Archer (1813–1857) had become a calotypist to make photographs of the people he was going to sculpt. Intrigued by the process and its problems, he started looking for an alternative. He found it in collodion, a highly flammable material composed of cotton wool soaked in nitric acid, then dissolved in ether and alcohol. It was a great improvement: colorless, grainless, and more sensitive than albumen, permitting far shorter exposures. In 1852, Archer published *A Manual of the Collodion Photographic Process* and changed the game.

Collodion was not without what technology analysts call "revenge effects." It was a viscous, highly flammable, toxic liquid. Many photographic chemicals smell bad—collodion stank. Seven precise steps were required from preparation through final varnishing.

That photographers would endure the burdens imposed by the process was evidence of its then immeasurable advantages. It simply made for better, sharper pictures than calotypes. It was cheaper. It was reliable. It was reproducible. Photographers were eventually making faster daylight exposures. Darkroom technologies evolved to allow enlargements. It spurred a new wave of camera development that went on for decades.

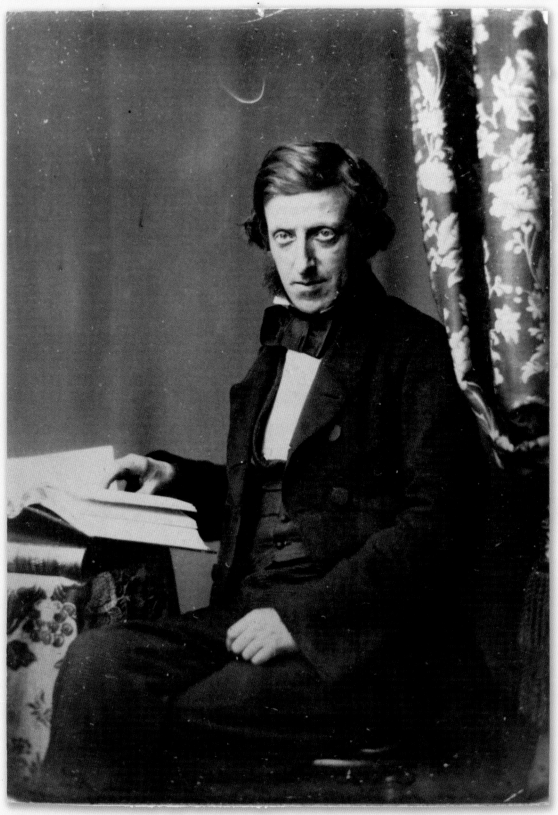

Frederick Scott Archer (English, 1813–1857). *[Self-portrait]*, original negative ca. 1849. Albumen print from original negative, printed later. George Eastman House collections.

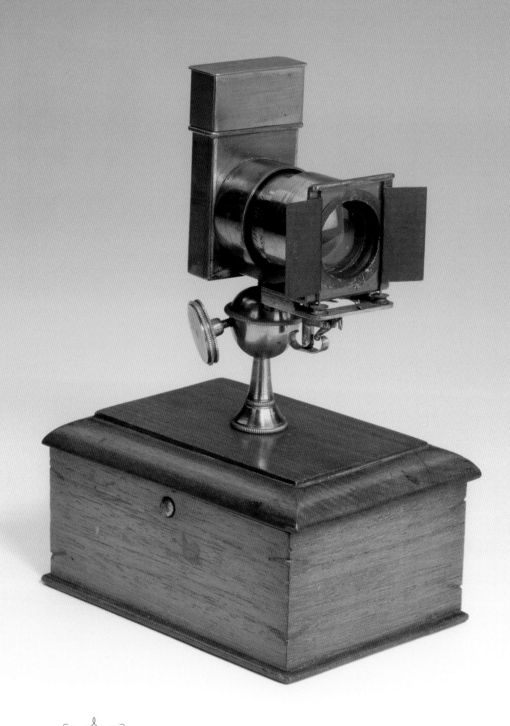

PISTOLS

ONE OF THE FIRST CAMERAS to take advantage of the greater sensitivity of the new process was Thomas Skaife's (1806–1876) Pistolgraph, introduced in 1859. Roughly resembling a pistol, it was the first camera with a mechanical shutter fast enough to take action-stopping pictures of slow-moving subjects. Powered by a rubber band, its shutter speed was about 1/10 second. The short exposures were partly enabled by a fast f/2.2 Petzval-type lens that let in lots of light.

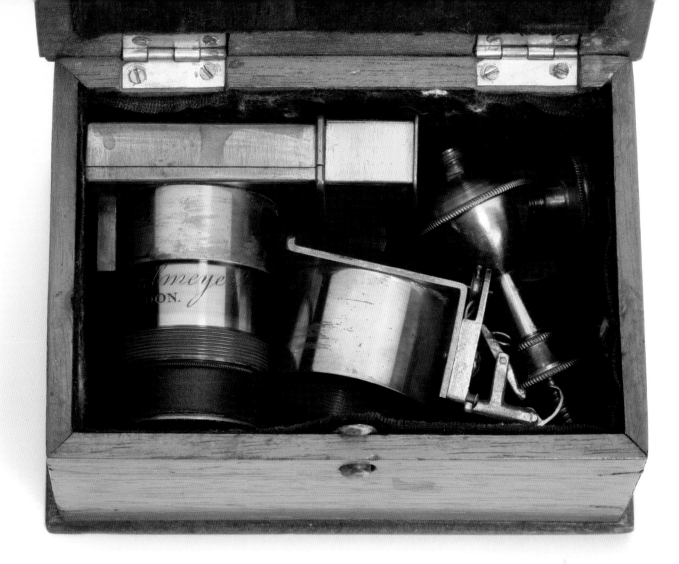

Pistolgraph
1859
Thomas Skaife, London, England. Gift of Eastman Kodak Company, ex-collection Gabriel Cromer. 1974:0084:0007.

Thomas Skaife's Pistolgraph, the first camera to incorporate a mechanical shutter, was capable of instantaneous photography. Its small image size, coupled with a fast f/2.2 Petzval-type lens and a rubber-band-actuated double-flap shutter with an estimated speed of 1/10 second, allowed for the photographing of some moving subjects. Somewhat resembling a small pistol, the camera mounted to the top of a wooden box—which also doubled as its storage case—with a ball-and-socket mechanism. At the camera's rear was a rectangular compartment used to both hold and sensitize a one-inch square wet plate.

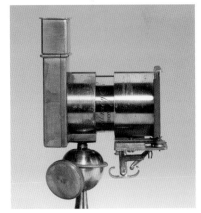

The camera took one-inch pictures that were suitable for lockets and other tiny frames. At the camera's rear was a rectangular compartment used to both hold and sensitize a one-inch square wet plate upon which the circular picture formed.

The camera could be mounted (for ultimate steadiness) on top of its wooden storage case. The story goes that when Skaife pointed his "pistol" at Queen Victoria, the police fell on him and forced him to open the camera to prove he was not trying to kill her.

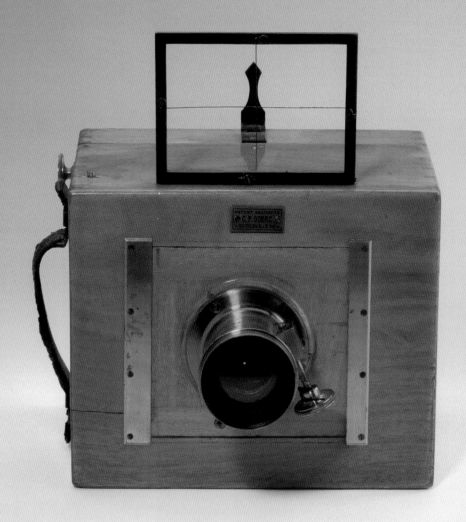

Anschütz Camera
ca. 1892
C. P. Goerz, Berlin, Germany. Gift of C. P. Goerz American Optical Company. 1974:0084:0042.

As photographic media became increasingly more sensitive, shutter designers came up with new ways to take advantage of the faster plates and films. In 1883, Ottomar Anschütz (1846–1907) refined the roller-blind shutter and mounted it just in front of the plate, close to the focal plane. Anschütz wanted to freeze the action of moving animals with little or no blurring. His solution was to make the width of the slit in the shutter curtain adjustable to achieve speeds up to 1/1000 second. Anschütz patented his invention and C. P. Goerz Optical Works incorporated it into a line of cameras produced in their Berlin factory. The first Anschütz cameras were boxes made of polished walnut and used 9 x 12-cm plates. This Anschütz box of 1892 has a Goerz Extra-Rapid Lynkeioskop lens with rack focusing and lever-operated diaphragm. The viewfinder was a metal frame with thin wires as crosshairs. The focal plane shutter continued to be refined and was used in large- and small-format cameras for more than a hundred years.

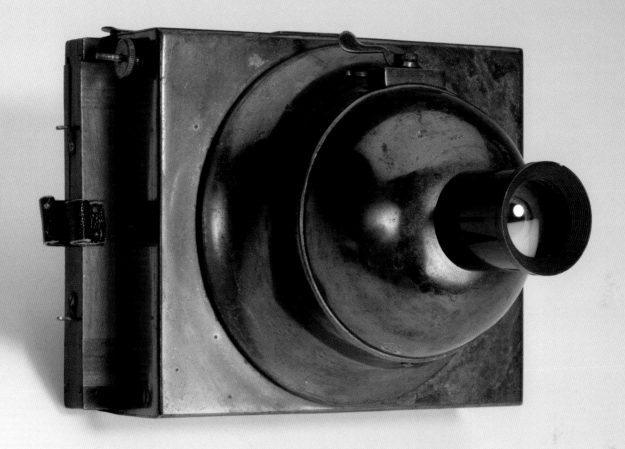

Photosphere
ca. 1889
Compagnie Française de Photographie, Paris, France. Gift of Eastman Kodak Company,
ex-collection Gabriel Cromer. 1974:0037:1816.

As the ranks of amateur photographers swelled in the 1880s, camera manufacturers were pressured to make their products easier to tote along, yet robust enough to take the bumps encountered on photo outings. Compagnie Française de Photographie of Paris answered with their Photosphere in 1889. Made of pre-tarnished, silver-plated brass, this odd-looking device used a rigid lens housing instead of a collapsing design. The lens was a periscopic 95mm f/13. The hemispherical part of the bell-shaped structure housed the spring-powered shutter, which had a matching shape. A tiny knurled knob on the side adjusted the spring tension for shutter speed settings, but it was strictly guesswork. Bubble levels on adjacent sides helped frame the subject, no matter which orientation of the 9 x 12-cm plates the photographer chose. A finder could be clipped on either of the two mounting shoes. Options like a twelve-plate magazine back and a clamp to secure the camera to your bicycle kept Photosphere popular and sales going along until the turn of century.

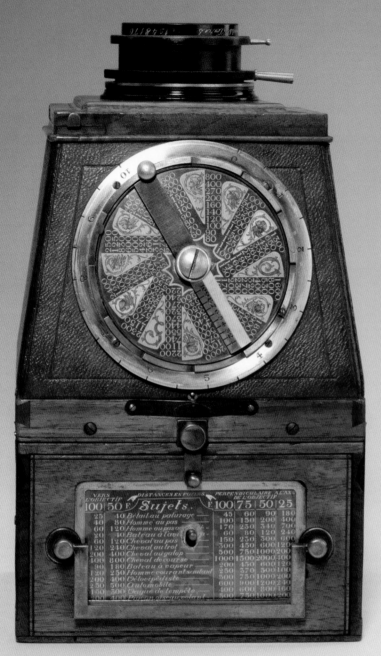

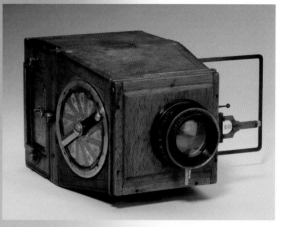

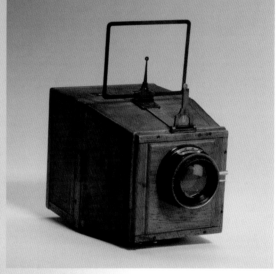

Sigriste
1899
J. G. Sigriste, Paris, France. 1974:0037:0025. Gift of Eastman Kodak Company, ex-collection Gabriel Cromer. 1974:0037:0025.

This beautiful leather-covered wooden box camera was manufactured by the Swiss Jean Guido Sigriste in Paris. With its tapered form, a style sometimes referred to as a Jumelle, the Sigriste camera looks much like a fine piece of French furniture. Introduced in 1899, it was a mechanical marvel made in several format sizes, including stereo versions. The Sigriste featured a focal-plane shutter with one hundred available speed combinations from 1/40 to 1/2500 second, which were accomplished through the adjustment of spring tension and slit width. An internal bellows was fixed behind the lens and tapered to an adjustable slit in the focal plane that traveled across the plate. The push-pull magazine changer held twelve plates that were protected by a tambour door as the box was withdrawn. This particular 4.5 x 6-cm model has a 110mm f/3.6 Krauss Zeiss Planar lens in a helical focusing mount. The retail price, without lens, was 350 francs.

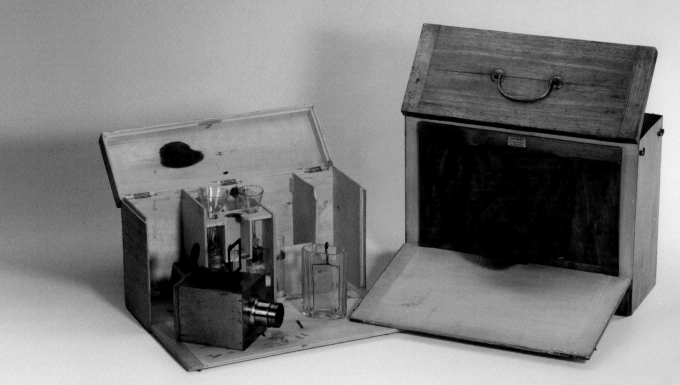

Chambre Automatique De Bertsch
ca. 1860
Adolphe Bertsch, Paris, France. Gift of Eastman Kodak Company, ex-collection Gabriel Cromer. 1974:0028:3315.

Adolphe Bertsch's Chambre Automatique was a portable wet-plate kit consisting of a camera, darkroom, and the rest of the equipment and chemistry necessary to sensitize and process wet-plate images. The carrying case also served as the darkroom, complete with an amber glass safelight mounted in the lid; a wooden panel with a sleeve covered an opening at the box's hinged front to allow light-tight access. The term "Automatique" in the kit's name refers to the fixed-focus nature of the camera and lens. Images were composed within the black wire frame finder located on the camera's top.

This example is fitted with a four-inch lens with a small, fixed aperture, f/20, to achieve sharp focus for objects from about five feet and beyond. Bertsch produced these camera/kits in a variety of sizes and styles, for both landscape and portraiture, as well as stereo images. Enlargements were possible using the Megascope, Bertsch's solar enlarger.

Nobody likes wet work

The wet-plate process was a great improvement but for one thing. Nobody likes wet. Wet is always a potential mess. Wet means tight tolerances for heat, light, and time.

Pictures had to be taken and developed while the plate was still damp. Manufacturers outdid themselves designing kits and accessories that facilitated the coating, handling, and processing of glass plates.

For example, in 1860, Adolphe Bertsch offered the Chambre Automatique wet-plate kit. It gave the photographer everything that was necessary to prepare and process wet plates. It included a camera, chemicals, beakers, funnels, and coating tanks. The camera was unusual in that it was actually made of brass, not wood.

Bertsch produced these camera/kits in a variety of sizes and styles, for both landscape and portraiture, as well as for stereoscopic images. (He also designed a solar enlarger he named the megascope.) The camera shown here, intended primarily for landscape photography, produced 6 x 6-cm square pictures. The small aperture would yield the foreground-to-background sharpness needed for scenes in nature. Its depth of field extended from five feet to infinity.

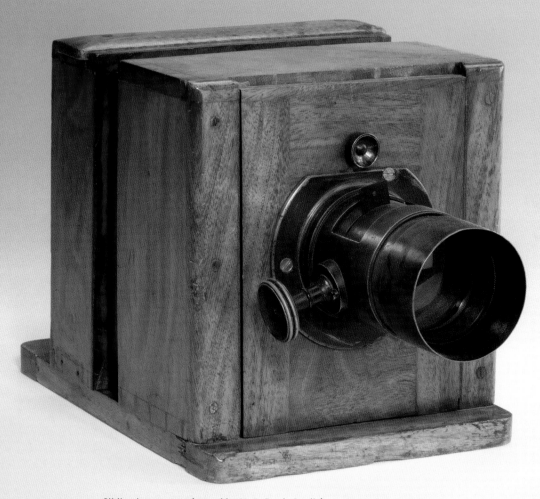

Sliding-box camera (owned by M. B. Brady Studio), ca. 1860. See page 44.

III

PICTURING THE WORLD

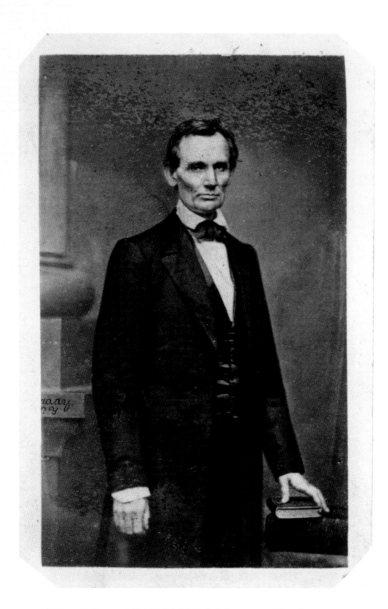

Mathew B. Brady, *ABRAHAM LINCOLN*, February 27, 1860. See page 41.

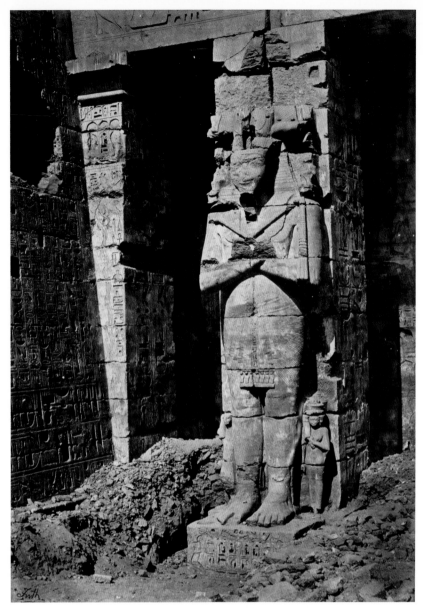

Francis Frith (English, 1822–1898). *EGYPTIAN IDOL AT THEBES*, ca. 1857. Albumen print.
Museum purchase. Richard and Ronay Menschel Library Collection.

Photography opened a window on faraway places with strange sounding names. By the age of 33, Francis Frith (1822–1898) had been in the cutlery business, run a successful grocery store, and started his own photography studio. In 1855 he sold his holdings and set out for the Middle East. His pictures of the Sphinx, the pyramids, and other scenes from Egypt and the Holy Land made him a legend. In 1859 he and his assistants declared his ambition to photograph every town and village in Britain. The company he created thrived on local views, and within a short time some 2,000 outlets in the U.K. were selling his pictures.

The inexpensive reproduction via the wet-plate negative was transforming photography and society. What Frith did for the Middle East and Great Britain, Auguste-Rosalie Bisson (1826–1900) did for the Alps and Samuel Bourne (1834–1912) did for India and the Himalayas. Soon others were capturing and selling prints and stereographs of famous and mundane views.

SEEING THE REAL WAR AT LAST

Photographing war was hard and risky work, its implications examined shrewdly by Susan Sontag (1933–2004) in her 2003 book *Regarding the Pain of Others*. Daguerreotypes had been made of the Mexican War in the 1840s, but practical constraints made it difficult to record much of relevance.

When the Crimean War (1853–1856) stirred controversy in England, the publisher Thomas Agnew decided profit awaited the person who returned with the pictures. Roger Fenton (1819–1869), an English lawyer who had also studied art, was his man. He was soon provided with letters of introduction from Prince Albert. Agnew's goal was not to reveal the horrors of all war, but a kind of mission-in-the-process-of-becoming-accomplished snow job.

Fenton was actually trained as a painter. His pictures often revealed a keen aesthetic sensibility, and he is credited with advancing the documentary photograph as fine art. Roberta Smith, an art reviewer for the *New York Times*, called Fenton "perhaps the world's first photojournalist."

The first widely published propaganda photos did their job. They show well-tended soldiers on the mend, as well as empty battlefields with only hints of the destruction that had occurred and not a single corpse. Meanwhile, written reports from the field revealed death in abundance, a lack of food and clothing, and a raging cholera epidemic.

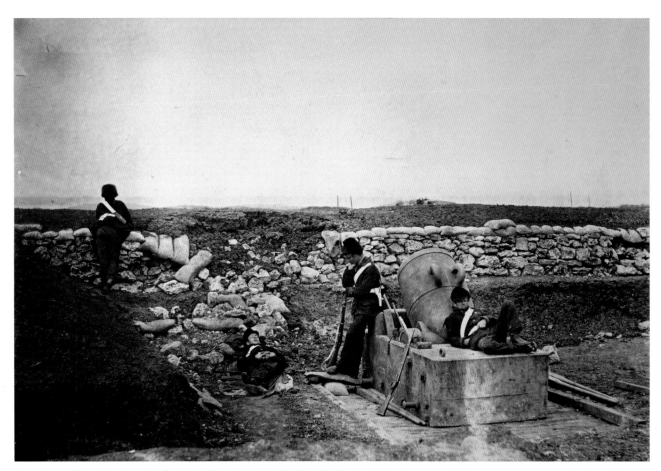

Roger Fenton (English, 1819–1869). *A QUIET DAY IN THE MORTAR BATTERY*, 1855. Salted paper print. Museum purchase, ex-collection Alden Scott Boyer. George Eastman House collections.

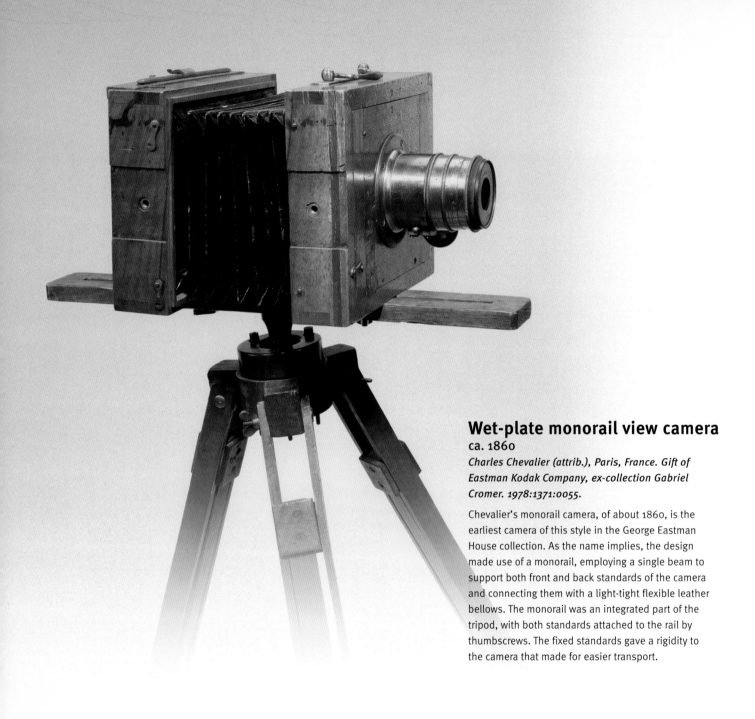

Wet-plate monorail view camera
ca. 1860

Charles Chevalier (attrib.), Paris, France. Gift of Eastman Kodak Company, ex-collection Gabriel Cromer. 1978:1371:0055.

Chevalier's monorail camera, of about 1860, is the earliest camera of this style in the George Eastman House collection. As the name implies, the design made use of a monorail, employing a single beam to support both front and back standards of the camera and connecting them with a light-tight flexible leather bellows. The monorail was an integrated part of the tripod, with both standards attached to the rail by thumbscrews. The fixed standards gave a rigidity to the camera that made for easier transport.

Fenton's strenuous daring in war zones—while driving his wagon with "photographic van" in large letters on its side—speaks for itself. He wrote: "The Russians fired constantly. I could hear the whir & thud that the balls were coming up the ravine on each side." And "When my van door is closed before the plate is prepared, perspiration is running down my face, and dripping like tears…The developer water is so hot I can hardly bear my hands in it." Fenton himself contracted cholera. He suffered from the intense heat. He broke his ribs. And for all his suffering, he was candid about the hypocrisy inherent in carrying out Agnew's assignment, noting laconically that his pictures suffered from "total want of likeness to reality."

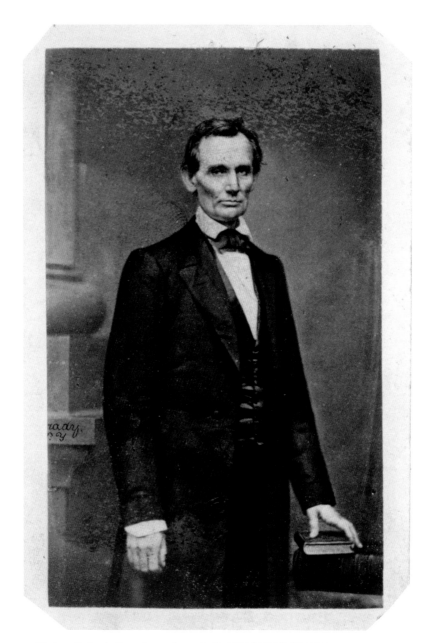

Mathew B. Brady (American, 1823–1896). *ABRAHAM LINCOLN*, February 27, 1860.
Albumen print. Gift of Alden Scott Boyer. George Eastman House collections.

The M. B. Brady studio opened in New York City, in 1844. Within a decade, Brady (ca. 1823–1896), would become the best-known portrait photographer in town. The powerful people streamed in.

A second studio was established in Washington in 1856. Brady photographed numerous U.S. presidents and is said to have made more than 10,000 celebrity portraits. They culminated in an 1850 book of lithographs, *The Gallery of Illustrious Americans*.

Brady's portrait of Abraham Lincoln showed the man's long fingers artfully curling under the hem of his coat. Lincoln later remarked, "Brady and the Cooper Institute [the site of his famous 1860 speech] made me President."

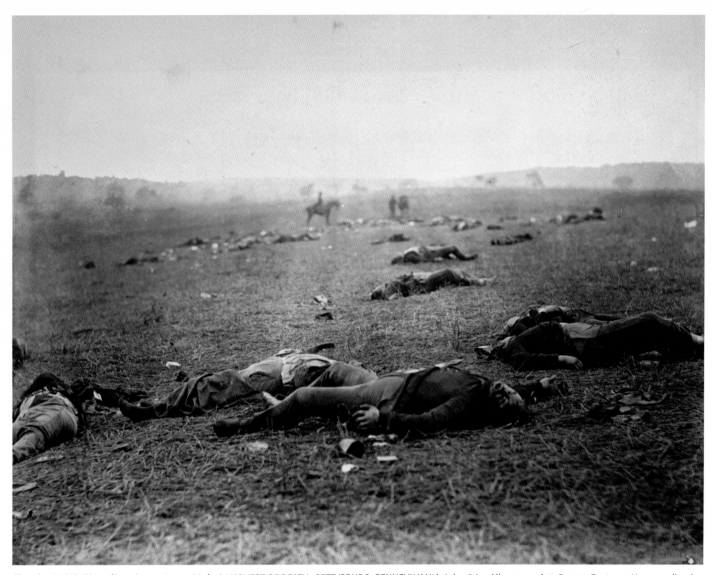

Timothy H. O'Sullivan (American, 1840–1882). *A HARVEST OF DEATH, GETTYSBURG, PENNSYLVANIA*, July 1863. Albumen print. George Eastman House collections.

The Civil War (1861–1865) was both his great success and downfall. Brady knew the security he was giving up, but said, "I had to go. A spirit in my feet said 'Go,' and I went." His photographs at the First Battle of Bull Run were taken so close to the battle that he was nearly captured. Brady's organization employed Alexander Gardner (1821–1882), Timothy H. O'Sullivan (1840–1882), and twenty-one other less notable photographers. Their traveling darkrooms followed the battles and sent back the grim results. The posthumous ten-volume *Photographic History of the Civil War* commemorated the scale of Brady's achievement.

With the wet-plate process still not capable of allowing shutter speeds fast enough to capture live battle action, the photographers documented the aftermath of actual combat. The photographs show bodies sprawled on fields as far as the eye can see; bodies slumped behind walls; bodies twisted in death; a single body in graphic close-up, still clutching his gun.

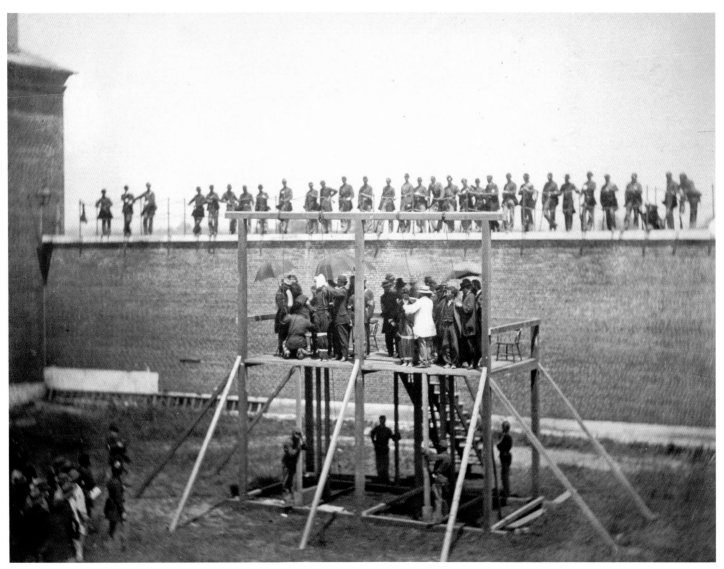

Alexander Gardner (Scottish, 1821–1882). *EXECUTION OF LINCOLN ASSASSINATION CONSPIRATORS. ADJUSTING THE ROPES*, July 7, 1865. Albumen print. George Eastman House collections.

After the war, Brady sold a collection of signed Civil War negatives to the U.S. Government. Others, with their emulsions scraped off, may have eventually been used for greenhouse construction.

When Brady exhibited photographs from the Battle of Antietam in his New York gallery, it brought the war home in a way many were unprepared to witness. Once the war was over, people did not want to be reminded. Brady's fortunes greatly declined. He died in a New York charity ward in 1896, broken both financially and in spirit.

Brady's career spans many of the important developments in photography that took place between the 1840s and the early 1860s. Two cameras in the collection illustrate this groundbreaking evolution in the history of photography.

Although much of Brady's work was lost, these two cameras, possibly from his studios, and an assortment of glass plates were discovered in Auburn, New York. They represent at least two fields in which Brady was deeply immersed: portraiture and stereography.

**Sliding-box camera
(owned by M. B. Brady Studio)**
ca. 1860

Nelson Wright (attrib.), New York, New York. Gift of Graflex, Inc. 1974:0028:3261.

Fixed-bed double-box cameras date back to the original design specified by Daguerre. They were made in numerous sizes and remained popular into the 1860s. This quarter-plate (3 ¼ x 4 ¼-inch) version was made by Nelson Wright and is fitted with a C. C. Harrison Petzval-type portrait lens. Both manufacturers were acquired by Scovill Manufacturing Company, one of the oldest photographic manufacturing firms in the United States. The camera was found with an assortment of M. B. Brady Gallery glass plates in Auburn, New York, hence the Brady association.

How the west was seen

Since 1840, Andrew Jackson and others argued that America would eventually contain a unified population between both shining seas. In the late 1860s, with the Civil War over and the transcontinental railroad under construction, the government began conducting geological surveys to map and photograph the vast area west of the Mississippi.

Timothy H. O'Sullivan, William Henry Jackson (1843–1942), Eadweard Muybridge (1830–1904), and Carleton E. Watkins (1829–1916) pioneered the documentation of the West by using horses and mules to haul huge wet-plate cameras through a magnificent and unexplored territory. Jackson brought huge 20 x 24-inch plates into the Rocky Mountains and proved especially adept at pouring wet collodion evenly over surfaces the size of a small window.

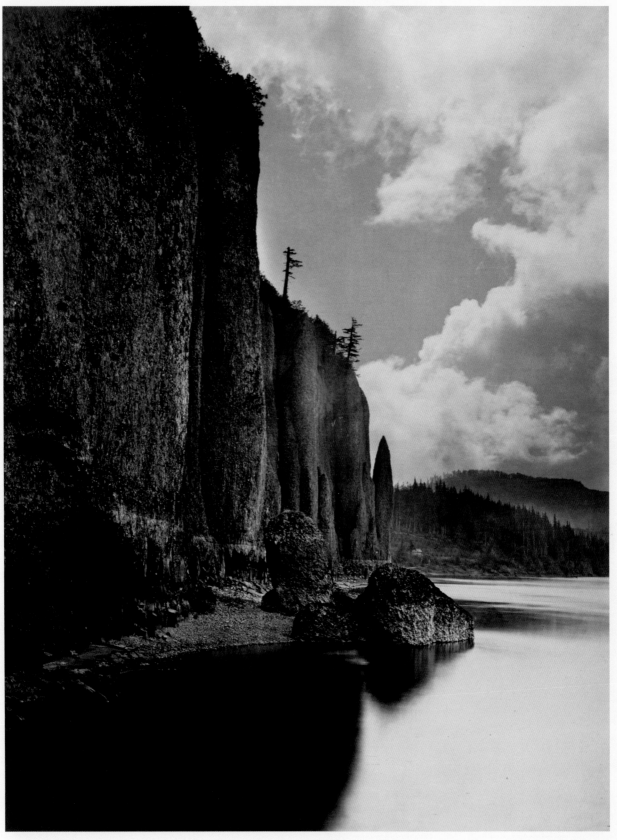

Carleton E. Watkins (American, 1829–1916). *VIEW OF YOSEMITE VALLEY FROM GLACIER POINT*, ca. 1875. Albumen print. George Eastman House collections.

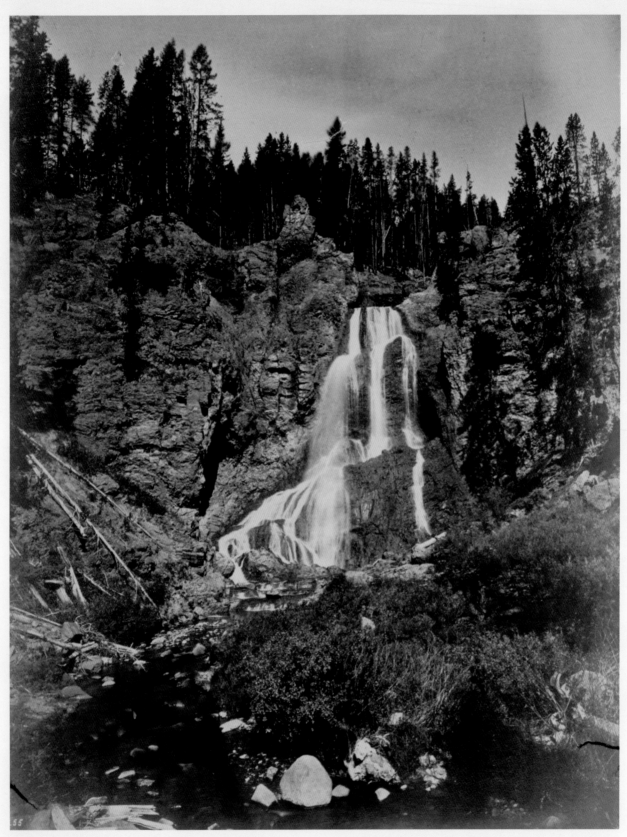

William Henry Jackson (American, 1843-1942). *CRYSTAL FALLS, ON CASCADE CREEK. BETWEEN THE UPPER AND LOWER FALLS, YELLOW-STONE SERIES*, 1871. Albumen print. Museum purchase, ex-collection Charles Carruth. George Eastman House collections.

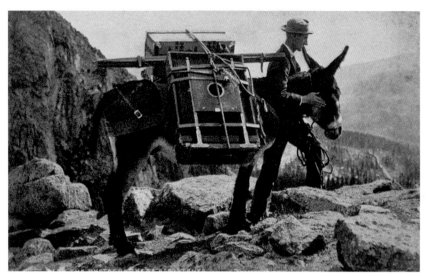

William Henry Jackson (American, 1843–1942). *THE PHOTOGRAPHER'S ASSISTANTS*, 1886. Albumen print. Courtesy of Gift of Beaumont Newhall, University New Mexico Art Museum, Albuquerque, 79.21.

Jackson's photos of Yellowstone helped create the first national park. Written accounts of earlier expeditions breathlessly told of gushing geysers, glowing hot springs, roaring waterfalls, and soaring mountains. It all sounded a bit too grand to be believed. But seeing Jackson's pictures was believing. Preservationists bound nine of Jackson's best photographs into individual gold-embossed volumes (enhanced by written accounts from conservation experts) and presented a copy to each U.S. Representative and Senator. On March 1, 1872, President Ulysses S. Grant signed the bill that created Yellowstone National Park.

WOMEN, CHILDREN, CELEBRITY

ABOUT THE SAME TIME that Brady showed what men looked like after dying in battle, Julia Margaret Cameron's daughter was 3,500 miles away, presenting her mother with a camera. Cameron (1815–1879) "longed to arrest all the beauty that came before me." She managed this through staged portraits of ethereal women and children, the greatest of the Victorian period.

Like many well-to-do women of her day, Cameron led a quiet life. But as her biographer Colin Ford noted, she was armed with an "iron will and irrepressible zeal." She persuaded Alfred Lord Tennyson, Charles Darwin, Henry Wadsworth Longfellow, Thomas Carlyle, Robert Browning, Sir John Herschel, and a host of some of the most notable people in the world at that time to pose for her.

Her pictures—especially those of women and children—were at once bold and tender. Often seeming underexposed and blurry, the photographs work both despite and because of that unique appearance. Beaumont Newhall, the eminent photo historian and former curator of George Eastman House, said of Cameron: "She blundered her way through technique, resorting to any means to get desired effects." Arguments have centered on whether such effects were intentional or a kind of happy accident that occurs when subject movement serves to enhance vitality. Ford contends persuasively that she was a great wet-plate photographer who knew precisely what she was doing.

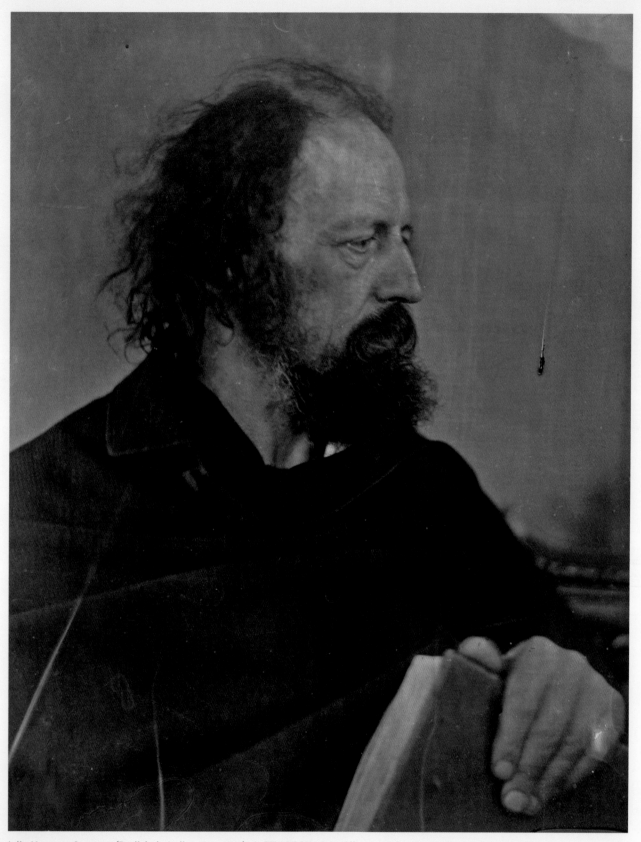

Julia Margaret Cameron (English, b. India, 1815–1879). *A. TENNYSON*, 1865. Albumen print. George Eastman House collections.

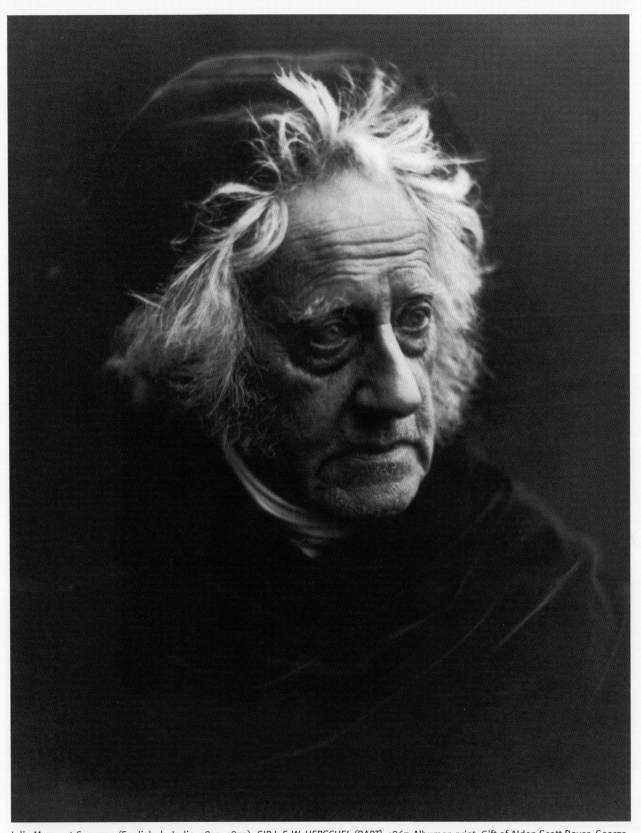

Julia Margaret Cameron (English, b. India, 1815–1879). *SIR J. F. W. HERSCHEL (BART)*, 1867. Albumen print. Gift of Alden Scott Boyer. George Eastman House collections.

Carte-de-visite camera (owned by André-Adolphe-Eugène Disdéri), ca. 1860. See page 64.

IV

TINKERING

André-Adolphe-Eugène Disdéri, *DUC DE COIMBRA*, ca. 1860. See page 65.

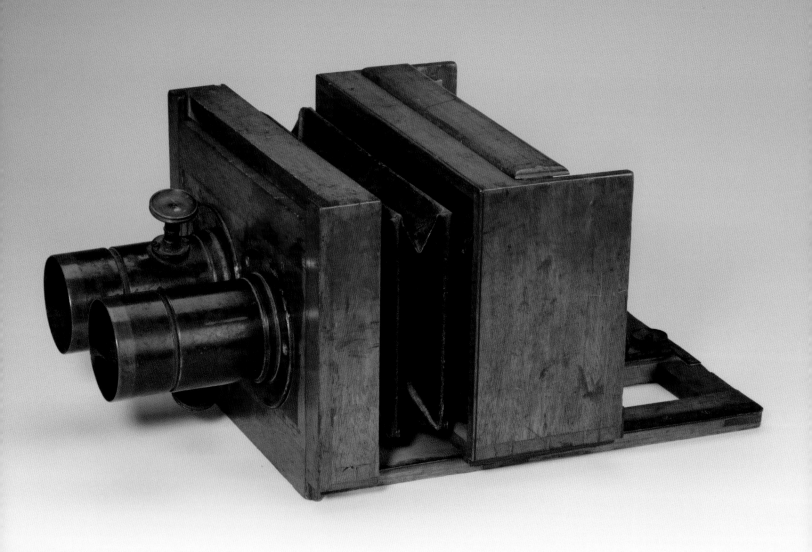

THE ENGLISH PHYSICIST Sir Charles Wheatstone (1802–1875) documented in 1832 the way in which human stereoscopic vision works. By the early 1860s, stereo cameras using two lenses had become common.

The stereo camera's design mimics the function of human eyes. Just like our eyes, the stereo camera's lenses are 2½ inches apart. That distance allows binocular vision—the ability to perceive depth. (There are also single-lens stereo cameras that take two separate exposures with the user moving the entire camera along a track to designated "eye" positions for each exposure.)

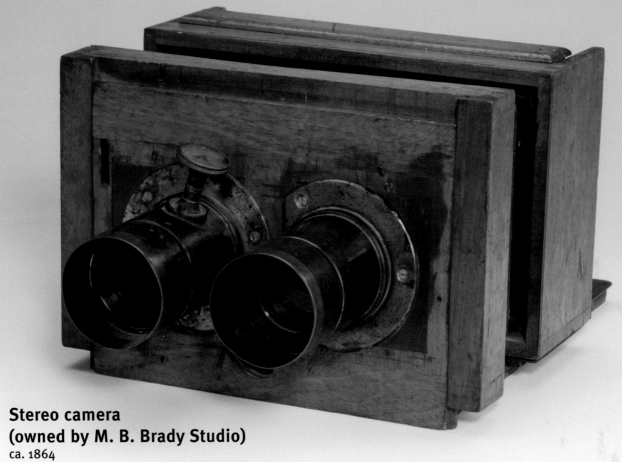

Stereo camera
(owned by M. B. Brady Studio)
ca. 1864

John Stock & Company, New York, New York. Gift of Graflex, Inc. 1974:0028:3542.

John Stock & Company manufactured double-box and stereo cameras in New York City during the 1860s. This camera, a folding-bed stereo model fitted with C. C. Harrison Petzval portrait lenses, made a pair of 4½ x 4¼-inch stereoscopic images on a 4½ x 8½-inch wet plate. After printing, the images were separated, cropped to 3 x 3 inches, and coupled again on standard 3¼ x 6¾-inch stereograph mounts.

Both this and the Nelson Wright double-box camera were found with an assortment of M. B. Brady Gallery glass plates in Auburn, New York, hence the Brady association.

The stereo camera made side-by-side sets of pictures (called stereo pairs) that fooled the brain. When someone peered into a stereoscope, the pictures fused, the brain saw no reason to think anything wrong, and people—at first—fell out of their chairs. But novelty in photography suffers from the "cheap shoe" phenomenon: just as people get comfortable, the fit wears out.

The stereo camera shown here may have belonged to the M. B. Brady Gallery. Made by John Stock & Company of New York City, the Brady stereo camera produced 4½ x 4¼-inch stereoscopic negatives. When printed, the resulting "twin" photographs were cropped to a standard 3 x 3 inches to fit onto the standard stereograph mounts, measuring 3¼ x 6¾ inches.

Stereo tail-board camera
ca. 1860
Unidentified manufacturer, France. Gift of Eastman Kodak Company, ex-collection Gabriel Cromer.
1974:0037:1000.

Produced by an unknown French manufacturer, this wet-plate stereo camera is fitted with a pair of Derogy Optician Petzval-type portrait lenses that are slotted to accept Waterhouse stops. It is a folding-bed bellows camera with an internal septum to maintain image separation within the negative of 5 x 8 inches that was the standard size for stereo photography during the nineteenth century. The resulting print would be cropped into two 3 x 3-inch images to be mounted on 3¼ x 6¾-inch stereo cards.

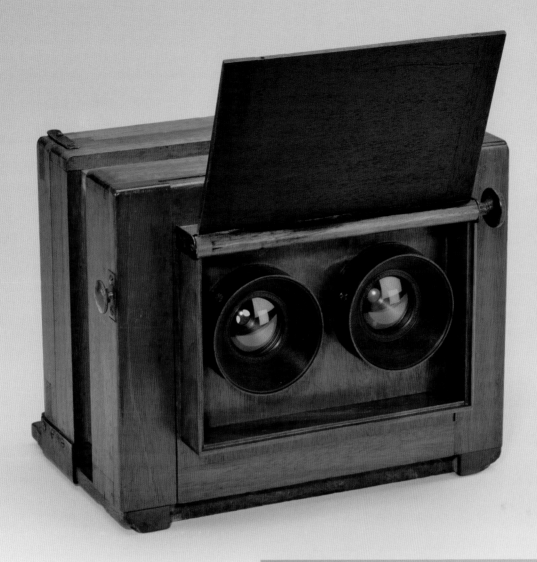

Stereo wet-plate camera with globe lenses
ca. 1860

Unidentified manufacturer, United States. Gift of 3M Foundation, ex-collection Louis Walton Sipley.
1977:0112:0001.

Most likely manufactured by one of the New York City camera companies in the early 1860s, this fixed-bed double-box stereo camera is fitted with a pair of Harrison & Schnitzer globe lenses. One of the earliest type of wide angle lens, the globe lens is named for the shape of its exterior. Using a hinged flap "shutter," the camera exposed stereoscopic images on 5¼ x 8¾-inch wet plates. When printed, the images were separated, cropped to 3 x 3 inches, and paired on standard 3¼ x 6¾-inch stereograph cards.

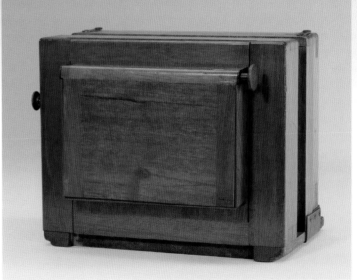

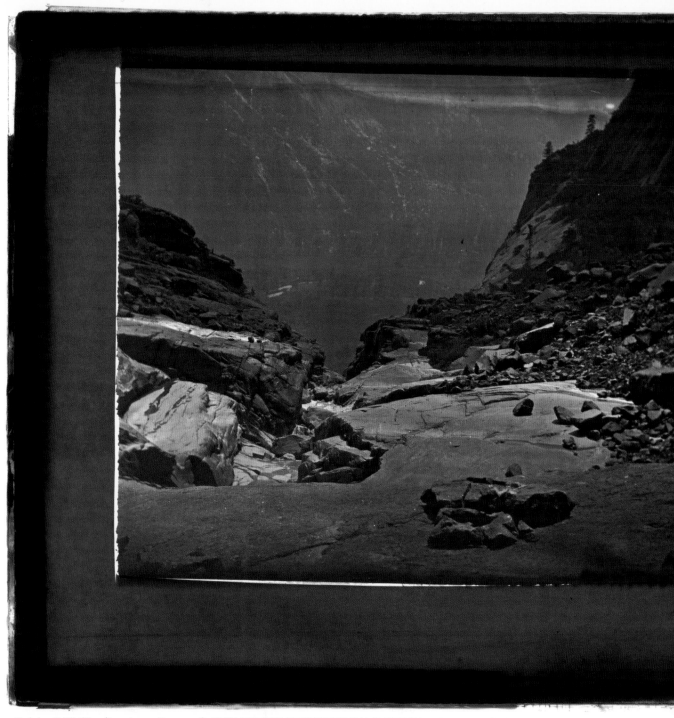

Carleton E. Watkins (American, 1829–1916). *FROM THE FOOT OF THE UPPER FALL OF THE YOSEMITE*, 1861. Collodion positive (glass stereograph). Gift of C. R. Witherspoon. George Eastman House collections.

Handheld stereoscopes brought you in to a little theater. Your eyes fitted snugly into the device and like horse-blinders, they blocked out all peripheral surroundings. The stereo card resembled a postcard with two seemingly identical pictures printed side by side. But the slight shift in perspective that was created by the 2½-inch separation of the camera lenses proved quite startling.

A thrilling view of the Matterhorn taken from a cliff's edge alerted the brain that you were about to

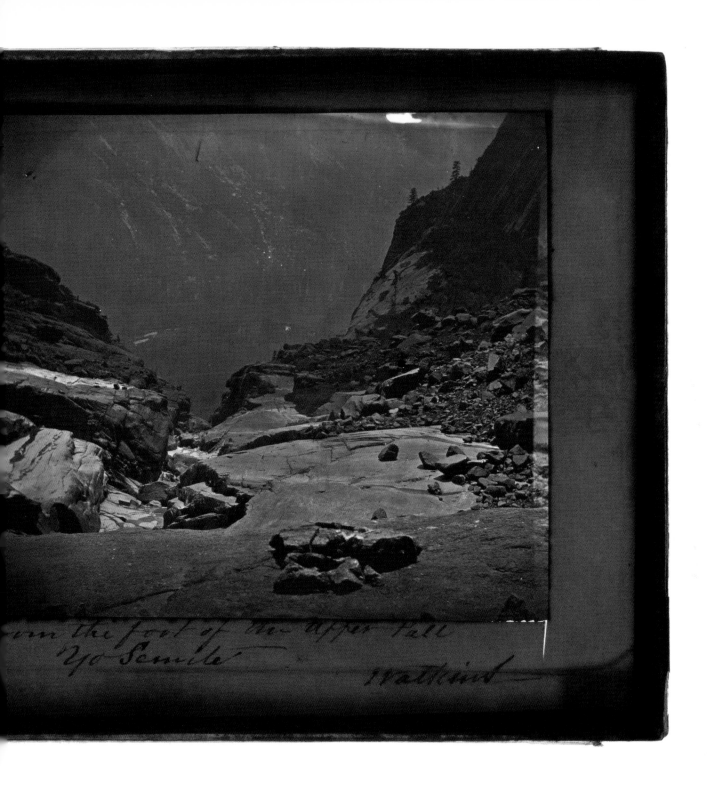

tumble off a mountain. Demand for stereoscopes raced all around world. Hundreds of thousands of stereographs of everything from landmarks, exotic lands, famous views, and celebrities were produced and quickly snatched up.

In the early 1920s, three-dimensional movies called anaglyphs were also briefly popular. As the nineteenth century wore on, cameras and photographs continued to improve. Two developments—one a process, the other a camera—brought about major reductions in cost.

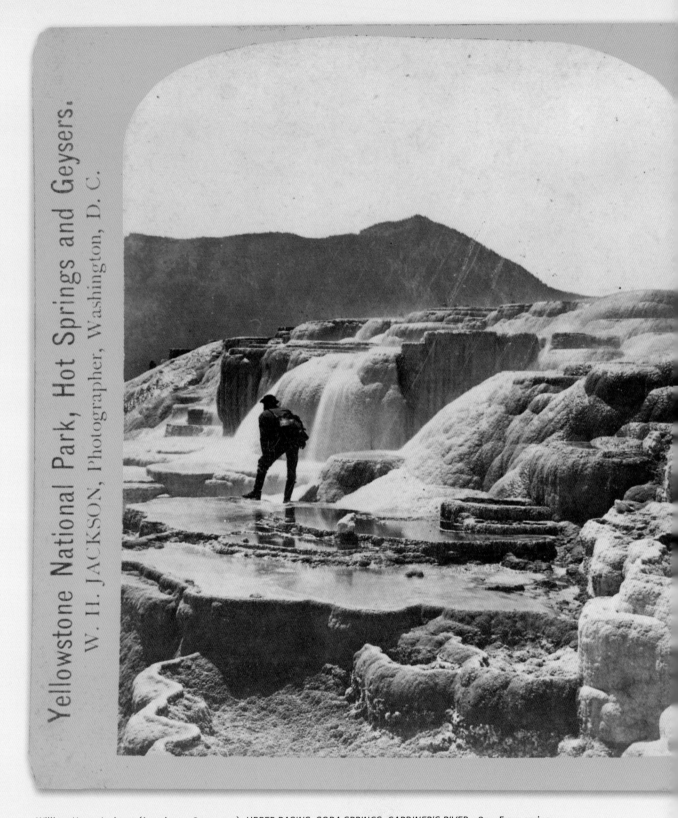

Yellowstone National Park, Hot Springs and Geysers.
W. H. JACKSON, Photographer, Washington, D. C.

William Henry Jackson (American, 1843–1942). *UPPER BASINS. SODA SPRINGS. GARDINER'S RIVER*, 1871. From series: *Yellowstone National Park, Hot Springs and Geysers*. Albumen print (stereograph). George Eastman House collections.

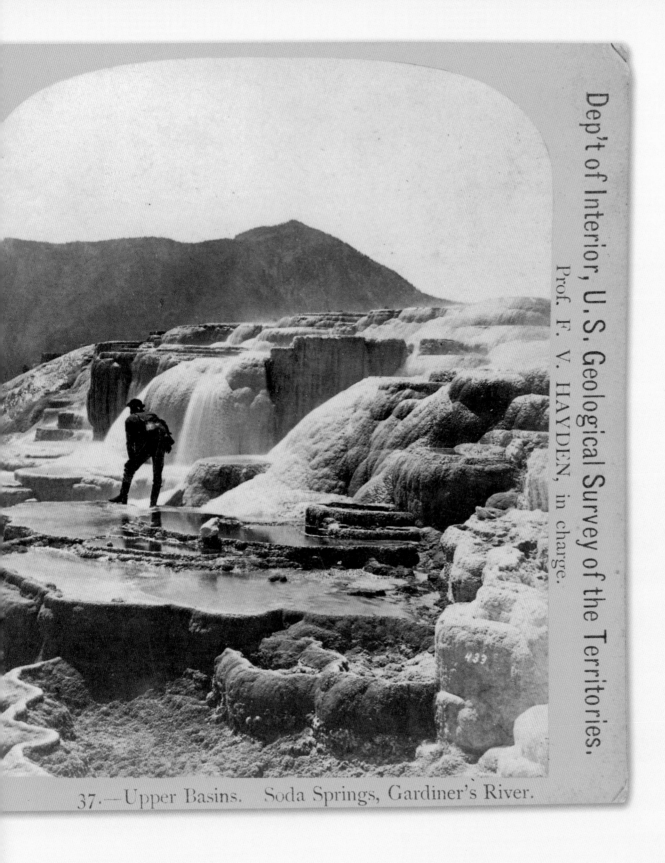

Dep't of Interior, U.S. Geological Survey of the Territories.
Prof. F. V. HAYDEN, in charge.

37.—Upper Basins. Soda Springs, Gardiner's River.

Stereo Photography

In 1938, an inventor named William Gruber realized that new Kodachrome film could be used to produce seven stereo pairs he could mount in circular discs and resolve through an inexpensive handheld viewer. The View-Master was introduced a year later and has been available as a children's device ever since. A stereo resurgence took place in the early days of TV during the 1940s and 1950s when the View-Master device with its cardboard wheels of 14mm Kodachrome transparencies became one toy adults loved to look through.

In 1982, the ingenious $250 Nimslo camera combined four half-frame 35mm images to produce lenticular prints that created the stereo illusion. In 1985, Polaroid announced a service to aid consumers in making their own holograms. Neither, however, ever caught on.

It is worth noting that in 1985 Dieter Lorenz, a German meteorologist, published *The Stereo Image in Science and Technology*, a spiral-bound edition that traces the history of the technology and includes dozens of stereo illustrations in color that can be viewed through the red-and-blue-lensed glasses supplied. It at once demonstrates both how remarkable and how limited the technology can be. Stereo photography is most in evidence today in the small holographic images on your credit card.

Telephot Vega Stereoscopic camera

1906
Véga S. A., Geneva, Switzerland. Gift of Roland Leblanc. 1974:0037:2009.

What may look like a 1950s-vintage clock radio is actually the Telephot Vega Stereoscopic camera of 1906. Manufactured by Véga S. A. in Geneva, Switzerland, the ingenious lens paths made this telephoto stereo camera special. Using two mirrors in each lens path, it not only shortened the twenty-two-inch focal length to make the camera body smaller, it also crossed the projected images, left lens to right image, so that the images are in the correct position and prints can be made without inversion. The lenses individually rack forward for focus, and the plate holder slides out three inches to further aid in the compactness of the camera. Intended for telephoto photography, the lenses are spaced approximately ten inches apart, more than triple a "normal" interocular distance, for a heightened stereo effect.

Verascope

ca. 1908
Jules Richard, Paris, France. Gift of D. L. Stern. 1974:0037:2297.

Stereo photography became more popular when manufacturers designed miniature cameras for roll film. The Verascope line of small stereo cameras from Jules Richard of Paris was of very rugged and durable all-brass construction, with function more important than style. This Model 6a from 1908 took 45 x 107-mm glass plates or could be fitted with the roll film holder as shown. The entire lens/shutter assembly, which consisted of six-speed Chromonos shutters behind a pair of Zeiss Tessar 55mm f/6.3 lenses, could be moved upward to correct perspective. A reflex finder between the lenses moved up as well to give an accurate view. The bubble level on top of the body was important for aligning the pairs. When new, the Verascope 6a cost $232 and the roll-film holder added another $52.

Homéos

1914

Jules Richard, Paris, France. Gift of Eastman Kodak Company,
ex-collection Gabriel Cromer. 1974:0037:2003.

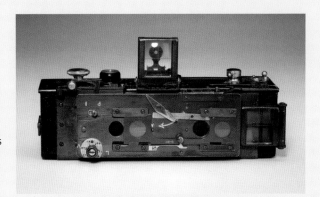

The Jules Richard firm of Paris was noted for its line of Verascope stereo
cameras dating back to the 1890s. Added to the Richard catalog in 1914,
the Homéos was the first stereo camera to use perforated 35mm ciné film
instead of glass plates or larger film rolls. Taking full advantage of the film's
narrowness, the designers created a very compact body. The lenses, either
Optis or Krauss 28mm f/4.5, made stereo pairs measuring 19 x 24 mm.
A folding Newton finder and bubble level atop the body helped the
stereographer compose scenes. A similar finder on the left side of this
1920 model, which had a slide to cover one lens for single-frame non-
stereo pictures, was for shooting single-frame horizontal-format pictures
with a vertically held camera.

Deckrullo Stereo Tropical

ca. 1921

Contessa-Nettel AG, Stuttgart, Germany. Gift of 3M Foundation, ex-collection
Louis Walton Sipley. 1977:0415:0128.

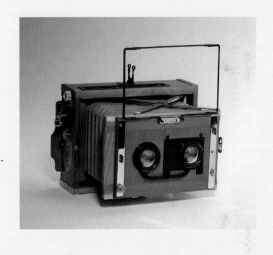

The Deckrullo Stereo Tropical, manufactured from 1921 to 1925, was the product of
Contessa-Nettel AG, a newly merged concern in Stuttgart, Germany. In 1926, the
company was part of a larger merger that formed the new firm Zeiss Ikon from the
firms of Ernemann, Goerz, and Ica. The tropical Deckrullo is a beautiful folding
teakwood-bodied stereo plate camera with tan leather bellows and nickel-plated trim.
The word "Deckrullo," meaning "covering roller blind," indicates it has a focal-plane
shutter, in this case with speeds to 1/2800 second. Available in several sizes, this
model 332 is the 10 x 15-cm plate size, with twin f/4.5 Carl Zeiss Jena lenses. An
ingenious feature of this camera is the ability to convert from stereo to panoramic
images. One of the lenses is mounted in an eccentric flip-over lens board, and with
the slightly shifting front standard, that lens can be centered for a panoramic single
exposure. At introduction, the retail price in the U.S. was $268.

Heidoscop (6 x 13 cm)

ca. 1925

Franke & Heidecke, Braunschweig, Germany. Gift of Franke & Heidecke.
1974:0037:2014.

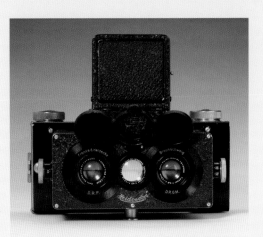

Stereo photography has been in and out of fashion several times since it was invented in
the 1840s. Franke & Heidecke of Braunschweig, Germany, began business in 1920, hoping
to cash in on the latest upswing in three-dimensional pictures. Their first product strongly
resembled a 1913 Voigtländer design by having a reflex viewfinder with its own lens set
between the matched pair of taking lenses. The Heidoscop had two Carl Zeiss Jena 7.5cm
f/4.5 Tessars focused in unison with the center lens. A ground glass on the top of the black
leather-covered body was the same size as the images on the 6 x 13-cm glass plates. Roll
film was rapidly gaining on glass plates in popularity, so Franke & Heidecke designed a
slide-in holder for 120 film. A later version made exclusively for roll film was sold as the
Rolleidescop. The reflex viewer and 6 x 6-cm format were later used for a non-stereo
camera that elevated Franke & Heidecke to world fame—that camera was named Rolleiflex.

Kirk Stereo Camera

ca. 1942

Kirk Plastic Company, Los Angeles, California.
1974:0037:2501.

Introduced in 1942, the Kirk Stereo Camera was constructed in an art deco style of brown marbleized "Plastonyx." It had two lenses with "Dual Synchro-Shutters" and a direct vision finder, with the option of a matching battery-powered viewer. Using No. 828 roll film, which allowed for either black-and-white or color (Kodachrome), it produced six 26 x 28-mm stereo slide pairs. The camera and viewer retailed for $29.75 in 1942.

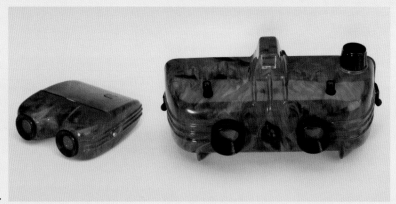

Stereo Realist Model ST41

ca. 1950

David White Company, Milwaukee, Wisconsin.
Gift of Dr. Iago Galdston. 1982:1620:0005.

The Stereo Realist Model ST41 was introduced in 1950, early in the 35mm stereo craze that ran until the mid-1950s. It was a high-quality, attractive, reasonably priced camera that embodied good quality lenses, rangefinder focus, and a parallax-free central viewing lens. Focus was achieved by moving the film plane, thus assuring perfect lens alignment. It retailed for $162.50 in 1950 and for analog (film) photographers is considered the first choice for stereo photography today.

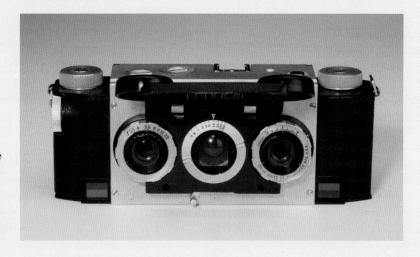

Kodak Stereo (35mm)
ca. 1954
Eastman Kodak Company, Rochester, New York. 1974:0037:2023.

The Kodak Stereo camera was introduced in 1954. Not the first of the 35mm stereo cameras, its introduction acknowledged the rebirth of stereo views and the 3D fascination popularized in the 1950s by Hollywood movies and products such as the Sawyer View-Master. This revived interest, along with a ready availability of supplies, made stereo cameras quite popular. The Kodak Stereo camera had a built-in spirit level, visible in the viewfinder, to assure the proper stereo effect.

The Kodaslide Stereo Viewer was a sturdy, attractive, art deco-inspired Bakelite viewer, available in both battery-powered and line power versions. It featured an interocular adjustment, focus, and brightness controls.

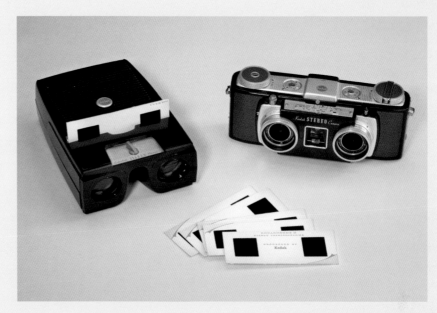

Stereo Mikroma II
ca. 1961
Meopta, Prague, Czechoslovakia. 1974:0037:2989.

Introduced in 1961, the Stereo Mikroma II was a revised version of the Stereo Mikroma, having added automatic shutter cocking with film advance. Both models originated as a stretch of the original Microma 16mm subminiature, which used single perforated 16mm film. The stereo versions produced twenty-two horizontal stereo pairs, 13 x 12 mm in size, from a roll of film. The cameras were available in black, brown, and green, and accessories included ever-ready cases, viewers, film cutters, and close-up attachments.

The manufacturer was founded in Czechoslovakia as Optikotechna, becoming Meopta after World War II, and today is a major optical supplier worldwide.

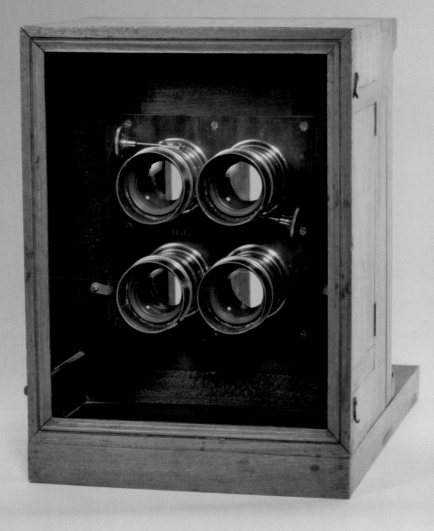

Carte-de-visite camera (owned by André-Adolphe-Eugène Disdéri)
ca. 1860
Unidentified manufacturer, France. Gift of Eastman Kodak Company, ex-collection Gabriel Cromer. 1974:0037:2590.

Produced by an unidentified French manufacturer, this camera belonged to photographer André-Adolphe-Eugène Disdéri. Disdéri patented a method of producing eight carte-de-visite images (visiting or business card, in reference to the 3½ x 2½-inch image size) on a single wet collodion plate. The camera is of the double-box type with a repeating back, which allowed the plate holder to slide from side to side, doubling the number of images per plate. Access to focus the four Petzval portrait lenses was through the hinged doors mounted on the camera's sides. In essence, the Disdéri carte-de-visite system lowered the cost of making portraits.

NEGATIVES TO POSITIVES AND VISITING CARDS

SHORTLY AFTER FREDERICK SCOTT ARCHER invented the wet-plate process to produce negatives, he showed how it could also produce positives. The result was the ambrotype, a name taken from the Greek word *ambrotos*, meaning "imperishable." The ambrotype was an underdeveloped negative that was placed in a cheap holder atop black paper or cloth. The black backing reversed the tones, giving the negative the appearance of an acceptable photograph.

The carte-de-visite camera, an innovation in camera design, also lowered the cost of photography. It made multiple pictures on a single wet plate, either simultaneously or incrementally. Patented in 1854 by the Parisian photographer André-Adolphe-Eugène Disdéri (1819–1889), it used four Petzval portrait lenses to produce eight images on a single wet collodion plate.

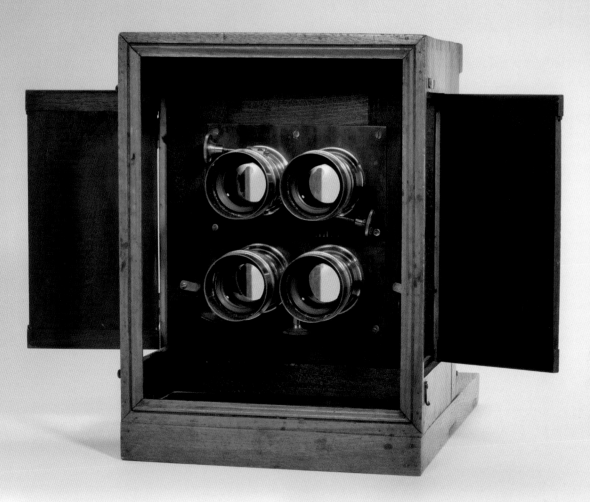

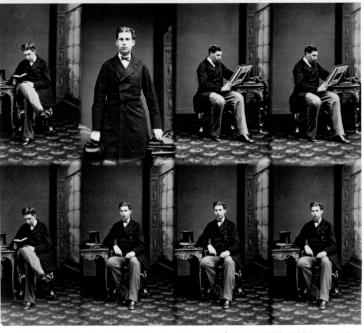

André-Adolphe-Eugène Disdéri (French, 1819–1889). *DUC DE COIMBRA*, ca. 1860. Albumen print, uncut carte de visite sheet. George Eastman House collections.

Wing Multiplying Camera
ca. 1862
Simon Wing, Boston, Massachusetts. Gift of the Wing Estate. 1974:0037:2889.

In the early 1860s, Simon Wing (1826–1910) of Boston, Massachusetts, introduced a number of studio multiplying cameras that, as the name suggests, allowed photographers to make an increased number of images on a single plate. This was achieved by moving either the lens or the back to allow exposure of different areas of the plate. Such cameras were commonly used in the production of tintypes, which were inexpensive direct-positive collodion images on a thin metal plate. Wing recognized the popularity of his apparatus for making tintypes and in 1863 patented a card mount that enabled the metal images to be displayed in the pages of photographic albums.

This particular camera could be fitted with a single lens or a four-lens set. Depending on the lens and back configuration, a single image or up to seventy-two images could be produced on a single 4 x 5-inch plate.

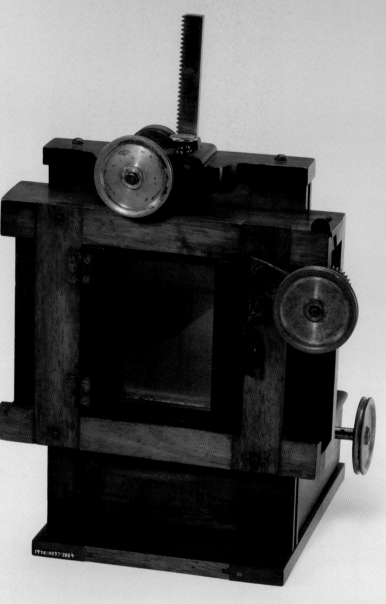

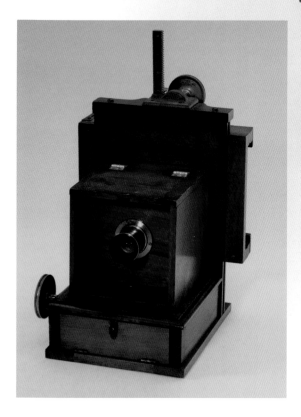

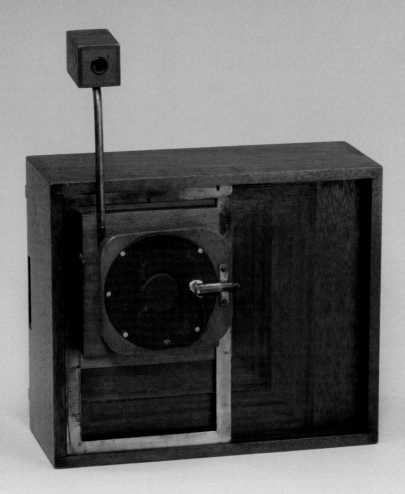

New Gem Repeating Camera
ca. 1882
Simon Wing, Charlestown, Massachusetts. 1974:0037:0155.

Simon Wing designed his New Gem Repeating Camera in 1882 to make fifteen 1 x 1⅛-inch images on a 5 x 7-inch metal "tintype" plate. The New Gem could do this by means of its moveable mount for the Darlot 120mm f/6 periscopic lens. The mount could be locked in one of three vertical positions in the brass frame, which itself was free to move sideways to be set at each of the five scribed marks. Overlapping sliding panels moved with the lens board to seal against light leaks. Inside the hardwood box, a rectangular wooden tube that moved with the lens, and extended to almost touch the plate, kept the image edges distinct. An eye-level viewfinder was mounted on a brass stalk attached to the moveable board so it was always aligned with the lens. The shutter was attached to the front of the lens and operated by a squeeze bulb and rubber tube. After development, the plate was cut apart to make the postage-stamp size pictures. Wing's Charlestown, Massachusetts, camera works priced the New Gem at $6.50.

Lower costs per portrait meant more business. The carte de visite took hold in Europe in the 1850s. Its popularity picked up speed in 1859 when Disdéri photographed Napoleon III. It flourished in the U.S. when Civil War soldiers sought inexpensive portraits as souvenirs for—or from—loved ones at home.

The carte-de-visite camera on pages 64 and 65 illustrates the design of the device. Its manufacturer is unknown, but according to collector Gabriel Cromer,

the camera belonged to none other than Disdéri himself. Using four lenses and a sliding plate holder to double the number of images, Disdéri's camera could produce eight carte-de-visite images (3½ x 2½-inch size) on a single wet collodion plate.

Using a sliding double-box to focus, the versatile Disdéri camera featured a movable (or repeating) back. The plate was about twice the size of the image area used by the four lenses. When the photographer

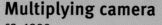

Multiplying camera

ca. 1900

Jacob Schaub, Logan, Utah. Gift of Dr. Raymond J. Bungard.
1992:1043:0001.

The multiplying camera had been around for more than four decades before Jacob Schaub of Utah patented his in 1900. The idea was to divide a plate or sheet of film into equal parts and expose each portion with a separate image. Some designs utilized moveable lenses, others multiple lenses, and some used both. Schaub's had one fixed lens, but the back could be indexed for six, fifteen, or twenty-four pictures. Inside the bag bellows a square tube behind the lens could accept one of the three reducing extensions according to image size desired. After that, the squeeze bulb opened the shutter, and the ground glass viewed while turning the lens focus knob, after which the shutter was closed again. Inserting a plate holder was easy with the bail lever that pulled the focus screen back far enough to slip in a holder without effort. Brass leaf springs secured the holder when the bail was released. A unique system of dividing the plates into equal sections used three rows of equally spaced holes in the back adjustment gear rack covers. A lever under each cover had a pin to fit the holes and lock the back for each exposure. The levers themselves were pivoted and locked in place to pick up the correct series of dividing holes. Schaub's camera never took off and only a few were made.

filled one half of the plate, he simply slid it over so that the unexposed half of the plate was now behind the lenses.

Because the four lenses could be covered or uncovered during picture taking, the photographer could either uncover all four lenses and get four pictures of one pose (or eight if the sitter held the pose while the photographer slid the plate over for the next series of four), or he could alternately cover and uncover lenses, creating a different pose for each lens.

An interesting side effect of using fast Petzval lenses with a smaller image size was that exposures could be shorter. Innovations that make picture taking easier

encourage play. Subjects still had to remain frozen when the shutter was open. But the process had become less formal somehow, and mischief entered the pictures. People rakishly tipped their hats, leaned on canes, and began to project a certain gleam in the eye.

Tin pictures in minutes

A DIFFERENT APPROACH to lowering cost by creating multiple images on a plate is revealed by the Wing Multiplying (or repeating) Camera. In the early 1860s, Boston's Simon Wing (1826–1910) introduced

Royal Mail Stamp
1907
W. Butcher & Sons, London, England. 1997:0207:0001.

The Royal Mail Stamp camera, manufactured from 1907 to 1915 by W. Butcher & Sons of London, was another multiplying camera. Unlike the moving lens, moving back cameras, this polished mahogany fixed-focus camera was designed to expose all images simultaneously. Typically, it was used to make multiple copies of carte-de-visite or cabinet portraits, and Butcher offered a copy stand for that purpose. The camera shown here was outfitted with the fifteen-lens front that made fifteen stamp-sized images, $\frac{3}{4}$ x $\frac{7}{8}$ inches each, on a $3\frac{1}{4}$ x $4\frac{1}{4}$ -inch plate. The front was removable, accepting a three-lens set, allowing the camera to produce either three or six exposures.

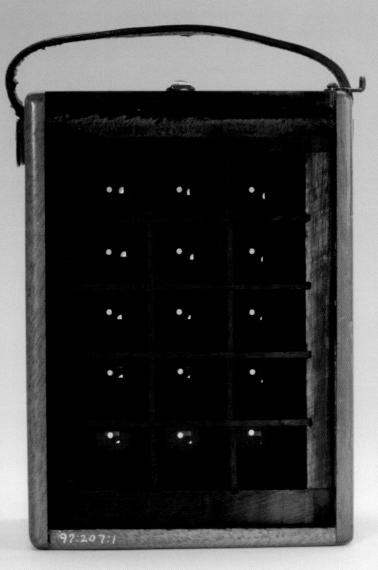

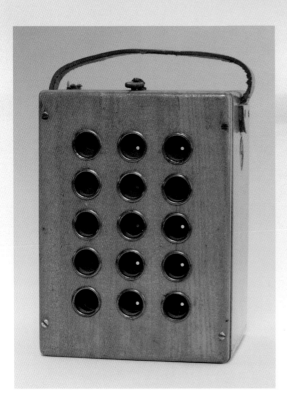

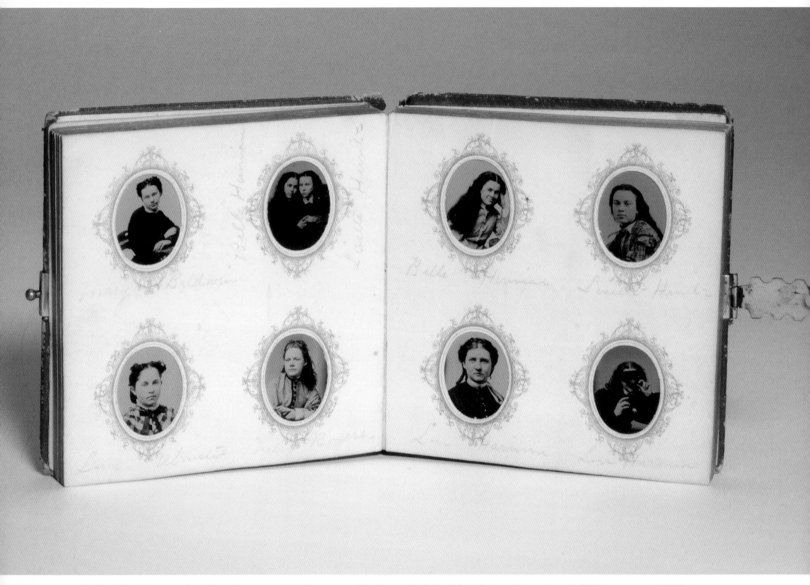

Unidentified photographer. *[Gem tintype portrait album owned by Emma M. Griswold, Lexington, Massachusetts]*, February 24, 1866. Tintypes. Gift of Alden Scott Boyer. George Eastman House collections.

several cameras that made multiple pictures on a single plate, using either a movable lens or plate. The image formed by the lens covered only a fraction of the plate. By precisely moving either the lens or the back, additional pictures could be formed on a single plate. This camera could use either a single lens or four-lens set; it could fit up to seventy-two pictures on one 4 x 5-inch plate.

The wet-plate process could record pictures on many supports, the most common being iron. Ferrotypes,

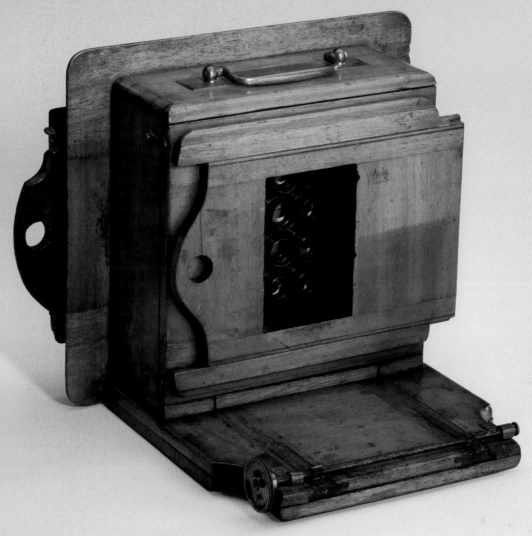

Gem Apparatus
ca. 1880

J. Lancaster & Son, Birmingham, England. Gift of Eastman Kodak Company, ex-collection Gabriel Cromer. 1983:1421:0081.

The Lancaster Gem Apparatus, of about 1880, produced twelve identical "gem"-sized images (less than one inch square) with a single exposure. Small, inexpensive photographs produced on ferrotype plates were very popular in the 1880s and 1890s. The lenses were focused on a ground glass simultaneously and internal partitions kept the images separated. An opening in the sliding front panel served as the shutter, making manually "timed" exposures. The camera's back accommodated wide plates for making more than a single group of images on a plate. Its list price was £5.

more often known as tintypes, were inexpensive and extended the market to people who otherwise might not have afforded pictures.

Roving street vendors took inexpensive, one-off photos wherever people gathered at seaside resorts, public events, and amusement parks, providing finished tintypes in minutes. Since their black support makes the images positive, they were virtually instant pictures. In 1863, Wing patented a card mount to display the metal images in photo albums.

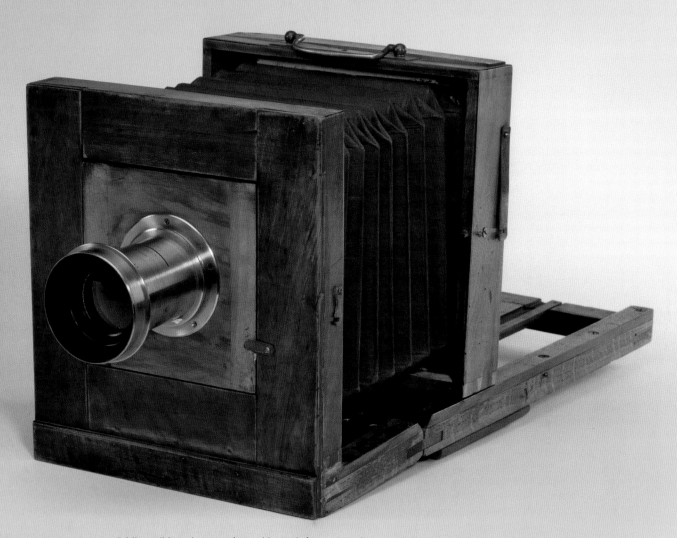

Folding tail-board camera (owned by Nadar), ca. 1860. See page 75.

V

PHOTOGRAPHY AND FAME

Nadar (Gaspard Félix Tournachon), *GEORGES SAND*, ca. 1860. Woodburytype.
See page 75.

Nadar (Gaspard-Félix Tournachon) (French, 1820–1910). *NADAR ÉLEVANT LA PHOTOGRAPHIE A LA HAUTEUR DE L'ART (NADAR RAISING PHOTOGRAPHY TO THE HEIGHT OF ART)*, May 25, 1862. From series: *Souvenirs d'Artistes*. Lithograph. Gift of Eastman Kodak Company, ex-collection Gabriel Cromer. George Eastman House collections.

To fuel the demand for low-cost portraits, photographers collaborated with celebrities in order to create and sell carte-de-visite celebrity portraits. Initially, celebrities sat for free to get the publicity. But when sales exceeded tens of thousands, they requested, and were paid, a commission.

Some celebrity photographers became celebrities themselves (Brady in America, for instance). Then there was Nadar. Like his countryman Daguerre, Nadar (whose true full name was Gaspard-Félix Tournachon) was an outgoing personality with connections to both the artistic and theatrical worlds. People of the *beau monde* came to his Paris studio to chat about weighty matters and to be rendered immortal in one of his portraits. Nadar even photographed Victor Hugo on his deathbed. The French actress Sarah Bernhardt showed up—as did a young American, George Eastman.

The balloon man

Nadar was one of the first to take pictures by artificial lighting, descending into the catacombs winding beneath Paris and then into the underground sewers with his camera and carbon-arc lights. He even purchased and outfitted his own hot air balloon, with which he floated over Paris to take the first aerial pictures in 1858.

Nadar's camera in the collection is a 5 x 7-inch model with a rack-and-pinion focusing system with a

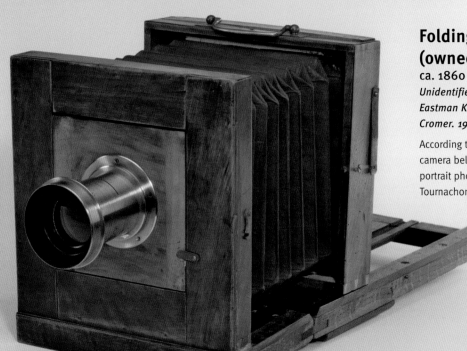

Folding tail-board camera (owned by Nadar)
ca. 1860

Unidentified manufacturer, France. Gift of Eastman Kodak Company, ex-collection Gabriel Cromer. 1974:0028:3510.

According to the collector Gabriel Cromer, this camera belonged to the well-known French portrait photographer Nadar (Gaspard-Félix Tournachon). The camera is a folding-bed 5 x 7-inch wet-plate bellows type, and it employs a bed-mounted rack-and-pinion focusing system. It was produced by an unidentified French manufacturer.

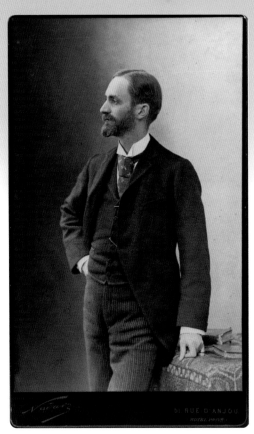

Nadar (Gaspard-Félix Tournachon) (French, 1820–1910). *GEORGE EASTMAN*, 1890. Albumen print. Gift of George Dryden. George Eastman Legacy Collection.

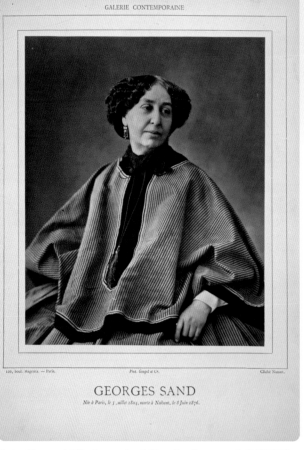

Nadar (Gaspard-Félix Tournachon) (French, 1820–1910). *GEORGES SAND*, ca. 1860. Woodburytype. George Eastman House collections.

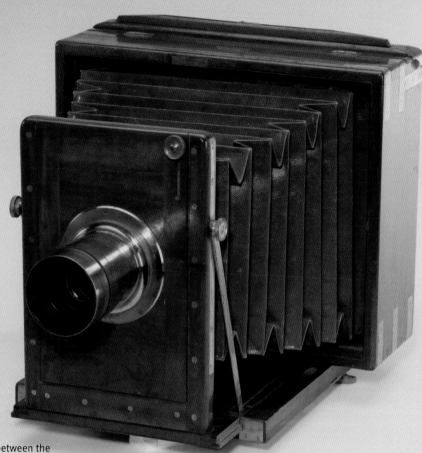

Universal Improved Kinnear Camera (10 x 8)
ca. 1857
W. W. Rouch & Company, London,
England. Gift of John Howard.
1974:0037:2100

The pleated leather bellows was first used
in cameras as a way to adjust the distance between the
lens and the sensitized plate. It occurred to 1850s Scottish
photographer, C. G. Kinnear, that designing a bellows with tapered sides would allow it
to fold almost flat. A camera using C. G. Kinnear's patented bellows design could be folded into a much
smaller package for storage or transport. Kinnear built his own cameras but also licensed his bellows to
other firms, such as W. W. Rouch of London. Their 1857 Rouch Universal Improved Kinnear Camera was
made in several sizes besides this 10 x 8-inch version. The Rouch's front standard was rigidly attached to
the baseboard, which was rabbetted so it could move freely in the grooved wooden guides on each side.
Turning the brass crank below the rear of the mahogany body rotated a threaded rod that moved the base
in or out for focusing. The lens was a Triple Achromatic made by J. H. Dahlmeyer, also of London. The Rouch
was a handy field camera that didn't take up much space in the knapsack or buggy.

folding bed and a canvas bellows. For its time, it was a
modern and innovative camera, perfect for portrait
assignments with esteemed clients. The folding bed
feature improved its compactness for transporting and
storing. When not in use, the hinged front standard
folded into the bed, reducing the camera's size by nearly
half. Now becoming a common feature, a relatively
light canvas-like cloth bellows replaced the need for a
heavy sliding box to achieve rough focus. With the
bellows extended to the appropriate distance for the
subject, the rack-and-pinion focusing system would
move the lens to bring the subject into sharp focus.

Although Nadar's camera may have been state of the
art for its time, another camera would offer even more
features to enhance portability. It used the bellows
design created and patented in the 1850s by the
Scottish photographer C. G. Kinnear and later pro-
duced by the London manufacturer W. W. Rouch.

Rouch knew large cameras remained the bane of field
photographers. They required large heavy glass plates
that were hard to coat. Not much could be done to
reduce the weight or to simplify the coating process,
but the rigid design of the 8 x 10 camera offered possi-
bilities. Kinnear designed a pleated bellows with

Miniature Chambre Automatique de Bertsch

ca. 1861

Adolphe Bertsch, Paris, France. Gift of Eastman Kodak Company, ex-collection Gabriel Cromer. 1974:0037:0001.

Adolphe Bertsch offered a miniature version of the Chambre Automatique that produced circular images two centimeters in diameter. Housed in a fitted mahogany case, the outfit included the camera, twelve plates, chemistry for sensitizing and processing the wet-plate images, and a loupe for viewing the small images.

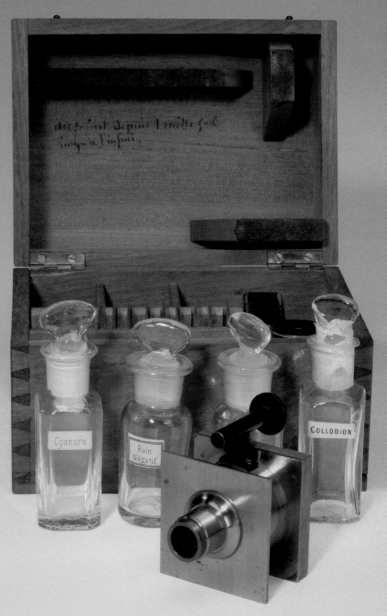

tapered sides that allowed it to collapse into a nearly flat package that reduced the bulk by seventy-five percent, a great relief for field photographers.

MINIATURES

BY THE EARLY 1840s, more than a thousand photographers in Europe and America were clicking away. And millions were buying pictures. The early photographers were mostly taking formal studies of landmarks, landscapes, and people. But by the early 1860s, journalists, doctors, prison officials, lawyers, and dozens of others realized that pictures provided data that no amount of words could convey.

In twenty years photography had swept around the world and made its impact on countless lives—an impact that would become more pronounced with each passing year. But photography was still a daunting process that called for a popular solution.

Adolphe Bertsch took one large step in that direction by creating a small camera. A miniature version of his full-size metal Chambre Automatique (1861), it produced circular pictures each about the size of a thumbnail (two centimeters, or ¼ inch in diameter).

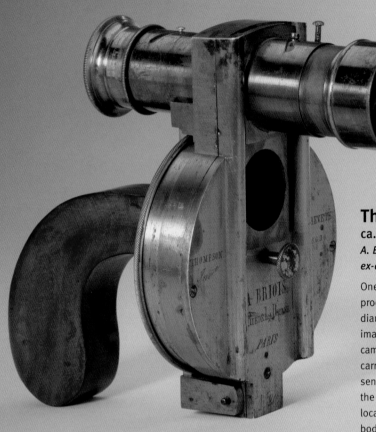

Thompson's Revolver Camera
ca. 1862
A. Briois, Paris, France. Gift of Eastman Kodak Company, ex-collection Gabriel Cromer. 1974:0037:0090.

One of the earliest handheld cameras, Thompson's Revolver produces four one-inch diameter images on a single three-inch diameter wet plate, making it among the first to yield multiple images on circular plates. It also is one of the first "inconspicuous" cameras, meaning it has an atypical appearance. Of course, someone carrying such a camera would surely be conspicuous in the usual sense. In use, the 40mm f/2 Petzval-type lens locks at the top of the camera for focusing and framing the image. Pressing the button located at the three o'clock position on the camera's drum-shaped body allows the lens to then slide down to the picture-taking position, trip the rotary shutter, and expose the plate. Afterward, the disc rotates ninety degrees for the next exposure.

Sold as part of an outfit, the camera came along with twelve plates, chemistry for sensitizing and processing them, a magnifier for viewing the small images, and a handsome mahogany carrying case.

Another departure from the common boxy camera design was the Thompson Revolver Camera (1862). Unlike its earlier counterpart, the Pistolgraph, the revolver camera was meant to be handheld—one of the first to be liberated from the tripod. Following the revolver theme, it was a multishot camera. Its brass cylinder held one circular wet plate capable of producing four one-inch-diameter images—one of the first to produce multiple images on circular plates. The dual function of its 40mm f/2 Petzval-type lens allowed the camera to go from focusing on the image to taking the picture. To focus the camera, the user moved the lens to the top cylinder, which became the viewfinder. To take the picture, the photographer pressed the "shutter button" on the camera's side and the lens then dropped into its image-focusing position at the back of the lower cylinder. When the lens dropped into position, it then tripped the shutter to take the picture.

Preceded by the stereo camera, the carte-de-visite camera, and repeating cameras, the miniature Bertsch and revolver cameras opened new doors in the evolution of the camera. As the uses of and participants in photography multiplied, so did the ideas concerning the design and function of the devices for taking pictures.

A theoretically practical device came from a French inventor fond of anagrams. Applying his own name to his device, Jules Bourdin (1838–1893) patented the Dubroni camera in 1864. It developed pictures inside the camera, becoming, in theory, the first commercially successful "instant picture" processing system.

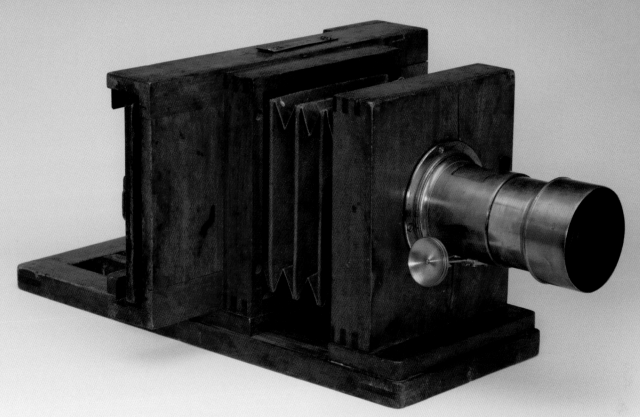

Lewis wet-plate camera
ca. 1862

H. J. Lewis, New York, New York. Gift of Polaroid Corporation.
1981:2814:0005.

Manufactured by H. J. Lewis of New York City and typical of Civil War-vintage studio equipment, this repeating back bellows camera produced two 3¼ x 4½-inch images on 4½ x 6½-inch wet plates. The large box at the back of the camera was used to index the plate holder. The camera's finish has a lovely patina, acquired from both age and heavy use, illustrating its workhorse status. Manufacturer and camera were directly related to W. & W. H. Lewis and their daguerreotype camera. Genealogically, Henry James Lewis was the second son of William and younger brother to William H., while stylistically, the camera is a direct descendant of the daguerreotype apparatus, even retaining the Lewis cast-iron bed locknut.

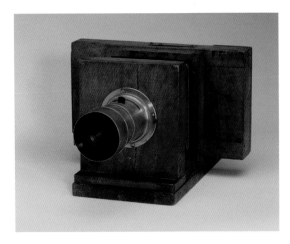

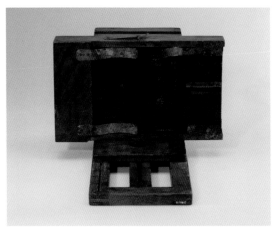

Various photographers. *[Panel of cartes and tintypes, received by post office dead letter office]*, 1861–1865. Albumen prints and tintypes. Museum purchase, ex-collection Phillip Medicus. George Eastman House collections.

Appareil Dubroni No. 1
ca. 1864
Maison Dubroni, Paris, France. Gift of Eastman Kodak Company, ex-collection Gabriel Cromer. 1974:0037:0002.

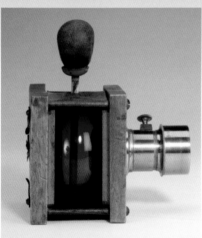

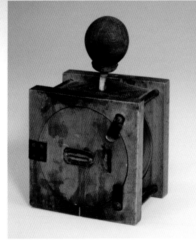

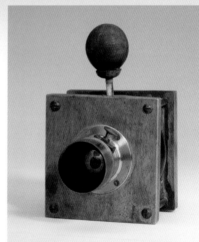

With the Dubroni, the photographer coats the plate with collodion, and then inserts it into the camera. Next, he would tilt the camera backwards and gently squirt the silver nitrate solution over the plate using a pipette in the camera's top. After taking the picture, he would remove the excess silver nitrate solution, develop and fix the plate while still in its glass envelope. By looking through a large yellow window in the camera's rear door, the photographer could see the plate's development stage and stop it when the image seemed fully developed. When he pulled the wet plate from the camera, he would have a fully developed negative.

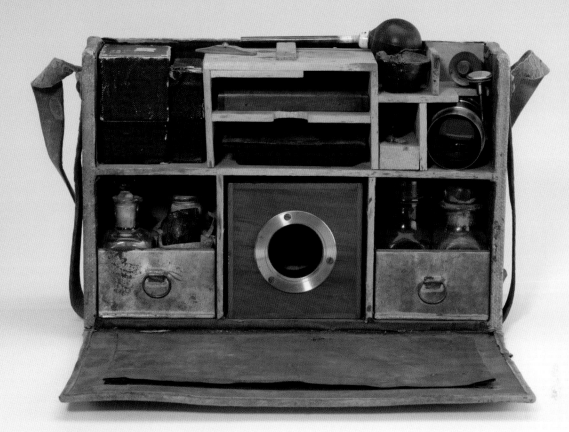

Dubroni Apparatus No. 2
ca. 1864
Maison Dubroni, Paris, France. Gift of Eastman Kodak Company, ex-collection Gabriel Cromer. 1974:0037:2280.

The idea of developing an image in the same apparatus in which it was exposed—usually described as in-camera processing—dates back to the early days of photography. The first of its kind to sell in quantity was the Dubroni, an anagram of the family name of G. J. Bourdin, the Frenchman who patented the camera in December 1864. Sold as a kit, it included everything necessary to produce images in camera.

The apparatus consisted of a small box camera, with a glass or ceramic container fitted inside. In operation, a glass plate was coated with iodized collodion and loaded into the camera. Using a pipette, silver nitrate was then introduced onto the plate through a hole at the top of the camera, sensitizing the plate. After exposure, the plate was left in the camera and developer was introduced by a second pipette, its action observed through the inspection amber glass

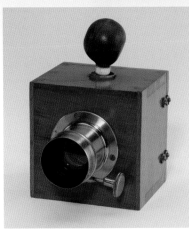

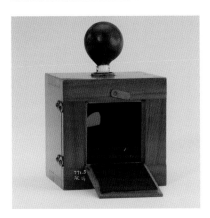

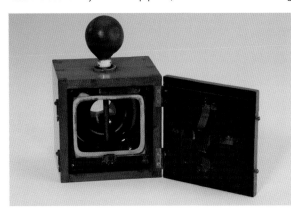

window at the camera's back. When finished, the solution was drained with a pipette. Finally, the plate was washed with water and then taken from the camera for fixing and another wash— a fully processed negative was ready for printing.

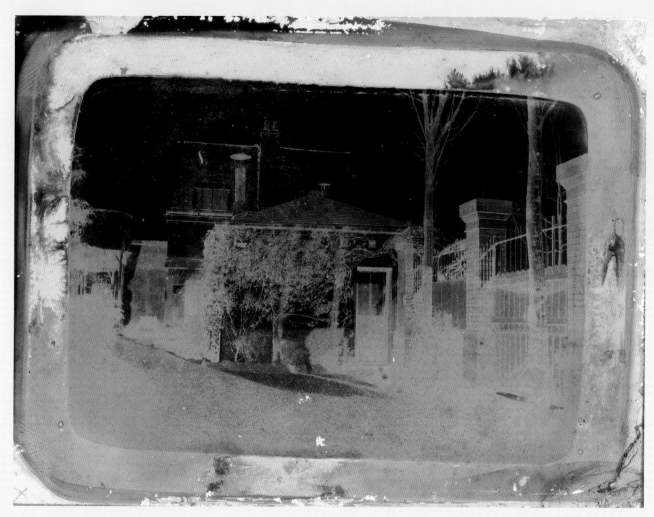

Unidentified photographer. *[Made with Dubroni wet-plate camera]*, ca. 1865. Negative (above), collodion on glass (right). George Eastman House collections.

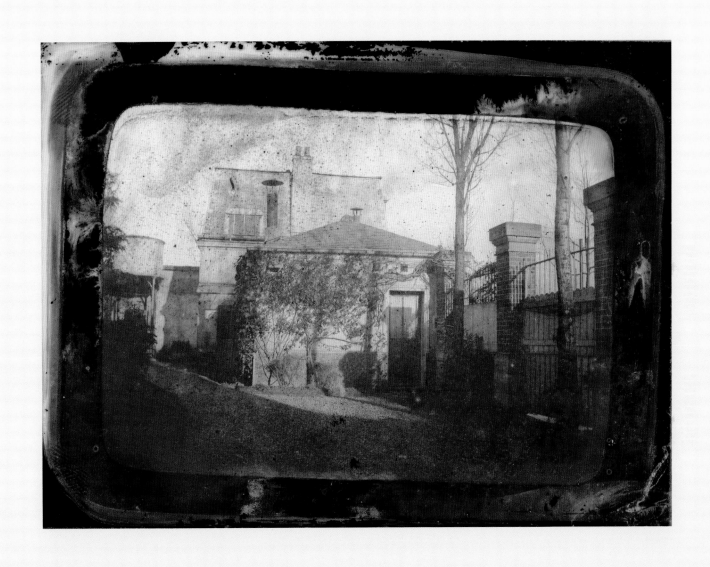

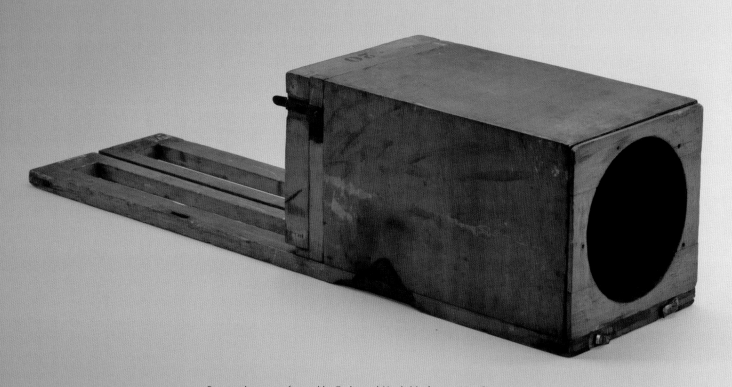

Racetrack camera (owned by Eadweard Muybridge), ca. 1884. See page 93.

FROM WET TO DRY

Eadweard J. Muybridge, *GALLOP; THOROUGHBRED BAY MARE-ANNIE G.*, ca. 1884–1887. See page 94.

THE ADVANTAGES OF THE WET-PLATE PROCESS—primarily the reproducible negative and lower cost—had brought pictures into the lives of ordinary citizens around the globe. It gave photography access to nearly every venue that could benefit from having a visual document of any subject or scene—as long as that subject did not move quickly.

And yet the wet-plate process frustrated everyone who used it. The prepared plate had to be used within minutes, before the coated surface dried and became desensitized.

GELATIN

INVENTORS LONGED TO RETAIN the sharpness and sensitivity of wet plates, without the problems always at hand when working with volatile liquids. The Englishman Richard Leach Maddox (1816–1902), a physician and microscopist, found himself irked when the illustrations he needed for a paper he translated were not available from a French publisher. As he set out to make his own photomicrographs, the toxic collodion process he used was oppressing his mind, if not corrupting his health. Irritation gave birth to a bright idea: why not suspend silver salts in a bromide-gelatin emulsion? When dried, the light-sensitive silver halides remained suspended within the gelatin.

The Maddox dry plates were less sensitive than wet plates. But refinements followed in England in the 1870s by Richard Kennett and Charles Bennett. Kennett stumbled upon prolonged heating of the gelatin-bromide solution as a way to increase the sensitivity of the dry plate so shorter exposure times could be used. He found that if the light-sensitive gelatin solution was heated slowly over several days, its sensitivity would increase.

Bennett found that by briefly boiling only the light-sensitive portion of the gelatin solution, he could avoid causing the wasteful gelatin breakdown (caused by prolonged heating) while increasing the solution's sensitivity to light. The technique of heating the light-sensitive solution is called ripening and is still used in film manufacturing.

Today we could consider the dry plate an example of a "disruptive technology." The wet-plate business began to decline. No longer would photographers have to pack up and shoulder a hundred pounds or more of chemicals, containers, darkroom tents, or boxes. They no longer had to submit themselves to a tiny cramped, stuffy, and foul-smelling tent or box to coat the plate with the wet emulsion in the dark. They no longer had to dash into the brilliant sunlight and slip the wet-plate holder into the camera and take the picture, then dash back to the darkroom to process it before the plate dried.

Picture taking became immensely easier and faster. Only a camera, dry plates, and light-tight dry-plate holders were required. The photographer could develop the plates at leisure—or hand the job off to somebody else.

The long shelf life of dry plates meant that they could be made days, even weeks ahead of time. Dry plates also meant a division of labor and a possibility for standardization of process: somebody else could make the dry plates, somebody else could process them. The photographer need only use them.

The dry-plate process not only made it easier for amateur photographers to get into the game, it made it easier for everyone to take more interesting pictures. Greater light sensitivity meant shorter exposures. Shorter exposures meant stopping action, revealing a new way of seeing the world. Cameras could come off their tripods and be held in the hands.

The gelatin dry plate made photography far more accessible. It transformed it from a profession into a leisure-time pursuit, into a hobby. But a far more disruptive technology was coming along. Gelatin also proved crucial to the invention of film.

Some photographers were slow to abandon their wet-plate cameras. But faster shutter speeds and other

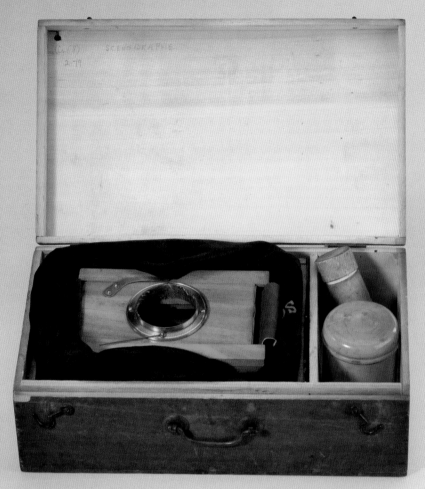

Scénographe
ca. 1874

E. Deyrolle fils, Paris, France. Gift of Eastman Kodak Company, ex-collection Gabriel Cromer. 1974:0037:1970.

An early dry-plate camera, the Scénographe was designed in 1874 to be the last word in lightweight portable cameras. E. Deyrolle fils of Paris kept its bulk to a minimum by using a thin brass sheet for the metal parts and a non-pleated cloth bag as a collapsible bellows. The folding finder and its plumb bob leveler were made of brass wire. Thin hardwood supports were used to keep the bellows taut when the camera was opened. The bottom bellows support had a tripod socket, for this camera was not for handheld use. The recently introduced gelatin dry plates were slow, making exposure times long, and only when supported on the tripod could the flimsy structure remain motionless long enough to take a blur-free 10 x 15-cm picture. As the name implies, the Scénographe was intended for scenic views and came appropriately fitted with a 180mm f/20 landscape lens. Exposures were controlled by the removal and replacement of a brass lens cap. The camera was priced at fifty francs.

improvements through the mid- and late 1870s steadily converted the reluctant. Not long after the great expeditions to the American West, the dry plate had come to dominate.

Camera designs continued to improve performance and lower prices. In 1874, E. Deyrolle fils of Paris designed the Scénographe to be a lightweight, portable camera for dry plates priced at fifty francs. To reduce its weight, Deyrolle minimized the volume of materials by using thin wood panels and thin sheet brass, an unpleated cloth bag for the bellows, and wire for the viewfinder and plumb bob leveler. To increase its compactness, the side panels were made detachable; the bellows could collapse and the wire finder folded down.

The Scénographe still needed a tripod to take sharp 10 x 15-cm pictures. As the name implies, the Scénographe was intended for scenic views. Because

Tourograph No. 1
ca. 1881
Blair Tourograph & Dry Plate Company, Boston, Massachusetts.
Gift of H. Edward Bascom. 1974:0037:2469.

Designed for the challenges of landscape photography, the 1881 Blair Tourograph No. 1 was the first dry-plate camera manufactured in the U.S. The self-contained and portable apparatus was touted as "Photography in a Nut Shell." Sliding front doors protected the lens, and the 5 x 7-inch dry plates were stored within the camera body for transport. In use, an indexed magazine of twelve plates was held in the smaller box located above the camera. Opening a brass dark slide located under each plate allowed the plate to gravity drop into the gate for exposure. Afterwards, the photographer manipulated the exposed plate back into the magazine through a cloth sleeve located at the back of the camera, then closed the dark slide. This procedure was repeated until all plates were used. Its retail price was $30.

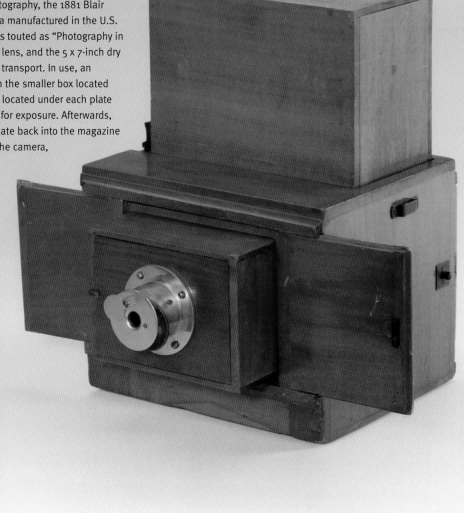

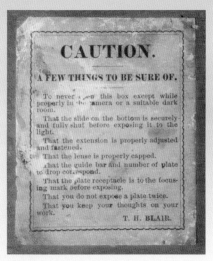

the exposures were long, no precise shutter mechanism was needed. The photographer pulled off a brass lens cap to start the exposure, waited a few seconds, and placed the cap back over the lens when he felt enough light had reached the dry plate.

The first camera manufactured in the United States to be used specifically with dry plates was the 1881 Blair Tourograph No. 1. Also a first, a dozen dry plates stored waiting for use in the magazine located on the top of the camera, each indexed with its own dark slide. Pulling out the slide allowed a fresh plate to gravity drop into the camera for exposure.

The great promise of the dry plate was its potential to simplify the business of taking pictures. For that to happen, cameras needed to become easier to operate. A big step in that direction was Walker's Pocket camera.

Walker's Pocket camera
ca. 1881
William H. Walker & Company, Rochester,
New York. Gift of George C. Clark.
1974:0037:1600.

"Photography made easy for everybody" was William H. Walker & Company's advertising slogan for Walker's Pocket camera in 1881. The Rochester, New York, firm sold the wooden box camera for ten dollars, including a double holder for 2¾ x 3¼-inch plates. Although it's doubtful anyone had a pocket roomy enough to carry the camera, ease-of-operation was as claimed. A swiveling tripod mount allowed easy leveling. Slipping the gravity-powered shutter assembly from the 3½-inch f/7.7 achromatic meniscus lens allowed the subject to be viewed on the ground glass back. With the shutter replaced and set in the upper position, the viewing door was opened and the holder snapped in place. When the shutter release was pulled, the exposure was made.

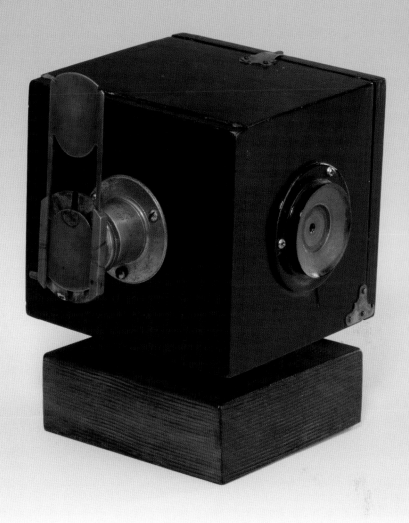

Introducing the camera in 1881, William H. Walker & Company of Rochester, New York, advertised the new invention with the slogan "Photography made easy for everybody." The price was lower, too. Retailing for ten dollars, the cube-shaped pocket camera came equipped with a double plate holder for 2¾ x 3¼-inch dry plates.

Walker & Company sold all supplies required for developing and printing the pictures. It was one of the few camera firms using the "American System" of manufacturing, meaning that parts were made to standard dimensions and interchangeable between units—a practice that drastically cut costs and increased profits. Walker later worked for fellow Rochester inventor George Eastman on the roll-film holder that would make the Kodak cameras possible and Walker's Pocket camera obsolete.

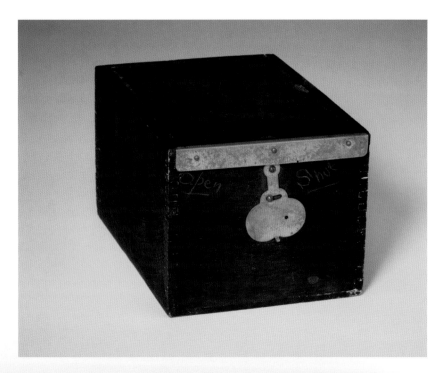

Student Camera No. 1
ca. 1888
Student Camera Company, New York, New York. 1974:0028:3459.

Manufactured by the Student Camera Company of New York City, the Student Camera No. 1 was probably introduced around 1888, based on a reference to the paper negative film of the competition in their brochure. Aimed at students, as the name implies, it was very inexpensive, retailing at just $2.50 for the complete outfit. Included was a small wooden box camera that exposed single glass plates held in place by tacks, plus all the necessary chemicals and supplies to get started. The original model made images of 2⅝ x 3⅜ inches; the No. 2 produced slightly larger images. It offered a choice of apertures, but there was no actual shutter. Instead, the exposure was controlled by the user's fingertip.

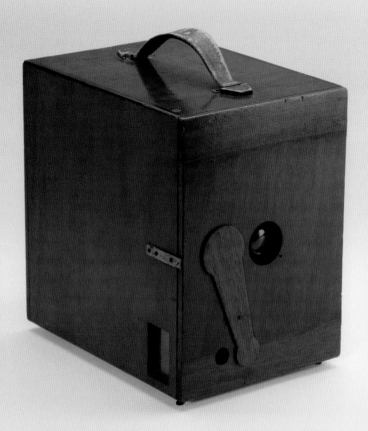

Box camera
ca. 1880
L. Dowe, San Francisco, California. 1974:0028:3554.

This large wooden dry-plate camera bears little in the way of identification except for two brass parts stamped "L. Dowe, Maker." One Lewis Dowe was a California photographer active for at least fifteen years during the last quarter of the nineteenth century, about ten of them in San Francisco. Perhaps he made this camera. Although simple in appearance, it was well designed and constructed. Built mainly of mahogany, Dowe's camera was fitted with a periscopic lens from R. D. Gray of New York. A sliding box mount for the plate holder facilitated focusing. From the camera's top, the movable box was operated by a brass lever that had a pointed end and a small knob, which the photographer would lift and move to the proper setting. A tiny pin on the pointer would drop into one of ten holes on the brass distance scale. The shutter was a spring-powered guillotine type that could be set for different speeds by placing the spring end in one of the seven notches provided. Access to the shutter and the aperture wheel was by a hinged door on the front, and a pivoting paddle-shaped cover protected both the taking and finder lenses when the camera was not in use. The camera had a leather carrying strap but no tripod mount.

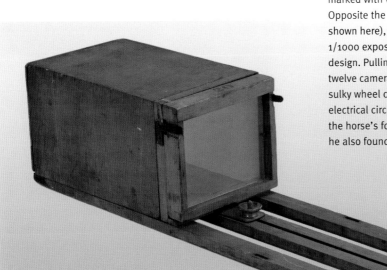

Racetrack camera (owned by Eadweard Muybridge)
ca. 1884
Scovill Manufacturing Company (attrib.), New York, New York.
Gift of George E. Nitzsche. 1978:1371:0047.

During the 1870s, Eadweard Muybridge worked with Leland Stanford, the California governor and railroad baron who founded Stanford University, to prove that a trotting horse briefly (very briefly) had all four hooves off the ground. At Stanford's farm in Palo Alto, Muybridge constructed a fifty-foot shed with a painted backdrop marked with vertical, numbered lines to measure intervals of space. Opposite the backdrop, he placed twelve cameras (including the one shown here), each equipped with electro-mechanical trip-shutter and 1/1000 exposure—high-speed photographic technology of his own design. Pulling a two-wheeled sulky, Stanford's horse raced past the twelve cameras, tripping them in sequence as the iron rim of the sulky wheel contacted wires stretched across his path and closed an electrical circuit to trip the shutter. Muybridge not only proved that the horse's four feet did, indeed, leave the ground at the same time, he also found his niche—motion photography.

Muybridge: motion stopped

That the transition from wet to dry plates was gradual is revealed by the use of wet plates in one of the most notable experiments in early photography.

Born in Kingston-on-Thames, England, Edward James Muggeridge (1830–1904) changed the spelling of his name three times, trying variants such as Muygridge, before settling on Eadweard Muybridge. He immigrated to the United States in the early 1850s and achieved a photographic reputation for his early pictures of Yosemite and the dramatic landscape of the American West.

For all his early achievements, Muybridge is best known for his innovative series of motion studies that he began as a request from Leland Stanford, president of the Central Pacific Railroad and ex-governor of California. The research began as an effort to determine whether all four hooves of a trotting horse left the ground simultaneously. Collaborating with Stanford, who was well versed in treatises in motion studies undertaken by French physiologist Étienne-Jules Marey, Muybridge made attempts in 1872, 1873, 1876, and 1877 to answer the question photographically. Results suggested an affirmative answer but ultimately were inconclusive.

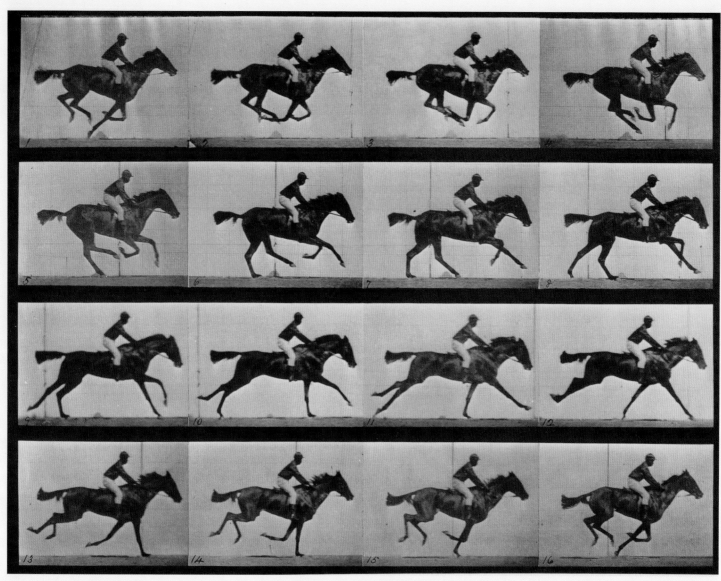

Eadweard J. Muybridge (English, 1830–1904). *GALLOP; THOROUGHBRED BAY MARE - ANNIE G.*, ca. 1884–1887. From series: *Animal Locomotion, Philadelphia.* Collotype print. George Eastman House collections by exchange, ex-collection George Nitzsche.

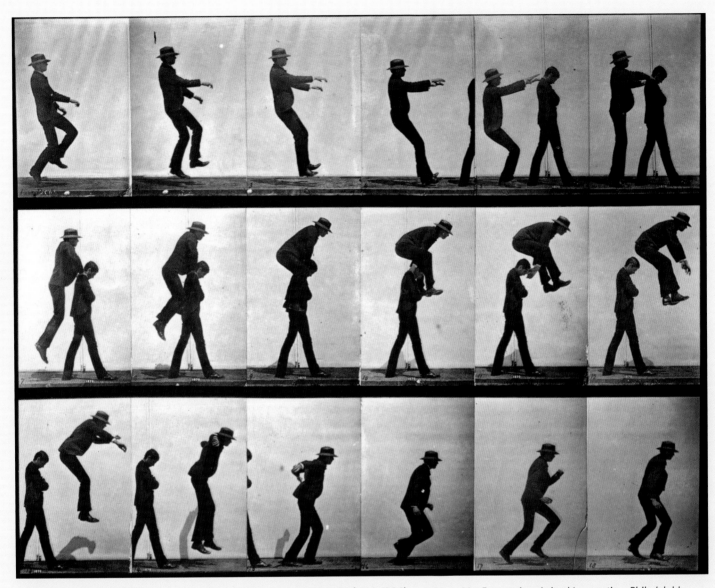

Eadweard J. Muybridge (English, 1830–1904). *JUMPING; OVER BOY'S BACK (LEAP-FROG)*, ca. 1884–1887. From series: *Animal Locomotion, Philadelphia.* Collotype print. George Eastman House collections by exchange, ex-collection Lou Marcus.

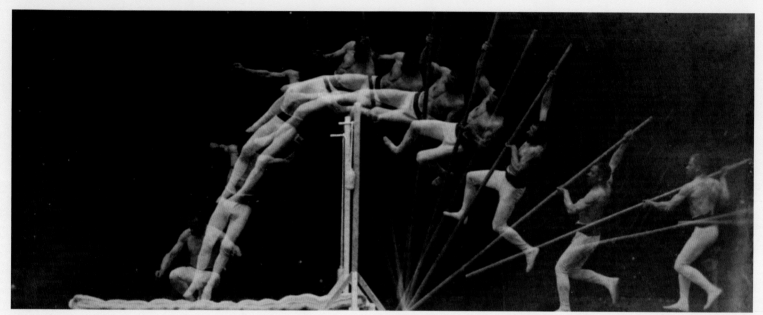

Étienne Jules Marey (French, 1830–1904). *[Chronophotographic study of man pole vaulting]*, 1890–1891. Albumen print. George Eastman House collections by exchange.

In 1878, the work moved to Stanford's Palo Alto farm, where Muybridge constructed a fifty-foot shed with a white-painted backdrop marked with lines to measure intervals of space. Opposite the backdrop, he placed twelve cameras, each equipped with an electro-mechanical trip-shutter that could take a 1/1000 second exposure—high-speed photographic technology of Muybridge's own design.

With Stanford's purebred horse "Abe Edgington" as research subject, on June 15, 1878, Muybridge realized a successful test when the trotting horse, pulling a two-wheeled sulky, released the cameras' shutters in sequential order after coming in contact with wires stretched across its path.

This test not only proved Stanford's assertion but also compelled Muybridge to further his decisive scientific investigation into human and animal locomotion and stop-action photography under Stanford's sponsorship until 1882. From 1884 to 1886, he continued his motion study work at the University of Pennsylvania.

Muybridge's motion work resulted in 781 studies devoted to the action of creatures such as dogs, cats, horses, bears, lions, and monkeys. He also studied people in motion; nude, semi-nude, and clothed men and women were photographed feeding dogs, wrestling, pole-vaulting, and hurling pails of water. Muybridge's anatomical revelations of bodies in motion were welcomed by both scientists and artists for whom they became a standard reference. His images were ultimately published as *Animal Locomotion* in 1887, an exhaustive set of reference books from which *The Human Figure in Motion* was excerpted and published as a separate title. Importantly, his groundbreaking work led to the momentous development of motion pictures in the 1890s.

Motion studies intrigued other photographers, most notably the American painter Thomas Eakins (1844–1916) and Frenchman Dr. E. J. Marey (1830–1904). Eakins used a unique revolving disk shutter that showed movement sequences at short intervals on a single picture. Marey developed the chronophotographic camera that further reduced the intervals between the still images in a sequence. It served as a prototype for the cameras used in cinematography. By the 1930s, motion photography was used to analyze the movements made by assembly-line workers in hopes of improving productivity.

EDISON: MOTION PICTURED

FREEZING SUBJECTS IN MOTION led to the vision of seeing pictures in motion. Thomas A. Edison (1847–1931) realized that a fast sequence of pictures of moving objects, if shown at a constant rate against the same background, would fool the eye into the illusion of movement. Edison called his brainchild "motioned pictures."

Edison's new movie camera and viewer relied on the 35mm format. It's said that George Eastman asked Thomas Edison how wide the film should be. Edison separated his thumb and forefinger and said, "About this wide."

It's a nice story, but it probably didn't happen. Edison's employee, W. K. L. Dickson, designed the Kinetoscope, a moving picture viewing machine based on the Greek words *kineto* (movement) and *scopos* (to watch). Its format was determined when Dickson acquired 70mm film from George Eastman's 1888 Kodak camera, then slit it down the middle. He then perforated the 35mm film to assure an even rate of transport through his motion camera, thus setting the standard for the 35mm picture industry.

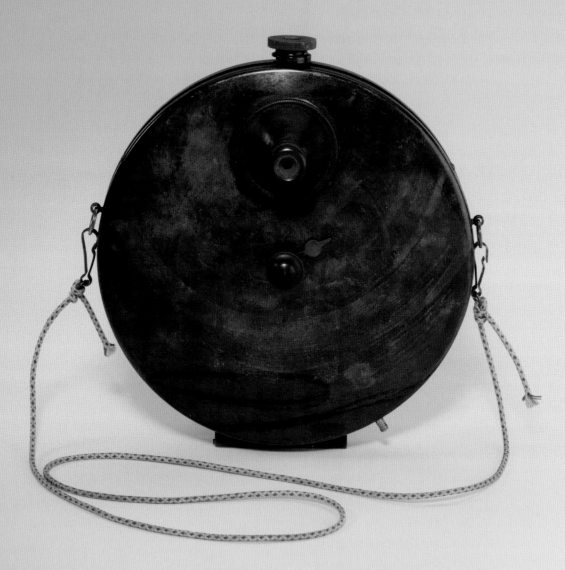

Concealed Vest Camera, No. 2, 1888. See page 113.

VII

SMALLER CAMERAS

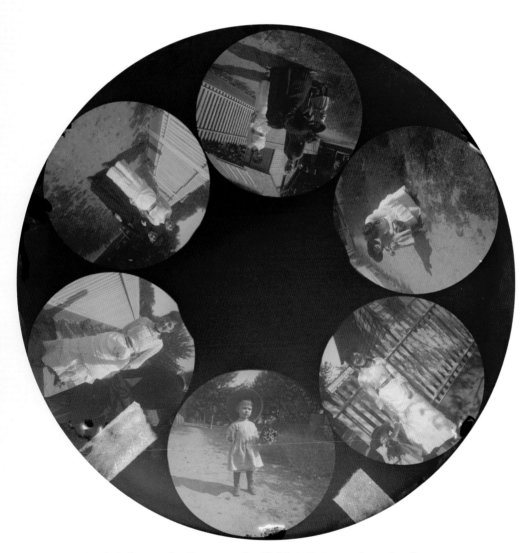

Unidentified photographer *[Images made with Stirn's Vest camera]*, ca. 1890. See page 113.

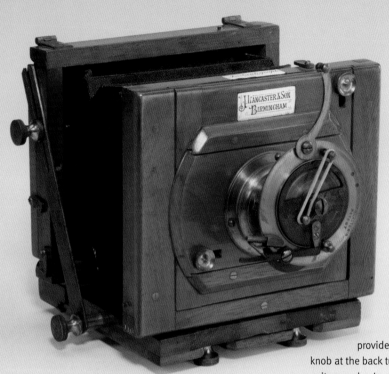

Instantograph (quarter-plate)
ca. 1882

J. Lancaster & Son, Birmingham, England. Gift of Elmer B. Cookson. 1974:0037:0132.

This early example of a quarter-plate Lancaster Instantograph of about 1882 shows the lens panel secured from below with thumbscrews through slots in the focusing slide. The arrangement was effective but prevented the camera from sitting level on a flat surface.

This changed in 1886 when the camera was redesigned as a folding model. It had a front-mounted rotary shutter that provided various instantaneous speeds by adjusting spring tension. A knob at the back turned a worm gear to focus. Well made and compact, it proved quite popular. In an advertisement from 1907, Lancaster claimed more than 150,000 had been manufactured. Its list price was £22.

Academy Camera No. 1
ca. 1882

Marion & Company Ltd., London, England. Gift of Eastman Kodak Company, ex-collection Gabriel Cromer. 1974:0037:0007.

The consistent quality, low cost, and time-saving convenience of dry plates created great demand for cameras by a growing legion of amateur photographers. Marion & Company of London took full advantage of the dry plate's popularity. Their Academy series of small cameras had detachable magazines that held a dozen plates, each in its own slot. A rack-and-pinion mechanism let the user move each plate into position, where it dropped into place when the camera was inverted. When the button was pressed, the rotary shutter exposed the plate, which then returned to its slot when the release knob on the rear was pulled. The magazine would then be indexed for the next plate, until all twelve pictures were taken. This Academy No. 1 took 1¼-inch square plates. It had a ground glass focus that utilized a separate lens above the taking lens, with both adjusted by another rack and pinion. Shutter speed was adjusted by moving the tension spring end into another of three slots. Academy No. 1 cameras were sold as sets containing everything needed to develop and print images, all in a fitted mahogany box. The set was priced at £6:10s in 1884.

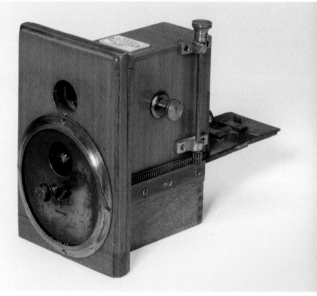

THE DRY-PLATE INNOVATION meant a new direction for designers. People did not want heavy, unwieldy cameras. As soon as people could hold their cameras in their hands and leave their tripods home, the market blossomed. Cameras were no longer just for professionals and serious amateurs. Small, eye-catching models (often oddly shaped) were meant to appeal to people who had never considered taking a picture.

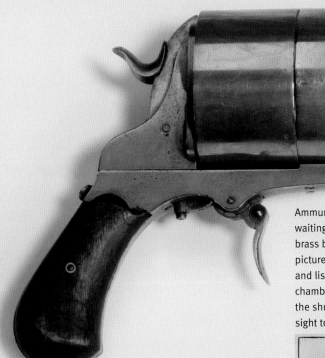

Photo-Revolver de Poche
ca. 1882
E. Enjalbert, Paris, France. Gift of Eastman Kodak Company, ex-collection Gabriel Cromer. 1974:0084:0022.

The 1882 Photo-Revolver de Poche, made by E. Enjalbert in Paris, not only looked like a handgun, it was operated like one. Ammunition in the form of ten 20 x 20-mm dry plates was loaded in the cylinder, waiting to be exposed by the periscopic 70mm f/10 lens inside the nickel-plated brass barrel. The shutter release was, naturally, the pistol's trigger. After each picture, the shooter thumbed the hammer back, rotated the cylinder a half-turn, and listened for the click indicating the exposed plate had entered the storage chamber. Turning the cylinder back again placed a new plate in position behind the shutter. The Photo-Revolver de Poche had no viewfinder, but it did have a front sight to help you draw a bead on your target.

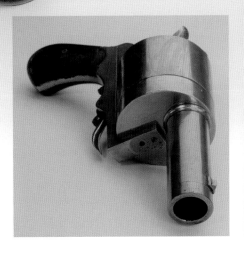

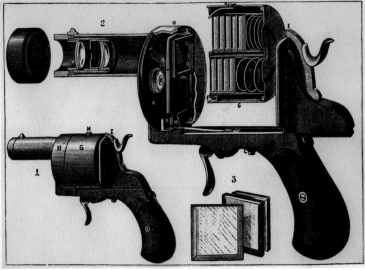

Unidentified artist. *[Illustration showing cutaway view of E. Enjalbert Photo-Revolver de Poche]*, 1883. George Eastman House Technology Collection.

PISTOLS AND DETECTIVES

WOOLGATHERING FREUDIANS have mumbled about the allusions to firearms and warfare that permeate the terminology of photography. Film was *loaded*; cameras were *aimed*; shutters were *cocked* and *fired*; pictures and subjects were *shot* or *caught* on film. The term "snapshot" referred originally to a quick gunshot taken by a hunter at a bird or animal that suddenly appeared. Moreover, the firearm itself continued to be a favorite model for some camera designers considering the shape of their inventions.

Many of these small cameras were called "detective cameras." At first the term was used loosely for cameras that required little or no setup to snap a quick picture. Sometimes the tag was applied to simple box cameras that could be used to photograph people in unposed or candid situations. The designation was used to label camouflaged devices, such as cameras that looked like gift boxes or books.

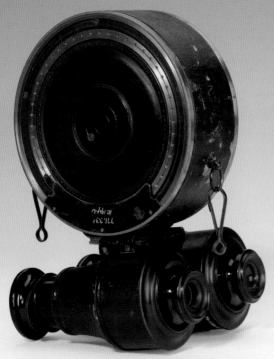

Photo-Binocular
ca. 1867
Geymet & Alker, Paris, France. Gift of Eastman Kodak Company, ex-collection Gabriel Cromer. 1974:0084:0015.

Manufactured by the French firm of Geymet & Alker in 1867, the Jumelle, which means binocular in French, is known as the Photo-Binocular camera in English. The entire camera is contained in one side of the binocular, while the other houses the viewfinder. A removable drum magazine holds fifty collodion dry plates, 4 x 4 cm each. By inverting the camera after exposure, the plate would be returned to the magazine and the dial rotated to drop another. The Photo-Binocular is sometimes called a detective camera because with the drum removed, the photographer appears to be looking through a pair of binoculars instead of operating a camera. The drum could be worn with a shoulder strap, looking like a canteen.

Photo-Livre
ca. 1888
H. Mackenstein, Paris, France. Gift of Eastman Kodak Company, ex-collection Gabriel Cromer. 1974:0037:1815.

Rudolf Krügener was a nineteenth-century German photographer with many camera-related patents to his credit. In 1888 he introduced his Taschenbuch, a box camera disguised as a small book. Book cameras weren't new, but Dr. Krügener's featured a clever mechanism for changing the 4 x 4-cm dry

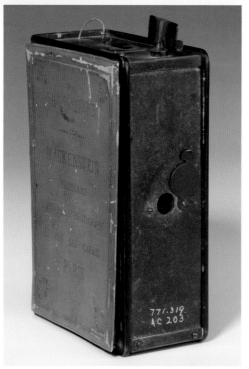 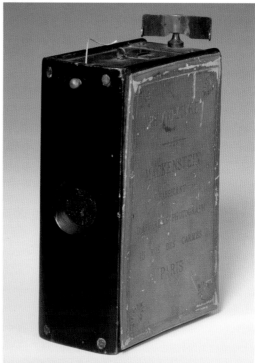

plates in the camera's built-in twenty-four-exposure magazine. The Taschenbuch was manufactured under different names for sale in various countries. This Photo-Livre version was made to be sold by Mackenstein of Paris. The 65mm f/12 lens was hidden in the "spine," and the shutter was actuated by pulling strings on either side of the camera. There was no viewfinder because using one to aim the camera would have revealed the ruse. Other manufacturers continued a tradition of the book camera, using roll films and even 110 Pocket Instamatic cartridges, so we may see a digital version one day.

Photo-Cravate
1890
Edmund & Leon Bloch, Paris, France.
Gift of Eastman Kodak Company,
ex-collection Gabriel Cromer.
1974:0084:0050.

Designed by Edmund Bloch of Paris, the Photo-Cravate had a tiny camera concealed behind an innocent-looking piece of 1890s men's neckwear. The body of the all-brass camera was only seven millimeters thick, but it contained six 25 x 25-mm dry plates in holders attached to a tiny conveyor chain. A small knob on the camera protruded through the tie like a shirt button and was turned to bring a fresh plate behind the 25mm f/16 lens, which was positioned on the necktie to resemble a stickpin jewel. Making an exposure meant squeezing and relaxing a rubber bulb with a tube that operated the pneumatic shutter. The savvy photographer would vary the exposure time according to the lighting conditions, holding the bulb longer to keep the shutter open. Known in English-speaking markets as the Detective Photo Scarf, the Photo-Cravate was priced at $21 in 1891, with replacement ties in various colors and patterns available separately.

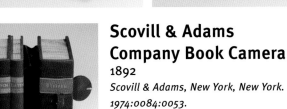

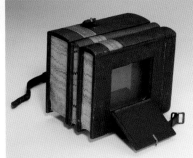

Scovill & Adams
Company Book Camera
1892
Scovill & Adams, New York, New York.
1974:0084:0053.

One of the rarest of all the detective cameras is the Scovill & Adams Company Book Camera of 1892. Disguised as a bundle of three schoolbooks, titled *French*, *Latin*, and *Shadows*, and secured by a leather carrying strap, its cover would be blown when put to photographic use. The multiple manipulations needed to prepare the camera for imaging required the group of books to be inverted, spines-up, in a most unnatural position. The retail price was $25.

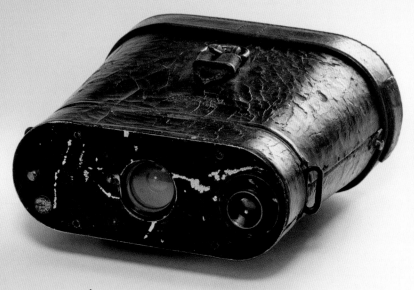

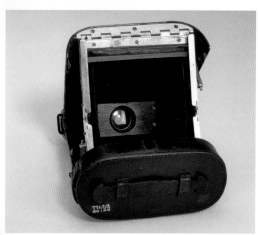

Photo-Étui-Jumelle
ca. 1893
Franck-Valéry, Paris, France. Gift of Eastman Kodak Company, ex-collection Gabriel Cromer. 1974:0084:0060.

The Photo-Étui-Jumelle of 1893 was manufactured by Franck-Valéry of Paris. It was yet another example of the then-popular "detective" cameras. In this case, when folded, the camera was disguised as a pair of binoculars in a traditional binocular case. The sides of the camera spread in a clamshell fashion and a plate was inserted. It was available in two plate sizes: 9 x 12 cm or 13 x 18 cm. The retail price was 180 Swiss francs.

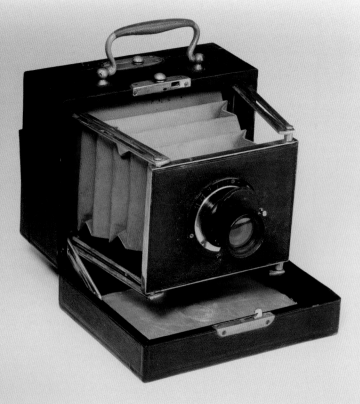

Kauffer Photo-Sac à Main
ca. 1895
Charles Alibert, Paris, France. Gift of Eastman Kodak Company, ex-collection Gabriel Cromer. 1974:0037:1549.

Though not really a detective camera, the Photo-Sac à Main, manufactured by Charles Alibert of Paris in 1895, was disguised, or at least housed, in a leather-covered wooden case resembling an

elegant ladies handbag. The camera used a strut-mounted leather bellows whose elegant nickel-plated trim and stylish latch enhanced the guise. The bag's rear compartment was roomy enough for three double 9 x 12-cm dry plate holders, along with a ground glass back.

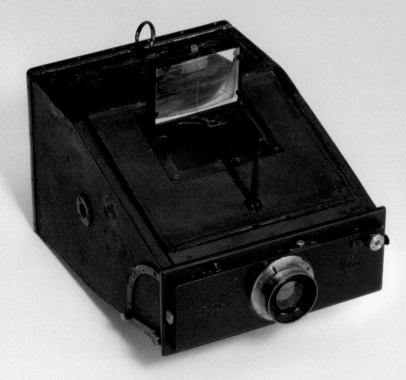

Steno-Jumelle
ca. 1895
L. Joux & Cie, Paris, France. 1974:0037:2891.

In the late nineteenth century, France introduced a type of camera known as the Jumelle, which means "twin" or "binocular." Generally wedge-shaped, this type of camera often had two lenses and resembled an opera glass. While some of them were stereo cameras and others had separate viewing and taking lenses, others had a single lens and were merely wedge-shaped. The Steno-Jumelle, manufactured in 1895 by L. Joux & Cie of Paris, is of the last variety. A wedge-shaped aluminum box with pebble-grained leather covering and an eye-level Newton finder, this camera, like most of its kind, has a plate magazine with a push-pull changing action. It holds twelve 9 x 12-cm plates and is fitted with the Goerz Anastigmat lens and a guillotine shutter.

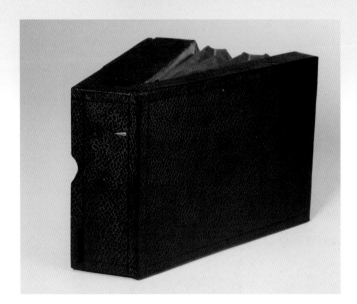

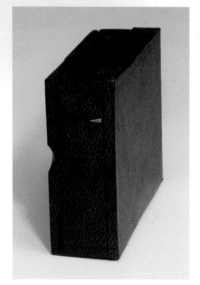

Pocket Kozy (original model)
ca. 1897
Kozy Camera Company, Boston, Massachusetts. Gift of Eastman Kodak Company. 1995:0151:0001.

The Pocket Kozy camera, first introduced in 1897 by the Kozy Camera Company of Boston, was different from traditional self-casing, folding cameras. Instead of using the classic drop-bed design, Hiram A. Benedict created a novel camera that opened like a book, with red leather bellows fanning out like pages. Eventually there were three versions, but the camera shown here is the first model, and surely fewer than a handful survive today. The first model had a flat front and opened with the bellows facing the rear of the camera, with the lens and shutter located in the "spine" position. The second and third models placed the bellows to the side with the lens on the curved front. All versions made twelve or eighteen 3½ x 3½-inch exposures on roll film. In 1897 the camera sold for ten dollars and could be purchased on a time payment plan. Benedict hoped to sell 100,000 units, though it is safe to assume that goal was not reached.

Vest Pocket Ensign (mounted in handbag)

ca. 1925

Houghton-Butcher Ltd., London,
England. Gift of Eastman Kodak Company. 1974:0037:1671.

Concealed and disguised cameras have always intrigued people. Designers loved dreaming up clever ways to incorporate photographic devices into everyday items. "Purse cameras" first appeared in the nineteenth century with bulky dry plate apparatus in big Victorian-era handbags. By the time Samuel Aspis of London patented his "Combination of Hand Bag...and Collapsible Photographic Camera" in 1928, roll-film vest pocket cameras were at the height of their popularity. Aspis designed his version around an ordinary Ensign Vest Pocket, which folded flat enough to mount inside a special leather clutch purse. To take photos, the purse flap was flipped over and a mirror panel unsnapped. The camera faceplate had to be pulled out to lock the struts, and it was then ready to begin filling up the roll of 127 film with pictures. Metal brackets riveted to the purse held the camera securely. The Aspis purse camera wasn't intended for surreptitious photography, but rather as a convenient way to always have a camera ready to use. And one would assume the fashion-conscious dame of the time would have shoes and earrings to match the Ensign clutch.

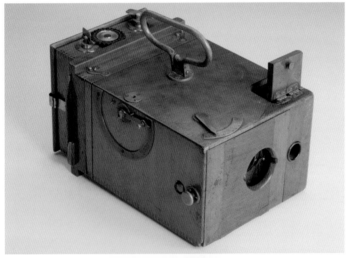

Schmid's Patent Detective Camera (improved model)

ca. 1883

E. & H. T. Anthony & Company, New York, New York.
Gift of Mrs. Lyle R. Berger. 1974:0037:1435.

Patented in 1883, Schmid's Patent Detective Camera was the first commercially produced handheld camera in the United States. Its small size, inconspicuous operation, and "instantaneous" exposures introduced the detective camera concept. The need for a ground glass for viewing was eliminated through the provision of a focusing register and pointer for setting the estimated subject distance; a ground glass was used to calibrate the scale. This "second version" shows a hinged brass handle and has an Eastman-Walker roll-film holder, custom fitted to the 3½ x 4¼-inch size. The price in 1891 ranged from $55 to $77, depending on the lens included.

Makers and sellers of these small cameras surely wanted to tap into the growing fascination with detectives such as Sherlock Holmes, who was introduced to readers by Arthur Conan Dolye in 1887. Patented in 1883, William Schmid's Patent Detective Camera was the first commercially produced American handheld camera. Its small size, waist-level reflex viewfinder, inconspicuous operation, and "instantaneous" exposures embodied the typical detective camera concept.

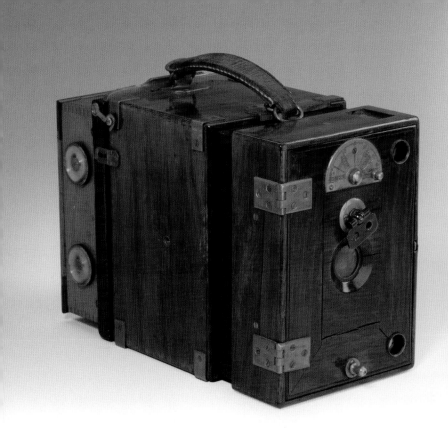

Express Détective Nadar Tropical
ca. 1888
Paul Nadar, Paris, France. Gift of Eastman Kodak Company, ex-collection Gabriel Cromer. 1974:0037:2905.

At first glance, the Express Détective Nadar Tropical didn't seem much different from any other "detective" cameras on the market in the 1880s. Closer examination revealed some unusual features. Though dry plates were still the photographic medium of choice for detective camera designers, Paul Nadar (1856–1939), son of the famed French portrait photographer, incorporated the American Eastman-Walker roll holder into the Express Détective. The holder used Eastman 3½-inch wide film in forty-eight-exposure rolls. Focusing the 150mm f/6.8 Steinheil Gruppen Antiplanat lens was by the somewhat outmoded sliding box-within-box method, improved by a rack-and-pinion mechanism. The shutter was a spring-loaded sector with speed controlled by varying the pressure of a friction shoe that rubbed against it as it turned. The camera was available in either a polished wood or leather-covered finish.

Demon Detective Camera No. 1
ca. 1889
American Camera Company, London, England. Gift of Eastman Kodak Company, ex-collection Gabriel Cromer. 1982:0237:0002.

Invented in 1889 by Walter O'Reilly, the Demon Detective Camera No.1 was manufactured by the American Camera Company of London, England. Stamped from nickel-plated brass, the back was quite decoratively embossed. Sitting at the end of the funnel-shaped front, the achromatic doublet lens and simple flap shutter made a single, circular, instantaneous exposure on a dry plate. There was no viewfinder to aid in aiming the camera. A hinged door at the bottom gave access for changing the plate. An advertisement announcing the larger No. 2 model claimed 100,000 of the smaller No. 1 model sold in twelve months. Its list price was five shillings, including plates and chemicals.

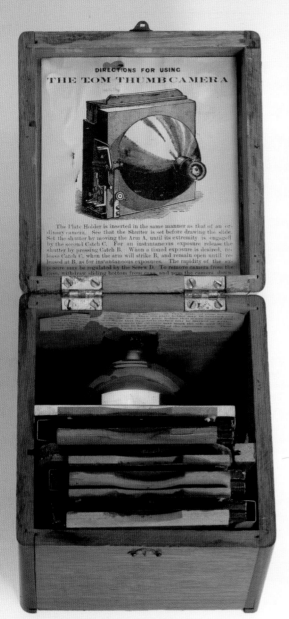

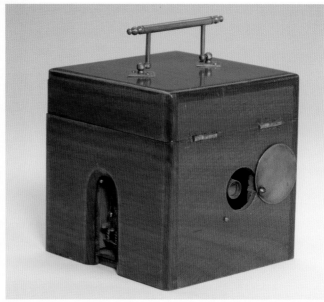

Tom Thumb Camera
ca. 1889
Max Juruick, Jersey City, New Jersey. Gift of Eastman Kodak Company.
1974:0037:2580.

The Tom Thumb Camera falls into the category of detective cameras, its disguise being the finished wooden carrying case. It also could be removed from the case and used as a handheld camera. Invented by James Ford and manufactured by Max Juruick of Jersey City, New Jersey, in 1889, the early versions were labeled Ford's Tom Thumb Camera. It used dry plates and produced 2½-inch square images that could be made round by inserting a circular mask.

Deceptive Angle Graphic
ca. 1901
Folmer & Schwing Manufacturing Company, New York, New York.
Gift of Graflex, Inc. 1974:0037:2326.

The Deceptive Angle Graphic was manufactured by Folmer & Schwing Manufacturing Company in New York City. At the time of its introduction in 1901, the public was fascinated by candid photography that used "detective" or "deceptive angle" cameras. It was designed to look like a stereo camera with a pair of fake lenses on the front while an obscure lens mounted on the side of the camera, ninety degrees to the photographer's perceived line of vision, took the actual pictures. The retail price, with Rapid Rectilinear lens, was $67 in 1904.

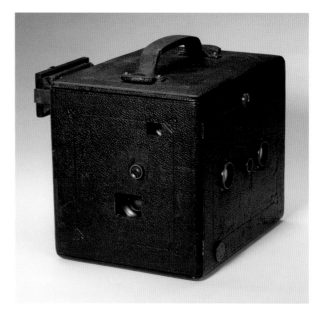

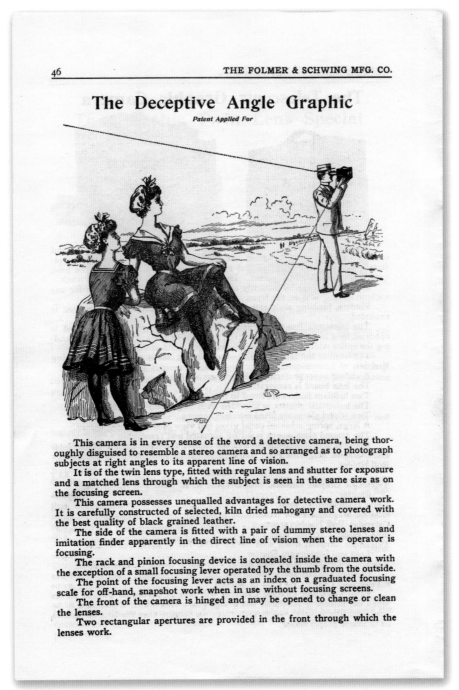

The Deceptive Angle Graphic

Patent Applied For

This camera is in every sense of the word a detective camera, being thoroughly disguised to resemble a stereo camera and so arranged as to photograph subjects at right angles to its apparent line of vision.

It is of the twin lens type, fitted with regular lens and shutter for exposure and a matched lens through which the subject is seen in the same size as on the focusing screen.

This camera possesses unequalled advantages for detective camera work. It is carefully constructed of selected, kiln dried mahogany and covered with the best quality of black grained leather.

The side of the camera is fitted with a pair of dummy stereo lenses and imitation finder apparently in the direct line of vision when the operator is focusing.

The rack and pinion focusing device is concealed inside the camera with the exception of a small focusing lever operated by the thumb from the outside.

The point of the focusing lever acts as an index on a graduated focusing scale for off-hand, snapshot work when in use without focusing screens.

The front of the camera is hinged and may be opened to change or clean the lenses.

Two rectangular apertures are provided in the front through which the lenses work.

Illustration showing Folmer & Schwing Deceptive Angle Graphic in use, 1904. George Eastman House Technology Collection.

Detective cameras appeared in cane handles, inside hollowed-out books, wrapped stylishly in cravats, hidden cleverly in bowler hats, enclosed deceptively in cheerful gift packages, secreted ingeniously in binoculars. If there was a way to disguise and deceive with an ordinary object, then there was certainly a crafty manufacturer ready to hide a small camera inside it.

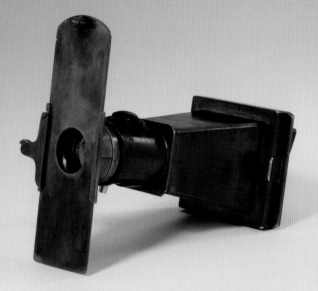

Metal Miniature Camera
ca. 1884
Marion & Company Ltd., London, England. 1974:0084:0033.

In the 1880s, Marion & Company of London advertised its Metal Miniature Camera as "easily carried in the pocket," which may have been possible with the clothing styles of the time. The availability of dry plates had simplified photography, and manufacturers responded by designing smaller cameras. The Metal Miniature had a cast brass body and rear door, rack-and-pinion focusing, and a brass shutter operated by gravity when the release lever was pressed. A ground glass was used to focus the 55mm f/5.6 Petzval-type lens, and a tiny knob on the lens barrel operated the diaphragm. Two-inch square dry plates could be developed and printed at home, using the equipment and chemicals included in the £5:10/outfit packed in a polished walnut case.

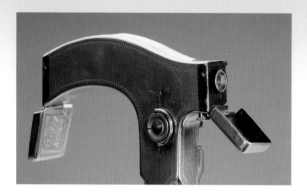

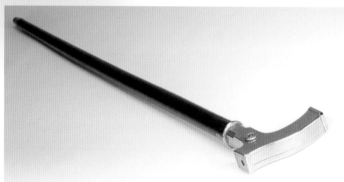

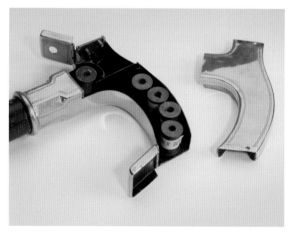

Ben Akiba
ca. 1903
A. Lehmann, Berlin, Germany. Gift of Eastman Kodak Company, ex-collection Gabriel Cromer. 1974:0084:0086.

Cameras have been disguised in just about every type of fashionable accessory, from hats to handbags, with many seemingly more likely found among the wares of the haberdashery than the camera shop. In this case, the camera is hidden in the handle of a gentleman's walking stick. Patented by Emil Kronke and manufactured by A. Lehmann, both of Germany, the Ben Akiba produced twenty images, 1.3 x 2.5 cm in size, on roll film. Given the small image size and emulsion of the time, the quality of the images produced would not be very good, relegating the cane camera to the novelty category. On the other hand, it may have been the turn-of-last-century answer to that age-old question: what to give the dapper gent who has everything?

A more straightforward miniature camera was the "pocket watch camera," introduced in 1886 by England's J. Lancaster & Son of Birmingham. The Lancaster Watch Camera was available in both men's and women's versions. The gentlemen's camera produced a picture of 1½ x 2 inches; a diminutive 1 x 1½-inch image issued from the ladies' version. Using miniature dry plates, the "pocket watch" had the disadvantage of taking only one picture at a time. Removing and reloading the very light-sensitive plates called for the novice photographer to step into a darkened room after each exposure. Alternately, he or she could slip the camera into a lightproof changing bag and then exchange plates by fumbling blindly around inside it.

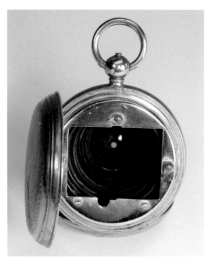

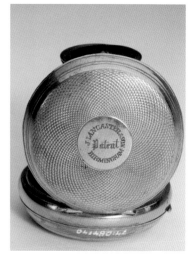

Lancaster's Patent Watch Camera
1886

J. Lancaster & Son, Birmingham, England. Gift of Eastman Kodak Company. 1974:0084:0040.

The Lancaster Patent Watch Camera was introduced in 1886 and manufactured by J. Lancaster & Son, Birmingham, England. It was made in men's or ladies' versions to resemble a pocket watch, with a self-erecting design using six spring-loaded tubes to function as a bellows upon opening. The men's version held a 1½ x 2-inch plate, while the smaller ladies' version used a 1 x 1½-inch plate. The original list price was £1/11/6.

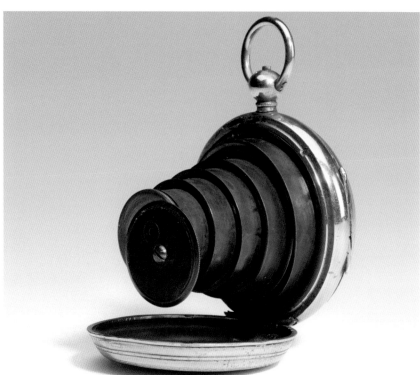

Advertisement for the Lancaster Watch Camera, *Photographic Almanac*, 1892. George Eastman House Technology Collection.

Lancaster's creation featured a clever, collapsible cone bellows made of metal. Upon opening the watch cover, springs in the watch back would push up a metal cone consisting of a series of increasingly smaller circular cylinders. This mechanism achieved sharp focus by extending the lens away from the camera body. True detective cameras were configured to avoid suspicion and fool the unwary. The Tisdell & Whittlesey Detective Camera made in New York excelled for this purpose. It appeared to be nothing more than an ordinary box; no one would give it a second look. A viewer hidden under the carrying strap allowed the sly photographer to aim and shoot without arousing suspicion.

Novelties seldom sell well for very long. The 1880s would see a change that moved photography once and for all into the hands and homes of anyone who could afford the pleasures conferred by photography.

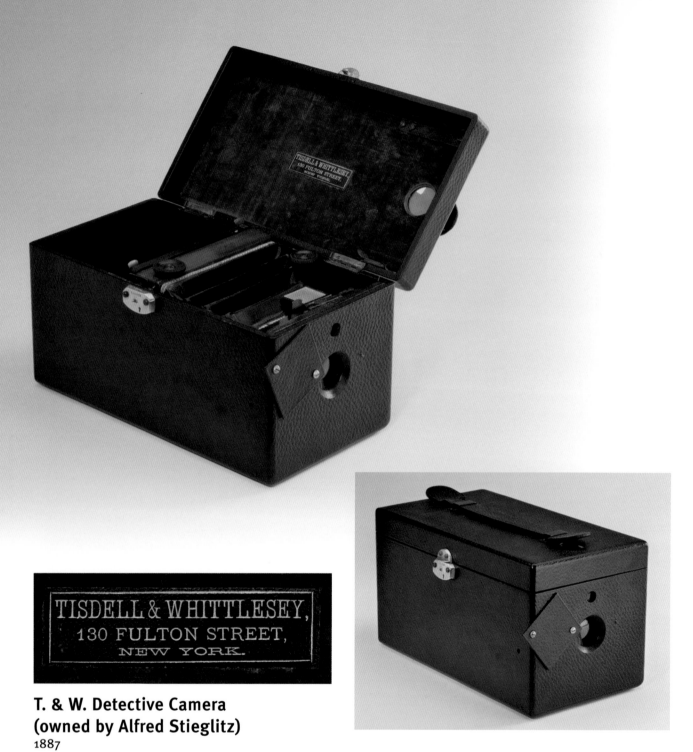

T. & W. Detective Camera
(owned by Alfred Stieglitz)
1887

Tisdell & Whittlesey, New York, New York. Gift of Georgia O'Keeffe. 1974:0037:1972.

With the Tisdell & Whittlesey Detective Camera made in New York, the photographer could aim and shoot without arousing much suspicion. The T & W looked like an ordinary box, perhaps one used to carry a camera, which it did. However, instead of needing to open the box and remove the camera, the "detective" sighted the subject with a viewer hidden under the carrying strap end. When the guilty party could be caught red-handed, a small panel on the side of the box was moved to uncover the lens, and the box lid opened just enough to cock the shutter. Pushing the lid closed tripped the shutter.

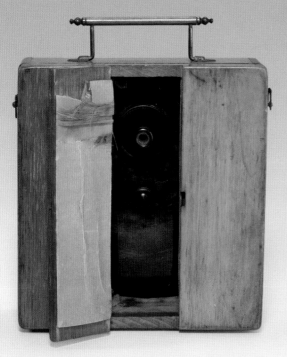

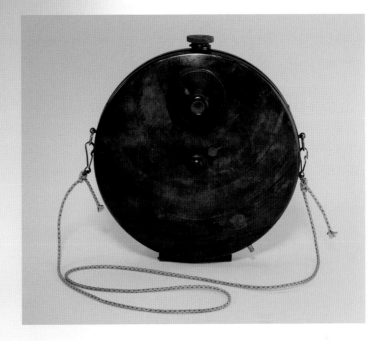

Concealed Vest Camera, No. 1
1888
C. P. Stirn, New York, New York. 1974:0037:2288.

Walking about with a hidden camera has long had its appeal. Judging by the sales figures for Stirn's Patent Concealed Vest Camera, in the 1880s there were plenty of surreptitious photographers willing to pay $20 for the seven-inch-diameter device. Invented by the American R. D. Gray, the vest camera was first made in New York by Western Electric, and then by C. P. Stirn, whose brother, Rudolf Stirn of Berlin, added further refinements. The camera was worn low on the chest, suspended by a neck cord. The lens and exposure advance knob protruded through buttonholes and the shutter was operated by pulling a string attached to a shaft near the bottom edge of the brass body. The circular dry plates were loaded into the camera by opening the clamshell rear door and inserting a six-exposure disc. This had to be done in a darkroom, as did the unloading. Included in the camera's price was a wooden storage box that had a threaded plate for tripod mounting. A small door on the box opened to reveal the lens and advance knob, and a hole was provided for the shutter string.

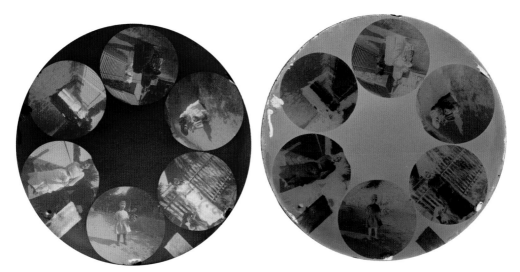

Unidentified photographer. *[Images made with Stirn's Vest camera]*, ca. 1890. Gelatin dry plate negative. George Eastman House collections.

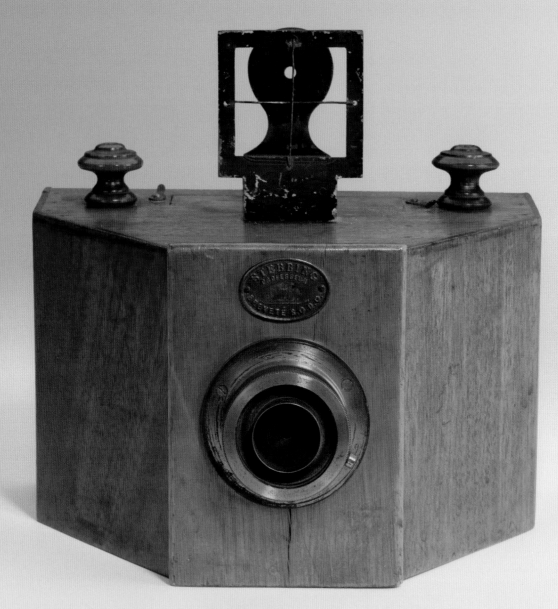

Stebbing's Automatic Camera, ca. 1883. See page 123.

ROLL FILM: THE BACKGROUND

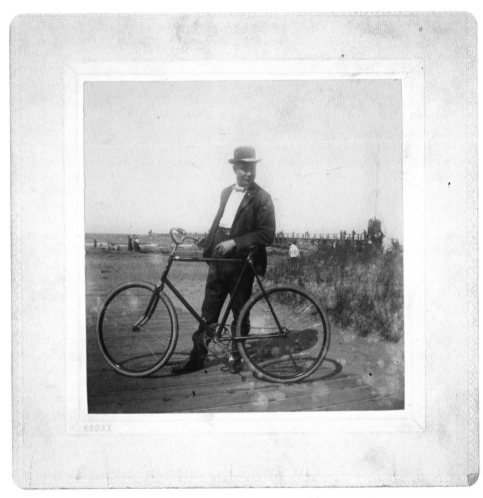

Unidentified photographer, *[Snapshot of man with bicycle]*, ca. 1895. See page 121.

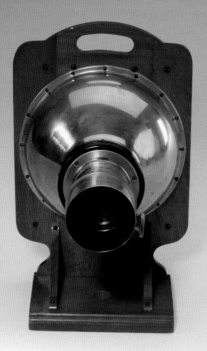

Herzog Amateur Camera (improved model)
ca. 1882
August Herzog, New York, New York. Gift of Eastman Kodak Company.
1982:0237:0010.

The Herzog Amateur Camera looks like anything but a picture-taking device. Its designer, August Herzog of New York, started business in the 1870s with his first Amateur camera. The wood and cardboard construction of that very simple dry-plate camera helped keep prices low enough for the average family budget. Although promoted as a children's toy, the Herzog Amateur was used by many adults due to its simplicity. In order to better serve that end of his market, Herzog redesigned the camera; this was the final version. Nickel-plated brass replaced cardboard, and the wood base was reinforced. The 3½ x 4½-inch dry plates were exposed to light fed through the Darlot 160mm f/4.5 Petzval-type lens. A knurled knob for the rack and pinion operated the sliding tube focus mount. Waterhouse stops could be inserted by the photographer, based on conditions. The plates of the day weren't sensitive enough to need a shutter, so the lens cap was removed to make the exposure. Herzog's patented plate holder allowed the media to be loaded in either a vertical or horizontal orientation.

American Challenge Swivel-bed Camera
ca. 1883
Rochester Optical Company, Rochester, New York. Gift of Eastman Kodak Company. 1997:0209:0001.

A very early monorail design, the American Challenge was a polished cherry wood camera atop a metal bed with an integral tripod head that swiveled. The square body could make 4 x 5-inch images in either horizontal or vertical positions. A sliding lens board gave rise and fall movements and could be reversed to store the lens inside the camera body for transport. Rochester Optical Company claimed it to be one of the most compact cameras made. Fully collapsed, it was just over two inches thick. In 1883 the Challenge retailed for $20.

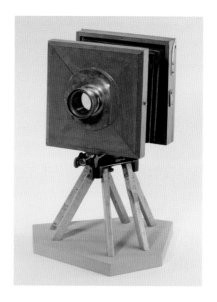

ROLL FILM BECAME A FOUNDATION for camera development for the next century. In essence, a blueprint had been agreed upon, and from this point forward advances in camera technologies would take place at a rapid rate. Film improved as well. Color prints replaced black-and-white ones as movies, magazines, and television converted to color. Trademarks like Kodachrome and Polaroid assumed brand identities.

As with most technological shifts, this one did not happen overnight. After the debut of roll film, dry plates did not simply disappear. Proponents, users, and makers of dry-plate cameras strove to maintain their investments. Films were cut to the same dimensions, and plate holders called "film sheaths" were modified to properly align the thinner material. New, improved dry-plate cameras continued to compete against film cameras. The very large cameras used for dry-plate photography would be popular with serious photographers for decades to come, because technical image quality depended upon the size of the material used to capture the picture. Bigger cameras held larger negatives, and bigger was usually better, especially where the very highest quality was called for.

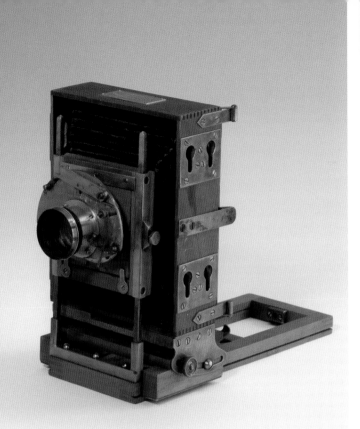
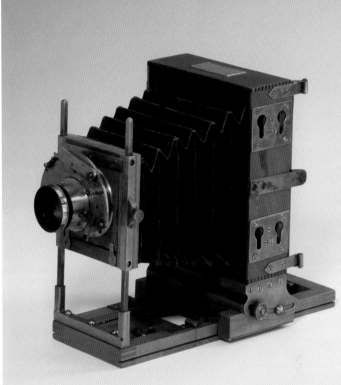

Anthony's Patent Novelette View Camera (4 x 5)
ca. 1884
E. & H. T. Anthony & Company, New York, New York. 1974:0084:0028.

Anthony's Patent Novelette View Camera was designed for a quick change from a horizontal to vertical format. Keyhole slots in the back engaged screw heads in the bed so that a slight movement to the side released the back. Then the bellows pivoted on the front, allowing the back and bellows to rotate together and be secured with a second set of keyhole slots. The Novelette camera was also available in a special long bellows version for view, portrait, or copy work requiring closer focusing. This 4 x 5 camera cost $15.50 in 1891.

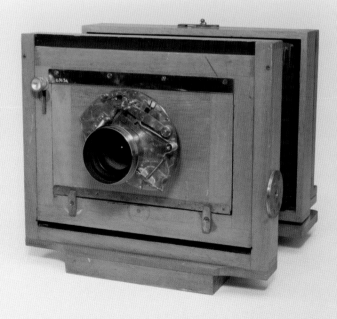

Waterbury View Camera
ca. 1886
Scovill Manufacturing Company, New York, New York.
1974:0028:3467.

The 6½ x 8½-inch Scovill Waterbury Camera Outfit, introduced in 1885, included the camera, double plate holder, wooden carrying case, tripod, and a Waterbury lens with a set of stops. Manufactured in three sizes by the American Optical Company and made of polished blond mahogany, the camera had a fixed front standard and a folding rear bed made rigid with a patented latch. Movements were limited to a single rear swing and front rise. Introduced in 1888, the Prosch Duplex shutter was a later improvement. In 1885, the outfit cost $20; adding an Eastman-Walker roll-film holder brought the price to $44.

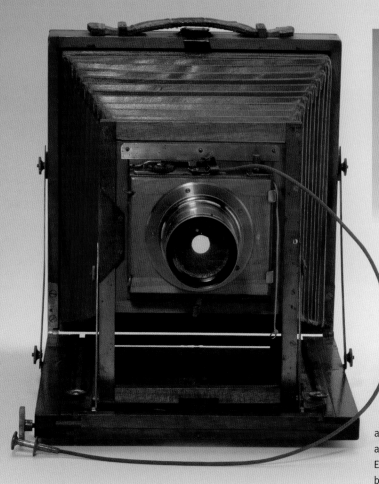

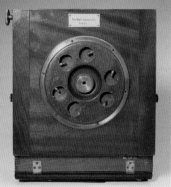

English Compact Reversible Back Camera
ca. 1888

Blair Camera Company, Boston, Massachusetts.
1978:1371:0017.

Named for a popular style, the full-plate (6½ x 8½-inch) Blair English Compact Reversible Back Camera folds into a thickness of only 3½ inches. Made in Boston, Massachusetts from 1888 to 1898, it was commercially available in a single swing version at a cost of $50; a double swing could be made to order. The bed hinges away from the rear standard, and the front standard folds up. The geared focusing track accommodates focus up to twenty inches. The Blair Rigid Extension allowed conversion to a larger size. A tripod top is built into the bed, with sockets for attaching the legs.

New Model View Camera
ca. 1885

Rochester Optical Company, Rochester,
New York. 1974:0037:1766.

Designed with the amateur photographer in mind, the New Model View Camera is what the Rochester Optical Company called a "good but cheap apparatus." The polished cherry body is fitted with a nickel-plated ROC landscape lens with rotating stops. Double-sided film holders accepted 5 x 8-inch dry plates. The complete outfit included lens, tripod, carrying case, and one film holder and sold for $12, according to an 1885 company catalog that stated the camera had been on the market for two years. Other sizes offered were 4 x 5 and 6½ x 8½ inches.

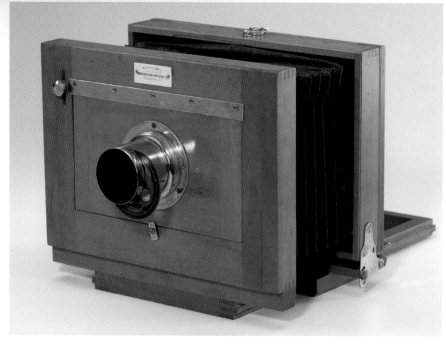

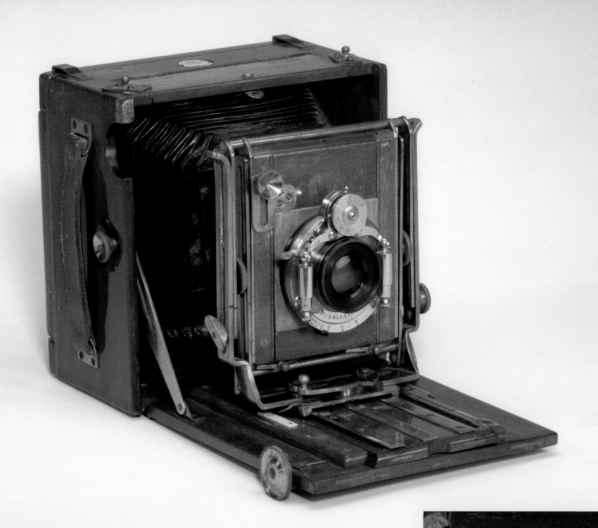

Rambler Tropical Field Camera
ca. 1898
J. Lizars, Glasgow, Scotland. 1974:0028:3472.

The manufacture of cameras in the late 1800s took the skills of many craftsmen not needed in today's business, like expert woodworkers to build teakwood or mahogany bodies and metalsmiths to construct standards, struts, and other brass parts. J. Lizars of Glasgow, Scotland, purveyors of optical, scientific, and photographic goods, took great pride in its line of Challenge hand cameras, such as this Rambler of 1898. Crafted of solid teakwood for resistance to heat and moisture, the Rambler was designed for field work. The lens board was adjustable for rise, shift, and tilt, and the "trap door" panel on the top of the body allowed the Russia leather bellows ample room for extreme rise settings. A Bausch & Lomb shutter controlled light through the lens to expose the 8 x 10.5-cm plates. Besides the fine cameras constructed at its Golden Acre Works in Glasgow, J. Lizars sold anything and everything a photographer needed, from a variety of manufacturers, including cameras from Goerz, Kodak, and others. Although no longer a photographic manufacturer, the firm remains in the optical business with a number of branches in Britain.

Some dry-plate cameras were designed to hold multiple plates. After making an exposure, a fresh plate would automatically drop into position. Other manufacturers tried a bridge strategy. Take the Presto camera of 1896, produced by the Magic Introduction Company in New York City. It accepted both roll film and dry plates. Shaped like an oval jewel with one end flattened, the miniature camera produced 1½-inch square pictures.

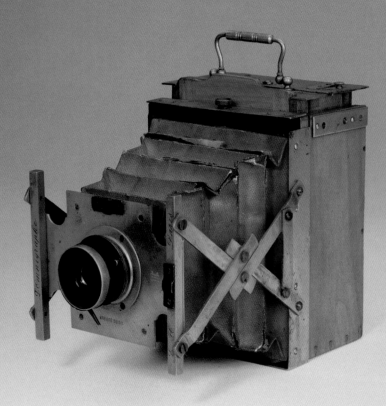

Omnigraphe
ca. 1887
E. Hanau, Paris, France. Gift of Eastman Kodak Company, ex-collection Gabriel Cromer. 1974:0037:2314.

A benefit of dry-plate photography was that it allowed a photographer to carry a supply of ready-to-use plates. For manufacturers, a logical design step would be a camera that carried extra plates inside; another would allow easy changing of the plates. Hanau of Paris took these steps and, using a pull-push plate changer, incorporated them into its 1887 Omnigraphe folding camera. After exposing a 9 x 12-cm plate, the photographer needed only to pull the nickel-plated brass handle on the magazine to allow the used plate to fall into the bottom of the chamber. A tambour door rolled out with the plates to keep them covered, and when the drawer was pushed back inside the camera, a fresh plate was in position. A counter on the back of the Omnigraphe tracked the number of shots. Scissors, or "lazy tongs," folding struts supported the Rapid Rectilinear lens. This version had a single speed rotating disc shutter.

Presto
ca. 1896
Magic Introduction Company, New York, New York. Gift of 3M Foundation, ex-collection Louis Walton Sipley. 1977:0085:0011.

Improvements in photographic plates and film allowed camera manufacturers to miniaturize their products. One of the smallest designs was the Presto camera of 1896, made by the Magic

Introduction Company of New York. An all-metal construction, Presto could be used with roll film to take 1¼-inch square pictures, or the roll holder could be removed and a mechanism holding four glass plates substituted. The pillbox body was stamped from brass as was the removable cover, which was held in place by friction. The shutter was dropped by gravity when the button was pressed, and then reset by turning the camera upside down. A rotating disc on the front had three selectable aperture sizes.

But the march of film and film cameras was relentless. Fostered by Eastman, a steady flow of easy-to-use cameras—each with increasingly advanced technological features—was paraded before the public.

Most early cameras held to a basic blueprint: a light-tight box with an opening for a lens. That core container would continue to be required. But as cameras would become smaller and films more sensitive, lenses and shutters would have to improve, too. No longer could a photographer expect to take a proper picture by uncovering a fixed lens, counting slowly, and then casually ending the exposure by replacing a lens cover over a plain wooden box.

Unidentified photographer. *[Snapshot of two dogs]*, ca. 1920. Gelatin silver print. George Eastman House collections.

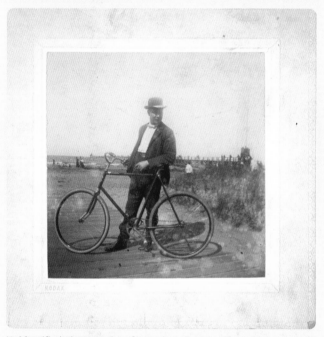

Unidentified photographer. *[Snapshot of man with bicycle]*, ca. 1895. Albumen print. George Eastman House collections.

Unidentified photographer. *[Snapshot of men fishing]*, ca. 1920. Gelatin silver print. George Eastman House collections.

Hannibal Goodwin's claim

THE IDEA FOR AND THE INVENTION of roll film is one more story that's a bit more complicated than legend has it. In 1914, a U.S. Federal Court of Appeals concluded that a man named Hannibal Goodwin had invented roll film. Goodwin died on the last day of the nineteenth century. A group of men from the photographic manufacturer Anthony & Scovill purchased the patent rights from his widow and, after experiments, were able to start a film factory in Binghamton, New York. In 1904, the name was changed to Ansco.

Eastman believed the Goodwin patent was invalid and that the invention belonged to Eastman Kodak Company. But in 1914, two U.S. Federal Courts of Appeals concluded that Hannibal Goodwin had invented roll film. Eastman settled the case for $5 million. Kodak went on with its own roll film development and the rest, as the next chapter shows, was history.

With films that needed exposures shorter than the Kodak's 1/25 second, stopwatch precision was now a necessity. Camera designers and manufacturers were forced to provide better shutters, better aperture controls, and a way to measure—and display—the amount of light reaching the film.

Squirting water on the wall

MORE SOPHISTICATED DESIGNS would soon improve the results obtained from the new, smaller camera models. It all came back to the management of light. Think of a camera as a hose that squirts water against a wall. Both the size of the opening of the nozzle (its aperture) and the length of time the faucet is open would determine how much water hits the wall. A short soak through a large aperture can yield just as much water as a longer one through a smaller opening.

Then think of the wall as an absorbent panel. The more porous its surface, the faster it will become soaked. Films and plates are likewise faster and slower, more or less porous. Thus their speed—their capacity to absorb light—is the third factor in determining just how much light should enter the camera as the shutter opens and closes.

Early films and plates were slow. Lens apertures were small. Exposures had to be long, requiring tripods. But the photographic industry relentlessly improved lenses, camera controls, and films. And one more thing: lighting.

Let there be light

SOURCES OF ILLUMINATION other than the sun, especially flash, made all kinds of new pictures possible. Magnesium powder did the job dramatically. Putting a spark to a small tray of the powder—or a magnesium ribbon—ignited an explosion of brilliant light and sent up clouds of smoke. Gas lighting helped, too.

By the late nineteenth century, cities began being wired for electricity. The benefits were everywhere, especially in factories. Electricity meant new forms of light, heat, and power.

New materials and ways of manipulating them were rapidly being developed. Advances in optical glass quality and lens design had come along just in time to meet the high demands imposed by both smaller negatives and smaller cameras. Plastic, invented in 1855, had led to the development of roll film and would eventually find its way into cameras. Improvements in shaping metal allowed the standardized production of small precision camera parts.

Spurred on by millions of consumer dollars at stake, Eastman and his competitors now had not only motivation but also the technical means to turn cameras into

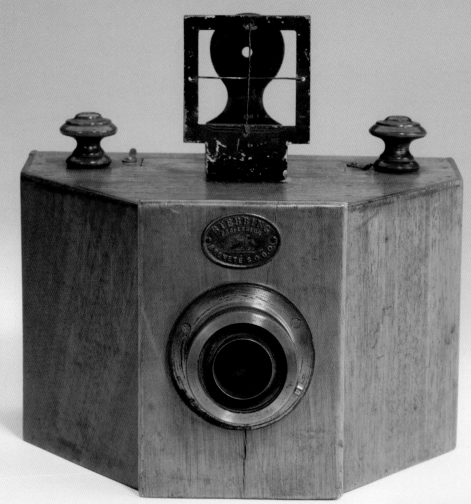

Stebbing's Automatic Camera

ca. 1883

E. Stebbing, Paris, France. 1974:0037:1501.

The Stebbing's Automatic Camera had several interesting features, including an audible click when enough film had been advanced for the next exposure, as well as a moveable pressure plate to precisely place the film in the exposure plane. The pressure plate action pierced the film to mark where it later should be cut for development. The concept had great promise and seemed to offer simplicity and ease of use, but the film proved troublesome, requiring lengthy drying time and suffering dimensional instability. This, coupled with the introduction of Eastman's roll film and the Eastman-Walker roll holder, which adapted to almost any camera, caused the demise of the $12 camera after only a few years.

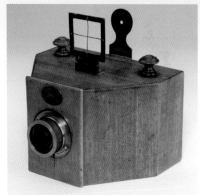

advanced but convenient devices that would perform precisely, reliably, and with relative ease. New camera presentations seemed to take place weekly, and the perception that roll film would motivate buyers inspired manufacturers and designers worldwide.

The first camera with an integral roll holder, Stebbing's Automatic Camera, was invented and manufactured in 1883 by Professor E. Stebbing of Paris. He used the word "automatic" in the name of his all-wood box camera to indicate that it required no focus. "Focusing is useless," he said. "It is controlled with too much care." His camera produced sixty to eighty 6 x 6-cm exposures on roll film on gelatino-bromide paper, and it could also produce single exposures on dry plates.

Kodak Camera (barrel shutter), 1888. See page 130.

IX

GEORGE EASTMAN

Frederick Church, *[George Eastman holding Kodak camera on board the S.S.* Gallia*]*,
February 1890. See page 131.

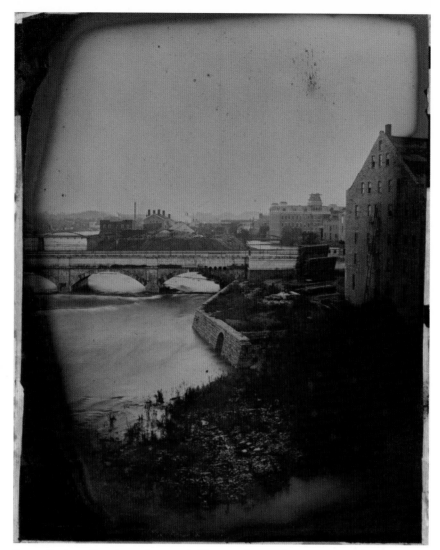

George Eastman (American, 1854–1932). *[Genesee River, Rochester, New York]*, ca. 1877. Ambrotype. Gift of George Dryden. George Eastman Legacy Collection.

To UNDERSTAND THE HISTORY OF THE CAMERA in the context of its universal penetration into the modern world, it's best to step back and take a look at one man.

Elizabeth Brayer's definitive biography of George Eastman recounts how, in 1877, the successful young bank clerk became interested in buying land in Santo Domingo. He had planned a trip that would have required his taking pictures of potential properties. "The voyage to Hispanola never came off," she writes, but she quotes Eastman: "In making ready, I became totally absorbed in photography." "For $49.58," Brayer writes, "he bought a

five- by eight-inch camera box, a view tripod, a darkroom tent, and twenty-four other photographic items." At that time, she adds, there were only two photographic amateurs in Rochester; only professionals could be expected to master the intricacies of the craft.

Eastman was prudent and successful from the start. By 1881, at the age of twenty-seven, he had bought his mother a house. He was dating several local belles, and he seemed marked for a successful career in banking. But when a promotion came up, he was passed over in favor of a relative of one of the bank's

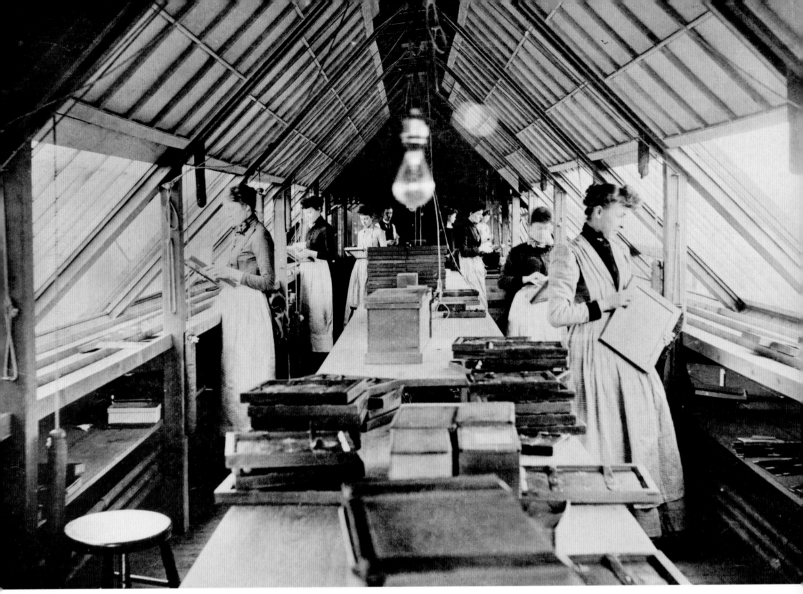

Unidentified photographer. *[Interior workshop at Kodak Ltd., Harrow, England]*, ca. 1900. Albumen print. George Eastman Legacy Collection. Between 1895 and 1905, most Kodak camera snapshots were developed by sunlight in rooftop workshops such as this.

directors. Eastman resigned from the bank and turned his interest to the photographic plate manufacturing business he'd been nurturing on the side, keeping up with journals, hand-coating wet plates in his mother's kitchen, and experimenting with dry plates.

EASTMAN'S GRAND VISION

LOOKING BACK, we can see that from the beginning George Eastman first intuited, then understood,

the big picture. Over the next nineteen years, he seized on roll film as the key concept and designed the cameras to use it.

He conjured the name Kodak. He set up the vertically integrated company that soon became a model for the economies of scale. He hired the very brightest people, many of whom were from the Massachusetts Institute of Technology (MIT).

He treated his employees well. Everything was in the service of a vision of the growth he alone saw coming.

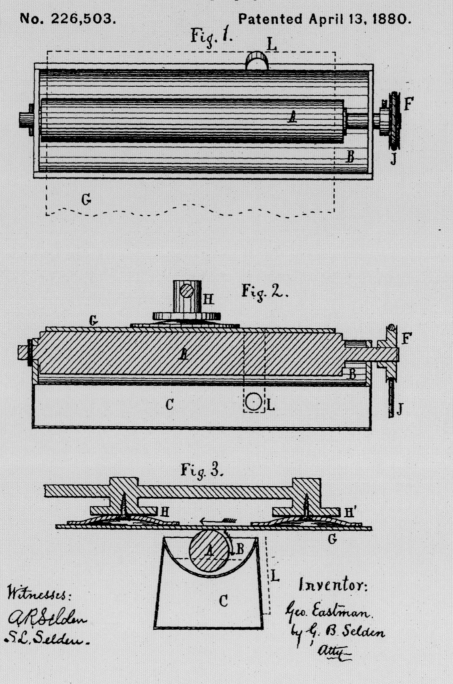

George Eastman (American, 1854–1932). Patent for *Method and Apparatus for Coating Plates for use in Photography*, 1880. Courtesy United States Patent and Trademark Office.

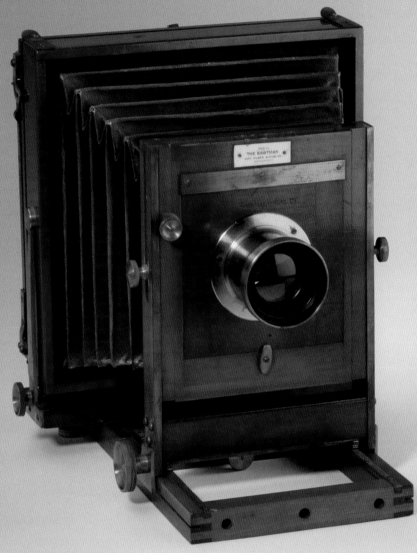

Eastman Interchangeable View Camera (5 x 7)

ca. 1885

Eastman Dry Plate and Film Company, Rochester, New York. Gift of Eastman Kodak Company. 1974:0037:1010.

Eastman's 1885 Interchangeable View Camera featured a back and bellows assembly that could be removed from the bed and front standard and exchanged for another size. Many different formats could be acquired at a total cost lower than a collection of individual cameras of each size. Well constructed from French polished mahogany and lacquered brass fittings, it offered double rear swing and double rising front movements. The smallest size, 4¼ x 5½ inches, was available for $26, while the largest, 20 x 24 inches, was priced at $100. The extra backs were $13 to $50.

We do the rest

THE FIRST KODAK CAMERAS SOLD FOR $25 and came loaded with film for a hundred 2½-inch circular pictures. When you used up a roll, you mailed the camera back to Kodak; Kodak developed the film and sent back your pictures, along with a fresh new roll of film. This "value proposition" took the ad slogan "You press the button, we do the rest." It caught on surprisingly well for a luxury item—$25 was a lot of money in 1888.

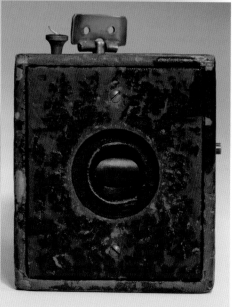

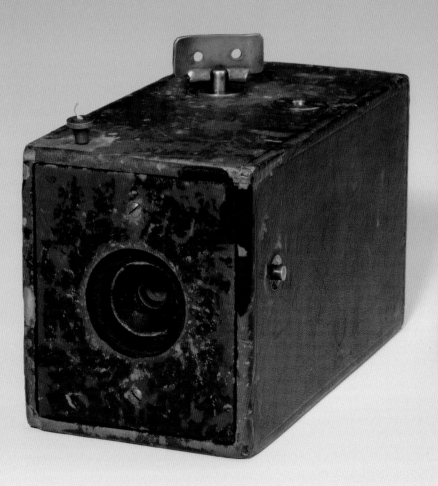

Kodak Camera (barrel shutter)
1888

Eastman Dry Plate & Film Company, Rochester, New York.
Gift of Eastman Kodak Company. 1990:0128:0001.

In 1888, the world first learned to say Kodak, which, in the beginning, was the name of this handheld box camera rather than an entire company. The camera was manufactured by Frank Brownell of Rochester, New York, for Eastman Dry Plate & Film Company, also of Rochester. The name was coined by George Eastman, who is said to have favored the letter "K" and wanted something memorable and pronounceable in multiple languages.

Expensive for the time at $25, the purchase of a Kodak included a factory-loaded roll of sensitized film, enough for one hundred 2½-inch circular images. After exposure, the still-loaded camera was returned to Rochester, where the film was developed, prints made, and a new roll inserted, all for ten dollars. This ease of use was such a key selling point that Eastman soon promoted sales with his slogan, "You press the button, we do the rest."

An early "point-and-shoot" camera, the Kodak revolutionized the photographic market with its simplicity of use and freedom from the mess of darkroom chemistry. The first successful camera to use roll film, it stood for convenience. Looking to build on this reputation, over several months in late 1889 George Eastman introduced a modified version of the original Kodak, now designated the No. 1, and three fresh models bearing the Kodak name, all loaded with the new Eastman's Transparent film.

Those first Kodaks marked the beginning of photography as a tool and pastime for the common person. Even more important than their sales figures was the major role they played in establishing what would become Eastman Kodak Company (in 1892) as the first international photofinishing concern. Soon, a seemingly endless line of new Kodak models offered more features and larger images, all contributing to the worldwide identification of the Kodak brand with the growing popularity of amateur photography. Illustrated here is Kodak camera serial number 6, thought to be the earliest known example.

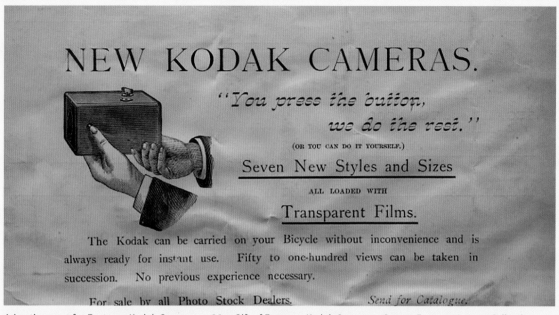

Advertisement for Eastman Kodak Company, 1889. Gift of Eastman Kodak Company. George Eastman Legacy Collection.

Unidentified photographer. *[Street scene with soldiers marching; Kodak #1 snapshot]*, ca. 1888. Albumen print. George Eastman House collections.

Frederick Church (American, 1864–1925). *[George Eastman holding Kodak camera on board the S.S.* Gallia*]*, February 1890. Albumen print (Kodak #2 snapshot). Gift of Margaret Weston. George Eastman Legacy Collection.

Verso of Original Kodak snapshot, ca. 1890. George Eastman House collections.

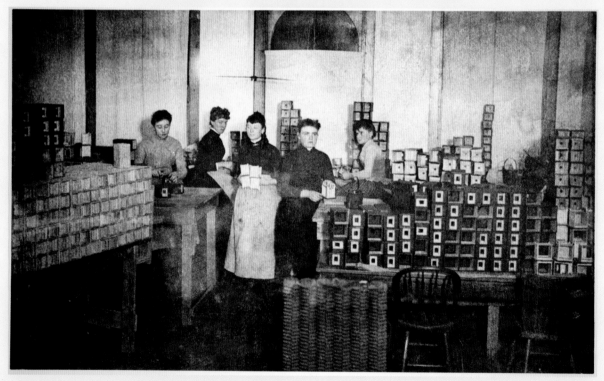

Unidentified photographer. *[Brownell Manufacturing Company workers assembling cameras]*, ca. 1888. Gelatin silver print. Gift of Eastman Kodak Company. George Eastman Legacy Collection.

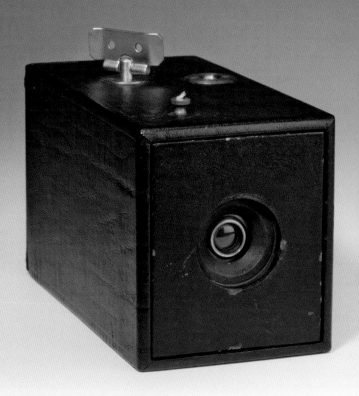

No. 1 Kodak Camera
1889
Eastman Dry Plate & Film Company, Rochester, New York.
1974:0037:1915.

With the introduction of the larger No. 2 Kodak in late 1889, a revision of the original model was retroactively named the No. 1 Kodak. Its major modification was the replacement of the complex barrel shutter with a simpler, less expensive sector shutter, along with minor hardware changes associated with the new shutter. Late in 1889, Eastman's Transparent film (nitrate) was introduced; all new Kodak camera models (No. 1, No. 2, No. 3, No. 3 Jr., No. 4, No. 4 Jr.) from now on were shipped with this, replacing Eastman's American film (paper-backed stripping film), which was more cumbersome to process. In the company's 1890 catalog, the No. 1 was described as "the original Kodak and it will always continue to be the Note Book of Photography." It remained factory-loaded with one hundred exposures, 2½ inches in diameter, and priced at $25. In total, about 10,000 No. 1 Kodak cameras were produced.

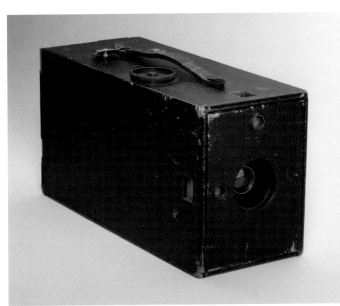

No. 4 Kodak
(owned by Robert E. Peary)
1889
Eastman Dry Plate & Film Company, Rochester, New York. Gift of Eastman Kodak Company. 1994:1480:0001.

This No. 4 Kodak is one of several used by then-Lieutenant Robert E. Peary on his 1897 Greenland expedition. Introduced in 1889 for $50, it was capable of producing forty-eight or a hundred pictures of 4 x 5 inches and weighed 4½ pounds. Still, Kodak literature claimed it was "much smaller than cameras by other makers for making single pictures." The camera featured an instantaneous shutter, rotating stops, adjustable speed, rack-and-pinion focusing, and two tripod sockets for horizontal or vertical timed exposures.

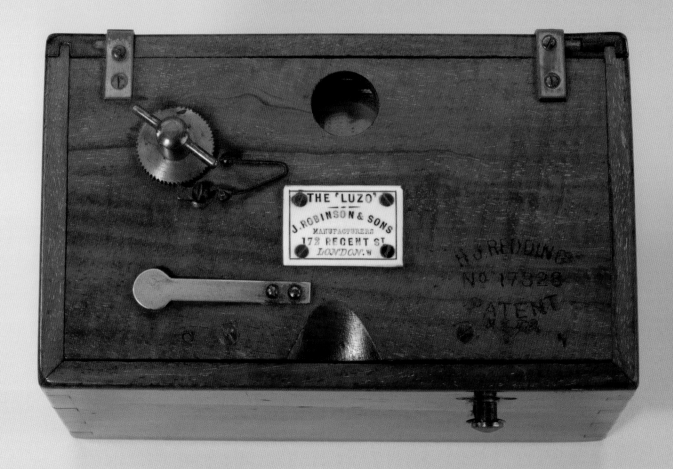

Luzo
1889

J. Robinson & Sons, London, England. Gift of Eastman Kodak Company. 1974:0037:1503.

The roaring success of Eastman's Kodak in 1888 convinced rival manufacturers that the roll-film camera was here to stay. Henry Redding designed the Luzo to use the Kodak's film, but he improved on Eastman's camera by changing the location of the film spools, resulting in a much smaller box. The Luzo also incorporated a reflex viewfinder, a feature lacking in the Kodak. Built by J. Robinson & Sons of London, Redding's camera was constructed mainly of polished Spanish mahogany. The external shutter mechanism was a simple sector design powered by a rubber band; tension could be varied by a brass slide below the shutter. Like the Kodak, the Luzo took one hundred round pictures per roll. Unlike the Kodak, processing was not available through the manufacturer, which left the photographer to sort this out on his own.

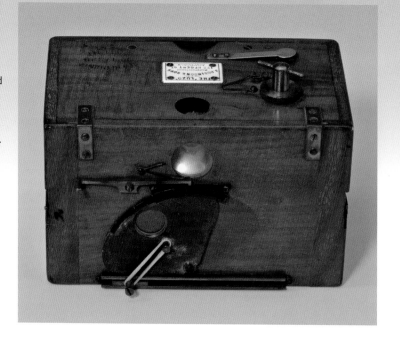

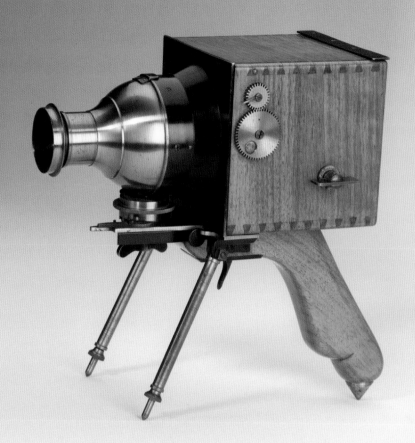

Escopette
ca. 1888
E. V. Boissonas, Geneva, Switzerland. Gift of Eastman Kodak Company, ex-collection Gabriel Cromer.
1974:0037:0014.

Eastman's 1888 Kodak introduced many people to photography and spurred the design of cameras built around Eastman roll films. Swiss inventor Albert Darier took advantage of the readily available Eastman 70mm wide films with his Escopette, also in 1888. The handsome hardwood box with dovetail joinery housed a 110-exposure roll and the film winding mechanism, while a bottle-shaped metal nose contained the spherical shutter and Steinheil periscopic 90mm f/6 lens. The shutter speed was adjusted by a ridged wheel with ratchet stops that set the spring tighter with each click. A brass key under the ratchet set the shutter, so it could be tripped by the photographer's trigger finger as the camera was held by the pistol-grip handle. The handle became part of a tabletop stand when the two adjustable brass legs were pivoted open. Carrying on the firearm theme, the metal parts were lacquered or gun-blued. E. V. Boissonas manufactured the Darier design and priced the camera at 190 francs.

Model A Daylight Kodak
1891
Eastman Company, Rochester, New York.
1974:0037:1080.

The Model A Daylight Kodak was introduced in 1891. Slightly larger than the No. 1 Kodak, it delivered twenty-four exposures of 2¾ x 3¼ inches on a special roll film that could be loaded in daylight because it was packaged in cardboard cartons with a black cloth leader and trailer. The deluxe leather-covered, wooden body retained the string-set sector shutter of earlier models. Kodak's 1892 catalog touted the camera to travelers and tourists as "the smallest camera that will make a good picture" with "advantages never before embodied in any other." It was priced at $8.50, and an outfit for developing and printing the pictures could be purchased for $1.50.

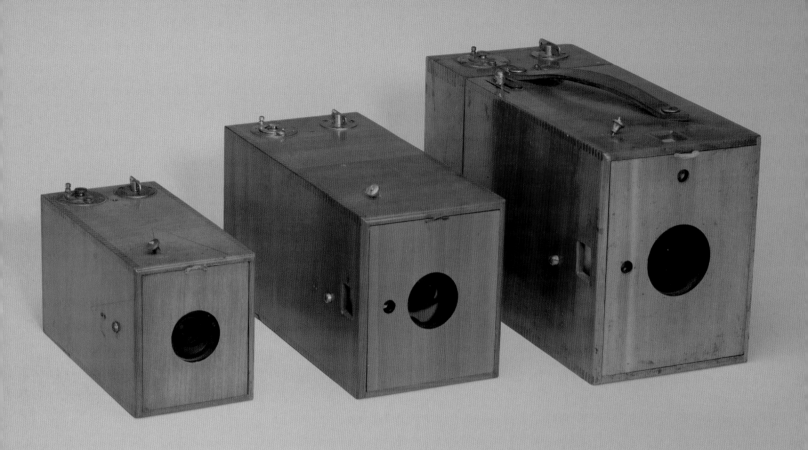

Model A Ordinary Kodak
1891
Eastman Company, Rochester, New York.
Gift of Eastman Kodak Company.
1974:0037:1887.

Model B Ordinary Kodak
1891
Eastman Company, Rochester, New York.
Gift of H. Cobb. 1974:0037:1121.

Model C Ordinary Kodak
1891
Eastman Company, Rochester, New York.
Gift of Eastman Kodak Company.
1974:0037:1265.

Eastman introduced three models of their Ordinary Kodaks in 1891. Like the original Kodak, they were all darkroom-only loaded roll-film cameras. The Model A is easily distinguished from the Model A Daylight Kodak by its "plain" wooden body and lack of built-in viewfinder. Billed as the "Young Folk's Kodak," the 1892 Kodak catalog asserted that "any boy or girl, 10 years old or over, can readily learn to make the finest photographs." The camera featured a fixed-focus lens (always "in focus") and "V" sighting lines marked on its body that aided in aiming the camera. It sold for six dollars, a savings of $2.50 over the deluxe model.

The Model B Ordinary Kodak, with its natural wood-finished body, featured a viewfinder and string-set sector shutter concealed by a removable front panel and a felt lens cap. It also had rotating stops in the lens "especially designed for young people who want a larger picture." For the selling price of ten dollars, it came loaded for twenty-four pictures of 3½ x 4 inches.

The largest of the Ordinary Kodaks, the Model C, had a natural wood-finished body featuring a focusing lever, adjustable shutter speeds, and two finders. Also, the camera's roll-film back could be removed and replaced with a glass plate holder. Priced at $15, it came loaded with twenty-four exposures for 4 x 5-inch pictures. Like the other Ordinary Kodaks, this model was discontinued in 1895.

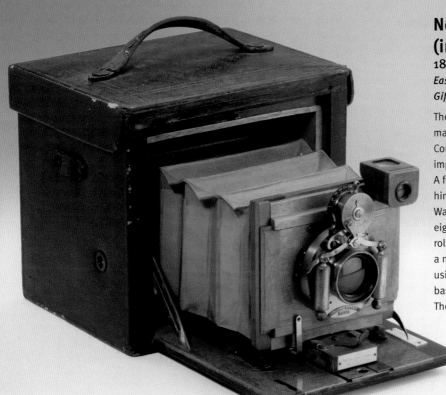

No. 4 Folding Kodak (improved model)
1893
Eastman Kodak Company, Rochester, New York.
Gift of Eastman Kodak Company. 1974:0037:1513.

The No. 4 Folding Kodak (improved model) of 1893, manufactured by Frank Brownell for Eastman Kodak Company of Rochester, New York, embodied several improvements over Kodak's original model of 1890. A folding bellows camera with a drop front and a hinged top cover that gave access to the Eastman-Walker roll holder, it was capable of making forty-eight 4 x 5-inch exposures on Eastman transparent roll film. Improvements in the 1893 model included a new Bausch & Lomb iris shutter, the flexibility of using either roll film or plates, and a hinged baseboard that permitted drop front movements. The retail price was $60.

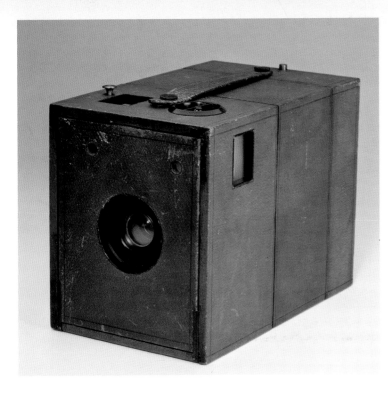

Kamaret
1891
Blair Camera Company, Boston, Massachusetts. 1974:0037:0020.

Introduced in 1891 by the Blair Camera Company of Boston, the Kamaret was a leather-covered wooden box camera, capable of producing twenty, fifty, or one hundred 4 x 5-inch images on either roll film or dry plates. It was advertised as "Being nearly one-third smaller than any camera of equal capacity," a claim that was obviously aimed at Eastman's already introduced No. 4 Kodak. The smaller size was made possible by Blair's patented space-saving method of placing the film spools forward of the film plane. The original retail price was $40.

Bull's-Eye Camera
1892
Boston Camera Manufacturing Company, Boston, Massachusetts.
1974:0084:0063.

The Bull's-Eye Camera was marketed in 1892 by Samuel Turner and his Boston Camera Manufacturing Company of Boston, Massachusetts. It was a simple roll-film box camera producing 3½-inch square images. The original Bull's-Eye Camera was the first to use printed paper backing on its film, with frame numbers visible through a small red celluloid window that became the standard for roll-film cameras. George Eastman, who always knew a good idea when he saw one, introduced a similar box camera called the Bullet in 1895. That same year, rather than continue payments on the red-window patent, Eastman bought Turner's company and the right to manufacture Bull's-Eye cameras. An original Bull's-Eye sold for $7.50, with extra twelve-picture film cartridges priced at fifty-five cents. The earliest examples, as shown here, have the "D"-shaped celluloid window; the later models have "O"-shaped windows.

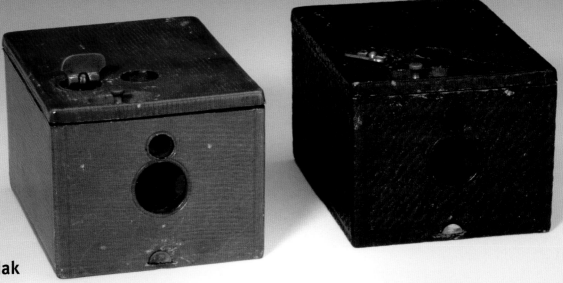

Pocket Kodak
1895
Eastman Kodak Company, Rochester, New York. Gift of Eastman Kodak Company. 1974:0028:3256 (red model). Eastman Kodak Company, Rochester, New York. Gift of Per A. Gyzander. 1978:1278:0001 (black model).

Continuing George Eastman's goal to bring affordable photography to the common person, the Pocket Kodak was introduced in 1895 by Eastman Kodak Company, Rochester, New York. Enormously popular, it was a small, leather-covered wooden box camera. Easily held in the palm of the hand, it used either roll film or individual plates to produce images 1½ x 2 inches in size. It was attractive in either red or black leather covering and retailed for five dollars.

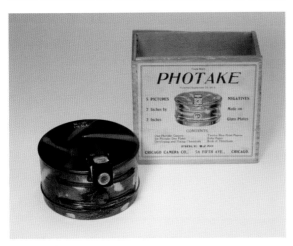

Photake
ca. 1896
Chicago Camera Company, Chicago, Illinois. Gift of Eastman Kodak Company. 1974:0084:0070.

The Photake camera was manufactured starting in 1896 by the Chicago Camera Company. It had a four-inch diameter cylindrical metal body resembling a coffee can. Five dry plates were arranged around the inner circumference of the can, and by rotating the outer cover, which contained the lens, the photographer could expose the next plate. Advertised as "An ideal Christmas gift," the camera was packed in a wooden box along with six dry plates and enough chemicals and paper to make twelve prints. It retailed for $2.50.

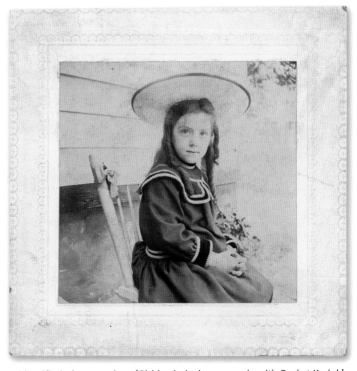

Unidentified photographer. *[Girl in chair; image made with Pocket Kodak]*, ca. 1910. Gelatin printing out paper. Gift of Mrs. Francis A. Schifferli Jr. George Eastman House collections.

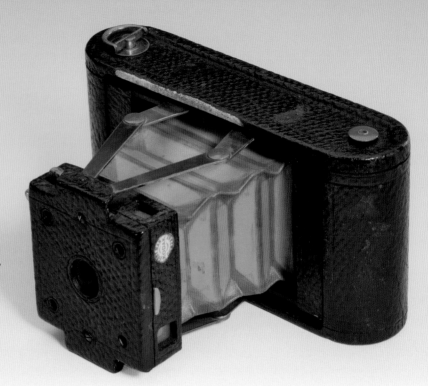

Folding Pocket Kodak
1897
Eastman Kodak Company, Rochester, New York. Gift of Eastman Kodak Company. 1991:2641:0002.

The first of a long series of folding cameras, the 1897 Folding Pocket Kodak made pictures in a new format of 2¼ x 3¼ inches and collapsed to a thickness of only 1½ inches. The slim camera could be carried in a (large) pocket or on a bicycle in the separately available case. Simple in operation, the self-setting shutter was always ready to make an exposure. The "Film Cartridge System" allowed loading in daylight. Distinctly different from later models, the lens window was a recessed conical shape. It was priced at $10 without film.

THE GREAT DESIGNER

EASTMAN WANTED A CAMERA in every household. To make that happen he turned to Frank Brownell, whose company produced the cameras—some sixty different models in all—sold by Kodak between 1885 and 1902. His innovations met with steady success, especially a series of five-dollar models.

Brownell's triumph came in 1900. The Brownie camera met Eastman's price requirement and performed well. Brayer describes how "the first five thousand sold immediately," with orders cascading in to the point where demand outstripped production.

Brayer tells how, spurred by advertising in consumer magazines such as *Colliers*, *The Saturday Evening Post*, and *The Youth's Companion*, the word Kodak became both a noun and a verb. "Kodak the Children" became the slogan for the magic of the snapshot.

Kodak cameras covered the world. The Dalai Lama grabbed his Kodak as he fled his Tibetan palace in 1904. The cameras went to battlefields and hospitals in the Boer War. In World War I, American doughboys carried a vest-pocket model, "the soldier's camera," to the trenches in France.

Eastman, a man not given to effusive praise, described Brownell as "the greatest camera designer who ever lived." A rumor persisted that the Brownie was named in his honor. In fact, the name was brilliantly appropriated from the impish little men whose adventures were chronicled in popular children's books by Palmer Cox.

Cox's Brownies scampering over the camera's carton and ads made sure children would know Brownie was made for them. Each Brownie came with a 54-page booklet offering picture-taking tips and inviting the buyer to become a free member of the Brownie Camera Club. Targeting children, girls as well as boys, was smart because they naturally took to the device and begged parents to buy one. But it was also brilliant; Eastman knew that successful photographers tend to upgrade: Any kid hooked on photography would likely buy cameras over a lifetime.

Eastman also made sure that parents knew the camera would be fun for them, too. A camera "you and your dad can enjoy together," one ad headlined.

Dads and moms found they did enjoy photography. A lot. The pictures they got back drew them into the market. Eastman knew that anything that caused people to get better at picture-taking would make them more

Brownie
(original model)
1900
Eastman Kodak Company, Rochester, New York.
1978:1657:0002.

Introduced by Eastman Kodak Company in 1900, the Brownie camera was an immediate public sensation due to its simple-to-use design and inexpensive price of one dollar. Every individual, irrespective of age, gender, or race could afford to be a photographer without the specialized knowledge or cost once associated with the capture and processing of images. An important aspect of the Brownie camera's rapid ascendancy in popular culture as a must-have possession was Eastman Kodak Company's innovative marketing via print advertising. The company took the unusual step of advertising the Brownie in popular magazines of the day, instead of specialty photography or trade magazines with limited readership. George Eastman derived the camera's name from a literary character in popular children's books by the Canadian author Palmer Cox. Eastman's astute union of product naming, with a built-in youth appeal, and inventive advertising placement had great consequence for the rise of modern marketing practices and mass consumerism in the twentieth century.

Unidentified photographer. *[Portrait of Frank Brownell]*, ca. 1890. Albumen print. George Eastman Legacy Collection.

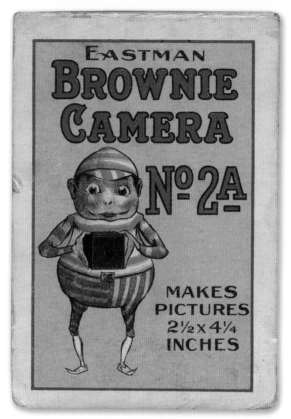

End flap of Eastman Kodak Company's No. 2A Brownie camera box illustrating Palmer Cox's Brownie character, ca. 1901. George Eastman House Technology Collection.

confident and skilled. As their enjoyment increased, they would take more pictures. The natural learning curve meant their yield of good and excellent pictures would grow. The cycle would feed on itself. All this would lead to more sales of fifteen-cent six-exposure rolls for the Brownie (and other rolls at higher prices), which would quickly cause George Eastman to become one of the richest people in the U.S.

The cameras were most often trained on family members, and the "album" began to evolve as a personal archive, one that gained in psychological value as time and people passed.

The earliest Brownie cameras (mostly sold in England) had a design problem with the back. The loading release was flimsy and its slide-off design had a loose fit. The back was redesigned by April 1900 with the slide-off back being replaced by a bottom-hinged back secured at the top of the camera with a sliding metal latch.

The Brownie created an industry, and Eastman plowed his early camera revenues into a research and development empire that eventually resulted in movie film, X-ray film, color slides and prints, and hundreds of applications.

Eastman would consistently resort to extensive advertising and promotion to sell his products. He knew, though, that all the advertising in the world would be useless if customers could not get their hands on the camera. Eastman took the unusual step of requiring dealers to keep the camera in stock. He knew that any customer who could see it, hold it, sense its heft, and take it home that hour was a far better prospect than someone who might order one based on some display advertising and a sales pitch. He lightened the financial burden on his dealers by having them carry the sample camera on consignment, which allowed Eastman to control the price. Many dealers did not want to sell a one-dollar camera; discounting it would eliminate the profit margin, thus eliminating the camera.

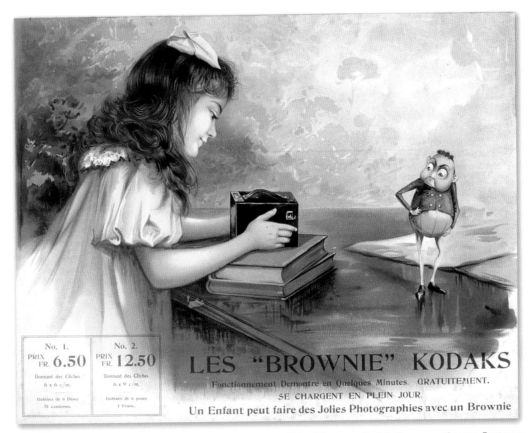

Advertising poster for "Les 'Brownie' Kodak," ca. 1905. Gift of Eastman Kodak Company. George Eastman Legacy Collection.

The use of inexpensive materials in the Brownie's construction, as well as Eastman's insistence that all distributors keep one camera on consignment, enabled the company to keep the camera's cost within the limits of consumers' pocketbooks. More than 150,000 Brownies were shipped in the first year of production alone, a staggering success for a company whose largest single-year production for any model to date had been 55,000 cameras. The Brownie launched a family of nearly two hundred camera models and related accessories, which during the next sixty years helped to make Kodak a household name.

Although George Eastman was always certain that he would succeed in introducing color pictures to the world on a large scale, he was not alive to see photographers admiring the color pictures they took with his Kodachrome film. Plagued by a chronic and painful illness, he shot himself on March 14, 1932. The note that he left behind read, "To my friends—My work is done—Why wait?"

A LEGACY OF WEALTH

AT HIS DEATH, EASTMAN WAS CONSIDERED one of the top five most important philanthropists in the United States. He had given away more than $100 million (about $2 billion today) to causes linked to education, health care, medical research, the arts, and hundreds of other charitable organizations.

Eastman's hometown of Rochester, New York, benefited most from his generosity, with the University of Rochester receiving close to half his fortune. Eastman's plan was for Rochester to be "the best city in which to live and raise a family."

Eastman's biographer, Elizabeth Brayer, makes the case that Eastman was a kind of natural-born genius, whose innate intellectual capacities combined with inexhaustible diligence to modify any project he chose to bring it in line with his sense of its ideal potential.

Three-cent postage stamp featuring George Eastman. Issued in Rochester, New York, on July 12, 1954, the 100th anniversary of Eastman's birth. Portrait by Nahum Ellan Luboshez (English, 1869–1925). Printed by Rotary Press.

This included music schools, dental academies, and lavish anonymous financial donations to institutions he thought mattered most at the time.

His philanthropic efforts were as progressive as his business practices. Thanks in part to his liberal upbringing and his first-hand experiences, Eastman became the country's largest supporter of African American education in the 1920s. He gave millions of dollars to Alabama's Tuskegee Institute and small but substantial sums to Howard University in Washington, D.C., Meharry Medical Institute (now Meharry Medical College) in Nashville, Tennessee, and Hampton Institute (now Hampton University) in Hampton, Virginia. He was especially generous to the Massachusetts Institute of Technology (MIT) in Cambridge, Massachusetts. His donations to the University of Rochester resulted in the formation of the Eastman School of Music and the Eastman Dental Center (which became part of the University's School of Medicine and Dentistry). His will included a bequest to the University of Rochester of his residence and $2 million for the property's upkeep. Shortly after World War II, Eastman's residence became the George Eastman House Museum of Photography.

Nahum Ellan Luboshez (English, 1869–1925). *[George Eastman]*, ca. 1921. George Eastman Legacy Collection.

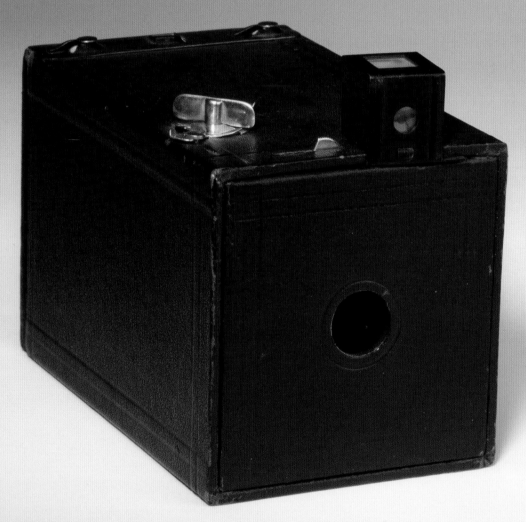

No. 1 Brownie (owned by Ansel Adams), ca. 1901. See page 148.

THE BROWNIE LEGACY

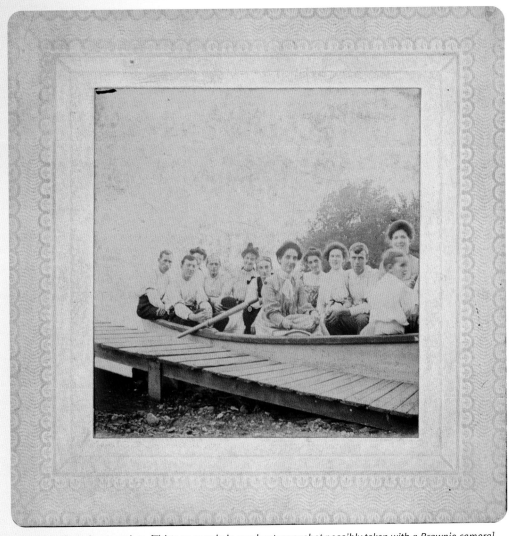

Unidentified photographer. *[Thirteen people in row boat; snapshot possibly taken with a Brownie camera],*
ca. 1905. See page 149.

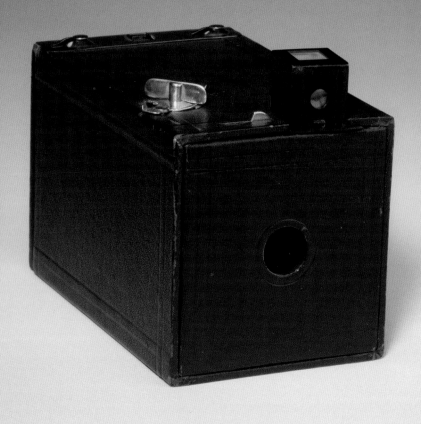

No. 1 Brownie
(owned by Ansel Adams)
ca. 1901
Eastman Kodak Company, Rochester, New York.
Gift of Ansel Adams. 1974:0037:1963.

The No. 1 Brownie, introduced in October 1901, was actually the original Brownie with running changes included. Upon the introduction of the larger No. 2 Brownie, the original Brownie was renamed the No. 1, still using No. 117 film and producing 2¼-inch square images. It also had the hinged rear cover, a revision to the original Brownie's box lid cover that proved troublesome. The original price was one dollar.

The camera shown here was the boyhood camera of Ansel Adams. It was a gift from his aunt for his first visit to Yosemite National Park in the summer of 1916. The fourteen-year-old Ansel was awestruck by the grandeur of the mountains and immediately began taking pictures.

NOT ONLY DID GEORGE EASTMAN come up with the first commercial photofinishing system, but he engineered the company that made it. This was the equivalent of expanding a rose garden into a national park. His coordination of its technical, marketing, research and development, and financial structures were extraordinary for someone with little education. He belongs on the stage with Thomas Edison, Henry Ford, Alexander Graham Bell, and all the other genuine innovators who started out with nothing and changed the world. The best proof of that remains a one-dollar camera.

THE BROWNIE RULES
THE WORLD

IT WOULD BE HARD TO OVERSTATE the impact of the Brownie camera on households, commerce, and culture during its lifespan. Ansel Adams (1902–1984), the best-known professional American photographer of the twentieth century, took his first photographs of Yosemite in 1916 using a Box Brownie—showing how the simplest cameras can take impressive photographs. Many other noted photographers got their first taste of picture-taking via the Brownie. As Henri Cartier-Bresson would write:

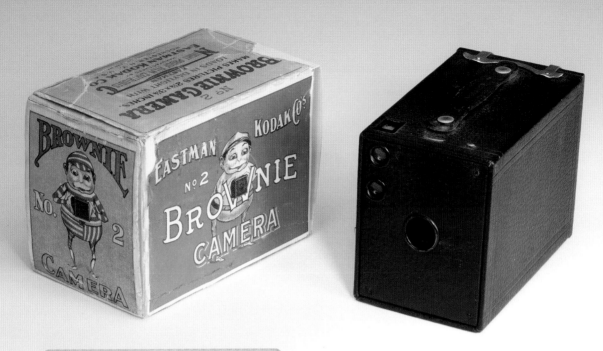

No. 2 Brownie
ca. 1901
Eastman Kodak Company, Rochester, New York. 1974:0037:1116.

The No. 2 Brownie camera, introduced in 1901, was still a cardboard box camera, but it included several important changes. It was sized for a new film, originally known as No. 2 Brownie film but renamed No. 120 in 1913 when Kodak gave numerical designations to their different films. No. 120 roll film is still in production today. In addition to the new film, which produced larger 2¼ x 3¼-inch images, the camera now sported two built-in reflecting finders and a carrying handle. With a retail price of two dollars, the No. 2 proved very popular, selling 2.5 million cameras before 1921 and remaining in production for more than thirty years.

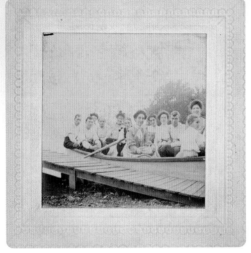

Unidentified photographer. *[Thirteen people in row boat; snapshot possibly taken with a Brownie camera]*, ca. 1905. Albumen print. Gift of Mrs. Francis A. Schifferli Jr. George Eastman House collections.

I like many another boy, burst into the world of photography with a Box Brownie, which I used for taking holiday snapshots....From the moment I began to use the camera and to think about it, that was the end to holiday snaps and pictures of my friends. I became serious. I was on the scent of something, and I was busy smelling it out.

The Brownie was actually a children's camera that an adult could pick up with pleasure and apply with discernment. And they did, a practice driven in part because almost anyone could afford one. For one or two dollars more, anyone could buy a better Brownie of their choice. And there was always a better Brownie.

In the first ten years of its existence, the company offered more than fifty different camera models. From 1900 to 1910, it offered dozens. Over the next forty years, nearly two hundred different models would reach the market.

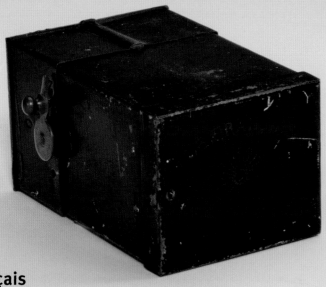

Français
ca. 1910

L. F. G. & Cie, Paris, France. Gift of Eastman Kodak Company, ex-collection Gabriel Cromer. 1974:0037:1495.

Even though by 1910 the roll-film camera was favored by amateur photographers, dry plates were still in use. L. F. G. & Cie of Paris made the tiny all-metal Français camera for use with 4 x 5-cm plates, which were packaged in pairs, enough to fit the two-sided holder that was mounted on a pivot shaft and swiveled like a portable chalkboard. A brass knob on the outside of the holder shaft let the user expose a plate, then shift the pointer from the "1" to the "2" position to make another. A simple lens and shutter on the front of the spice-can-shaped Français limited it to bright daylight use.

Dandy
ca. 1910

Crown Camera Company, New York, New York. Gift of Eaton S. Lothrop Jr. 2000:1037:0001.

The enormous success of Eastman Kodak Company's one-dollar Brownie attracted many would-be competitors. Crown Camera of New York City hoped to tap the growing market for inexpensive, foolproof photography with their tiny Dandy camera. The body was constructed of very thin cardboard covered with textured black paper. Exposures were made on sensitized 1⅛-inch diameter metal discs packed in individual black envelopes. The photo discs were loaded by holding the envelope over a slot at the rear of the camera top, gently squeezing its sides, and allowing the disc to drop inside. A sliding metal cover sealed the slot. After taking the picture using the Dandy's primitive lens and shutter, the envelope was used to retrieve the disc, so it could be processed with the tank and chemicals included in the Dandy's one-dollar home photography outfit.

Cartridge Premo No. oo
ca. 1916
Eastman Kodak Company, Rochester, New York. Gift of M. Wolfe.
1974:0028:3139.

Kodak box cameras came in many sizes, but none were smaller than the Cartridge Premo No. oo introduced in 1916. The "double aught" was designed as a child's camera, but many adults bought one for themselves. Despite its size, not much larger than a box of 35mm film, the No. oo was capable of images rivaling many larger cameras. The good quality lens and reliable shutter made it a great value at only seventy-five cents. Six-exposure rolls of the 35mm wide film sold for a dime.

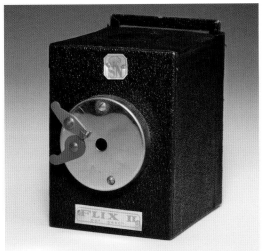

Flix II
ca. 1930
Unidentified manufacturer, Japan. Gift of Eastman Kodak Company.
1991:1587:0001.

The Flix II was a simple box camera from an unidentified Japanese manufacturer, one of many such cameras made in the 1930s and referred to as Yen cameras, due to their selling price. It had a ground glass viewing screen and produced a 4.5 x 6-cm image from a single piece of film loaded in a paper film holder. Yen cameras were available from street vendors under numerous trade names.

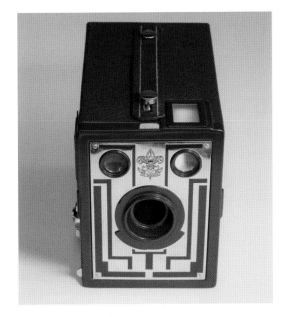

Boy Scout Brownie
ca. 1932
Eastman Kodak Company, Rochester, New York. 1975:0015:0025.

The Boy Scout Brownie, produced in 1932 by Eastman Kodak Company, was one of many specialty cameras based on standard models. The original version made 2¼ x 3¼-inch images on No. 120 roll film and stayed in production just one year, before being replaced with the Six-20 Boy Scout Brownie, which used No. 620 roll film. A metal box camera with card-covered leatherette case in Boy Scout olive drab, it had a special name plate displaying the Scout insignia against a geometric design. The original retail price was two dollars.

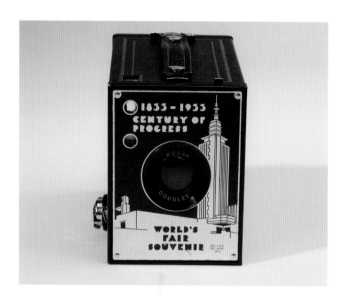

Century of Progress
1933
Eastman Kodak Company, Rochester, New York. Gift of Eastman Kodak Company. 1975:0015:0023.

Another special model based on standard production cameras was the Century of Progress camera, introduced in 1933 by Eastman Kodak Company of Rochester, New York. It was issued to commemorate the Chicago World's Fair. Billed as "A Century of Progress International Exposition," the fair celebrated the hundredth anniversary of the incorporation of the City of Chicago. The camera was a special version of the Brownie Special No. 2, with a front panel depicting an art deco skyscraper. Its original retail price, at the fair, was four dollars.

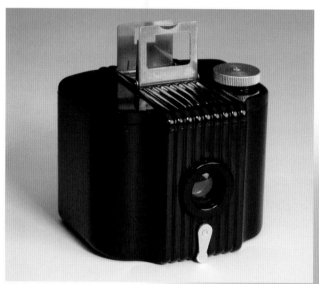

Baby Brownie
ca. 1934
Eastman Kodak Company, Rochester, New York. Gift of Donald H. Evory. 1976:0017:0003.

A molded Bakelite-bodied box camera styled by Walter Dorwin Teague, the Kodak Baby Brownie of 1934 embodied Teague's classic art deco style, with strong vertical ribs in a band around the camera. It used a simple, folding open finder and produced eight images on No. 127 roll film. The retail price was the same as the original 1900 Brownie camera at one dollar.

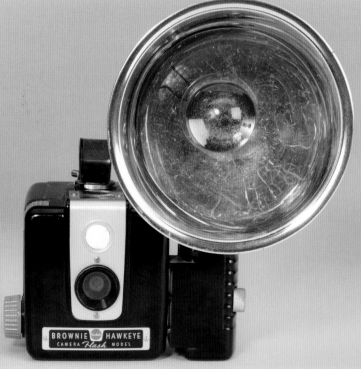

Brownie Hawkeye Flash Model
ca. 1950
Eastman Kodak Company, Rochester, New York. Gift of Fred W. Hoyt. 1981:0038:0004.

The Kodak Brownie Hawkeye Flash Model, produced from 1950 to 1961, was the most popular Brownie camera of all time. Though a simple box camera in a molded black Bakelite body, it featured an attractive art deco design and a brilliant waist-level finder. Introduced a few months after the non-synchronized model, it used a detachable flash holder and produced twelve 2¼-inch square images on No. 620 roll film. The retail price in 1950 was $6.95 for the camera alone and $12.75 for the outfit.

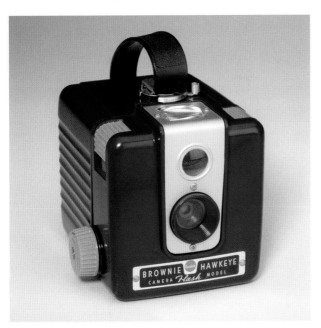

Brownie Hawkeye Flash Model (blue)
ca. 1950
Eastman Kodak Company, Rochester, New York. Gift of Eastman Kodak Company. 1996:0596:0006.

The most successful Brownie camera ever, the Kodak Brownie Hawkeye Flash camera was produced from 1950 through 1961 by Eastman Kodak Company of Rochester, New York. It seems everyone had one. The original model was released in 1949 as a non-flash synchronized Bakelite twin-lens reflex box camera with art deco styling and a large bright finder at a retail price of $5.50. Two years later, the Flash model was released with a price of $6.95. Both cameras were very striking in their black and gray design, though the camera shown here with a painted blue finish is actually a prototype that was never released. Since Bakelite was available only in black and brown, any other color required painting. The extra cost of a painted finish probably accounts for this prototype never reaching production.

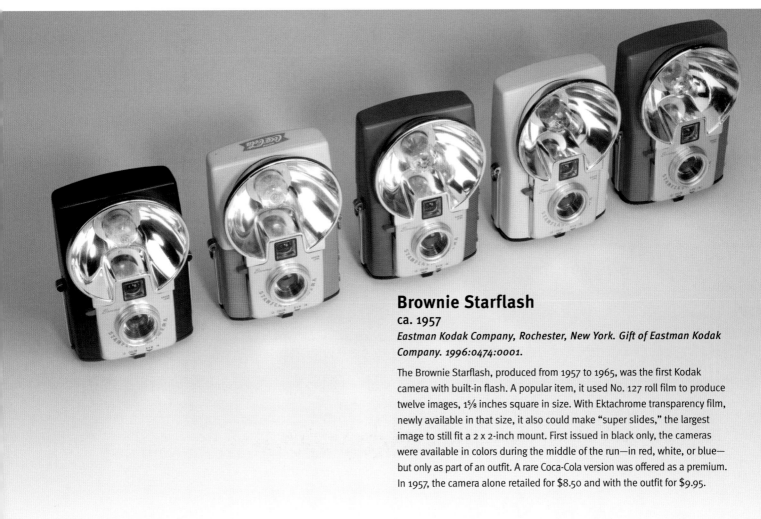

Brownie Starflash
ca. 1957
Eastman Kodak Company, Rochester, New York. Gift of Eastman Kodak Company. 1996:0474:0001.

The Brownie Starflash, produced from 1957 to 1965, was the first Kodak camera with built-in flash. A popular item, it used No. 127 roll film to produce twelve images, 1⅝ inches square in size. With Ektachrome transparency film, newly available in that size, it also could make "super slides," the largest image to still fit a 2 x 2-inch mount. First issued in black only, the cameras were available in colors during the middle of the run—in red, white, or blue—but only as part of an outfit. A rare Coca-Cola version was offered as a premium. In 1957, the camera alone retailed for $8.50 and with the outfit for $9.95.

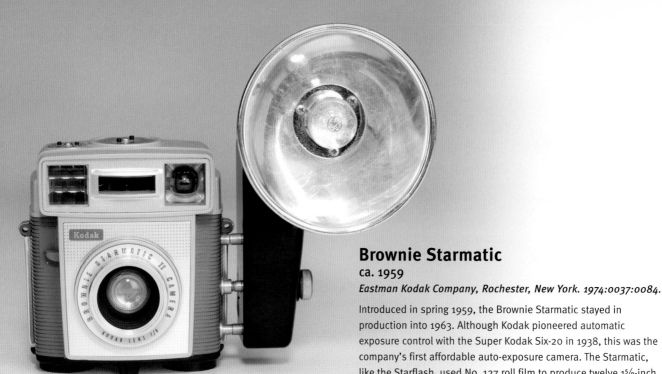

Brownie Starmatic
ca. 1959
Eastman Kodak Company, Rochester, New York. 1974:0037:0084.

Introduced in spring 1959, the Brownie Starmatic stayed in production into 1963. Although Kodak pioneered automatic exposure control with the Super Kodak Six-20 in 1938, this was the company's first affordable auto-exposure camera. The Starmatic, like the Starflash, used No. 127 roll film to produce twelve 1⅝-inch square images. Unlike the Starflash, it returned to the use of a separate flash holder. It retailed for $34.50 in 1959.

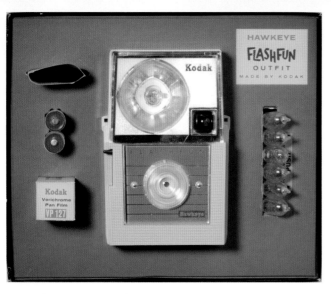

Hawkeye Flashfun
ca. 1961
Eastman Kodak Company, Rochester, New York. Gift of 3M Foundation, ex-collection Louis Walton Sipley. 1977:0415:0115.

Eastman Kodak Company became the dominant force in the business by selling inexpensive, easy-to-use cameras by the millions. Eye-catching style helped sell Kodaks to first-time buyers, and straightforward operation kept them buying film. Kodak designed a series of colorful plastic 127 roll-film cameras in the 1950s with built-in flash, eliminating the need to affix and remove a flashgun. The 1961 Hawkeye Flashfun was one of the last of this line and like most Kodaks was sold as a complete outfit that included film, flash bulbs, and even batteries. These cameras were soon replaced by the quick loading Instamatics, which carried on the Kodak tradition of easy, low-cost photography for everyone.

Brownie Vecta

ca. 1963

Kodak Ltd., Harrow, England. Gift of Eastman Kodak Company. 2001:0119:0002.

Introduced in 1963 by Kodak Ltd., London, the Brownie Vecta was a bold replacement for the Brownie 127 Model II. The radical design was the work of award-winning British designer Kenneth Grange, whose other clients included Kenwood, Wilkinson Sword, Parker Pens, and Ronson. The camera's ergonomic shape made it easier to grip than a basic box model. Molded in gray plastic with a bar shutter release, the Vecta produced eight images per roll on No. 127 roll film like most of its predecessors, but in a vertical format. An unusual characteristic was a film advance knob that wound "the wrong way," turning counter-clockwise.

George Eastman's goal was to have a camera for every target market at every price point. He sought to start consumers with the Brownie and move them into the more expensive models—the Kodaks. The No. 3A Folding Pocket Kodak, Model A, introduced in 1903, was significant for its "postcard" format. It produced 3¼ x 5½-inch negatives (and from them, contact prints). The prints could be made on postcard stock, with the reverse side printed for addressing (a message area was delineated in 1907), and mailed as postcards.

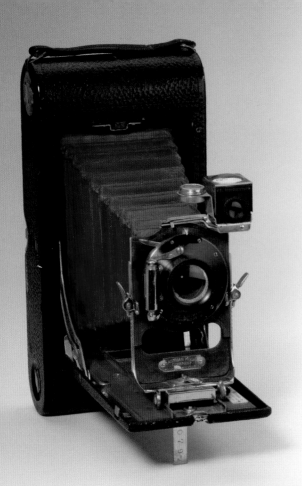

No. 3A Folding Pocket Kodak, Model A
ca. 1903
Eastman Kodak Company, Rochester, New York. 1974:0037:2577.

The No. 3A Folding Pocket Kodak, Model A, introduced in 1903, was manufactured by Eastman Kodak Company, Rochester, New York. It was a folding bellows camera of leather-covered wood and metal construction. Though Folding Pocket Kodak cameras had been manufactured since the late 1890s, the significance of this model was the introduction of the new "postcard" format, which produced 3¼ x 5½-inch images on No. 122 roll film. The prints could be made on postcard stock, with the reverse side printed for address (a message area was added in 1907), and mailed as postcards. The original price was $20.

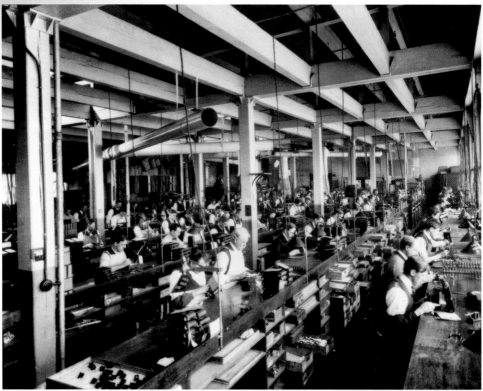

Unidentified photographer. *[Interior view of the camera assembly line at Eastman Kodak Company]*, ca. 1903. Gelatin silver print. George Eastman Legacy Collection.

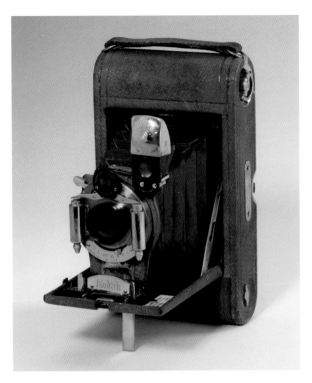

No. 3 Folding Pocket Kodak De Luxe
ca. 1901
Eastman Kodak Company, Rochester, New York. 1974:0037:1347.

The No. 3 Folding Pocket Kodak De Luxe was a specially trimmed version of the standard No. 3, manufactured by Eastman Kodak Company, Rochester, New York, in 1901. A vertical-style folding bed camera, the No. 3 produced 3¼ x 4¼-inch images on No. 118 roll film. The most popular of the Folding Pocket Kodak line, around 300,000 units were manufactured by 1915, when it was replaced with the Autographic models.

The De Luxe version was trimmed in brown Persian morocco covering, including the lens board, and featured a gold silk bellows. It had a Kodak name plate of solid silver and came in a hand-sewn carrying case with silver trim. Only seven hundred De Luxe models were produced. The retail price was $75, compared to $17.50 for the standard model. This camera is an unnumbered factory model that was never offered for sale.

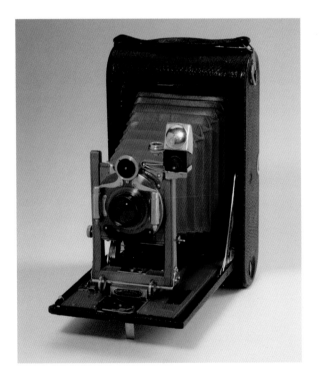

No. 4A Folding Kodak
ca. 1906
Eastman Kodak Company, Rochester, New York. 1974:0028:3341.

Introduced in 1906, the No. 4A Folding Kodak was the largest of the conventional roll-film cameras. Derived from the No. 3A Folding Pocket Kodak, the camera's picture size was increased to 4¼ x 6½ inches. Normally fitted with a Double Combination Rapid Rectilinear lens and No. 2 Bausch & Lomb Automatic shutter, there were many other lens and shutter options, especially in the United Kingdom. With the folding design and aluminum framework, the camera was portable enough to use while traveling. A glass plate adapter and film holders were available separately. The basic model sold for $35, but more advanced optics could push the price over $100.

Then, in 1906, along came the No. 4A Folding Pocket Kodak. Designed for adults, it bore a hefty retail price of $100 (or more, depending on its lens). With the 4A's bigger size came attractive features: a Double Combination Rapid Rectilinear lens and a No. 2 Bausch & Lomb Automatic shutter. It produced pictures 4¼ x 6½ inches, making it the largest of the folding Kodak roll-film cameras. This print size gradually became a de facto standard, the expected size of prints in years to come.

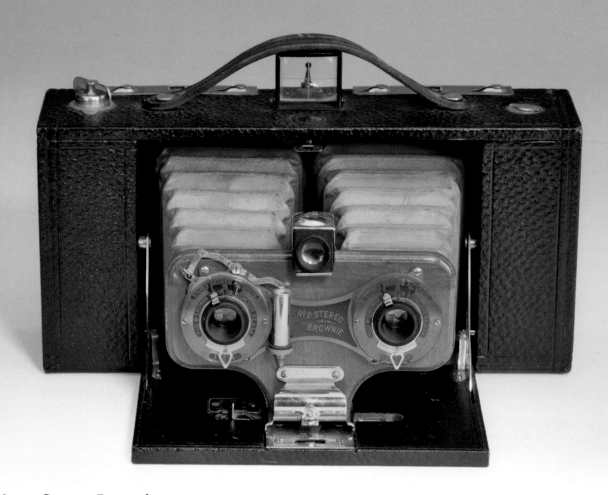

No. 2 Stereo Brownie

1905

Eastman Kodak Company, Rochester, New York. Gift of Eastman Kodak Company.
1974:0028:3451.

The No. 2 Stereo Brownie introduced in 1905 by Eastman Kodak Company, Rochester, New York, was the only Brownie stereo camera. A twin bellows folding camera of leather-covered wood construction, it was atypical among stereo cameras in that it had two bellows rather than the customary single bellows with septum. By reducing the manufacturing cost, Kodak made it possible to bring the popular stereo photography to the masses. The retail price was $12.

The No. 2 Stereo Brownie of 1905 was a kind of trial balloon to determine whether a brief resurgence in stereo photography might be profitable for Kodak. If an appetite still existed for a consumer stereo camera, the low $12 price would satisfy it. Eastman may have been encouraged to introduce the Stereo Brownie by the appearance of the Stereo Graflex just a few years earlier. It was a high-end camera with dual eyepiece magnifiers and reflex viewing (meaning that the user saw the image in an upright position and in stereo); the Stereo Graflex viewing hood used two lenses similar to a Holmes style stereo viewer, so the photographer would see a three-dimensional image on the ground glass.

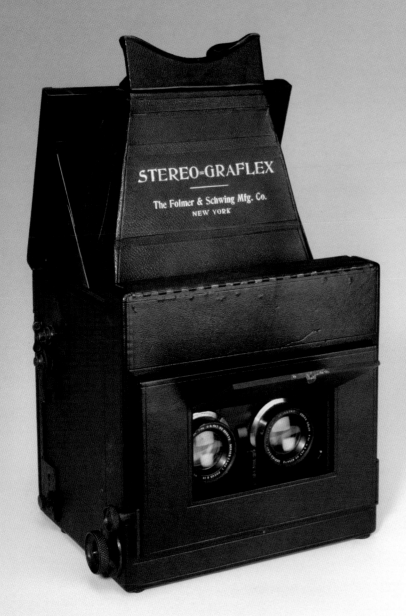

Stereo Graflex

ca. 1903
Folmer & Schwing Manufacturing Company,
New York, New York. Gift of Dr. Henry Ott.
1983:0836:0006.

Unique among stereo cameras, the Stereo Graflex of 1903 provided stereoscopic viewing on a ground glass by incorporating dual eyepiece magnifiers—just as used in a stereoscope viewer. The reflex viewing of the Graflex cameras enabled the operator to arrange and study the composition right up to the time of exposure. The image would be seen upright, though still laterally reversed. The minimum focal length was 5⅞ inches and the telescoping front allowed a maximum of nine inches. Designed to use 5 x 7-inch dry plates, this camera sold for $318, including the matched pair of Goerz Celor Series III lenses.

Since the Stereo Graflex came at a very high-end price ($318), Eastman likely thought that his $12 camera could successfully make the specialized art of stereo photography appealing to the masses.

But the fad had died out, and Eastman's expectations were not met. The Stereo Brownie sold fewer than five thousand units total.

MALES FATALLY WOUNDED

Eastman relentlessly attacked the market with shrewd pricing, a growing number of camera models to meet nearly any consumer niche or need, and business acquisitions that cemented the company's leadership position in photography. At the Chicago

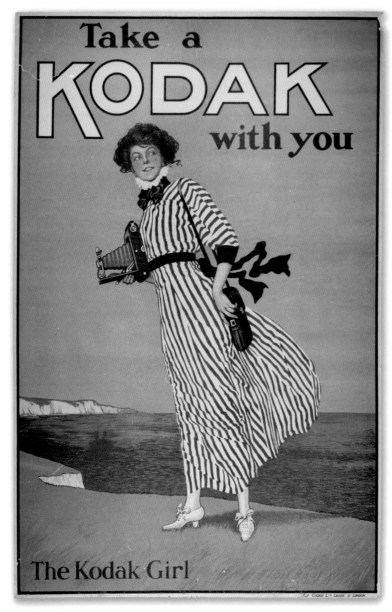

Advertisement featuring The Kodak Girl, ca. 1913. Lithograph. Gift of Eastman Kodak Company. George Eastman Legacy Collection.

World's Fair in 1893, Eastman introduced the Kodak Girl—a fetching model holding the latest Kodak camera. She appeared first as an engraving then, as newspaper and magazine print production improved, as the product of a seemingly casual summer snapshot. She seemed open to adventure, progressive. Her fashionable ensembles were designed to inform and inspire young women of the day.

And not just the women. In *Kodak and the Lens of Nostalgia*, Nancy Martha West quotes *Cosmopolitan* magazine from 1901: "The writer personally knows half a dozen young swains who fell in love at the start," adding, "down to the last hallboy, the males in this office have been fatally wounded. That is, the unmarried males, of course." The Kodak Girl's cameras and costumes changed each summer for nearly ninety years.

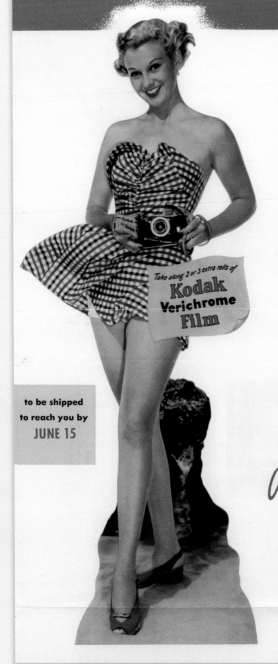

Here's the latest in the famous Kodak series

1950 KODAK SUMMER GIRL

• Every time customers — or potential customers — see this life-size bathing beauty, they're pretty certain to be reminded to "Take along 2 or 3 extra rolls of Kodak Film."

The Kodak Summer Girl will be glad to work in your store but she is sure to be much in demand; so it's important that you place your order now. Measuring 62 inches high, and done in full color, this extra member for your sales staff has a sturdy easel back that will keep her looking fit throughout the season.

One Kodak Summer Girl is yours free on request; for additional quantities the charge is 10 cents each. Order No. A6-284 on the Advertising Order Blank.

And with each full-size **Kodak Summer Girl a miniature just like her will be included**

• When the smartly attired 1950 Kodak Summer Girl reaches you, she will have with her a small sister only 20½ inches tall.

The miniature — in full color, also — is just the right size to take her stand at the film counter where she can do a good sales job on her own; or she can be used in the window — and get attention, too.

to be shipped to reach you by JUNE 15

remember **. . . the Kodak Summer Girl can work in a variety of spots**

• Don't commit the error of assigning your Summer Girl to one store position and leaving her there. Many Kodak dealers have learned the wisdom of shifting her about. Sometimes she can look mighty well in the window; sometimes she should be given a chance to meet people near the entrance door and, sometimes, she can stand beside the camera counter, the film counter, the finishing counter. For, wherever she is, the Kodak Summer Girl can brighten things up—and go right on with her selling.

Advertisement featuring The Kodak Summer Girl, 1950. Gift of Eastman Kodak Company. George Eastman Legacy Collection.

Toy Cameras

WHEN EASTMAN AIMED THE BROWNIE AT CHILDREN, he was inoculating prospects who might remain customers for fifty years. Camera designers understood that young imaginations are limitless. Any company that can hitch its wagon to a cartoon figure that kids recognize may benefit, if only briefly.

Consider a famous talking fish. The Charlie Tuna camera, a 126 model with a flashcube on its head, was based on the StarKist mascot—a 1961 creation of the Leo Burnett ad agency. Charlie was a dapper bohemian with his beatnik beret and sunglasses. But Charlie failed in his one ambition: to be tasty enough to wind up in a tiny can of StarKist. He was forever being thrown back into the sea as an anonymous voice intoned, "Sorry, Charlie." StarKist did not want "tuna with good taste, but tuna that tastes good." The camera could be had for $4.95 plus three StarKist labels. Whether sales ticked up during the January to April 1971 promotion would be interesting to discover.

As the pictures here show, novelty cameras for kids have taken dozens of forms, and one can only assume their creators anticipated some financial return. Those associated with TV stars (such as Roy Rogers) and famous cartoon characters (such as Mickey Mouse, Bugs Bunny, Snoopy, Spider-Man, and so on) imply a business plan behind them. The most bizarre plastic novelty camera of all—and the one most valued by collectors—is the Ideal Toy Company's Kookie Kamera. It took photos on positive paper, which was then cut and developed in its own tank. And remember that the Kookie hit the stores in 1968—heady times for creative designers.

Ensign Mickey Mouse
ca. 1935
Houghton's Ltd., London, England. Gift of Eastman Kodak Company. 1990:0458:0003.

The worldwide popularity of Mickey Mouse quickly led to the licensing of his image from Walt Disney by numerous companies looking to cash in on the character's fame. The first photographic manufacturer to market a Mickey Mouse camera was Ensign, Ltd., of London, in 1934 (established in 1930, Ensign, Ltd., was the distributor of Houghton's Ltd. products). It was a simple box camera constructed mainly of wood and covered with a geometric-patterned black material. Six-exposure rolls of special Mickey Mouse M10 film could be sent to the local chemist for developing and printing, or done at home with the Mickey Mouse Developing Dish and Printing Outfit.

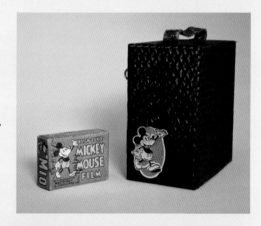

Donald Duck
ca. 1946
Herbert George Company, Chicago, Illinois. Gift of Eastman Kodak Company. 1990:0458:0004.

The Donald Duck camera was introduced in 1946 by the Herbert George Company of Chicago, Illinois. Formed by Herbert Weil and George Israel, the firm produced inexpensive plastic cameras for more than fifteen years before being sold and renamed the Imperial Camera Corporation. The first design patented by George Israel, the Donald Duck camera was originally made in olive drab plastic but was soon switched to black. Its rear shows figures of Donald and his nephews Huey, Dewey, and Louie in relief.

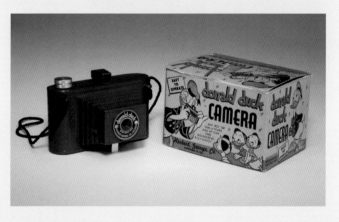

Mickey Mouse Brownie
ca. 1946
Eastman Kodak Company (attrib.), Rochester, New York. 1999:1114:0001.

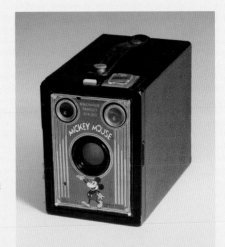

The Mickey Mouse Brownie story is shrouded in mystery, having been unknown until about 1995. At that time, several cameras surfaced with the explanation that Eastman Kodak Company had worked up a prototype, in cooperation with Walt Disney, for this special version. Neither company has records of such a project, though there is one known example with an original printed box.

The basis for the camera is the Brownie Target Six-20 of 1946 with a special faceplate depicting Mickey Mouse. Curiously, though the camera is a 1946 model, the style of Mickey Mouse and the Disney Company logo date to the 1930s. Also of interest is that those cameras that have surfaced use three different types of faceplate attachment hardware. Since the decal and box look to be of the period, perhaps there is reason to believe that Kodak did initiate a special project in the 1930s. In any event, great interest in these cameras has led to high prices realized at auction.

Roy Rogers and Trigger
ca. 1951
Herbert George Company, Chicago, Illinois. 1974:0028:3339.

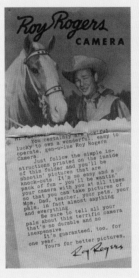

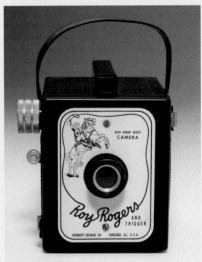

Manufactured in 1951 by the Herbert George Company of Chicago, the Roy Rogers and Trigger camera had a front plate depicting Roy mounted on a rearing Trigger. The otherwise standard Herbert George "Imperial" black Bakelite camera produced twelve images on No. 620 roll film. Issued at a price of $3.99, it was one of the many memorabilia items made for fans of the "King of the Cowboys" and remains a popular collectible today.

Instruction manual for Herbert George Company's Roy Rogers and Trigger camera, ca. 1951. George Eastman House Technology Collection.

Kookie Kamera
ca. 1968
Ideal Toy Corporation, Hollis, New York. Gift of Andrew H. Eskind. 1974:0028:3534.

From its manhole cover base to saucepan flash cube holder, Ideal Toy Corporation's Kookie Kamera was a wonder of whimsy. This 1968 toy was a real working camera that made direct-positive pictures on rolls of sensitized paper in plastic "Kookie Kassettes." The lens housing was modeled after an empty soup can, which distorted the image and could be rotated to alter the effect. The photographer sighted the subject through the bloodshot-eye viewfinder and then pressed the shutterbug to make the exposure. After snapping the picture, the "cranker" knob advanced the paper into the developer tank under the camera and a push-pull slide actuated a cutoff blade. A swiveling egg timer told the user when three minutes had elapsed, so the print could be removed and rinsed in water. "A ridiculous thing from…Ideal" was printed on the box, but in the course of having fun with the Kookie Kamera, kids absorbed some valuable knowledge about photography.

Charlie Tuna
ca. 1970
Whitehouse Products Inc., Brooklyn, New York. 2004:0298:0001.

The Charlie Tuna camera was modeled from the popular cartoon character in the StarKist Tuna TV commercials of the 1970s. Charlie's dream was to be selected by StarKist for cooking and canning, but while he always tried to demonstrate his "good taste," StarKist wanted tuna that would taste good. This large camera could be awkward to carry, but it was easy to use. Instamatic 126 film cartridges were simply dropped in place; the lens was hidden in Charlie's wide smiling mouth, and his hat served as the flash cube socket. Whitehouse Products produced the Charlie Tuna in Brooklyn, New York, where they had been building less colorful cameras since the 1940s.

Mick-A-Matic
ca. 1971
Child Guidance Products, Bronx, New York. 1974:0028:3059.

The Mick-A-Matic was more than a toy. Produced in 1971 by Child Guidance Products in New York, it was a functional camera that used drop-in 126 Instamatic film cartridges. The lens was in Mickey Mouse's nose, and his right ear served as the shutter release; a flash attachment could be mounted between the ears. The shape of the Mick-A-Matic made it attractive to children, though somewhat difficult for their small hands to operate. The camera was sold mostly in toy departments.

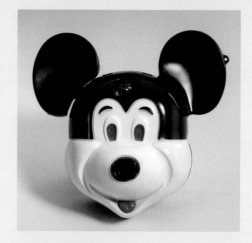

Bugs Bunny
ca. 1978
Helm Toy Corporation, New York, New York. Gift of F. S. Spira. 1982:0501:0001.

The Bugs Bunny was one of several cartoon character cameras made by Helm Toy Corporation of New York City in the 1970s. Helm's simple plastic box design for the ubiquitous Instamatic 126 film cartridge made it possible to use different style front covers for a variety of characters. The Bugs Bunny front showed the cwazy wabbit reclining over the lens, his elbow resting on a sign that read, "EH-DOC SMILE!" While sold as toys, these cameras introduced many children to the fun of photography and made them photographers for life.

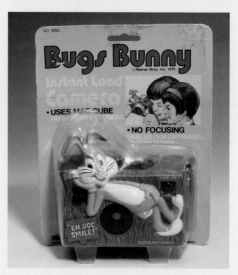

Snoopy-Matic
ca. 1982
Helm Toy Corporation, New York, New York. Gift of F. S. Spira. 1982:0501:0002.

The Snoopy-Matic was the high point of the novelty camera fad made possible by the popular Instamatic 126 film cartridge. Helm Toy Corporation of New York produced this all-plastic doghouse design in 1982, along with other cartoon character-based cameras. Snoopy's door functioned as the lens, with the windows serving as viewfinder and shutter button. Flash cubes could be snapped onto the chimney for low-light situations. Despite their whimsical styling, many of these odd-shaped novelties delivered decent quality pictures.

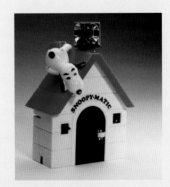

Spider-Man
ca. 1982
Vanity Fair Industries, Melville, New York. Gift of F. S. Spira. 1982:0501:0003.

Produced by Vanity Fair Industries of Melville, New York, the Spider-Man camera was one of several cameras that used the same style plastic bodies. By molding in various colors and applying different decals, the cameras were marketed under the names of many cartoon characters and superheroes. The Spider-Man, like most novelty cameras of the 1960s and 1970s, used Instamatic 126 film cartridges, ideal for children. The built-in handle, large shutter button, and thumb-lever film advance made it easy to use. Flash cubes could be used for indoor pictures. A lens housing with a simulated knurled ring and a stepped-up ramp for the flash mount gave it a shape just like the cameras Mom and Dad used.

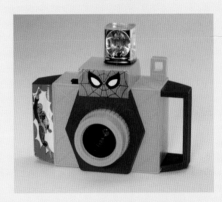

Photo Mission Action Man
ca. 1998
Hasbro, Pawtucket, Rhode Island. Gift of Jerry Friedman. 2004:0989:0001.

Cameras disguised as toys were easy to design around the Instamatic 110 film cartridge. Hasbro of Pawtucket, Rhode Island, offered one in 1998 as part of their Action Man series, based on a popular children's TV show. The all-plastic twelve-inch-tall hero, packaged as Photo Mission Action Man, had a video camcorder on his shoulder. Inside his torso was a working 110 still camera that shot through the lens in his chest armor. A button near his right shoulder blade tripped the shutter and captured whatever image was framed by the viewfinder atop the shoulder camcorder. Film was loaded by removing a panel on his back and advanced with the ridged thumbwheel on the belt. The film pack was oriented vertically, as were the pictures.

Taz instant camera
ca. 1999
Polaroid Corporation, Cambridge, Massachusetts. 1999:1031:0001.

The 1990s was a tumultuous decade for the photographic industry, especially Polaroid Corporation in Cambridge, Massachusetts. The groundbreaking technology of the 1972 SX-70 had matured to the point where it was relegated to cameras marketed to children. Polaroid's 1999 Taz was a special version of its One Step 600, molded in brown and tan plastic. The flip-up Tazmanian Devil head housed the electronic flash and opened to reveal the fixed-focus lens and Taz teeth decals, while a Looney Tunes logo served as the shutter release button. Polaroid made special film for the camera, sheets pre-printed with Taz and other Looney Tunes characters in the border, but it could also use normal ten-exposure Polaroid 600 Instant film packs. Cartoon character-themed cameras were once common items in toy departments, but Taz was one of the last to be made. And "Th-th-th-that's all, folks!"

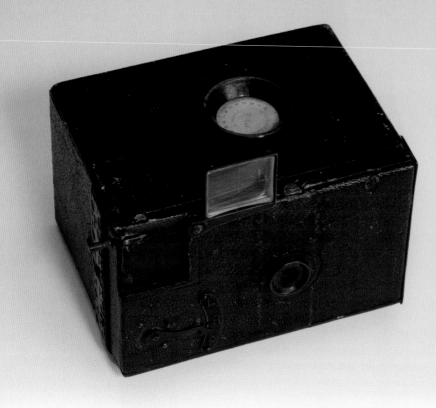

Le Pascal
ca. 1900
Japy Fréres & Cie, Belfort, France. Gift of Eastman Kodak Company, ex-collection Gabriel Cromer. 1974:0037:1526.

Designed by François Pascal and introduced in 1899 by Japy Fréres & Cie of Belfort, France, Le Pascal was a small, leather-covered wooden box camera, unique for its film transport. The first roll-film camera to feature a rapid advance mechanism, it was claimed that a full roll of twelve exposures could be completed in less than six seconds. In operation, the user loaded the roll film, then wound the advance key, which simultaneously wound the spring motor, moved all the film to the take-up spool, and activated the shutter. Upon triggering the shutter release button, it rewound each exposure onto the original spool. This reverse film action would be used eighty years later in some 35mm cameras. A folding viewfinder also functioned as an interlock, preventing shutter release when folded flat. The original list price was 14,75 francs.

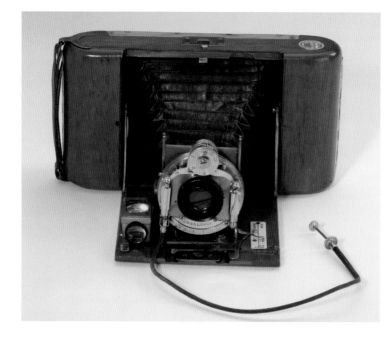

Challenge Dayspool No. 1 Tropical
ca. 1903
J. Lizars, Glasgow, Scotland. 1974:0084:0090.

The cameras from J. Lizars of Glasgow, Scotland, saw duty in every corner of the British Empire. To ensure dependability in the hot dampness of India or Africa, Lizars used Indian teakwood for cameras like this 1903 Challenge Dayspool No. 1 Tropical. As the name suggests, it could be loaded in daylight with spooled 3¼-inch wide film. The removable back could be replaced by a holder for sheet film or dry plates. A Beck Symmetrical lens with Bausch & Lomb Unicum shutter was provided on the basic version. The lens mount had rise and shift movements for perspective adjustment. A Dayspool No. 1 Tropical cost ten shillings more than the standard leather-covered model price of £3/12/6. The camera was offered with a variety of British and German lenses at extra cost.

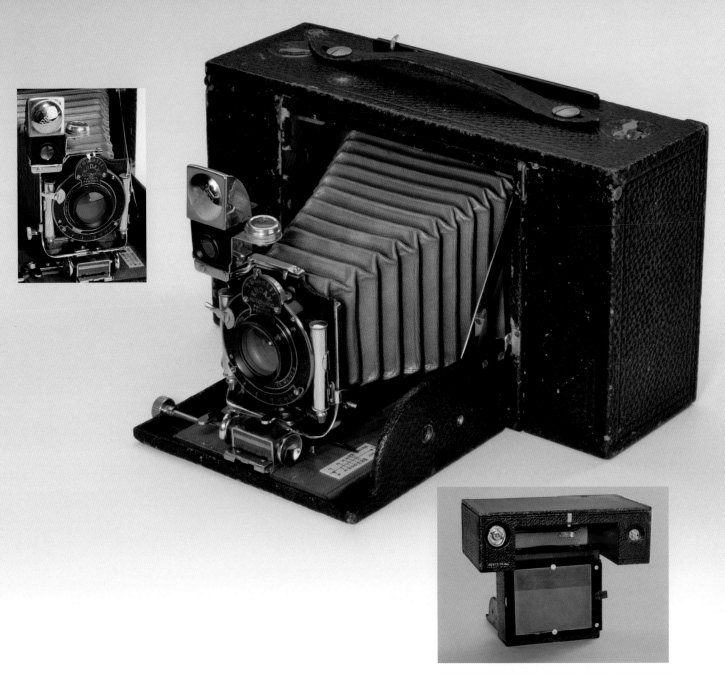

No. 4 Screen Focus Kodak, Model A
1904
Eastman Kodak Company, Rochester, New York. Gift of Paul Lange.
1974:0037:1235.

The 1904 No. 4 Screen Focus Kodak permitted focusing on a ground glass without removing the roll of film from the camera. Thus, accurate focusing could be done for each exposure as with a plate camera. To do so, the roll holder, protected with a dark slide, was rotated away ninety degrees from the focal plane. An extension bed allowed focusing on subjects as close as twenty-two inches. With daylight-loading film, the camera could make twelve exposures of 4 x 5 inches. By removing the roll holder, it could operate as a plate camera. In total, about four thousand cameras were manufactured and sold over a six-year period. The Screen Focus Kodak initially sold for $30 and was available with a wide variety of lenses and shutters.

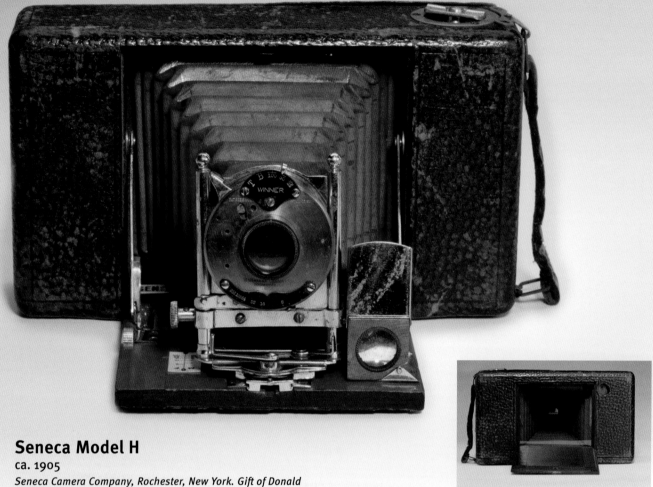

Seneca Model H

ca. 1905

Seneca Camera Company, Rochester, New York. Gift of Donald Weber. 2006:0341:0001.

Upon first inspection, the Seneca Model H looks like a typical early 1900s folding roll-film camera, featuring a polished mahogany bed and maroon leather bellows. A closer look reveals a rather unusual hinged door located in the back, which, when opened, uncovers a sheet of clear glass. This is a focusing back used in conjunction with Ansco Vidil roll film, a special film that mounted a semi-transparent parchment paper focusing screen before each piece of sensitized film. This somewhat odd arrangement provided an accurate method for composing and focusing, similar to the ground glass system used by view cameras, while supplying the convenience of roll film. At that time, the majority of roll film cameras used highly inaccurate reflecting finders and distance scale focusing.

From today's perspective, the Vidil film system is a fairly complicated way to compose and focus a camera. However, due to the rather slow film speed of the time—roughly ASA 5, compared to a modern average of about ASA 400—proper exposures required a large lens opening and slow shutter speed, resulting in very little depth of focus. An accurate focusing system is a solution to this problem. Vidil was only listed in the Ansco catalogs for about five years. Its high selling price, about twice that of other roll films, may have been its downfall.

INGENUITY EVERYWHERE

KODAK WOULD DOMINATE THE MARKET for most of its first hundred years. But ingenious competitors never stopped introducing innovations. M. L. Friard of Paris made a camera for a concept Kodak would not consider for another eighty years: the one-time-use camera (OTUC) or, as it is now often called, the "disposable" camera.

Visitors astounded by the sights at the 1900 Paris Exposition but who had forgotten their cameras found

Le Champion Appareil Photograph-Complet
1900
M. L. Friard, Paris, France. Gift of Eastman Kodak Company, ex-collection Gabriel Cromer. 1974:0028:3475.

If you were at the Paris Exposition in 1900 and had forgotten your camera, for fifty centimes you could buy Le Champion Appareil Photograph-Complet. In a packet about three inches square by one half-inch thick, M. L. Friard of Paris gave you everything needed to produce four pictures. Once opened, the heavy paper camera was unfolded and snapped together. In place was a sensitized dry plate, ready to be exposed by pulling the shutter string. A folded paper finder atop the camera helped compose the scene, and once captured, chemicals included in the kit developed the plate for printing. The outfit even included a paper funnel. Four sheets of print paper were inside, as well as a printing frame and the necessary chemistry. A set of detailed instructions guided the user through the process. Le Champion is the oldest one-time-use camera in the collection.

Encore
ca. 1940
Encore Camera Company, Hollywood, California. Gift of Eastman Kodak Company. 1991:1587:0010.

The Encore camera of 1940 was an inexpensive, cardboard camera with factory-loaded film. After pictures were taken, the still-loaded camera was returned to the factory with one dollar for processing, just like the original 1888 Kodak camera. The Encore was sometimes used as an advertising premium, often printed with a company's promotional message.

Photo-Pack-Matic
ca. 1965
Fex, Lyon, France. Gift of Eastman Kodak Company. 1991:1587:0007.

The Photo-Pack-Matic was a one-time-use camera made by Fex of Lyon, France, in the mid-1960s. It came pre-loaded with black-and-white film for twelve 4 x 4-cm exposures. When the last shot was snapped, it was sent to Fex for processing and your prints came by return mail. Photo-Pack-Matics were sold mostly in France, for the U.S. equivalent of $2.50 in 1967. Processing was included in the price. The single use, or "disposable," idea wasn't new, but it wouldn't become popular until large manufacturers like Eastman Kodak Company and Fuji entered the market two decades later.

that, for fifty centimes, they could buy Le Champion Appareil Photograph-Complet. The customer simply unfolded and snapped together the heavy paper camera. The scene was composed by viewing it with the folded paper finder atop the camera. Its dry plate was loaded and ready. The customer just pulled a string and—voila!—the shutter clicked. Friard's kit included all that was needed to produce four pictures, including chemicals (even a paper funnel for mixing them) and four sheets of print paper with printing frame.

Buster Brown No. 2
ca. 1906
Ansco, Binghamton, New York.
Gift of Eastman Kodak Company.
1991:2786:0001.

The Buster Brown No. 2, introduced in 1906 by Ansco of Binghamton, New York, was their answer to the Kodak Brownie. This simple box camera was advertised as being designed with special reference to the wants of boys and girls. Like the Brownie, it made use of a popular cartoon character. The images were 2¼ x 3¼ inches on Ansco 4A (Kodak No. 120) roll film, and the original retail price was two dollars.

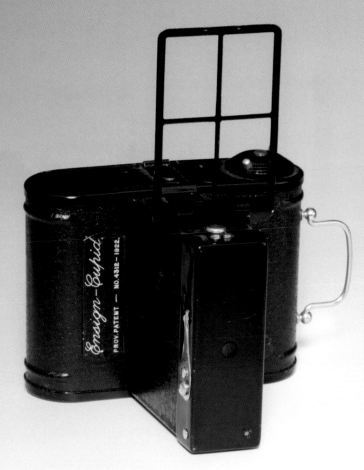

Ensign Cupid
ca. 1922
Houghton-Butcher Ltd., London, England. Gift of Kodak Ltd.
1974:0037:0138.

Instead of using a collapsible lens mount with bellows or telescoping design, Houghton-Butcher of London, England, chose to simplify the 1922 Ensign Cupid by placing the lens in a rigid metal snout on the tobacco-can-style body. The Cupid yielded twelve 4 x 6-cm half-frame images from each roll of six-exposure Ensign-Speedy 2¼B film. This was done by having two frame number windows on the camera back and a tag with instructions on how to wind the film. An f/11 lens and simple shutter eased the picture-taking exercise, making the Cupid ideal for beginners or children. The big crosshair finder folded flat when not in use. The tiny carrying handle was bright metal with room for only a single fingertip. Finished in black crackle, the camera was durable enough to take the abuse expected of new and young photographers. For fifteen shillings, the Ensign Cupid outfit included a reflex finder, leather case, and three rolls of film.

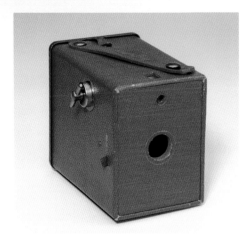

Kiddie Camera
ca. 1925
Ansco, Binghamton, New York. Gift of Eastman Kodak Company. 1991:0540:000.

Photographic companies were always looking for ways to attract new customers, and encouraging children to try using a camera was a constant pursuit. In 1925, Ansco of Binghamton, New York, started making a special version of their Dollar Camera, a small basic box for 127 film. Other than the leather strap and cherry red covering, the Ansco Kiddie Camera was identical to the Dollar. The film loading process wasn't a job for young hands, however, and was best left to Mom or Dad. Despite the difficulties, many youngsters who started out on cameras like the Ansco Kiddie enjoyed taking their first photos and became lifelong shutterbugs.

Le Champion was the forerunner of a design that has sold more cameras than any other. Sales of late twentieth-century one-time-use cameras have been estimated to be in the hundreds of millions of dollars.

In 1906, the Ansco company fought the Brownie head-on with a look-alike camera that had a sound-alike name, a similar price point, and a comparable advertising theme. Advertised with reference to the wants of boys and girls, Ansco's Buster Brown No. 2 camera was also named for a popular cartoon character and sold for two dollars, the same price as the No. 2 Brownie.

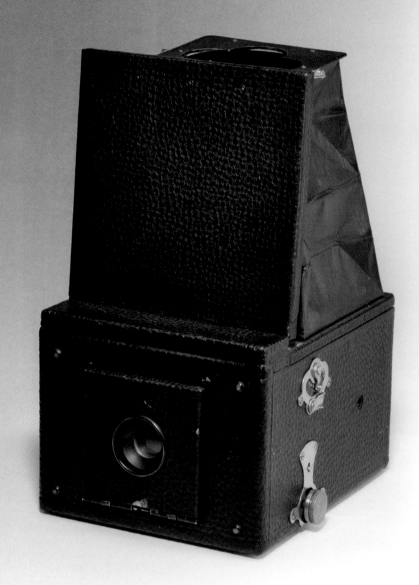

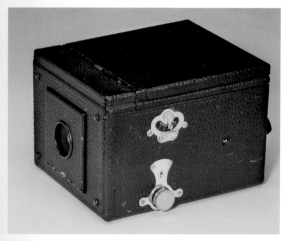

Premograph
ca. 1907
Eastman Kodak Company, Rochester, New York.
1974:0037:1618.

The Premograph brought reflex viewing to amateur photographers in 1907. A reflecting viewer permitted the operator to see, in advance, the image right side up as it would be captured. The box SLR camera featured an automatic lens cover that opened when the lens was moved into picture-taking position and closed automatically as the lens was retracted. Twelve exposures of 3¼ x 4¼ inches came in the Premo film pack, which allowed individual films to be removed for processing before the entire pack was used. A succeeding model, the Premograph No. 2, sold for $20 in 1909 and with more advanced lenses went as high as $54.

Unlike the rather primitive and inexpensive viewing system of so many of the Brownies, Kodak's Premograph camera revealed a viewfinder that showed the subject upright but still laterally reversed (similar to the image in a mirror). Its mirror functioned as a shutter. Introduced in 1907, the camera sold for only $10.

A single-lens reflex camera, the Premograph featured an automatic lens cover that opened when the lens was moved into picture-taking position. It closed automatically as the lens was retracted.

Twelve exposures of 3¼ x 4¼ inches came in the Premo film pack, which allowed individual films to be removed for processing before the entire pack was used.

A later model, the Premograph No. 2, sold for $20 in 1909; better lenses were optional and might drive the price as high as $54.

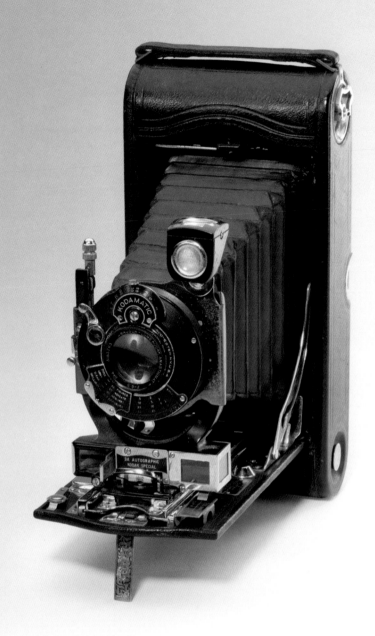

No. 3A Autographic Kodak Special, Model B with Rangefinder
ca. 1916

Eastman Kodak Company, Rochester, New York. Gift of Thomas E. Hunt. 1987:0380:0001.

The No. 3A Autographic Kodak Special, Model B, introduced by Eastman Kodak Company as a running change in 1916, was the first camera to offer a coupled rangefinder. Not a small camera, it produced images in the popular 3¼ x 5½-inch postcard size on No. A-122 roll film. Indeed, Kodak claimed, "We have been careful not to let the desire for mere compactness destroy the optical efficiency." With a rising and falling front, rack-and-pinion focusing, f/6.3 Zeiss Kodak Anastigmat lens, and a finish of genuine Persian morocco leather, as well as the coupled rangefinder, this was a quality instrument at a retail price of $66. It remained in production for twenty-one years.

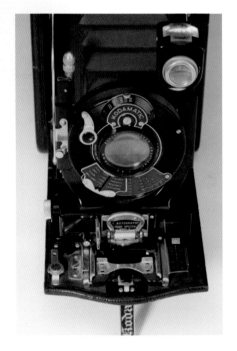

FINDING THE RANGE

A COMMON METHOD FOR FOCUSING was to set the lens to a prescribed distance. Typically this involved "scale focusing," moving a pointer that indicated a specific distance on a measured ruler on the camera. By moving the pointer along a small indexed rule, which was mechanically linked to the lens, the photographer also moved the lens nearer or farther from the film (thus adjusting its focus). With folding cameras, this meant that the person taking pictures simply indicated the distance with the pointing device and then slid the bellows along a track until they locked into the corresponding stop point.

The need to combine focusing and viewing resulted in the "coupled rangefinder." This mechanism focuses the lens at the same time as the photographer is finding the camera-to-subject distance through the

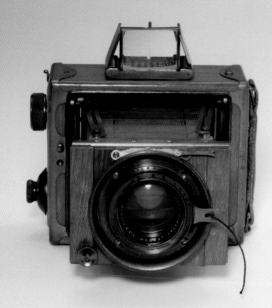

Tropen Klapp Camera
ca. 1920
Ernemann-Werke, Dresden, Germany. Gift of Mrs. R. C. Campbell. 1974:0037:2648.

A sportsman of the 1920s demanded only the best equipment in his pursuit of excitement, whether sailing, playing polo, or big game hunting. Ernemann-Werke in Dresden, Germany, catered to the well-heeled adventurer with their line of Ernemann Sportsman focal-plane cameras. With these sturdy, compact, precision Klapp, or collapsible designs, action on the field of play could be captured with the fast lenses and shutters Ernemann provided. For harsh environments, the Tropen Klapp 6.5 x 9-cm version used teakwood and lacquered brass construction. The helical-mount Ernon 12cm f/3.5 lens could be quickly focused, using the ground glass or the distance scale and folding Newton finder. Selecting one of the twenty-four shutter speeds and setting the diaphragm behind the lens helped deliver precise exposures. The sportsman considered the $150 spent on a Tropen Klapp a fair price for "The World's Finest Camera."

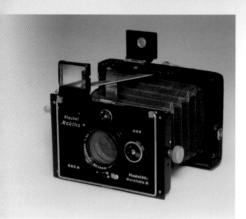

Makina
ca. 1920
Plaubel & Company, Frankfurt, Germany. Gift of Eastman Kodak Company. 1974:0037:2901.

Advances in photographic technology were used to great advantage by Plaubel of Frankfurt, Germany, in the design of their 6.5 x 9-cm Makina series of cameras. Improved films that permitted sharp images from smaller formats made convenient "vest pocket" cameras possible, and the Makina was one of the first to enter the market in 1912. It was a folding-type camera using the "lazy tongs"-style struts that locked rigidly in place when the bellows was extended. The strut-locking plates in the lens panel moved by turning the focus knob, and as the strut angle changed, so did the lens-to-film distance. A scale and pointer indicated the range. The photographer had a choice of viewfinders: a folding optical unit or the wire sports frame for scenes with action, or the rear ground glass for still subjects. Plaubel made their own lenses, this one a fast Anticomar 10cm f/2.9 with a dial-set Compur shutter that had a 1/200 second maximum speed. The Makina was improved and refined over the years and remained in production until about 1960. This model from around 1920 cost $95.

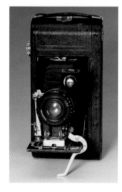

1A Automatic
ca. 1924
Ansco, Binghamton, New York. Gift of GAF Corporation. 1985:1250:0013.

Almost from the beginning of the photographic industry, a constant push to simplify the process of taking pictures kept engineers busy. In 1924, Ansco of Binghamton, New York, introduced motorized film advance in a folding camera with the 1A Automatic. The key-wound spring motor brought the next frame rapidly into position when the shutter release was pressed, allowing the six 2½ x 4¼-inch exposures on special rolls of 116 Ansco Speedex 6A film to be made in rapid-fire succession. A fingertip button on the lens bed handled focusing of the Ansco Anastigmat f/6.3 lens. F-stops down to f/32 and shutter speeds to 1/100 second were set with conventional rim controls. The 1A Automatic was priced at $75, much more than similar Anscos without automatic winding.

viewfinder. The No. 3A Autographic Kodak Special, Model B, introduced by Eastman in 1916, was the first camera to incorporate the coupled rangefinder.

It works like this: a coupled rangefinder visually displays the scene in such a way as to reveal that the lens has been properly focused. Typically, the rangefinder shows the scene in two misaligned parts until the photographer turns the lens and the two images fuse into a unified whole. With a rising and falling front, rack-and-pinion focusing, f/6.3 Zeiss Kodak Anastigmat lens, and a finish of genuine Persian morocco leather, as well as the coupled rangefinder, the Autographic was a quality instrument at a fair price of $66. It remained in production for twenty-one years.

Pupille

ca. 1932

Kodak AG, Stuttgart, Germany. Gift of Cyril J. Staud.
1974:0037:2146.

The Pupille, originally produced by the Dr. August Nagel Camera-Werke of Stuttgart, was added to the company's lineup when Eastman Kodak Company bought the German firm in 1932. It was a small, palm-sized precision camera producing sixteen 3 x 4-cm images on No. 127 roll film. With its best lens, the Schneider f/2, it was billed by Kodak as having "a truly lightning fast lens." It also had a then-unique spiral focusing tube that eliminated the traditional bellows. The little feature-rich camera was priced at $90 in 1932.

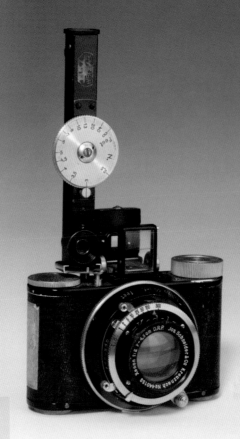

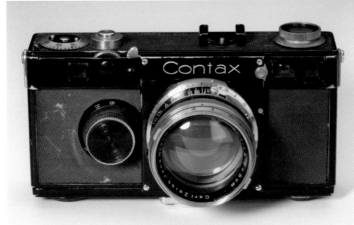

Contax I (540/24)

ca. 1932

Zeiss Ikon AG, Dresden, Germany. Gift of 3M Foundation, ex-collection Louis Walton Sipley. 1977:0415:0004.

The success of the Leica camera following its debut in 1925 was not lost on Zeiss Ikon AG of Dresden, Germany. Their entry into this new market was the Contax in 1932. It differed from the Leica (see page 216) in many ways, beginning with its brick-shaped body. The removable back made film loading much easier than the Leica. The Contax had a coupled long-base rangefinder for accurate focus of the ten available bayonet-mount lenses. A ridged wheel next to the shutter button made it easy to focus quickly and make the exposure. The Contax shutter was a metal focal plane that moved vertically and had a top speed of 1/1000 second, twice as fast as rival Leica's. A large knob next to the lens was turned to wind the shutter and advance the film. The Contax used either standard 35mm magazines or a pair of special cassettes. The model pictured has a fast 5cm f/1.5 Carl Zeiss-Jena Sonnar lens and cost $256.

The 1932 Contax I camera featured a coupled rangefinder, with separate but adjacent "windows" for focusing and composing. Contax II of 1936 merged the focusing and composing window. Most post-World War II rangefinder cameras adopted this mechanism on cameras offered between 1947 and 1955.

But the coupled rangefinder was not what fascinated customers about the Autographic camera. The Autographic cameras enabled users to write notes on the back of the film while it was still in the camera. The photographer would flip open the camera's special hinged backdoor to reveal the opaque backing paper. Writing with a metal stylus compacted a carbon layer in the

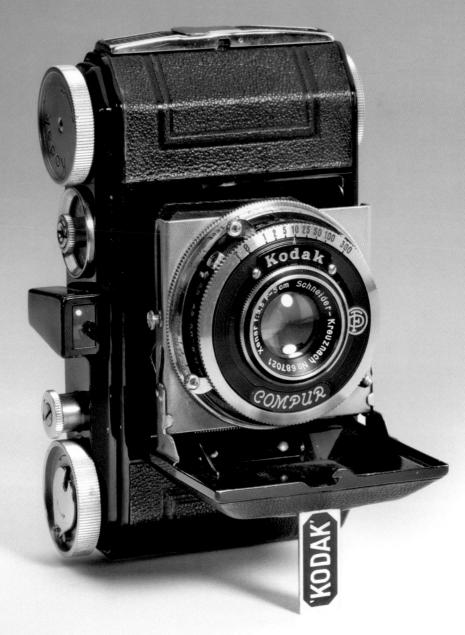

Retina I (Type 117)

1934

Kodak AG, Stuttgart, Germany. Gift of Eastman Kodak Company. 1992:0259:0001.

The Retina I (Type 117) was Kodak's first 35mm miniature camera. Introduced in December 1934, it was manufactured by Kodak AG, the German subsidiary of Eastman Kodak Company in Stuttgart. The Retina I was the first camera designed and released by the renowned Dr. August Nagel after his company was acquired by Eastman Kodak Company. It was a compact, leather-covered metal body with self-erecting lens, and it was the first camera to use the now familiar Kodak 35mm daylight-loading film magazine. The retail price with f/3.5 lens was $57.50.

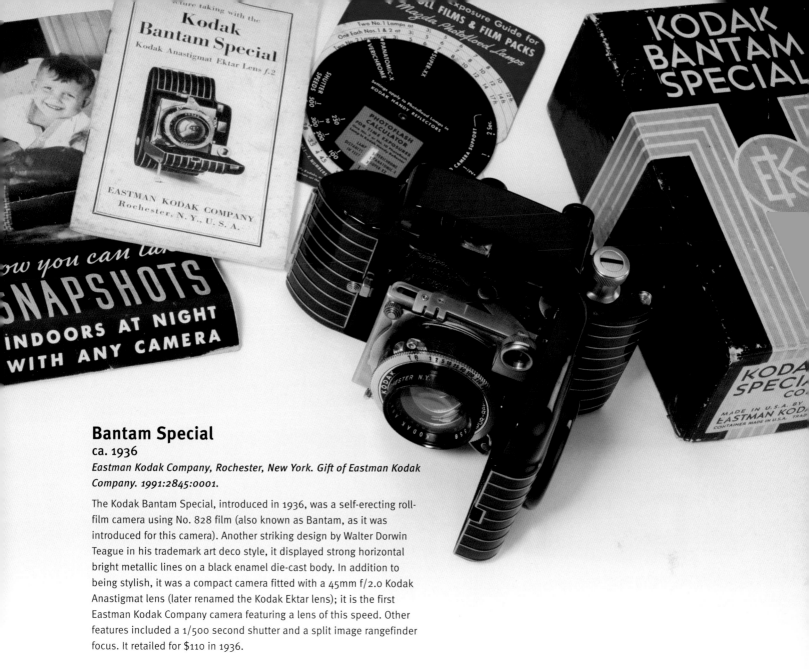

Bantam Special
ca. 1936

Eastman Kodak Company, Rochester, New York. Gift of Eastman Kodak Company. 1991:2845:0001.

The Kodak Bantam Special, introduced in 1936, was a self-erecting roll-film camera using No. 828 film (also known as Bantam, as it was introduced for this camera). Another striking design by Walter Dorwin Teague in his trademark art deco style, it displayed strong horizontal bright metallic lines on a black enamel die-cast body. In addition to being stylish, it was a compact camera fitted with a 45mm f/2.0 Kodak Anastigmat lens (later renamed the Kodak Ektar lens); it is the first Eastman Kodak Company camera featuring a lens of this speed. Other features included a 1/500 second shutter and a split image rangefinder focus. It retailed for $110 in 1936.

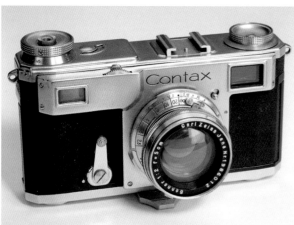

Contax II
ca. 1936

Zeiss Ikon AG, Stuttgart, Germany. Gift of Elizabeth L. Warner. 1992:0694:0012.

Zeiss Ikon's Contax of 1932 quickly became a favorite of professionals and connoisseurs for its accurate focusing and line of superb lenses. Improved models were added to their catalog in 1936, including the Contax II. Changes to the new Contax included moving the winding knob from the front to the top, with the release button relocated to the knob's center. Also, a single viewing window on the back eliminated the separate viewport for the coupled rangefinder. Retained from the original was the quiet focal-plane shutter, upgraded to a top speed of 1/1250 second. The folding support "foot" mounted on the camera's base plate helped steady the camera when using the new self-timer operated by the chrome lever on the front. With a Carl Zeiss Jena 5cm f/2 Sonnar lens, the chrome Contax II was priced at $275. The Contax rangefinder line continued with only minor changes until the 1960s.

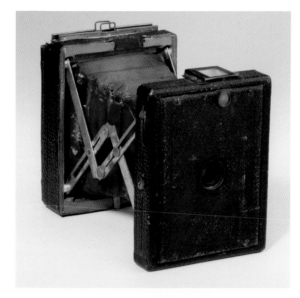

Vest Pocket Monroe
ca. 1898
Monroe Camera Company, Rochester, New York. 1974:0037:1553.

Introduced in 1897 by Monroe Camera Company of Rochester, New York, the Vest Pocket Monroe predated the Gaumont Block-Notes, making it probably the first of the tongs-style "vest pocket" type of miniature-plate cameras. From a collapsed size of less than 1½ inches, including the double plate holder, the camera extended to 4¼ inches on brass lazy-tong struts. Shown here is the 1898 version, which featured brass struts. The Vest Pocket Monroe sold at a retail price of five dollars and produced 2 x 2½-inch images.

Monroe Camera Company, along with the Premo, Poco, Rochester, and Ray Camera companies, was absorbed into the Rochester Optical Company in 1899, which was acquired by Eastman Kodak Company in 1903.

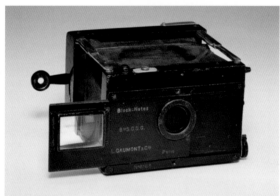

Block-Notes
ca. 1902
L. Gaumont & Cie, Paris, France. Gift of Homer Phimister. 1974:0037:0034.

Introduced in 1902 by L. Gaumont & Cie of Paris, the Block-Notes was among the earliest of the popular precision-made vest pocket cameras, which folded flat for ease of carrying and produced reasonably sized images, typically around 4.5 x 6 cm. On this camera, the flat front lens holder and rear plate holder, both black-enameled sheet metal, were connected by a bellows and held open by folding struts. Sliding the combination front viewing element and lens cover also cocked the shutter. The list price was 220 francs.

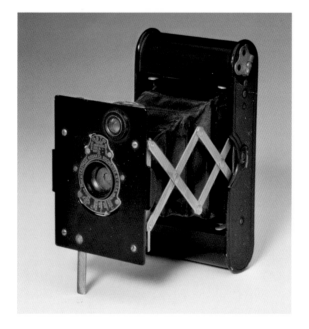

Vest Pocket Kodak
1912
Eastman Kodak Company, Rochester, New York. Gift of 3M Foundation, ex-collection Louis Walton Sipley. 1977:0415:0098.

"So flat and smooth and small as to go readily into a vest pocket" was the claim in Kodak's 1912 catalog that introduced the new Vest Pocket Kodak. When closed, this camera was one inch thick, but in use its lens and shutter pulled out on struts known as "lazy tongs." It made exposures of 1⅝ x 2½ inches, and enlargements could be made to postcard size for fifteen cents. The meniscus achromatic lens was pre-focused, and the ball bearing shutter offered settings for time, bulb, 1/25, and 1/50 second. The beginning of a long-lived series, it was originally offered for a price of six dollars.

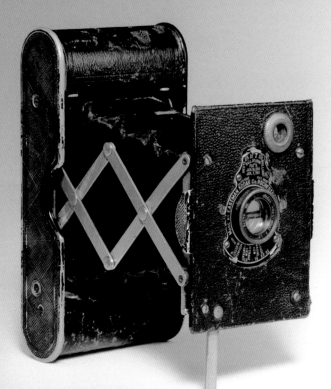

Vest Pocket Kodak Autographic Special (owned by Ansel Adams)

ca. 1915

Eastman Kodak Company, Rochester, New York. Gift of Ansel Adams. 1974:0037:1248.

George Eastman purchased the Autographic patent from Henry J. Gaisman, founder of the Autostrop Company that manufactured safety razors, for $300,000 in 1914. The autographic feature allowed the photographer to make a note on the film backing with a metal stylus through a hinged door on the back of the camera. By briefly exposing the open door to the sky, the notation printed through to the film. This feature, introduced by Eastman Kodak Company in 1915, added eleven years and about 1.75 million units to the production of the popular Vest Pocket Kodak.

The Vest Pocket Autographic Kodak Special was the same collapsing roll-film camera as the original, but with better lenses, pin grain leather covering, and nickel-plated fittings. The film was now No. A-127, a larger size reflecting the autographic feature. The retail price in 1916 was $11.50.

The camera shown here was used by the young Ansel Adams on his second visit to Yosemite National Park in 1917. Having photographed Yosemite the previous year with his No. 1 Brownie, Ansel now used this new camera, which had a better lens, the f/7.7 Kodak Anastigmat. At the young age of fifteen, he was already concerned about the quality of his photography, though he wouldn't make it his profession until about 1930.

Unidentified photographer. *[Autographic snapshot of two girls with dog "Mickey"]*, ca. 1915. Gelatin silver print. Courtesy Joe R. Struble.

backing paper, rendering it translucent. Notes, dates, and other jottings—usually along the lower border—appeared on the print. It all seemed ever so slightly magical, and many people loved it at first, but the magic soon wore off, and the feature died of disinterest.

Eastman bought the patent on the note-taking feature from Henry J. Gaisman, founder of the Autostrop Company (manufacturer of safety razors), for $300,000 in 1914. The feature was installed on the Vest Pocket Autographic Kodak, which sold for $11.50 when it was introduced in 1915.

Kodak's ability to offer film, cameras, and photofinishing gave them a pronounced competitive edge. This was reflected by the appearance of the 1912 Vest Pocket Kodak, which sold for only six dollars. "So flat and smooth and small as to go readily into a vest pocket" claimed Kodak's catalog. When closed, it was only one inch thick.

Although its negatives were a mere 1⅝ x 2½ inches, for another fifteen cents per picture, the company would enlarge them to postcard size. An Autographic feature was added in 1914.

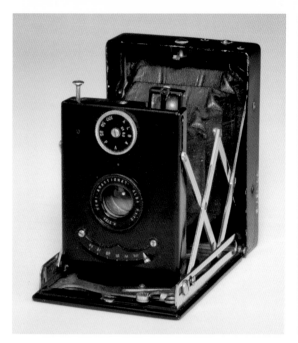

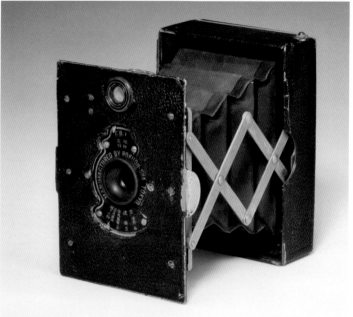

Alba 63
ca. 1914
Albini Company, Milan, Italy. Gift of Philip Condax.
1977:0737:0008.

Another vest pocket camera, the Alba 63 was introduced in 1914 and made by Albini Company of Milan, Italy. This attractive, all-metal, black-enameled body with plated struts had a folding bed, a Newton finder, and a ground glass viewing screen. It produced a 4.5 x 6-cm image on dry plates.

Korok Hand Camera
1914
Konishi Honten, Tokyo, Japan. Gift of Eastman Kodak Company.
1991:2846:0001.

The oldest Japanese camera in the collection is the Korok Hand Camera, introduced in 1914 and made by Rokuoh-sha, the manufacturing branch of Konishi Honten of Tokyo. A vest pocket-style camera, it bears a resemblance to the Contessa Duchessa, a German plate camera. Korok is an abridgement of Konishi Rokuemon, a name by which the founder of Konishi Honten was known. Established in 1873, the company went through a number of name changes over the years, with Konica likely the best known outside of Japan. Now known as Konica Minolta, in 2006 the firm transferred some digital camera assets to Sony Corporation and withdrew from the camera and photo imaging business.

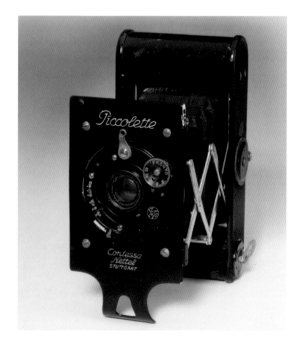

Piccolette
ca. 1919
Contessa-Nettel AG, Stuttgart, Germany. Gift of Mario A. Gennosa.
1974:0037:2251.

When the Piccolette was first introduced to America in 1919 as "a radical departure from the accepted pocket camera," it was clearly being contrasted with the Vest Pocket Kodak. While Contessa-Nettel AG of Stuttgart, Germany, used the same No. 127 roll film to produce 1⅝ x 2½-inch images in its aluminum-bodied folding camera, the Piccolette did offer some improvements over the Kodak. Most significant was the drop-out film holder, which made loading film easier. It also had an extension on the lower front lens board acting as a support when the camera was open, without having to swing a separate leg into place. The original Piccolette, however, did not have an optical viewfinder, using a wire frame finder instead, as seen in the camera shown here; by 1920 an optical finder was incorporated.

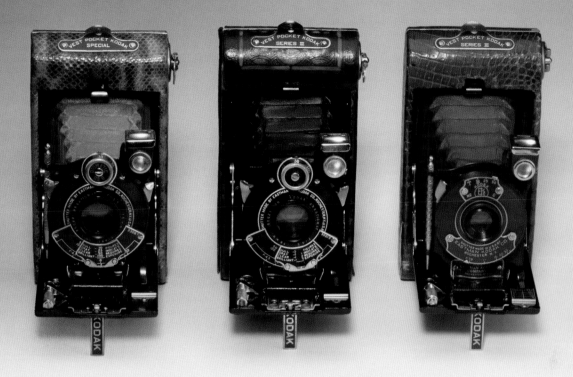

Vest Pocket Kodak Series III
ca. 1926
Eastman Kodak Company, Rochester, New York. Gift of Eastman Kodak Company. 1999:0197:0132 (snakeskin); 1999:0197:0130 (green hand-tooled leather); 1999:0197:0129 (alligator).

Unusual versions of Kodak's colorful Vest Pocket cameras exist in several forms. For example, custom-made faceplates are known with fraternal organization insignia. Color variations were sometimes nothing more than production changes. These three special variations may have been prototypes for management review, presentation models made in very limited numbers, or after-market conversions. The snakeskin-covered Vest Pocket Kodak Special has matching brown hardware and name plates. The alligator-skin VPK Series III is also matched in brow—a different shade of brown. The green VPK Series III is covered in elaborately embossed leather with hand-painted accents in green, blue, and red. The 1930 Vest Pocket Kodak Series III in the colors of blue (Bluebird), green (Cockatoo), brown (Jenny Wren), red (Redbreast), and gray (Seagull) were priced from $12 to $18 depending on the lens and shutter combination. The VPK Special was $23.

Kodak Ensemble
ca. 1929
Eastman Kodak Company, Rochester, New York. Gift of Eastman Kodak Company. 1975:0015:0015.

The Kodak Ensemble, introduced in 1929, was a Kodak Petite camera packaged in an attractive suede fabric-covered strap-style hard case, with a mirror, matching lipstick, powder compact with rouge, and change pocket. It was marketed for the holidays as the "gift for the searcher who is looking for something a little different, something novel, but thoroughly practical." The Petite used No. 127 roll film to produce 1⅝ x 2½-inch images. Obviously aimed at women, it came in three colors—beige, green, and rose—and retailed at $15 for the outfit. The cosmetics were supplied by The House of Tre Jur.

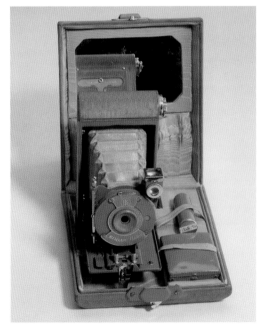

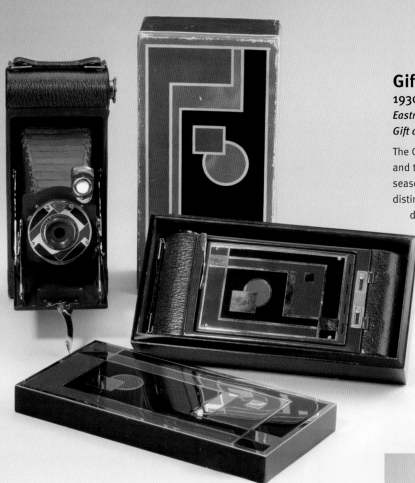

Gift Kodak

1930

Eastman Kodak Company, Rochester, New York.
Gift of Eastman Kodak Company. 1993:1392:0001.

The Gift Kodak, introduced in 1930, like the Ensemble and the Coquette, was aimed at the holiday gift-giving season. Unlike the other two, the Gift Kodak had a distinctly masculine appeal. Styled by industrial designer Walter Dorwin Teague, it was a special version of the 1A Pocket Kodak with a bed and shutter plate design in brown and red enamel and polished nickel, it produced 2½ x 4¼-inch images on No. 116 roll film. The camera was covered in brown leatherette, and the gift box was an ebony-finished cedar box with an inlaid cover matching the camera face. The retail price was $15.

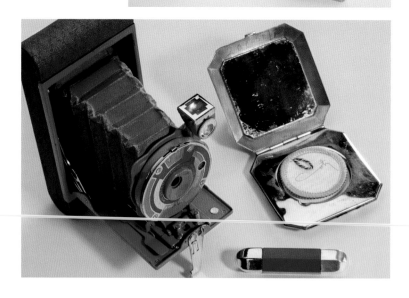

Kodak Coquette

ca. 1930

Eastman Kodak Company, Rochester, New York.
Gift of Eastman Kodak Company. 1974:0028:3452.

The Kodak Coquette, introduced in 1930, included a Kodak Petite camera, like the Ensemble of the previous year. This time, the color selection was strictly blue. The exterior was a striking face with a geometric art deco pattern in two tones of blue enamel and nickel designed by Walter Dorwin Teague. Inside, the camera used No. 127 roll film to produce 1⅝ x 2½-inch images. Packaged with a matching lipstick and compact, the Coquette aimed at high style and was marketed as being for "the smart, modern girl...a bit of Paris at your Kodak dealer's." The Teague-designed gift box was a striking silver and black with a geometric pattern. Including cosmetics by Coty, the retail price was $12.50.

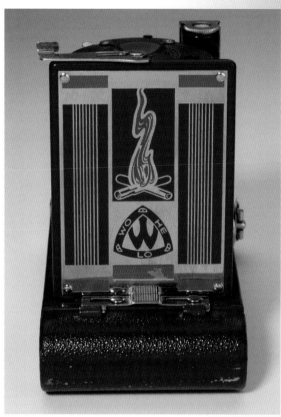

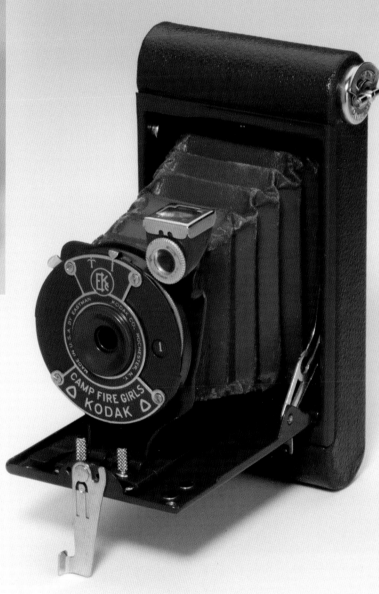

Camp Fire Girls Kodak
ca. 1931
Eastman Kodak Company, Rochester, New York.
Gift of Eastman Kodak Company. 1975:0015:0011.

The Camp Fire Girls Kodak camera, introduced in 1931, was, like the Boy Scout and Girl Scout Kodaks of the prior year, a special version of the Vest Pocket Kodak Model B. Covered in brown leatherette, it featured an enameled plate with the Camp Fire Girls logo on the front door and "Camp Fire Girls" on the shutter plate and used No. 127 roll film. The retail price in 1931 was six dollars. It is the rarest of the three U.S. scouting cameras.

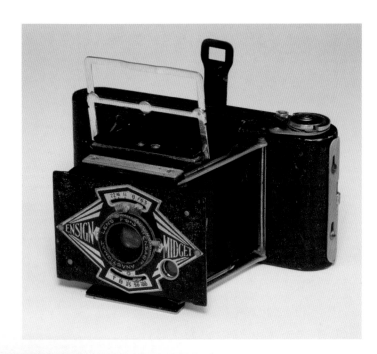

Ensign Midget 55

ca. 1934
Houghton-Butcher Ltd., London, England. Gift of Dr. Rudolf Kingslake. 1993:0525:0001.

The Ensign Midget 55 was "no wider than a sixpence" when folded, according to the London firm's 1935 catalog. The top of the Midget line, the Model 55 designation came from its fifty-five shilling price tag. Featuring an Ensar f/6.3 focusing lens, adjustable aperture, and three-speed shutter, it looked like a child's toy but produced images sharp enough to enlarge on the six-exposure rolls of 35mm wide Ensign E10 film. The designers of the Midget series allowed no wasted space and managed to include a two-position reflex finder, folding eye-level bull's-eye finder, prop stand, and locking struts that held the lens board rigidly in position. Many "vest pocket" folding cameras were available then, but none were smaller than the Houghton-Butcher Ltd. series of Midgets.

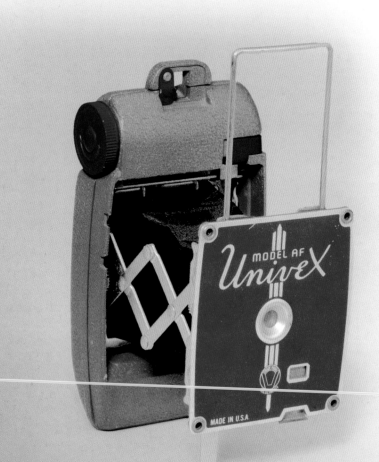

Univex AF

ca. 1935
Universal Camera Corporation, New York, New York. Gift of Eastman Kodak Company. 1991:1587:0005.

The Univex AF camera was manufactured in 1935 by Universal Camera Corporation of New York City, a company founded by two successful businessmen who reasoned that America needed a line of cameras affordable to all. The AF was an attractive, palm-sized, collapsible camera of cast metal construction with paper bellows, available in a variety of colors. An important sales point for a nation trying to come out of the Great Depression was the retail price of one dollar. It produced six 28 x 38-mm images on Univex No. 00 roll film that was manufactured in Belgium and priced at ten cents. Though quite successful, with twenty-two million rolls sold by 1938, manufacturing was suspended in 1940, after the German occupation of Belgium.

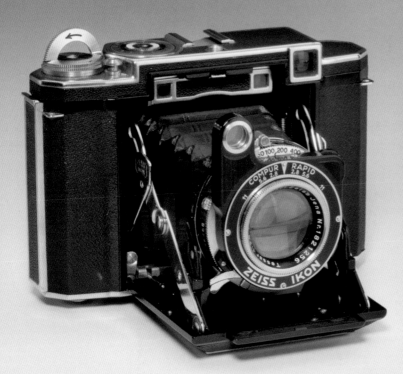

Super Ikonta B (530/16)
ca. 1937
Zeiss Ikon AG, Dresden, Germany. Gift of Homer W. Smith.
1982:2231:0001.

The Zeiss Super Ikonta B, manufactured by Zeiss Ikon AG, Dresden, was a medium-format camera that folded flat for convenience. It provided a 6 x 6-cm image on No. 120 roll film. The 530/16 model was produced from 1937 through 1956 and featured a combined rangefinder and viewfinder window. With the Zeiss Tessar lens, the Super Ikonta B is considered by many to be the best folding roll-film camera ever made. The retail price in 1937 was $150.

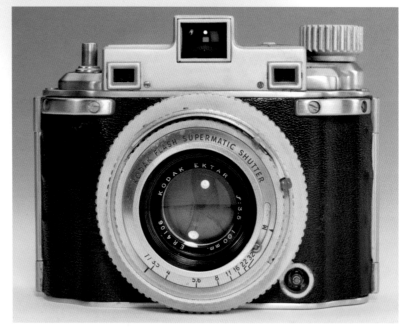

Medalist II
ca. 1946
Eastman Kodak Company, Rochester, New York.
Gift of Allen C. Priday. 1987:1509:0001.

The Medalist II of 1946 was an improved version of the Medalist of 1941. The original was designed as a medium-format, sturdy multipurpose camera using No. 620 roll film. It had a wide-base split image rangefinder, double helix focusing tube, and a complete array of replacement backs, allowing ground glass focusing, film pack, plates, and sheet film as well as an extension back to be used for close-up and macro work. It found use as a military camera, a copy camera, and with professionals, advanced amateurs, and photojournalists. It had, arguably, the finest lens ever made for a non-interchangeable lens camera in the 100mm f/3.5 Kodak Ektar.

The Medalist II had some minor control revisions, a coated lens, and a flash synchronization connector with the Kodak Flash Supermatic shutter. The retail price of the Medalist in 1941 was $165, and in 1946 the Medalist II was priced at a lofty $270.

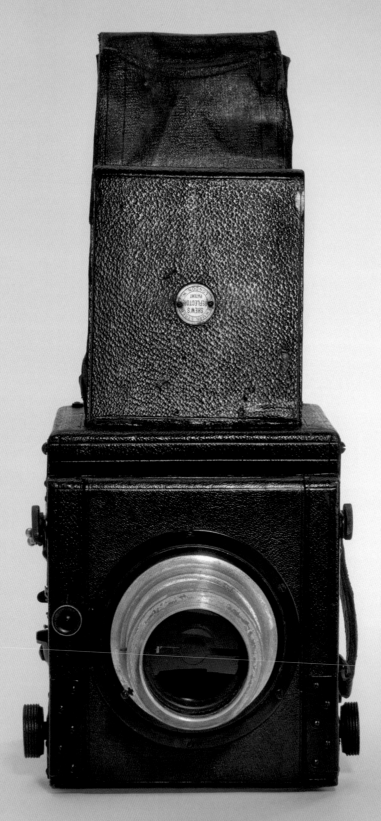

Delta Reflex (owned by Alvin Langdon Coburn), ca. 1910. See page 195.

THE CAMERA MAKES MONEY (AND ART)

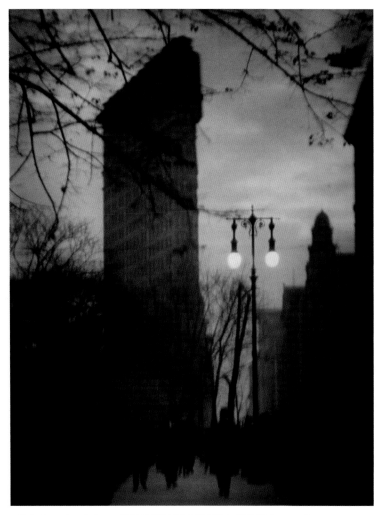

Alvin Langdon Coburn, *THE FLAT IRON BUILDING, EVENING*, 1912. See page 197.

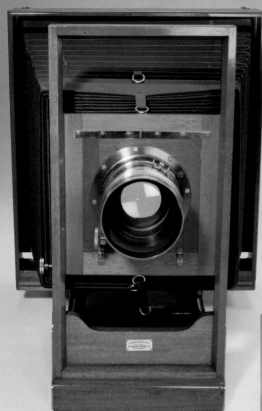

Improved Empire State View Camera (14 x 17)
ca. 1890
Rochester Optical Company, Rochester, New York. Gift of 3M Foundation, ex-collection Louis Walton Sipley. 1977:0415:0374.

In the 1890s, the Rochester Optical Company made some very large view cameras, including this 14 x 17-inch Improved Empire State View, part of a line that included sizes up to 20 x 24 inches. Unlike the smaller models, this camera featured a fixed front standard and rear focus. Made of mahogany with polished brass fittings, it offered movements to satisfy professional photographic needs. The 1893 catalog shows two models: single and double swing, priced at $50 and $55 respectively (excluding lens).

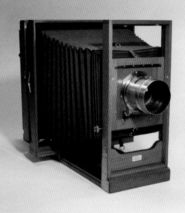

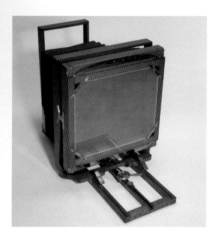

GEORGE EASTMAN DID NOT INVENT popular photography, but he made it possible. He understood that few things mean as much to people as their own pictures. He also knew that few things matter less to anybody than other people's personal pictures.

There is a second kind of popular photography, the kind we gaze on all day long: the leather jacket on the catalog cover, the sullen beauty in the fashion ad, the kitten on the birthday card. The world swims in images as striking at first as they are forgettable moments later. Making pictures requires skill and often years of apprenticeship to master the craft. And as all those perfect pictures imply, commercial photography is a vastly lucrative business.

There is a third kind of popular photography, anchored in craft, that belongs to a different realm. Much early fine art photography was a natural outgrowth of early portrait photography, which often employed soft focus and other techniques to emulate the misty look of paintings. It was often taken up by studio portrait photographers, who found fewer customers as pictures by skilled amateurs threatened their livelihoods.

Century Grand Studio Camera

ca. 1904

Century Camera Company, Rochester, New York. 1978:1371:0057.

It would seem to go without saying that the essential tools of the photographer are a studio and a camera. And yet, for the portrait photographer of the past, it was not as simple as that. Just as any hammer won't do the job right for the carpenter, most cameras were not suited to the work of the portrait photographer. When nails are pounded, the tool of choice is a claw hammer, not a mallet or ball-peen or sledge, and when formal portraits were made, the best camera for the job was a studio, not field, detective, or subminiature, model. Cameras, like hammers, are designed for specific purposes.

For more than fifty years, the Century Studio camera was the prime apparatus used for portraiture. The company began producing cameras in 1900 and within two years listed studio cameras in its catalogs. Eastman Kodak Company acquired Century in 1903 and Folmer & Schwing Manufacturing in 1905, merging the two to create its professional apparatus division, which produced studio cameras through 1926. After that, the division was spun off and the new company continued to make the Century Studio Camera, first as

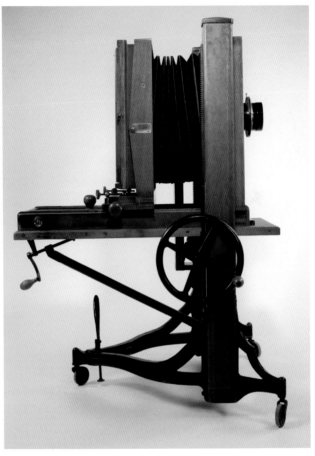

Folmer Graflex (1926–1946) and then as Graflex, Inc. (1946–1955). The camera was sold separately or in a grouping known as the Century Universal Studio Outfit. The outfit, which was as large as a wing chair, consisted of the camera, the Semi-Centennial Stand, and one plate holder. Numerous styles of backs were offered, allowing the photographer a choice of image sizes.

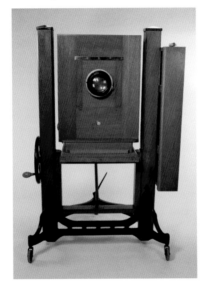

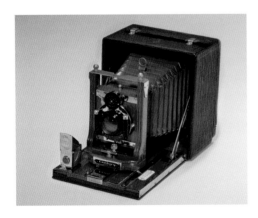

Century Model 46

ca. 1905

Century Camera Company, Rochester, New York. Gift of Eastman Kodak Company. 1999:0160:0001.

The Century Model 46 was a beautiful 4 x 5-inch field camera made by the Century Camera Company of Rochester, New York. The company began manufacturing in 1900, but by 1903 it was purchased by George Eastman. The camera shown here in gorgeous condition with mahogany base, red leather bellows, revolving back, and brass fittings carries a name plate reading "Eastman Kodak Co., Succ'rs to CENTURY CAMERA CO." The first camera in which Century introduced the double section brass bound telescopic bed, it has a Centar series II lens in Century shutter. The original retail price was $32, but with Bausch & Lomb or Zeiss lenses the price more than doubled.

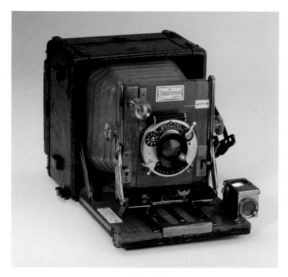

Sanderson De Luxe

ca. 1908

Houghton's Ltd., London, England. Gift of Arthur Sintzenich.
1974:0037:1619.

Frederick Sanderson was an English woodworker unhappy with the hand cameras available to him in the 1880s, so he decided to build his own. One source of his frustration was in making lens movements for perspective adjustments. His solution was so ingenious that he patented it and arranged to have his camera manufactured in quantity. The Sanderson lens board was mounted in slotted struts, allowing extreme upward movement. Large knurled knobs could be tightened easily while viewing through the rear ground glass. In addition, small levers on each side unlocked the lens board for tilting. This Sanderson De Luxe was made of Spanish mahogany and brass, with the body covered in black leather. It used either plates or film for 3 ¼ x 4 ¼-inch images. The Blitz Double Astigmat 5-inch f/6.8 lens is mounted on a Koilos shutter. The price in a 1910 catalog was £13.

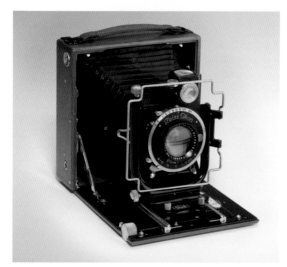

Tropen-Favorit

ca. 1927

Zeiss Ikon AG, Dresden, Germany. Gift of Birdsall Nichols. 1981:2772:0001.

Zeiss Ikon AG of Dresden, Germany, produced cameras for what they called "all the world," meaning they were designed to withstand extreme climates. This special 9 x 12-cm plate and film pack folding camera was built with a teakwood body to withstand the punishing humidity and heat of the tropics. The leather parts were specially treated to repel insects, and nickel plating helped keep the metal looking new. Made in the early 1930s, it's similar to Zeiss Ikon's Tropen-Adoro. A Carl Zeiss Jena Tessar 15cm f/4.5 lens worked through a Compur shutter with a 1/200 second top speed. Front rise and shift movement adjustments for perspective control, reflex viewer with bubble-level, and wire frame sports finder were useful for composing pictures. Focus was with ground glass through the lens or a distance scale on the base, controlled with a rack-and-pinion movement.

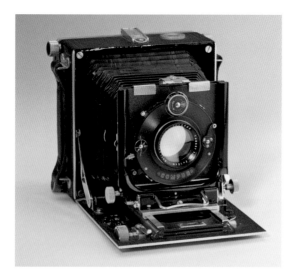

Technika

ca. 1936

Linhof Präzisions Kamera Werke GmbH, Munich, Germany. Gift of Graflex, Inc. 1974:0037:2436.

The Technika, introduced in 1936, was manufactured by Linhof of Munich, Germany. First in a series of Technika cameras, which were distinguished from the Standard series by the inclusion of an adjustable back for perspective control, it featured a heavy, sturdy construction of a leather-covered metal body with triple extension drop baseboard. While resembling a Graflex Speed Graphic, the Technika had the extra adjustability useful in architectural and scientific work.

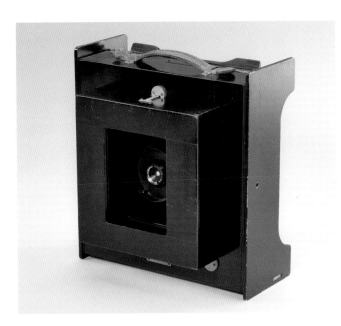

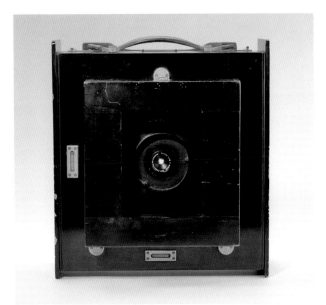

Eastman Wide-Angle View
ca. 1931
Kodak Ltd., Harrow, England. Gift of Eastman Kodak Company. 1993:0210:0002.

Introduced in 1931 by Kodak Ltd., Eastman Kodak Company's British subsidiary, the Eastman Wide-Angle View was designed to photograph interiors and other areas with tight access. A simple box design, the full-plate-sized camera has no means of focusing since the wide-angle f/18 Zeiss Protar lens provides enough depth of field to make it unnecessary. There is no viewfinder as the image is composed directly on the ground glass. The lens board can also be mounted backwards, with the front element facing the film, and used for extreme close-up copy work.

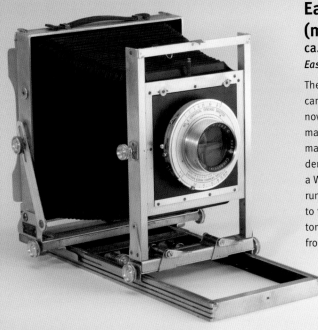

Eastman Commercial View (magnesium)
ca. 1937
Eastman Kodak Company, Rochester, New York. 1989:0015:0001.

The Eastman Commercial View was the tried-and-true Eastman 2D View camera recast in magnesium, a lightweight and extremely strong metal now used primarily in aircraft construction. The magnesium construction made the camera much more durable than its mahogany sibling but ultimately led to its demise. After only a few years of production, a World War II shortage of the metal ended the run (planes were more important than cameras to the war effort). A clever accessory was a tongs-style lens board, which gave the fixed-front camera front tilt and swing movements of twenty degrees. This 8 x 10-inch model cost $175, excluding the 14-inch f/6.3 Commercial Ektar lens shown.

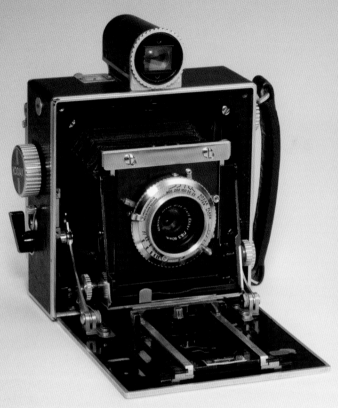

Teknar
1946
Eastman Kodak Company, Rochester, New York. Gift of Eastman Kodak Company. 1990:0128:0006.

Eastman Kodak Company designed the Teknar to be an American alternative to the German Linhof Technika line of precision field cameras. Constructed mainly of aluminum, it was a rugged camera intended for location work in harsh environs. Never taken beyond the experimental stage, the 1946 prototype had many features important to photographers, such as back adjustments for both focus and perspective correction and a lens board that could rise and tilt. Focusing was either by ground glass or a coupled rangefinder that could be mounted atop the black leather-covered body. Also on top was a distance scale that could be set to match the lens being used. Image size was 6 x 9 cm both for sheets or No. 620 film, which was used when the roll holder was in place. A Kodak Flash Supermatic shutter with maximum speed of 1/400 second and a coated 80mm f/6.3 Kodak Wide Field Ektar lens is on this example, but markings on the bed rails show positions for six other lenses up to 338mm f/5.6.

A BOMBSHELL AT THE TEA PARTY

ENTER DR. PETER HENRY EMERSON (1856–1936). In 1885, he gave up medicine to practice photography, and in 1889 published *Naturalistic Photography for Students of Art*. It was termed "a bombshell dropped in a tea party" for its insistence that photographers stop taking gauzy pictures of swooning maidens and instead take advantage of the camera to make sharply focused compositions of real-world subjects.

Emerson asserted that photography should reveal the naturalness of a scene by evoking its essence and corresponding emotion through the natural way of how we see—while emphasizing the qualities unique to the camera and photograph. If those notions seem somewhat contradictory, Emerson thought human vision did not see the overwhelming detail caught by the camera.

In an 1891 pamphlet, "Death of Naturalistic Photography," Emerson later renounced his own views. As the science of materials and development defined the tonal range of photography, he felt that the results revealed photography was too mechanical and too limited to be viewed as art per se. But as Beaumont Newhall describes in *The History of Photography*, such a distinction seems "of little importance in light of his finest photographs."

ALFRED STIEGLITZ: THE FIRST GRAND MASTER

ONE OF EMERSON'S EARLY FOLLOWERS, the American Alfred Stieglitz (1864–1946) may be considered the most influential figure in American photography, if not American art. He led a countermovement, the Photo-Secessionists, who regarded photography "as a distinctive medium of individual expression." Over his long life he made one remarkable

Alfred Stieglitz (American, 1864–1946). *THE TERMINAL (NEW YORK),* 1893. Transparency, gelatin on glass (lantern slide). Part purchase and part gift of An American Place, ex-collection Georgia O'Keeffe. George Eastman House collections.

Alfred Stieglitz (American, 1864–1946). *[Georgia O'Keeffe, hand on back tire of Ford V8],* 1933. Gelatin silver print. Part purchase and part gift of An American Place, ex-collection Georgia O'Keeffe. George Eastman House collections.

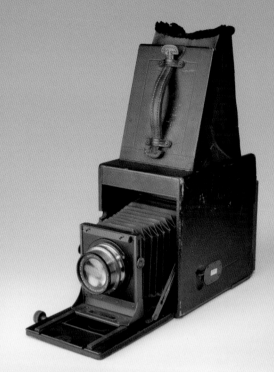

RB Auto Graflex
(owned by Alfred Stieglitz)
ca. 1910
Folmer & Schwing Division of Eastman Kodak Company, Rochester, New York.
Gift of Georgia O'Keeffe. 1974:0037:0032.

American photographer Alfred Stieglitz was dedicated to establishing photography as art through his own work and that of others. Stieglitz opened Gallery 291 in New York to showcase works that otherwise would not be seen by the public. His Folmer & Schwing Auto Graflex 4 x 5-inch camera may not have been a joy to behold, but the hard-working photographer learned it was one to use. No polished wood, shiny brass, or luxurious Russia leather on this single-lens reflex field piece—Stieglitz wasn't interested in a show horse. He needed a workhorse, and his Auto Graflex with the Goerz Celor 8¼-inch f/5 lens and reliable focal-plane shutter had enough flexibility to grab images of fast action or capture the splendor of the Manhattan skyline. Its revolving back could be set from portrait to landscape orientation in one second. Folmer & Schwing of Rochester, New York, built all Graflex cameras to endure the rigors and roughness of hard travel and to be ready when called upon. The Auto Graflex had a lot in common with Alfred Stieglitz.

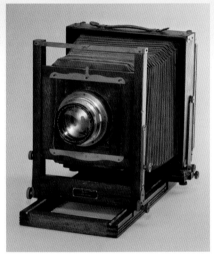

Eastman View No. 2D
(owned by Alfred Stieglitz)
1921
Eastman Kodak Company, Rochester, New York. Gift of Georgia O'Keeffe. 1978:1371:0054.

Alfred Stieglitz (1864–1946) was instrumental in elevating photography to an art form. His gallery on Fifth Avenue in New York exhibited photographers' works along with paintings by modernists like Picasso and Cézanne. For his own pictures, Stieglitz relied on equipment like the Eastman View No. 2D. From its beginning, the Kodak brand was associated with amateur photography, but Eastman Kodak Company also sold a lot of professional items. Cameras like the 2D View were added to its catalog through the acquisition of companies such as Rochester Optical, Century, and Graflex. Introduced in 1921, the Eastman View No. 2D remained in the lineup until 1950. The "D" in the model number denotes "Dark" finish, which allowed the use of less expensive mahogany stock for the body. Stieglitz's 8 x 10-inch camera listed for under $50, much less than fancier brands, but he didn't skimp when fitting it with a lens. A Goerz Double Anastigmat of 14-inch focal length was chosen to pass light through a Packard-Ideal pneumatically operated shutter. Eastman offered a Graflex focal-plane shutter with the 2D View for an additional $41.

picture after another—portraits, New York City scenes, Lake George, New York, scenes and more than three hundred photographs of the painter Georgia O'Keeffe. His journal *Camera Work*, published from 1903 to 1917, is considered the most important arts magazine of its time. He brought modern European art to America and persuaded New York's Metropolitan Museum to display photographs as art. He helped launch the careers of young photographers such as Ansel Adams, Edward Weston, and Paul Strand.

The early twentieth century had seen an abundance of emerging photographers in Europe and America, names like Clarence H. White, Gertrude Kassebier, F. Holland Day, and Alvin Langdon Coburn.

The most famous was the American Edward Steichen (born Luxembourg, 1879–1973), whose 1955 exhibition at the Museum of Modern Art, *The Family of Man*, featured five hundred pictures by two hundred and seventy three photographers in sixty eight countries, that argued for our common humanity.

Delta Reflex
(owned by Alvin Langdon Coburn)
ca. 1910
J. F. Shew & Company, London, England. Bequest of Alvin Langdon Coburn. 1967:0059:0001.

In the early 1900s, the single-lens reflex hand camera became popular with serious photographers and remained so in the decades to come. Most were similar to the Delta Reflex 3¼ x 4 ¼-inch revolving back model made by J. F. Shew of London in 1909. A tall leather viewing hood unfolded for sighting the image from the lens, reflected by an angled mirror onto a ground glass screen. This permitted the photographer to adjust the rack-and-pinion focus for the sharpest possible image. But pictorialists like Alvin Langdon Coburn (1882–1966), whose camera is illustrated here, wanted a somewhat diffused image for the entire depth and used "soft-focus" lenses like those made by Pinkham & Smith of Boston. Coburn used P&S Semi-Achromatic lenses to make his artistic portraits and landscape scenes, and his testimonials helped sell other impressionistic photographers on the concept. Although they designed and manufactured their own products, both J. F. Shew and Pinkham & Smith sold broad lines of photographic apparatus and supplies made by firms in England, Europe, and the United States.

GROUP f/64

THE THREE GIANTS OF AMERICAN fine art photography in the first fifty or so years of the twentieth century were Edward Weston (1886–1958), Ansel Adams (1902–1984), and the less well-known Paul Strand (1890–1976). Their black-and-white pictures have a solidity and often abstract radiance that reflect the photographer's insistence that the world is wonderful beyond words.

In 1932, a group of photographers including Adams, Edward Weston and his son Brett, Imogen Cunningham, and seven others formed Group f/64. Their purpose was to assert that aesthetic aim with even greater emphasis. As f/64—the designation of the smallest camera aperture—implied, pictures should be in focus from foreground through infinity. Large-format cameras were to be employed. The results were to be "pre-visualized." High-quality contact prints were to set the standard for fine grain, sharpness, and musical tonal controls. Subjects came to include boulders, bedpans, and people, as well as peppers, magnolia blossoms, and shells. The best retain iconic status.

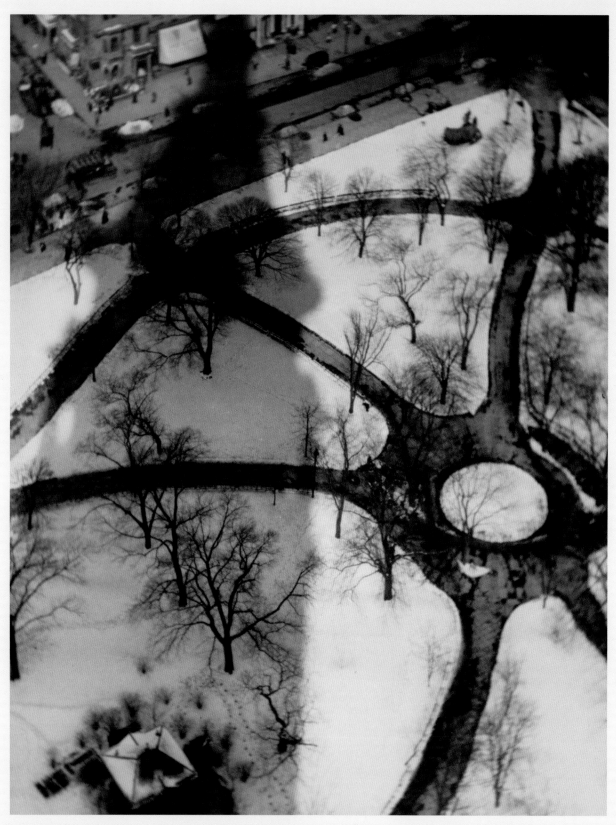

Alvin Langdon Coburn (British, 1882–1966). *THE OCTOPUS, NEW YORK*, 1912. Platinum print. Gift of Alvin Langdon Coburn. George Eastman House collections.

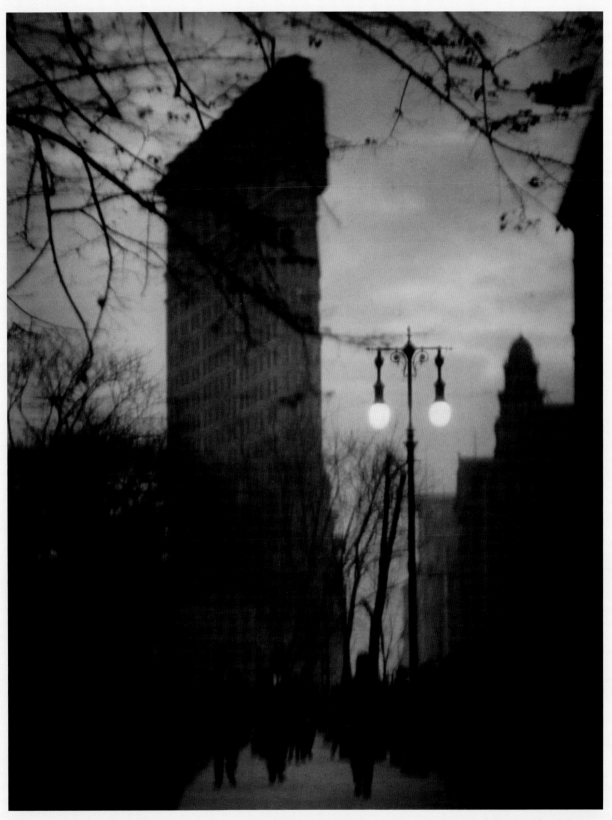

Alvin Langdon Coburn (British, 1882–1966). *THE FLAT IRON BUILDING, EVENING*, 1912. Platinum print. Gift of Alvin Langdon Coburn. George Eastman House collections.

Edward Weston (American, 1886–1958). *PEPPER NO. 30*, 1930. Gelatin silver print. George Eastman House collections.

Nickolas Muray (American, b. Hungary, 1892–1965). *BABE RUTH*, 1927. Gelatin silver contact print. Gift of Michael Brooke Muray, Nickolas Christopher Muray, and Gustav Schwab. George Eastman House collections.

THE NEWS IN PICTURES

PHOTOJOURNALISM AND DOCUMENTARY photography flourished with the spread of improved printing technologies in magazines and newspapers. Dramatic photos sold papers. Spellbound readers flipped through newspapers and magazines, searching for reports of war, society news, and sports heroes such as Babe Ruth.

Until the mid-1920s, photos of distant breaking news could not be reproduced in a timely manner. But in 1924, electronic transmission of pictures over telephone lines was proved feasible. Soon photos of news events were transmitted almost instantaneously around the world, ready for the next edition of the local newspaper.

Beyond the everyday news, photographers with a social conscience—or a personal agenda—now had a means of bringing about change. Americans Jacob A. Riis (born Denmark, 1849–1914) and Lewis W. Hine (1874–1940) stand out for both their dedication and photographic skill.

Riis started out in the late 1800s using dry plates,

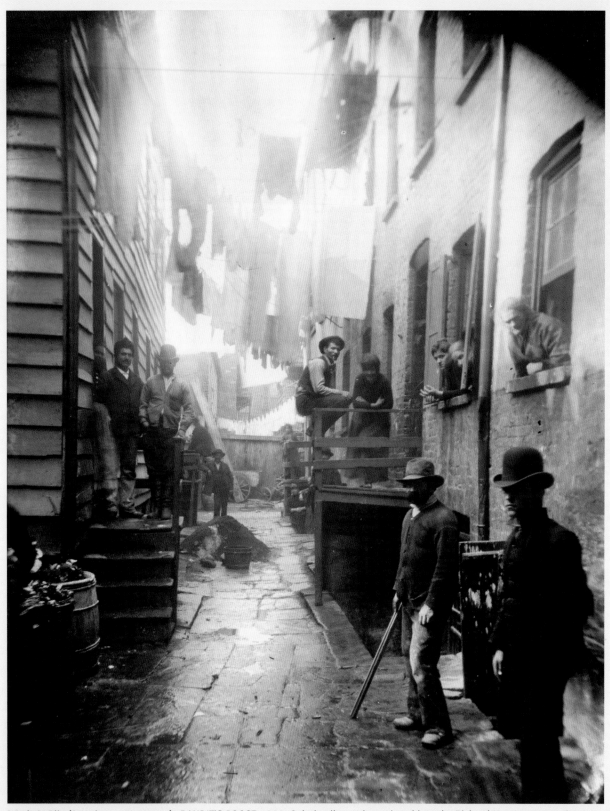

Jacob A. Riis (American, 1849–1914). *BANDIT'S ROOST*, 1888. Gelatin silver print, printed later by Richard Hoe Lawrence. George Eastman House collections.

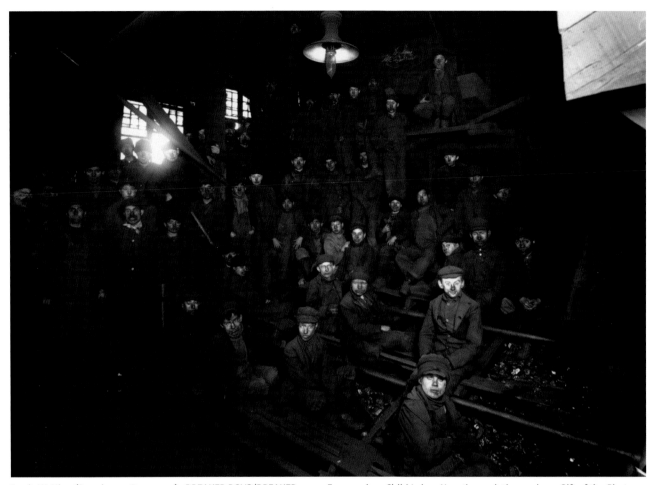

Lewis W. Hine (American, 1874–1940). *BREAKER BOYS/BREAKER*, 1912. From series: *Child Labor*. Negative, gelatin on glass. Gift of the Photo League, New York, ex-collection Lewis Wickes Hine. George Eastman House collections.

often with magnesium flash powder, to illuminate the squalid poverty and lives of the poor in large cities. His social documentary culminated in the 1890 book *How the Other Half Lives*, a virtual tour of New York tenements and slums. Beginning as a factory worker, Hine studied at New York University and became a teacher, then undertook photography, hoping to make an impact. At the turn of the century, he worked for ten years with the National Child Labor Committee, which was dedicated to reforming child labor laws of the time in the United States. He traveled the country

photographing and documenting the lives of children doing the jobs of adults in textile mills, coal mines, and glass factories. His disturbing, highly compelling pictures could not be ignored by lawmakers and were critical in influencing child labor legislation.

Some of Hine's most exciting pictures are devoted to the construction of the Empire State Building in New York City in 1930 and 1931. To achieve them, he would teeter across the open girders and photograph workmen welding steel beams at dizzying heights above the streets below.

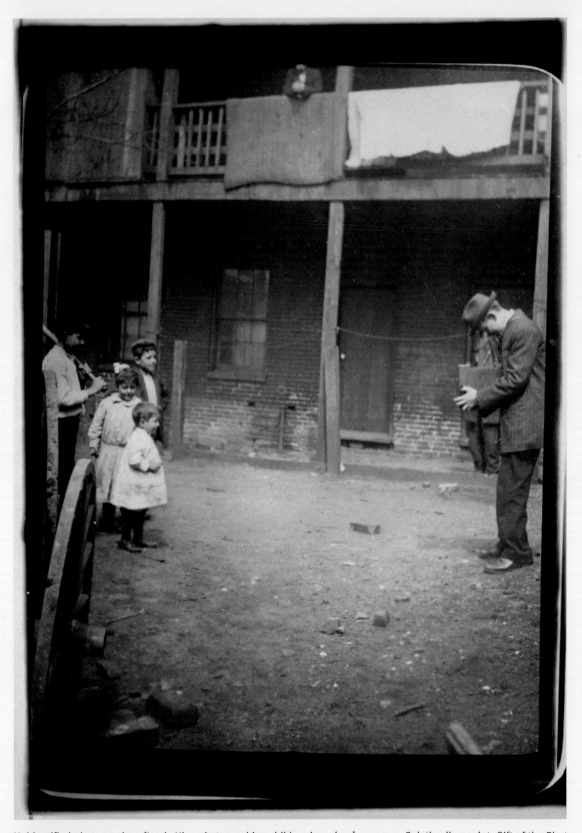

Unidentified photographer. *[Lewis Hine photographing children in a slum]*, ca. 1910. Gelatin silver print. Gift of the Photo League, New York, ex-collection Lewis Wickes Hine. George Eastman House collections.

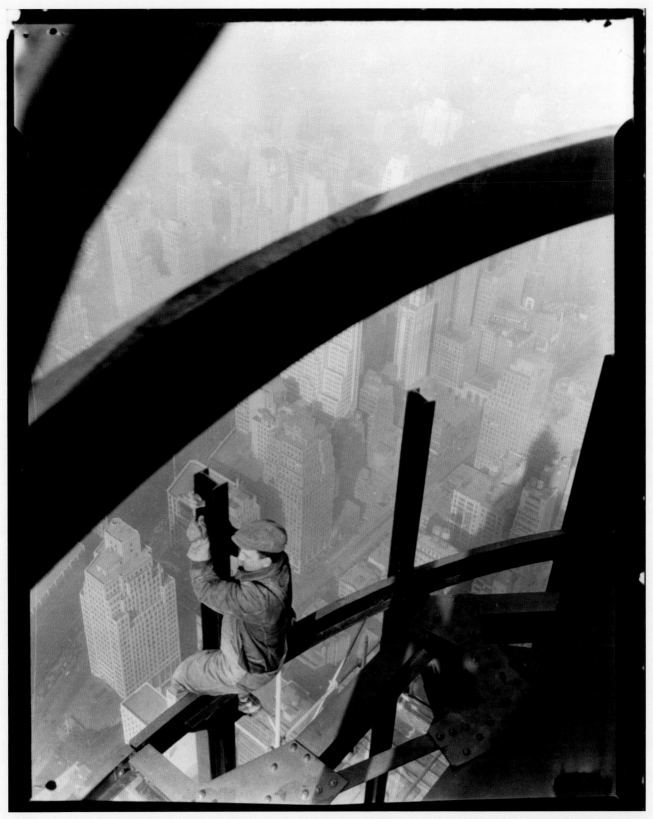

Lewis W. Hine (American, 1874–1940). *[Man on girders, mooring mast, Empire State Building]*, ca. 1931. From series: *Empire State*. Gelatin silver print. Gift of the Photo League, New York, ex-collection Lewis Wickes Hine. George Eastman House collections.

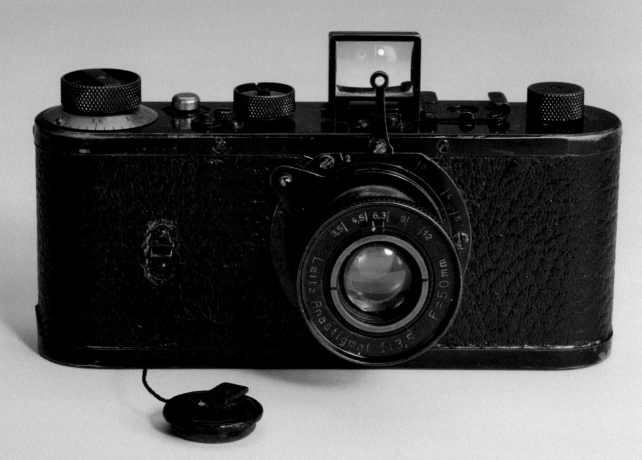

0-Series Leica, 1923. See page 213.

XII

THE CAMERAS
BEHIND
THE NEWS

Oskar Barnack, *[Eisenmarkt: one of the first images made with the Ur-Leica]*, 1914. See page 213.

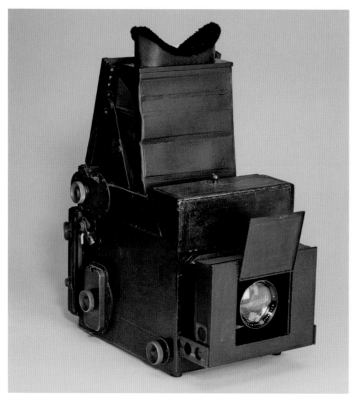

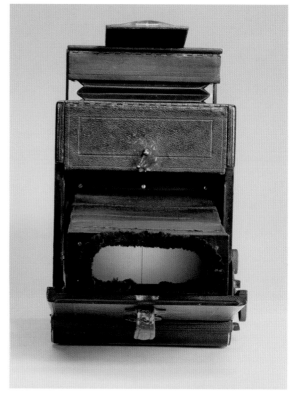

Press Graflex
ca. 1908
Folmer & Schwing Division of Eastman Kodak Company, Rochester, New York. Gift of Graflex, Inc.
1974:0037:2593.

Manufactured by Eastman Kodak Company's Folmer & Schwing division in Rochester, New York, from 1907 to 1923, the Press Graflex shared features with many Graflex cameras of the time. These included an extensible front with no bed, a detachable spring back holding individual plates or a film pack, a focal-plane shutter curtain, and a large reflex viewing hood that was contoured to the photographer's face. The Press Graflex was available only in the 5 x 7-inch size and, as the name implies, was targeted to the newspaper photographer. The retail price with a Bausch & Lomb Zeiss Tessar lens was $169.50.

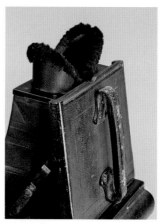

MUCH OF THE GREAT WORK of the photojournalists and documentarians (including Hine) was created with a camera patented in 1901 by Folmer & Schwing, a New York City company. The camera was the Graflex.

George Eastman bought Folmer & Schwing in 1905, probably in order to obtain the Graflex technology. He moved the company to Rochester and

kept it largely intact by creating its own division within Kodak. Combined with his 1903 purchase of the Century Camera Company, Eastman now had the camera designs and patents, along with a skilled workforce, to make and market professional cameras.

Launched in 1907, the Press Graflex shared features with many Graflex cameras of the time—

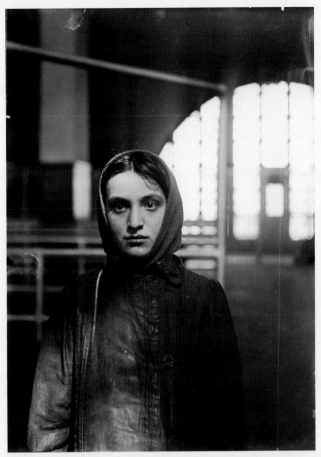

Lewis W. Hine (American, 1874–1940). *YOUNG RUSSIAN JEWESS AT ELLIS ISLAND*, 1905. From series: Ellis Island. Gelatin silver print. Gift of the Photo League, New York, ex-collection Lewis Wickes Hine. George Eastman House collections.

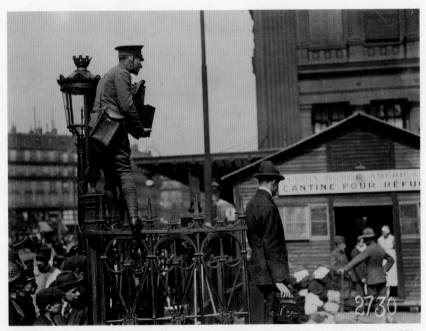

Unidentified photographer. *CAPTAIN LEWIS W. HINE, STAFF PHOTOGRAPHER, AMERICAN RED CROSS, RECORDING THEIR WORK WITH REFUGEES IN PARIS*, 1917. Gelatin silver print. Gift of the Photo League, New York, ex-collection Lewis Wickes Hine. George Eastman House collections. Hine is using a Press Graflex.

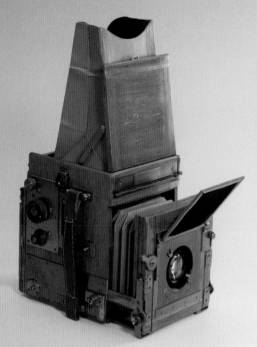

Soho Tropical Reflex

ca. 1905

Marion & Company Ltd., London, England. 1974:0037:2909.

Based on a design by A. Kershaw in London, England, this type of tropical camera was originally distributed by Marion & Company Ltd., also of London. Due to several mergers and company name changes and a production run of more than forty years, cameras of this design have worn numerous manufacturer labels. This specific example is made by Soho Limited and dates from the 1940s. Constructed of French polished teakwood and brass hardware, the Soho Tropical Reflex camera has a special red leather bellows and focusing hood, making it among the most attractive cameras ever produced. It incorporates some novel mechanics, with the reflex mirror moving back as it retracts, allowing the use of shorter focal length lenses. The rotating back is matched with a rotating mask in the reflex viewer to accommodate horizontal and vertical use.

Naturalists' Graflex

1907

Folmer & Schwing Division of Eastman Kodak Company, Rochester, New York. Gift of David Fischgrund. 1990:0011:0001.

Designed especially for a naturalist's work, photographing birds and wild animals with long-focus or telephoto lenses, the Naturalists' Graflex was manufactured by the Folmer & Schwing division of Eastman Kodak Company of Rochester, New York, from 1907 to 1921. It was similar to many of the Graflex cameras of the period, with the exception of its very long extension front that accommodated lenses up to twenty-six inches in focal length. Features included a spring

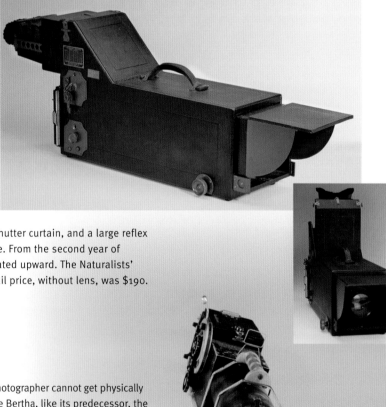

back to hold individual plates or film packs, a focal-plane shutter curtain, and a large reflex viewing hood that was contoured to the photographer's face. From the second year of production, the viewing hood was hinged so it could be rotated upward. The Naturalists' Graflex was available only in the 4 x 5-inch size and the retail price, without lens, was $190.

Little Bertha

ca. 1941

Graflex, Inc., Rochester, New York. 1974:0028:3537.

Long lenses are used for photographing objects to which the photographer cannot get physically close, such as sporting events or animals in the wild. The Little Bertha, like its predecessor, the Naturalists' Graflex, was designed for such purposes. Also like the Naturalists', Little Bertha was based on a production Graflex model, in this case, a 4 x 5 RB Graflex Super D. Modifications were added to the camera base to support the 30-inch (and forty-pound!) f/8 lens. To allow for fast focusing, a chain-drive system, complete with three adjustable focus points—for baseball, it could be pre-focused on the different bases—was added to the side of the camera. This example was used in the 1940s at the *Chicago Sun Times*, probably for stadium sports photography.

Minex Tropical

ca. 1920

Adams & Company Ltd., London, England. 1974:0028:3131.

Adams & Company of London built cameras for the discriminating individual for whom price was no object. Only the finest materials were used in their 1920 Minex Tropical single-lens reflex folding cameras. Polished teakwood bodies with lacquered brass fittings told the world you insisted on the best, while the bellows and viewing hood of Russia leather had the feel of a kid glove. But, after all, this was still a camera, so Minex had to deliver superior results, and it could. The Taylor-Hobson Cooke Aviar 5¼-inch f/4.5 lens in the leather-covered mounting board had a teak and brass flip-up door for protection when not in use. The brass focus racks had three-inch extensions that could be unfolded to allow the lens and bellows to travel beyond the edge of the baseboard for telephoto work. Capturing fast action was easy with the Minex's 1/1000 second focal-plane shutter. Unlike most other camera manufacturers, Adams only sold direct from their 24 Charing Cross Road premises. At £85 for the 3½ x 2½-inch model, the Minex Tropical was not within the means of working folks, but Adams did take trade-ins toward the purchase price. The used cameras were refurbished and sold through Adams' Second-Hand Apparatus store.

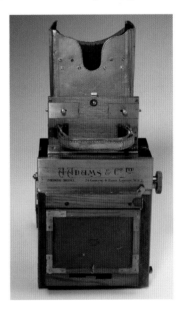

including a rubberized-cloth focal-plane shutter and an extensible front with no bed. Eventually, all Graflex (meaning all Folmer & Schwing single-lens reflex cameras) would have the extensible front, a detachable spring back holding individual plates or film packs, a focal-plane shutter curtain, and a large reflex viewing hood that was contoured to the photographer's face.

The first twenty-five years of the twentieth century found manufacturers churning out new consumer models at a furious pace, while development of professional models stagnated. Invested in equipment (particularly the large negatives) and trained in specific techniques that they had used successfully over time, professionals were slow to adopt (or even consider) much of the new camera equipment.

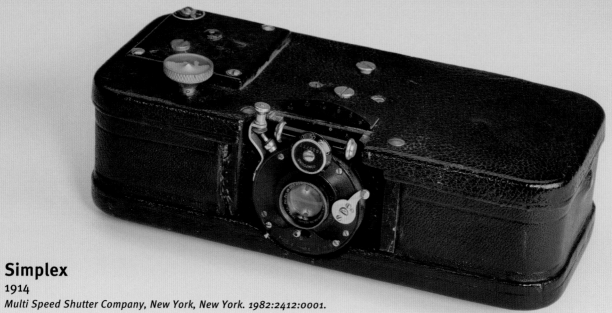

Simplex
1914
Multi Speed Shutter Company, New York, New York. 1982:2412:0001.

The great popularity of the 35mm camera in pre-digital days began in the late nineteenth century when Thomas Edison's laboratory chose 35mm as the width of the film for their motion picture system. Movie studios used large rolls of the perforated film stock and made available short leftover lengths. It wasn't long before still cameras were built around this film size, and the 1914 Simplex was one of the earliest. The Multi Speed Shutter Company of New York already built movie cameras, so they knew well the film they chose for the Simplex. Movie frames were set at 24 x 18 mm and, at first, the 35mm still cameras adopted this format. However, by removing a metal mask from the film plane, the Simplex's Bausch & Lomb Zeiss Tessar 50mm lens could cover two frames, giving a 24 x 36-mm negative. This "double-frame" size soon became the standard for 35mm cameras, leading to designs such as the Leica in the 1920s. Fifty feet of film could be loaded into a Simplex. That was enough for 400 double-frame exposures, or twice as many 24 x 18-mm images.

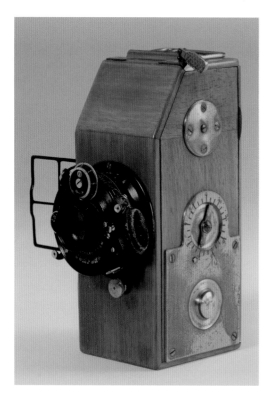

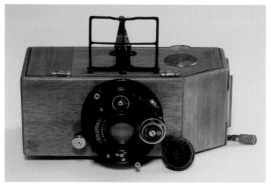

Sico
ca. 1923
Wolfgang Simons & Company, Bern, Switzerland. 1974:0037:0052.

In 1920, Wolfgang Simons & Company of Bern, Switzerland, produced an early 35mm camera. The compact Sico had a five-inch-long body made mostly of wood with brass fixtures. The 35mm film was unperforated with a paper backing and rolled for twenty-five exposures of 32 x 40 mm. A ratchet mechanism advanced the film by raising the flat knurled pull next to the finder. The 6cm f/3.5 Sico Rüdersdorf lens was controlled by a Compur 1/300 second shutter and focused by a lever under the shutter housing. The Sico could be used as a projector by mounting it to the optional Projektionsapparat.

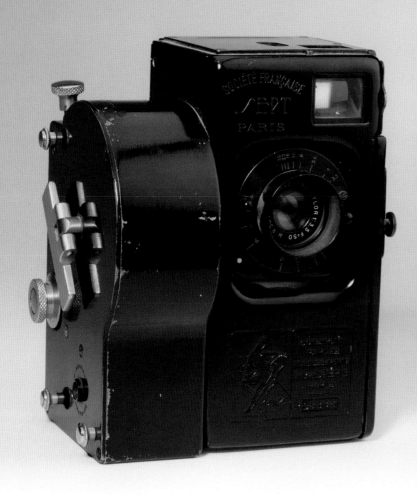

Sept
ca. 1922
Etablissements André Debrie, Paris, France.
1974:0037:2071.

André Debrie of Paris, manufacturer of the Sept (French for the number "seven"), named their 1922 camera for the seven very different functions it was designed to perform. This multi-functioned $225 apparatus shot 35mm ciné film in eighteen-foot lengths and could take either motion pictures or still photographs. It also could project movies or be used as an enlarger to print negatives onto either photographic paper or positive film. A spring motor both drove the movie mechanism and could advance frames for the still camera, which could shoot individual frames, timed exposures, or a burst of shots in quick succession. Movie studios were a market for short lengths of 35mm film, and the demand for shorts fueled the development of the 35mm cameras that would eventually become the prevalent format around the globe.

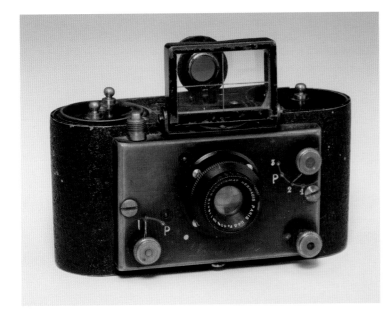

Furet
ca. 1923
E. Guérin & Cie, Paris, France. 1974:0028:3245.

The availability of 35mm ciné film led to a revolution in still camera design. Format sizes varied by manufacturer, but E. Guérin & Cie of Paris designed the 1923 Furet to shoot a 24 x 36-mm frame. Used earlier on the Simplex of 1913 and then adopted by Leica, this size became the world standard for 35mm cameras. The Furet body was cast aluminum and most of the rest was brass. Its lens was a fixed-focus 40mm f/4.5 Hermagis with a variable aperture. A three-speed shutter, a folding viewfinder, and a frame counter added to the usefulness of the black-crackle-finished camera. The shutter release button was located on the top right side. Barely three-and-one-half inches wide, the petite Furet was one of the smallest 35mm cameras ever built.

Julius Huisgen (American, b. Germany, 1910-1996). *[Oskar Barnack at his desk, Wetzlar, Germany]*, 1933. Gelatin silver print. Courtesy Leica Camera AG.

THE IMMORTAL LEICA

JUST AS FILMS WERE GETTING BETTER, making bigger enlargements possible, the Leica camera changed the world. Then, as now, the Leica was made to the highest mechanical standards, all designed to help a photographer take the highest quality photographs in the easiest, least obtrusive way.

Its inventor, Oskar Barnack, developed prototypes as early as 1913, and in 1925, Ernst Leitz introduced the 35mm Leica A, sold as the Leica I Model A in the U.S. In 1935, each of its new interchangeable lenses—both a 35mm wide-angle and a 135mm telephoto—turned the Leica into a different instrument. "Little negatives, big pictures," was Barnack's motto.

O-Series Leica

1923

Ernst Leitz GmbH, Wetzlar, Germany.

1974:0084:0111.

Starting about 1905, when he worked at the firm of Carl Zeiss in Jena, Germany, Oskar Barnack (1879–1936), an asthmatic who hiked for his health, tried to create a small pocketable camera to take on his outings. At the time, cameras using the most common format of 13 x 18 cm (5 x 7 inches) were quite large and not well suited for hiking. Around 1913, Barnack, by then an employee in charge of the experimental department of the microscope maker Ernst Leitz Optical Works in Wetzlar, designed and hand-built several prototypes of a small precision camera that produced 24 x 36-mm images on leftover ends of 35mm motion picture film.

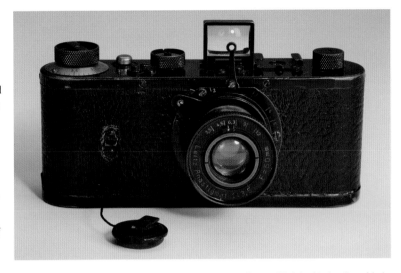

Three of these prototypes survive. The most complete one has been dubbed the "Ur-Leica," meaning the very first or "Original Leica," and is in the museum of today's firm of Leica Camera AG in Solms, Germany.

Barnack used one of his cameras in 1914 to take reportage-type pictures of a local flood and of the mobilization for World War I. That same year, his boss, Ernst Leitz II, used one on a trip to the United States. However, no further development of the small camera took place until 1924, when Leitz decided to make a pilot run of twenty-five cameras, serial numbered 101 through 125. Still referred to as the Barnack camera, these prototypes were loaned to Leitz managers, distributors, and professional photographers for field testing. Interestingly, the evaluations were not enthusiastic, as the testers thought the format too small and the controls too fiddly, which they were. For instance, the shutter speeds were listed as the various distances between the curtains, instead of the fraction of a second it would allow light to pass. In spite of its reviews, Leitz authorized the camera's production, basing his decision largely on a desire to keep his workers employed during the post-World War I economic depression. An improved version of the "0-Series Leica," the Leica I, or Model A, with a non-interchangeable lens was introduced to the market at the 1925 Spring Fair in Leipzig, Germany. The name "Leica," which derives from Leitz Camera, appeared only on the lens cap.

Shown here is a 0-Series Leica, serial number 109. It is one of three known examples with the original Newton viewfinder.

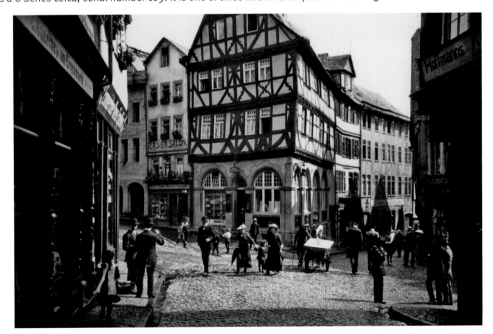

Oskar Barnack (1879–1936). *[Eisenmarkt: one of the first images made with the Ur-Leica]*, 1914. Gelatin silver print. Courtesy Leica Camera AG.

Leica I Model A
1926
Ernst Leitz GmbH, Wetzlar, Germany.
1974:0037:2925.

Introduced in 1925 at the Leipzig Spring Fair in Germany, the Leica I Model A was the first production model of the Leica camera manufactured by the firm of Ernst Leitz GmbH in Wetzlar, Germany. It claimed to be "the smallest camera with a focal plane shutter." A horizontally running focal-plane shutter provided speeds from 1/25 to 1/500 of a second. It came with a non-interchangeable, collapsible 50mm f/3.5 lens sold in three variations (Anastigmat, Elmax, and Elmar), the Elmar being the most common. The black enamel body had a

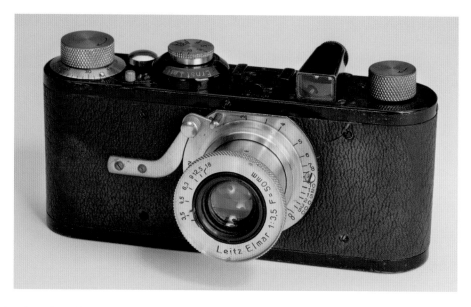

placement of feature controls that was imitated so often it became a standard. Early examples like this one had a large mushroom-shaped shutter release button. The camera sold for $114, and the optional "FODIS" rangefinder accessory cost $11. The serial number on the camera shown here is 5283.

Leica I Model B
(rim-set compur)
1930
Ernst Leitz GmbH, Wetzlar, Germany.
1974:0028:3346.

Known as the Compur Leica, the Leica I Model B featured a lens mounted in a Compur leaf shutter, which provided the slow shutter speeds that were lacking on the Leica I Model A. Early Model B Leicas had a dial-set Compur shutter; later ones had a rim-set Compur shutter. The model shown here is a Rim-Set Compur Leica, on which speeds from one second to 1/300 second (plus bulb and time) were set by rotating a ring around the face of the shutter. The independent shutter-cocking lever made double exposures

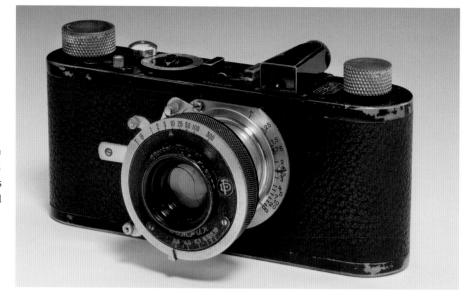

possible. The exposure counter was relocated from under the film advance knob to the space previously used for the shutter speed dial. Produced in small batches, Dial-Set Compur Leicas were built from 1926 to 1928, and Rim-Set Compur Leicas from 1928 to 1931.

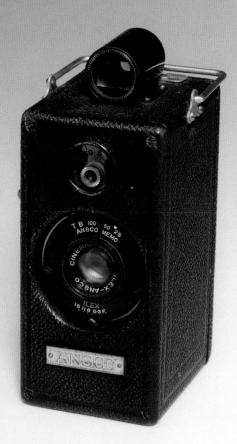

Memo
ca. 1927
Ansco, Binghamton, New York. Gift of Eastman Kodak Company.
1974:0037:0053.

The Ansco Memo is referred to as the 1927-type due to the number of different Ansco Memo cameras produced. Introduced in 1927, it was a half-frame 35mm camera constructed of wood and having leather covering. There was a Boy Scout model in which the painted wood was olive drab as well as an early version with varnished wood finish and brass trim. The 35mm film was originally housed in a wooden cassette, providing fifty 18 x 23-mm images. The camera featured a unique sliding button on the rear to advance the film. The retail price in 1927 was $20, including a soft suede carrying case.

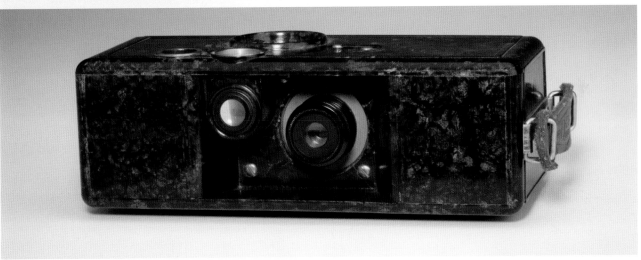

Q. R. S. Kamra
ca. 1928
Q. R. S. Co., Chicago, Illinois. Gift of Graflex, Inc. 1974:0037:2075.

The Q. R. S. Kamra was introduced by the Q. R. S. Co., Chicago, in 1928. Perhaps better known for its player piano rolls, the firm manufactured this 35mm camera in a brown marbleized Bakelite body and marketed it as taking "instantaneous pictures instantly." It claimed to shoot forty pictures in twenty seconds from a daylight loading metal cartridge. This was accomplished by cranking the film into position while maintaining your sight on the subject, then capturing the image with a slight reverse motion on the crank. The company later became QRS-DeVry Corporation and then DeVry, which became famous as a mail order electronics institute. The retail price of the camera, or Kamra, was $22.50 in 1928.

Leica II Model D

ca. 1932

Ernst Leitz GmbH, Wetzlar, Germany.
1974:0028:3087.

Remote Shutter Release "OOFRC"

ca. 1935

Ernst Leitz GmbH, Wetzlar, Germany.
1974:0028:3247.

The Leica II or Model D, manufactured from 1932 to 1948, was the first Leica model with a built-in coupled rangefinder. The camera pictured here was made in the first year of production and has a finder with a built-in yellow filter to improve contrast. Attached is an unusual mechanism called the Remote Film Advance and Shutter Release, code-named "OOFRC" and produced from 1935 to 1939, which allowed remote operation of the camera—especially useful in studying wildlife. By pulling one string, the film was advanced and the shutter cocked. A second string tripped the shutter to make an exposure. The pull-up film rewinding knob extends above the rangefinder housing for easier rewinding. The Leica II sold for $56 (without lens or case) and the release for $24.

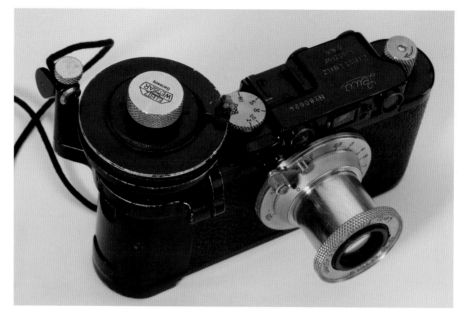

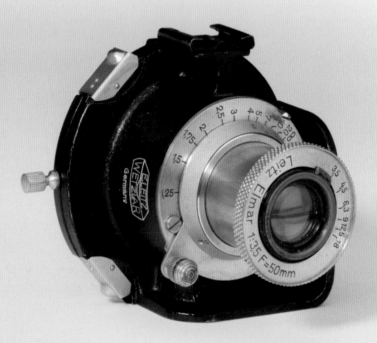

Leica Single Exposure

ca. 1936

Ernst Leitz GmbH, Wetzlar, Germany. 1974:0028:3364.

Designed for testing film, or making exposures when less than a full roll of film was required, the Leica Single Exposure is a tiny view camera. A metal housing holds a lens in front and a ground glass viewing back, while an accessory shoe allows the use of a viewfinder to match the lens in use. Exposure is controlled by a special Ibsor shutter that is mounted to the front of the lens. To make an exposure, the viewing back is exchanged for a metal film holder. A dark slide protects the film from additional exposure. Introduced in 1934, there were two versions with different shutters, "OLIGO" at $31.50 and "OLORA" at $12.75.

Argus A2
ca. 1939
International Research Corporation, Ann Arbor, Michigan.
Gift of Argus, Inc. 1974:0037:0057.

The Argus A of 1936 was certainly not the first American-made 35mm camera—it followed the Simplex of 1913 in the "double frame" horizontal 24 x 36-mm format—but it could claim to be the least expensive precision American-made 35mm. At a mere $12.50, its retail price was a fraction of the cost of the Simplex and far less than the German Leica.

Manufactured by International Research Corporation of Ann Arbor, Michigan, the Argus A had a resin body, similar to Bakelite, and featured a good quality lens in a fast shutter. For film, it used daylight type 1 loading cartridges (now known as the Kodak 35mm film magazine, introduced in 1934 with the Kodak Retina I camera), daylight loading spools with paper leader and trailer (the Zeiss Contax I type), or bulk 35mm film loaded in daylight type 1 cartridges.

By 1939 Argus had introduced the A2 (shown here), which was a model A with an integral exposure meter. Interestingly, the A2 assumed the price position of the A at $12.50, while the original model was reduced to $10, making it an even better bargain.

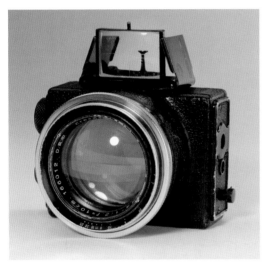

Ermanox (4.5 x 6 cm)
ca. 1924
Ernemann-Werke, Dresden, Germany. Gift of
Mike Kirk. 2001:0484:0001.

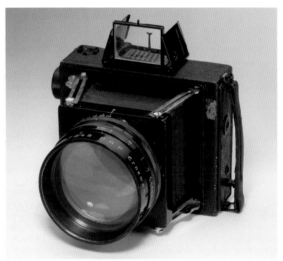

Ermanox (9 x 12 cm)
ca. 1924
Ernemann-Werke, Dresden, Germany. Gift of
Charles Spaeth. 1974:0037:1475.

Before the Ermanox, indoor pictures and other low-light situations needed very long exposure times or some form of flash device. In 1924, the Ernemann-Werke in Dresden, Germany, announced a different approach to available light photography with what they billed as "the most efficient camera in existence." The Ermanox's massive 10cm f/2 Ernostar lens dwarfed the cigarette-pack-sized body and could focus enough light on a 4.5 x 6-cm film plate to record scenes using normal room light with a shutter speed fast enough to freeze motion. The focal-plane shutter had a 1/1000 second top speed and was quiet enough for unobtrusive use during a theater performance. Focus was either through the lens with a ground glass screen or the distance scale on the lens ring; a folding optical finder on the top was used for image composition. The camera was priced at $190.65, which included a film pack adapter, three plate holders, and a carrying case. Larger Ermanox models were added, such as this 9 x 12 cm with a collapsing bellows and a 16.5cm f/1.8 lens that otherwise was a scaled-up version of the original camera. It sold for $550 in 1926.

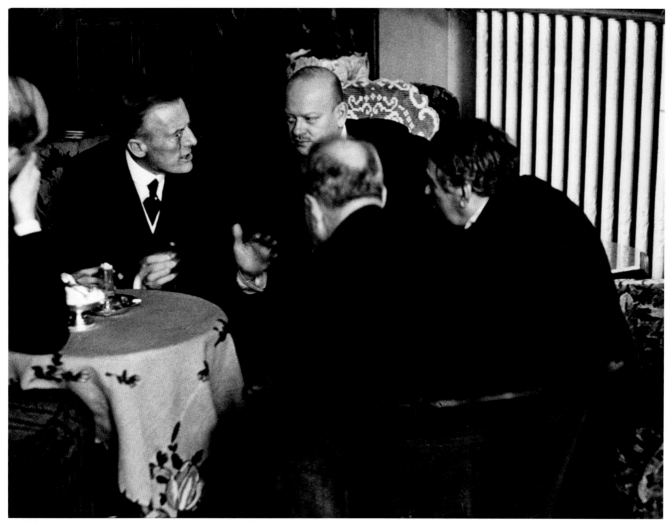

Erich Salomon (German, 1886-1944). *[A summit meeting in 1928: The architects of Franco-German rapprochement, Aristide Briand and Dr. Gustav Stresemann, meet in the Hotel Splendide in Lugano with British Foreign Minister Sir Austen Chamberlain. From left to right: Zaleski, Poland; Chamberlain; Stresemann; Briand; Scialoia, Italy]*, 1928. Gelatin silver print. George Eastman House collections.

Part of the Leica's appeal came from the very idea of the "candid camera." Erich Salomon (1886–1944) first used a handheld model, the Ermanox, to photograph German high society as Hitler was gaining power. (Salomon would die in a concentration camp.)

Before long Alfred Eisenstadt and Henri Cartier-Bresson were using Leicas to make pictures of scenes such as V-J Day kisses in Times Square and street life in Paris. The cumbersome Speed Graphic with its powerful flash was still an awesome weapon for news photographers covering Hollywood openings and shooting crime scenes. But the Leica ratified the 35mm format.

In the 1960s, German, American, and especially Japanese camera companies gradually substituted the single-lens reflex format for the rangefinder system.

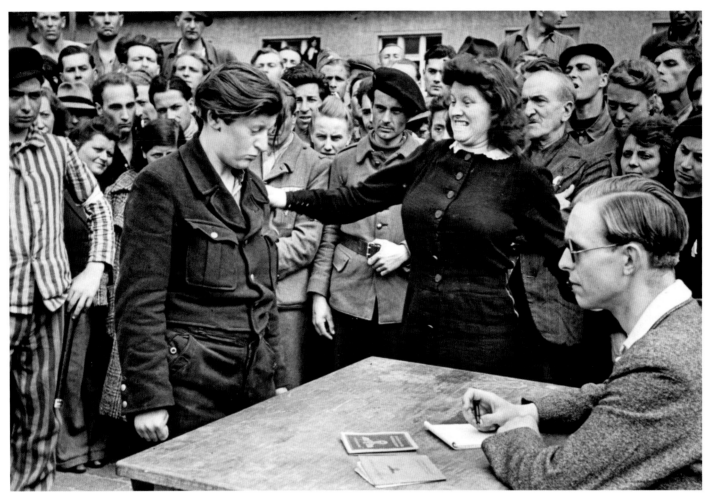

Henri Cartier-Bresson (French, 1908–2004). *DESSAU: EXPOSING A GESTAPO INFORMER*, 1945. Gelatin silver print. George Eastman House collections by exchange.

Production was streamlined and camera prices lowered. By marketing their cameras to affluent amateurs, companies such as Nikon, Canon, Olympus, Asahi Pentax, and Minolta grew the business. Meanwhile films, papers, lenses, and processes all improved—each significant innovation serving as a "force multiplier" to drive camera sales, spur film and print consumption, and propel a growth curve that implied permanent prosperity.

For those who truly needed big negatives (4 x 5 inches or larger), the existing large format cameras could be modified and improved by adding new lenses or adapters to accept new films. Many portrait cameras, as well as studio models, would lead long and useful lives well into the 1930s and 1940s.

Although professional photography product sales languished in the first part of the twentieth century,

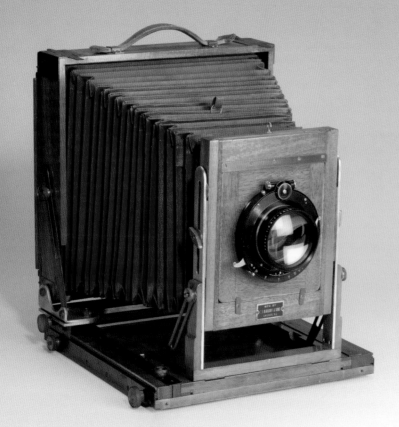

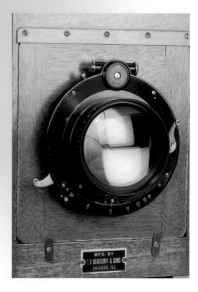

Deardorff Commercial Camera
1923
L. F. Deardorff & Sons, Chicago, Illinois. Gift of Eastman Kodak Company. 1997:2438:0001.

In 1923, L. F. Deardorff & Sons produced its first series of ten 8x10-inch wooden view cameras, which were handmade—including the hardware—using recycled tools and materials. The mahogany for the woodwork came from tavern counters scrapped during Prohibition. Sold as the Deardorff Commercial Camera, it remained on the market with few alterations (hardware changed from brass to nickel plate in 1938; front swings were added in 1949) and became the professional workhorse view camera. As described in their 1935 catalog, it was "a definitely new camera specially designed and constructed to meet the demands of modern advertising." Some consider the Deardorff as the Harley-Davidson of view cameras, both being iconic products from small family-owned companies. The camera illustrated here is the second camera made from the first series; it has never been used.

they were not completely excluded from the technological advances. Like the manufacturing pioneers in photography, other manufacturers had both a personal and business interest in photography. Many of them sought rewards not solely based on profits. They were people who wanted to make money doing something that they enjoyed. Trademarks like Deardorff, Leica, Zeiss, and Rollei would emerge on products that acquired a faithful, enthusiastic following.

One of the most respected names in professional photography was Deardorff. Laben F. Deardorff (1862–1952) of Chicago, Illinois, entered the photog-

raphy business about 1885 and during the next fifteen years worked in many areas of the field, including for photographic supply houses and manufacturers. Early on, he began to repair cameras on the side. By 1900, he generally worked for himself, still covering many areas of the business, such as selling supplies, repairing cameras, and serving as a commercial photographer. For a stint in the early 1910s, he ran the repair shop of an Eastman Kodak Company store.

A number of Deardorff's improvements to cameras were incorporated into production models of the Rochester Optical Company. The ROC Premo View

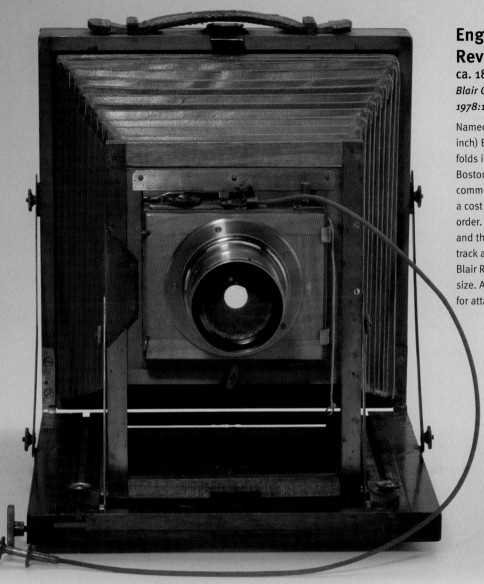

English Compact Reversible Back Camera
ca. 1888
Blair Camera Company, Boston, Massachusetts. 1978:1371:0017.

Named for a popular style, the full-plate (6½ x 8½-inch) Blair English Compact Reversible Back Camera folds into a thickness of only 3½ inches. Made in Boston, Massachusetts from 1888 to 1898, it was commercially available in a single swing version at a cost of $50; a double swing could be made to order. The bed hinges away from the rear standard, and the front standard folds up. The geared focusing track accommodates focus up to twenty inches. The Blair Rigid Extension allowed conversion to a larger size. A tripod top is built into the bed, with sockets for attaching the legs.

(sold through 1910) looks quite similar to the cameras he would eventually manufacture and sell under his own name. By the early 1920s, Deardorff worked with several sons repairing photographic and medical equipment. He had acquired the assets of the C. J. Olstad Camera Company, and local commercial photographers—Chicago was a city rich in both architecture and architectural photography—urged him to make a replacement for the now hard-to-find Premo View cameras.

In 1923, L. F. Deardorff & Sons produced its first series of ten 8 x 10-inch wooden view cameras,

handmade using recycled mahogany from tavern counters scrapped during Prohibition. Sold as the Deardorff Commercial Camera, it remained on the market for decades.

Another more specialized professional camera is the whimsically but aptly named Hill Cloud Camera (after its British designer Robin Hill). Made in 1923 by R. & J. Beck, Ltd., of London, the Cloud camera incorporated the first ever fisheye (or "sky") lens, covering a field of 180 degrees. When used in pairs for stereoscopic viewing, it was possible to estimate the relative altitudes of clouds.

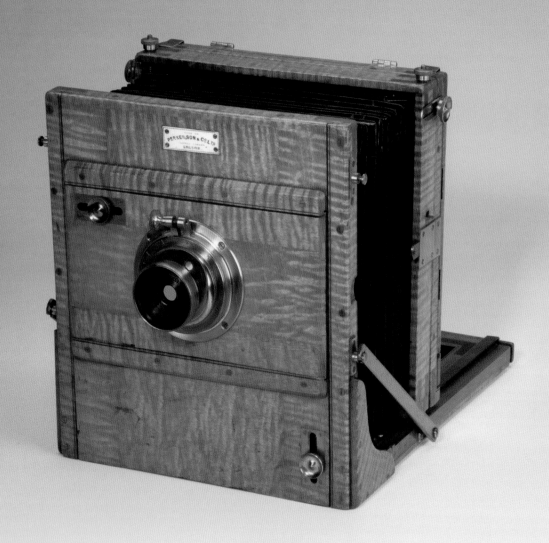

Optimus Long Focus Camera
ca. 1892
Perken, Son & Rayment, London, England.
1974:0028:3086.

A traditional English pattern field camera, the Optimus Long Focus Camera was manufactured by Perken, Son & Rayment, London, from 1891 to 1899. Dating back to the 1860s, this style of camera, which always had a stationary front standard and a rear bellows extensible on a long tailboard, remained in production for more than a hundred years. Finished in brass-bound tiger mahogany, this 10 x 8-inch camera has several well-planned features, including front rise and shift and rear swing movements, rack-and-pinion rear tilt, very strong outboard front struts for rigidity, and a hidden helical rack-and-pinion drive that controlled the tailboard. It also has a reversible back with a proprietary design book-style plate holder and a double-hinged dark slide landscape lens with a four-aperture wheel stop. The retail price was $227 in 1891.

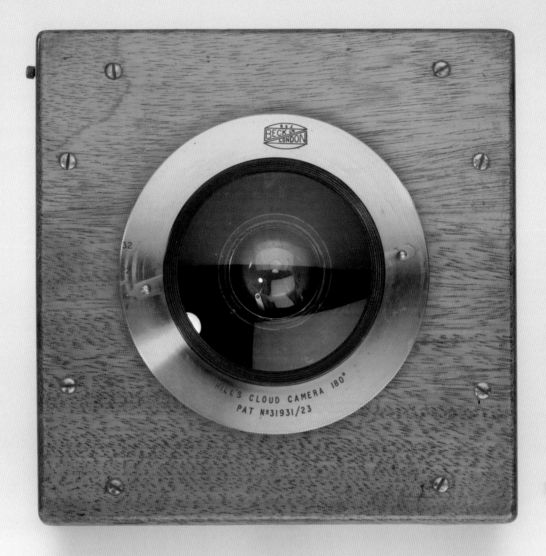

Hill Cloud Camera
ca. 1923
R. & J. Beck, Ltd., London, England. Gift of Ralph Steiner. 1974:0037:2840.

The Hill Cloud Camera of 1923 was manufactured by R. & J. Beck, Ltd., of London. Designed by Robin Hill, it was intended to photograph the entire sky on a 3¼ x 4¼-inch plate. The polished mahogany body measures 5¾ inches square by 1⅝ inches deep and is used horizontally, with the lens pointed up and fixed for correct focus. Hill's design covered a field of 180 degrees, making it the earliest fisheye or "sky," lens. The camera has three apertures and three orange/red filters to enhance contrast and differentiate between cloud types. When used in pairs for stereoscopic viewing, it was possible to estimate the relative altitudes of clouds. The camera could also be used to project a negative back to a normal perspective.

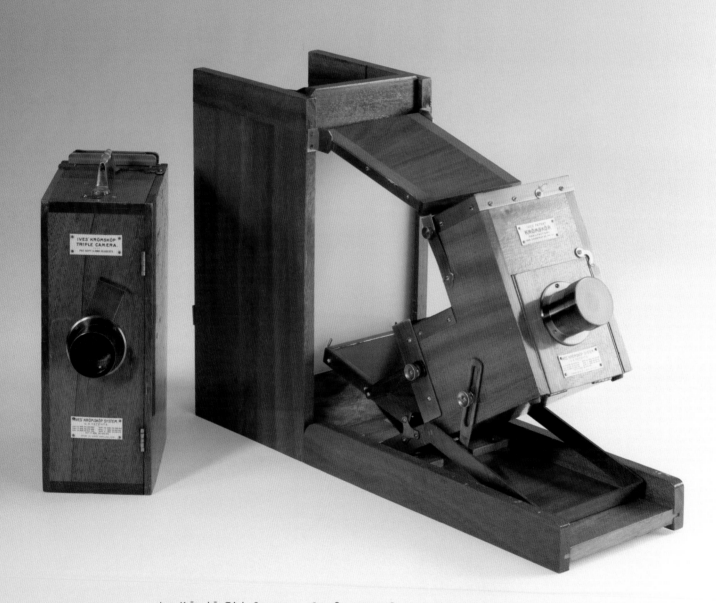

Ives Krōmskōp Triple Camera, ca. 1899. See page 228.

XIII

COLOR
AND
FLASH

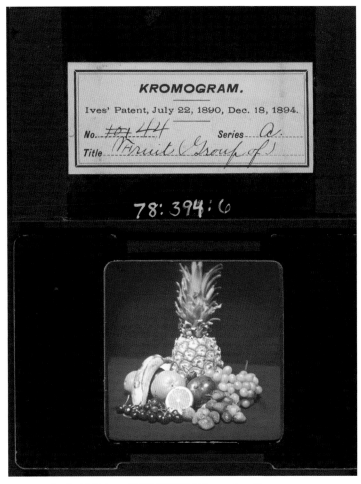

Frederick E. Ives, *FRUIT (GROUP OF)*, ca. 1894. See page 229.

James Clerk Maxwell and Thomas Sutton (Scottish, 1831–1879 and English, 1819–1875). *[Tartan ribbon]*, 1861. Later chromogenic reproduction. Gift of Dr. Walter Clark. George Eastman House collections.

COLOR PHOTOGRAPHY was possible early on, but was not very practical—or commercially lucrative—for nearly a century. Beaumont Newhall's *History of Photography* tells how a Baptist minister named Levi L. Hill produced a colored daguerreotype in 1850, and how the photographic world marveled. But Hill could never explain just how he did it, noting that "invisible goblins" somehow kept him from repeating his success.

Over the next eighty-five years, many ingenious methods—all involving the separation and recombining of two or three separate color hues—tried to paint, as opposed to merely write, with light. In 1861, James Clerk Maxwell showed he could reproduce the colors in a ribbon by projecting red, blue, and green light in combination on a screen—a process known as additive color. Both additive and subtractive methods

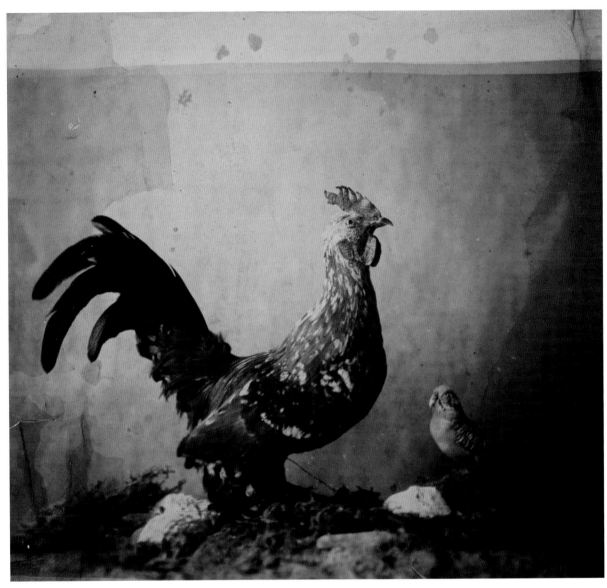

Louis Ducos du Hauron (French, 1837–1920). *[Still life with rooster]*, ca. 1869–1879. Three-color carbon transparency. George Eastman House collections.

(the latter employing yellow, cyan, and magenta) are combined variously to reproduce the entire spectrum in color slides, motion pictures, print, TV, and desktop displays.

The technology built on these two systems is the basis for all color photography. But three-color gum bichromate prints, autochrome images, carbro prints, and an early two-color Kodachrome system—all technically ingenious—proved cumbersome, costly, and unfaithful to the colors of the world. A later system, the Kodak dye-transfer method, resulted in magnificent color prints, but only dedicated printers would ever master its intricate complexity. Various methods of ink-jet printing have made it possible for scanned digital files to be reproduced with extraordinary fidelity at very large scale.

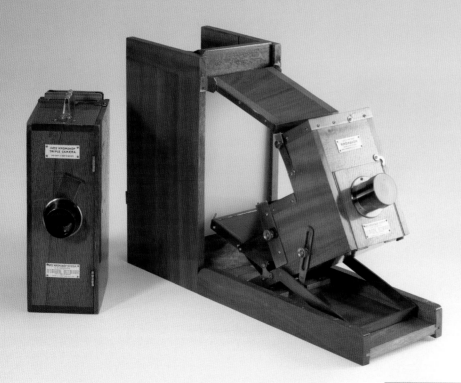

Ives Krōmskōp Triple Camera
ca. 1899
F. E. Ives, Philadelphia, Pennsylvania.
Gift of Raymond O. Blanchard.
1977:0037:1043.

Ives Krōmskōp Monocular Viewer
ca. 1899
F. E. Ives, Philadelphia, Pennsylvania.
Gift of 3M Foundation, ex-collection Louis
Walton Sipley. 1977:0415:0217.

Ives Krōmskōp Night Illuminator
ca. 1899
F. E. Ives, Philadelphia, Pennsylvania.
Gift of 3M Foundation, ex-collection Louis
Walton Sipley. 1977:0415: 0375.

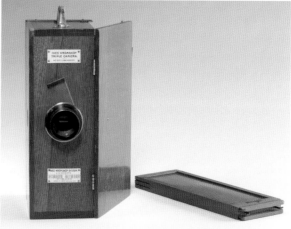

The Ives Krōmskōp system consisted of a paired apparatus for the capture and viewing of still images in full color. Offered in both monocular and stereoscopic versions, it was an additive color system developed and patented in the late 1890s by Frederic Eugene Ives (1856–1937) of Philadelphia, a prolific inventor and perfecter of the inventions of others with more than seventy patents to his name, including those for the practical printing of pictures in newspapers and magazines.

The Ives Krōmskōp Triple Camera simultaneously made three color-separation records of the scene behind red, green, and blue filters. A set of positive transparencies from these records, when viewed in perfect mechanical alignment produced the colors of the original scene. The camera used a single 2½ x 8-inch glass plate, exposing the three 2¼ x 2½-inch images side by side. Positives made from these negatives were strung together with cloth tapes so that an image set, or Krōmogram, could be laid over the step-like structure of the Krōmskōp viewer. Looking into the viewing lens revealed a magnified full-color image. For times when daylight was not available for the viewer, a night illuminator was provided.

Externally, the camera was a simple mahogany box with brass-mounted lens, sliding-plate shutter, and brass carrying handle. Internally, prisms deflected light to the left and right for the red and green exposures. Undeflected light passed straight back to make the blue exposure. Adjustable masks balanced the light for the individual records according to the sensitivity of the plate being used. The ivorene label above the lens shows September 5, 1899, as the patent date. The lower label lists seven patents on the system from 1890 to 1899.

The Krōmskōp Monocular Viewer was a brass-bound mahogany box with a brass-mounted viewing lens and an adjustable reflector. Each step was capped by a colored filter, which was, in descending order, red, blue, and green. The Krōmogram's cloth strips, acting as hinges, allowed the three images to be arranged on the steps in the proper sequence.

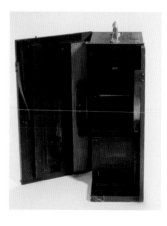

Frederick E. Ives (American, 1856–1937). *FRUIT (GROUP OF)*, ca. 1894. Transparency, gelatin on glass (Krōmograms). George Eastman House collections.

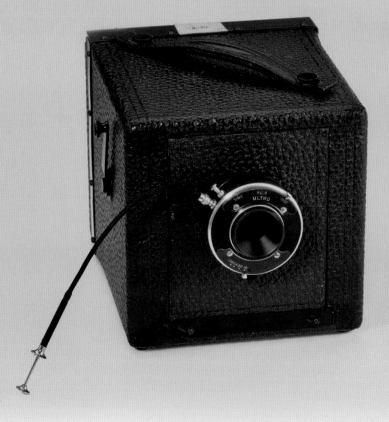

Hicro Color Camera

ca. 1915

Hess-Ives Corporation, Philadelphia, Pennsylvania.
Gift of Eastman Kodak Company. 1974:0037:1011.

The Hicro camera was introduced around 1915 by the Hess-Ives Corporation of Philadelphia, through the combined efforts of Henry Hess as financial backer and Frederic Eugene Ives, the noted inventor of imaging processes. It was an attempt to simplify the making of a set of color separation negatives, which were the required starting point for many early color processes, including those for magazine and newspaper reproduction. Three negatives were made, one each recording the red, green, or blue content of the scene.

The Hicro camera was a 3¼ x 4¼-inch box camera requiring a special plate holder containing three glass plates. A lever dropped the plate for the blue record to the floor of the camera, while the other two plates remained in the holder to record the green and red content of the scene. A beam splitter was swung into position to direct some of the exposing light to the blue plate. Tilting the camera put all plates back in the holder. With the aid of Ives's darkroom expertise, skilled photographers were able to make charming portraits with soft gradations of color, but the complexities of the camera and the printing process stood in the way of mass acceptance.

The camera was available with fixed or adjustable focus lenses priced at $25 and $38 respectively; it was manufactured under contract by the Hawk-Eye Works of Eastman Kodak Company.

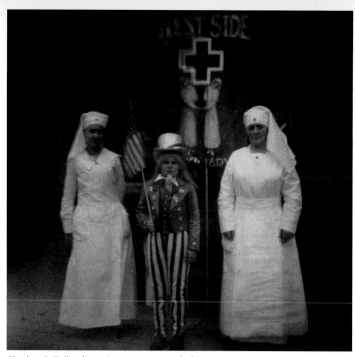

Charles C. Zoller (American, 1854–1934). *[Two nurses and child dressed as Uncle Sam in WWI support parade, Pasadena, California]*, ca. 1917. Color plate, screen (Autochrome) process. Gift of Mr. and Mrs. Lucius A. Dickerson. George Eastman House collections.

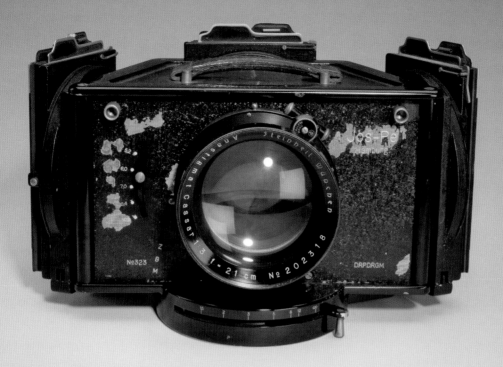

Tri-Color Camera
(owned by Nickolas Muray)

ca. 1925

Jos-Pe Farbenphoto GmbH, Hamburg, Germany.
Gift of 3M Foundation, ex-collection Louis Walton Sipley.
1978:1472:0003.

The Tri-Color Camera was introduced in 1925 by Jos-Pe
Farbenphoto GmbH, Hamburg, Germany. The company name was
derived from one of the owners, Josef Peter Welker. This nineteen-
pound, all-metal camera produced three black-and-white
negatives simultaneously, each recording one of the three
additive primary colors. Two internal beam splitters directed the
image to three separate 9 x 12-cm plate holders, each one with
either a red, green, or blue filter. Matrices made from these
negatives could be printed in succession with the complementary
subtractive primary dyes, cyan, magenta, and yellow respectively.
This produced a single-layer full-color print. The negatives could
also be used to make photo-engraved plates for magazine and
newspaper printing.

 This camera was owned and used by the famed Hungarian-
born American photographer Nickolas Muray (1892–1965),
a respected celebrity portrait photographer and pioneer in color
advertising photography. His Jos-Pe had a huge, 210mm
Steinheil Cassar f/3 lens in a Compound shutter.

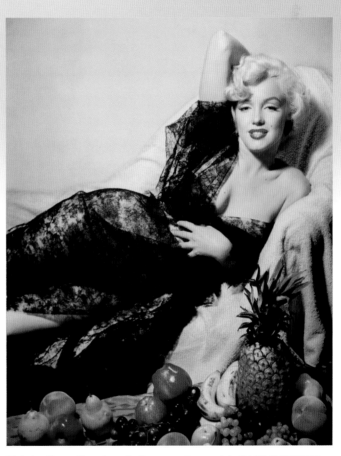

Nickolas Muray (American, b. Hungary, 1892–1965). *MARILYN MONROE...
ACTRESS*, 1952. Color print, assembly (Carbro) process. Gift of Michael
Brooke Muray, Nickolas Christopher Muray, and Gustav Schwab. George
Eastman House collections.

Louis Michael Condax (American, 1896–1972). *[Charles Edward Kenneth Mees]*, 1951. Color print, dye imbibition (dye transfer) process. Gift of the photographer. George Eastman House collections.

TWO MUSICIANS WHISTLING IN THE DARK

LEOPOLD MANNES (1899–1964) and Leopold Godowsky (1900–1983) were the sons of prominent New York musicians whose lives were changed by a bad movie. In 1918, they went to see *Our Navy in Prizma Color*, a film made by the two-color additive process. As Douglas Collins points out in *The Story of Kodak*, the color was atrocious. And this got them going.

In their high school physics lab, Mannes and Godowsky made a significant advance—solving an optical problem caused by multiple lenses, and obtaining a patent. They went off to Harvard and the University of California, where musical training combined with science courses to produce a pair of similarly multidisciplined minds. They returned to New York,

kept up with their musical careers and their photographic experiments, and changed their methods. As Godowsky put it, they had decided to switch from combining individually captured images to capturing the images in register on a single substrate—in other words, from the optical approach to the chemical approach.

Progess was never as fast as they had hoped, but in 1929, Dr. C. E. Kenneth Mees (1882–1960), the Englishman George Eastman recruited to head the Kodak research labs, convinced Mannes and Godowsky to move to Rochester, where they were paid in salaries and royalties for their patents. Timing development processes to the second by playing the final movement of Brahms's C Minor symphony in the dark, the two men finally succeeded. Kodachrome film was announced on April 15, 1935. First released as 16mm movie film, it became available for 35mm still cameras the next year.

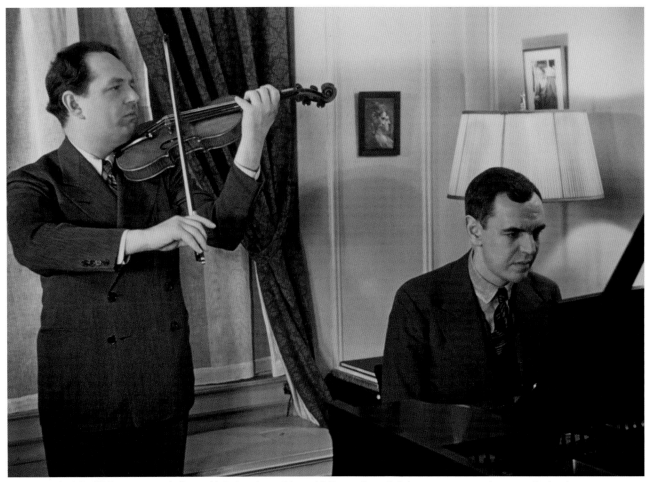

Dr. Walter Clark (English, 1899–1991). *[Leopold Godowsky and Leopold Mannes]*, 1938. Color transparency, chromogenic development process. George Eastman House collections.

Kodachrome contained three layers of black-and-white film, sensitized to the red, green, and blue portions of the spectrum. In processing, yellow, cyan, and magenta color dyes replaced the developed silver. Its speed rating at introduction was only ISO 8, slow by today's standards for handheld cameras; however, faster speeds followed.

35mm Eastman Kodak Company Kodachrome box, ca. 1936. George Eastman House Technology Collection.

The processing of Kodachrome film was excessively complex—so complex that, at least initially, Kodak sold the processing with the film; Eastman Kodak Company labs were the only ones that could process the film. The finished Kodachrome slides hold gloriously brilliant colors that still compel countless thousands of loyalists. The value of the trademark was suggested by Paul Simon's catchy 1973 release *Kodachrome*, ending with eleven repetitions of "Mama, don't take my Kodachrome away."

Agfa, a German company, would announce its color transparency film a year after Kodachrome, in 1936. When World War II ended, however, the company lost patent rights for dye-couplers to public domain as war reparation. This allowed Kodak and other companies to introduce films such as Kodacolor, Ektachrome, and

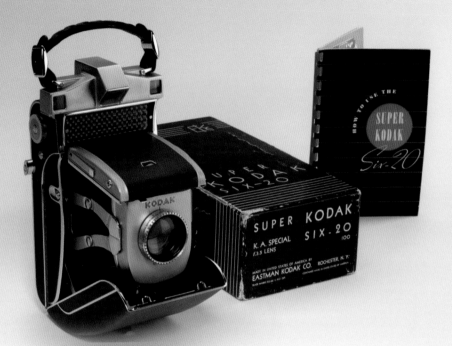

Super Kodak Six-20
1938
Eastman Kodak Company, Rochester, New York. Gift of Eastman Kodak Company. 2001:0636:0001.

Introduced in 1938 as the world's first automatic exposure camera, the Super Kodak Six-20 used a large selenium photocell to control the aperture before the exposure was made. With a clamshell design styled by Walter Dorwin Teague, it featured a wide base rangefinder and a crank wind film advance and produced 2¼ x 3¼-inch images on No. 620 roll film. Though advanced, the camera was unreliable, which, coupled with a high retail price of $225, made it the least widely sold of the Kodak cameras aimed at the general public.

Fujichrome. Agfa would continue to produce cameras, films, and papers (under the Ansco trademark in the U.S.) but never seriously hurt Kodak's business.

In 1942, Kodak introduced a color negative film that was designed first for the military. Kodacolor film, from which color prints could be produced, came with a speed rating of 25. Kodak included processing with the purchase of the film, until a 1954 court ruling barred Kodak from bundling the two together in the United States, on the theory that this kept other processing laboratories out of the market.

By the 1960s and 1970s, Kodacolor was the film of choice for millions of snapshot photographers, since it produced paper prints rather than slides. It kept getting sharper, faster, and finer grained. It remains the most popular film ever made, by far the most important—and profitable—product in Kodak's vast catalog of sensitized materials.

Kodak introduced Ektachrome film in 1946. Like Kodachrome, it provided positive transparencies. Unlike Kodachrome, it did not have to be mailed away to a lab for processing. The film was fairly easy to process and many professionals did it themselves.

Kodachrome and other positive transparency films required precise exposure. The photographer could get around this problem by taking a series of different exposures, to be sure of getting at least one good one. But "bracketing" wasted film and money. The goal became to make a camera that could precisely measure the amount of light required and then deliver an exact exposure.

Claiming to be the world's first automatic exposure camera, the Super Kodak Six-20, introduced in 1938, seemed to be the answer to the problem of inexact measurements of light. At $225, this folding camera used a large selenium photocell on its top to measure the light from the scene to be photographed. The photographer would set the shutter speed, and the camera automatically set the aperture to give a good exposure.

Electric photocells measured the ambient light before taking the picture and sent a reading that could be used to set shutter speed and aperture selection. Shutter and aperture designs had progressed to the point where their performance was reliable under a wide variety of lighting conditions.

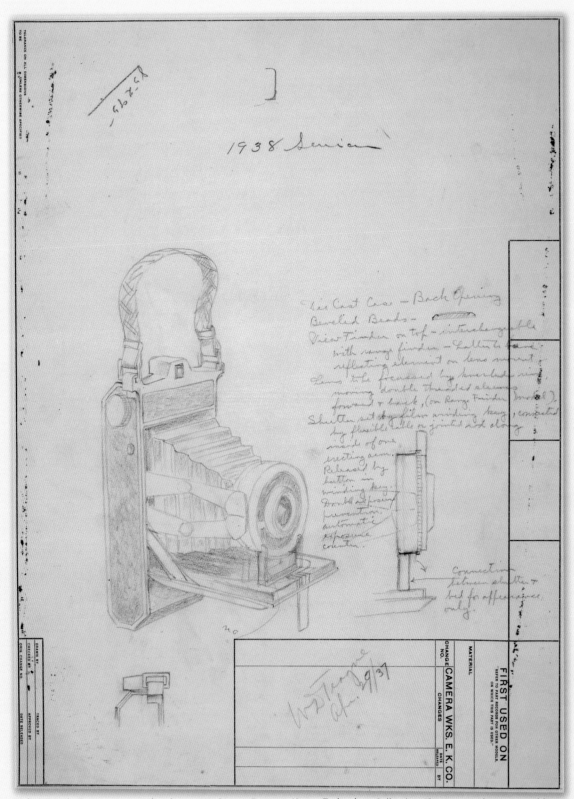

Walter Dorwin Teague camera drawing, 1938. George Eastman House Technology Collection. The camera shown resembles what became Eastman Kodak Company's Super Kodak Six-20.

Panoramic Cameras

As OPTICAL ENGINEERING AND DESIGN became more sophisticated, so, too, cameras began to come along that saw things differently. Our eyes see a world in motion—the wavelengths of light that pass through the eye and into the brain are transmitted to the mind as a continuous field that changes as scenes shift and our eyes move at will. The eye has an angle of vision of about 180 degrees, most of it binocular. As it sweeps across the field of vision, it selects what to focus on and what to ignore.

A 50mm lens on a 35mm camera is considered "normal" because its fifty-three-degree angle of view corresponds to that central area of the field our eyes pay most attention to. Wide-angle and telephoto lenses expand or restrict that angle, sometimes (as with a fisheye lens) to the point of fascinating distortion.

This accounts for the appeal of the panoramic photograph. A strong panoramic photograph displays a scene so well that it enhances our sense of being there. This makes them especially powerful tools to comprehend widespread grandeur and disaster: sunsets, long views of cities, battlefields. Yet when the subject appears too contorted or compressed, a still photograph's psychological validity comes into question. However dramatic the scene, something tells us what we are seeing is a portion—a twisting—of the literal truth.

There are two kinds of panoramic cameras. One employs a rotating slit that may take in 160 degrees or more. Some cover an entire 360-degree rotation to produce a circular record of the total surround. The second, often called a banquet camera, uses a 2.4:1 format to create pictures that sweep across the scene by recording a signal in the camera that instructs the photofinishing system to produce a very wide print. Inexpensive 35mm, APS, and one-time-use cameras do this, and they aid the eye to compose properly by imposing a frame across the viewfinder.

Cyclographe á foyer variable (focusing model)

1890
J. Damoizeau, Paris, France. Gift of Eastman Kodak Company, ex-collection Gabriel Cromer. 1974:0037:2331.

As roll film technology progressed, so did panoramic photography. Introduced in 1890 by J. Damoizeau of Paris, the Cyclographe á foyer variable had a key-wound clock drive motor to turn a brass wheel on the camera's underside that rotated the mahogany and brass camera on its pivot dowel. The drive wheel was geared to the transport to move the nine-inch wide film over a narrow slit at the same speed, but in the opposite direction. This made a 360-degree sweep possible. A bellows adjusted by a rack and pinion allowed focusing of the Darlot landscape lens.

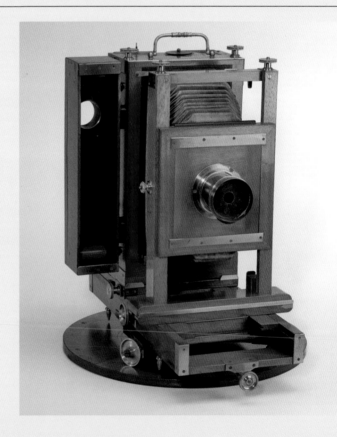

Wonder Panoramic Camera
1890
Rudolf Stirn, Berlin, Germany. Gift of the Damon Runyan Fund. 1974:0084:0048.

The Wonder Panoramic Camera of 1890, made by Rudolf Stirn in Berlin, Germany, depended on the photographer for its motive power. A string, hanging through a hole in the tripod screw, wound around a pulley inside the wooden box camera. When set up to take a panoramic photo, the user swiveled the metal cap from the lens to start the exposure. Once the string was pulled, the inside pulley rotated, and through a clockwork mechanism the take-up spool turned and pulled the 3¼-inch wide Eastman film past a one-millimeter-wide slit where it was exposed by the 75mm f/12 lens. The rotation could be set for a full 360-degree sweep, giving an eighteen-inch long negative, or three shorter lengths at ninety-degree intervals. For $30 you got the Wonder, a roll of film, folding tripod, and carrying case.

Cyclographe à foyer fixe (fixed focus)
ca. 1894
J. Damoizeau, Paris, France. Gift of Eastman Kodak Company, ex-collection Gabriel Cromer. 1974:0084:0065.

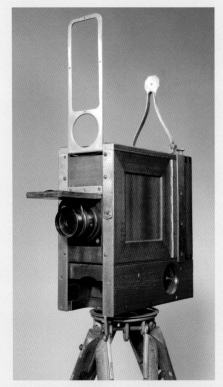

Cameras designed for panoramic pictures used various methods to capture the extra-wide images. Some used a swinging lens that swept light across a stationary length of film. Others used a non-moving, very wide-angle lens on fixed film. And still others, like the Cyclographe manufactured by J. Damoizeau in Paris in 1894, had clock-spring motors that rotated the entire camera at the same time as the nine-cm wide film was moved in the opposite direction across a narrow slit. Built into the bottom of the polished mahogany camera was a nickel-plated turntable, which allowed it to rotate and record the scene. Travel limits could be set to whatever angle the photographer chose. Shutterless, the Cyclographe controlled exposure by the rotational speed and by the three-position aperture disc on the Darlot 130mm f/11 meniscus lens. A folding eye-level finder and a bubble level on the top aided the photographer in composing the photograph. Despite its narrow body, the Cyclographe had doors on both sides, giving access to storage chambers for ten rolls of film.

Stéréo Cyclographe
ca. 1894
J. Damoizeau, Paris, France. Gift of Eastman Kodak Company, ex-collection Gabriel Cromer. 1974:0037:1041.

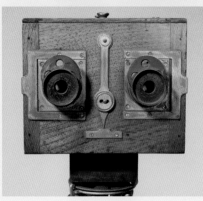

J. Damoizeau's Stéréo Cyclographe combined two fixed-focus panoramic cameras in one mahogany box. The lenses were mounted eight centimeters apart with a plumb bob indicator between them to help the photographer set the camera level. A single spring-wound clock motor powered both transports for the nine-cm wide film as well as turning the shaft that rotated the camera on its tripod base. With its 360-degree capability, the Stéréo Cyclographe could make 9 x 80-cm pairs that required a special viewer. These images were generally used for mapping purposes. Like the Cyclographe á foyer fixe on which the Stéréo was based, a compartment on each side stored five rolls of spare film.

Al-Vista 4A
ca. 1900
Multiscope & Film Company, Burlington, Wisconsin. Gift of Eastman Kodak Company. 2002:0959:0002.

Beginning in 1897, Multiscope & Film Company of Burlington, Wisconsin, was known for its Al-Vista series of panoramic roll-film cameras. The Model 4A was a spring-motor powered, swing-lens design with almost 180 degrees of lens travel. A travel distance control could be set for any of five picture lengths, from four to twelve inches. Typical of the swing-lens panoramics, the Al-Vistas had no mechanical shutter. A metal cap shielded the film from light when the lens was parked for the next picture, and a strip of plush fabric did the same job once the lens completed its sweep. A friction brake on the lens pivot shaft controlled the exposure time. An external adjustment knob increased brake pressure to slow the travel speed. The Al-Vista Model 4A was one of more than a dozen different panoramics in the Multiscope catalog.

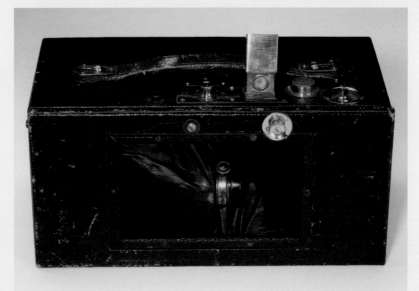

Périphote
ca. 1901
Lumière Fréres, Paris, France. Gift of Eastman Kodak Company, ex-collection Gabriel Cromer. 1974:0037:2845.

The Périphote panoramic camera was a variation on the swinging lens-stationary film design in that it took a 360-degree image on the 2¾-inch wide film. Built by Lumière Fréres of Paris in 1901, the Périphote was a drum within a drum. A spring-wound clock motor rotated the outer drum; the inner drum held the roll of film and its take-up spool. Attached to the apparatus was a 55mm Jarret lens and a prism that directed the light through a half-millimeter-wide slit aimed at the film. With the spring fully wound and the camera sitting on its base flange, the photographer rotated a small lever to start the process. The film then passed through a slit to the smaller drum's exterior, wrapping completely around it before going back inside for respooling. Once started, the operator had to walk backwards around the camera as it made its sweep to avoid being photographed.

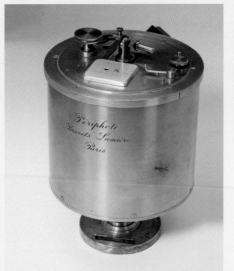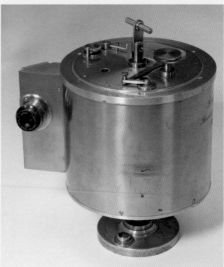

Stéréo-Panoramique Leroy
ca. 1903
Lucien Leroy, Paris, France. Gift of Carl W. Steinkamp.
1974:0084:0097.

Photographers wishing to take pictures for three-dimensional viewing bought cameras made specifically for stereo, while those making panoramic shots required another type of specialty camera. In 1903, Lucien Leroy of Paris designed a dual-purpose metal box with two lenses and a septum for making 6 x 6-cm stereo pairs on 6 x 13-cm dry plates, just like so many other stereo cameras of the day. What made the Stéréo-Panoramique notable was its rotating lens mount that allowed the right side lens to be repositioned to the center of the front panel to shoot panoramas. When that lens was moved to the panoramic position, the internal septum pivoted up out of the way. With the left lens capped, the Stéréo-Panoramique was ready to take an 80-degree view. The matched Krauss Protars were fixed focus with aperture diaphragms that were set individually. Three sector shutters operated in unison, regardless of mode. Twin bubble levels on the top helped with handheld shots. The Stéréo-Panoramique Leroy had the typical French machinery look of the period. Buyers needed 315 francs to own one of these versatile instruments.

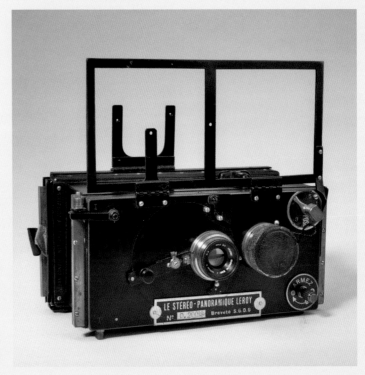

Baby Al-Vista No. 2
1909
Multiscope & Film Company, Burlington, Wisconsin. Gift of Eastman Kodak Company.
1997:2735:0001.

Panoramic photography usually involved toting a large, heavy camera on location. The 1909 Baby Al-Vista No. 2 was a lightweight, scaled-down version of Multiscope & Film Company's popular swinging-lens cameras. The Baby's Rapid Rectilinear lens swept a 160-degree arc across a 6¾-inch length of standard 2¼-inch wide roll film. Exposures were controlled by attaching metal "fans" to the spring-motor shaft extension atop the morocco leather-covered box. Air resistance slowed the sweep speed of the lens assembly, lengthening the exposure time. The larger the fan paddles, the slower the travel. Three fans were included in the Baby's five-dollar price. Instead of the bubble levels found on higher-priced cameras, Baby Al-Vista had a small circular window covering a steel BB set in a shallow depression on the camera top. When the little ball was centered, the camera was level.

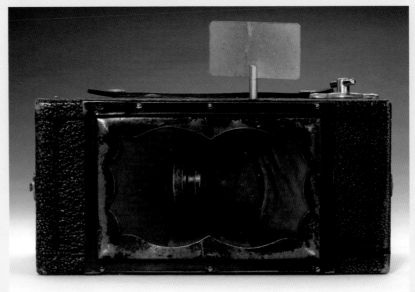

3A Panoram Kodak
1926
Eastman Kodak Company, Rochester, New York. Gift of Eastman Kodak Company. 1974:0037:2662.

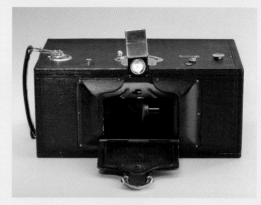

The 3A Panoram Kodak was basically a box camera for taking pictures of broad landscapes or large groups of people. To expose the long, narrow picture, the spools and rollers were located to hold the film against a curved guide, while the lens was mounted on a pivot, allowing it to swing 120 degrees when the shutter button was pressed. However, instead of a shutter, a flattened, funnel-shaped tube attached to the inside of the lens swept the light across the film. The result was a 3¼ x 10⅜-inch image that allowed everyone to be in the picture. The lens funnel opening was lined with a plush material and parked firmly against a stop covered with the same black fabric, making a light-tight seal. To help the photographer hold the camera straight, there were two bubble levels near the viewfinder. The 3A Panoram cost $40 in 1926. The size A122 film was available in either three or five exposure rolls.

FT-2
ca. 1958
Krasnogorsk Mechanical Factory (KMZ), Krasnogorsk, USSR. 1974:0028:3342.

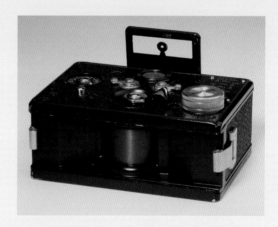

The FT-2, a 35mm panoramic camera produced from 1958 to 1965, was made by Krasnogorsk Mechanical Factory (KMZ), a suburban Moscow manufacturer known for its Zorki and Zenit cameras. It featured a swing lens covering 120 degrees and produced twelve 24 x 110-mm images on standard 35mm film loaded in special cassettes. A military camera designed to verify artillery fire, the FT-2 was presented at the Brussels World Exhibition of 1958 and put into civilian production to make its manufacture profitable.

Deardorff Precision 8/20
ca. 1960
L. F. Deardorff & Sons, Chicago, Illinois. Gift of Eastman Kodak Company. 2008:0302:0001.

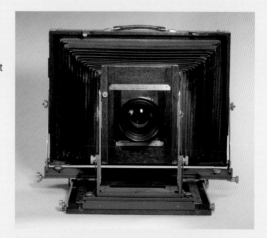

For forty years, New York's Grand Central Terminal hosted the "World's Largest Photograph," the Kodak Colorama. The backlit transparencies that graced the terminal's east balcony measured eighteen by twenty feet, with a new image mounted every month. For Eastman Kodak Company, these scenes were simply advertisements for its cameras and color film. However, creating these enormous color slides required special equipment and processes, beginning with the camera, an 8 x 20-inch Deardorff Precision. It was almost inevitable that L. F. Deardorff & Sons would be part of the Colorama story. A name synonymous with large-format photography since Laben Deardorff founded his company in the 1920s, the firm's reputation was made with large studio cameras, sturdy workhorses with all the distortion- and perspective-correcting movements needed by commercial photographers. The Precision View was built for large murals, but Kodak's photographers pushed it to extremes undreamed of by its designers. Beautifully constructed of mahogany, cast aluminum, and brushed nickel, the Deardorff combined precision with durability. Lenses like the Schneider-Kreuznach Symmar S 360mm f/6.8 could cover the twenty-inch wide film, so no cropping was needed.

Handmade panoramic camera

1970

David Avison, Chicago, Illinois. Gift of the Estate of David Avison. 2004:0653:0002.

This medium-format panoramic camera was handmade by David Avison (1937–2004), one of the most accomplished panorama photographers of our day. Unsatisfied with available panoramic cameras, he used his combined skills as an avid photographer and a Ph.D. in physics to design and build this remarkable camera between 1970 and 1972. A banquet-style panoramic camera, constructed of machined and anodized aluminum with a 75mm Schneider-Kreuznach Super Angulon lens and a detachable film magazine with dark slide, it produced five 6 x 18-cm images on No. 120 roll film. The lens is mounted on a rising/falling front with a parallax correcting open finder. David Avison taught physics and photography at the university level, and his work is preserved in a number of museum collections.

Globuscope

ca. 1981

Globuscope, Inc., New York, New York. Gift of Globuscope, Inc. 1981:0061:0001.

Looking more like a science-fiction movie prop than a camera, the 1981 Globuscope 35mm panoramic was developed by the Globus brothers for use in their New York City commercial photography studios. Their successful results led the brothers to have the apparatus manufactured for sale. Despite its futuristic appearance, the Globuscope uses the rotating body and film slit design perfected a century earlier. What Globus did differently was make an extremely compact and simple-to-use device. Removing the oval stainless steel cover makes loading a thirty-six-exposure film magazine as easy as with any 35mm camera. Once the dome is back on, the handle is rotated to wind the spring. Like all such cameras, the Globuscope does not have a shutter. Exposures are controlled by aperture setting and selection from two rotation speeds. A brass button on the handle triggers the process. The camera makes two complete 360-degree revolutions, using twelve inches of film for each exposure. The photographer can then print the entire scene or crop it as desired. The camera can also be held by the body, with the handle rotating for dramatic effects with moving subjects.

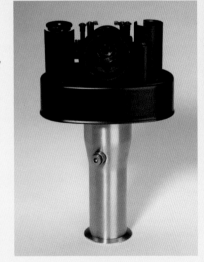
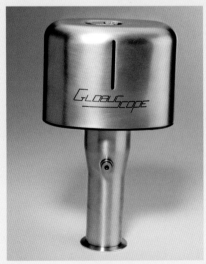

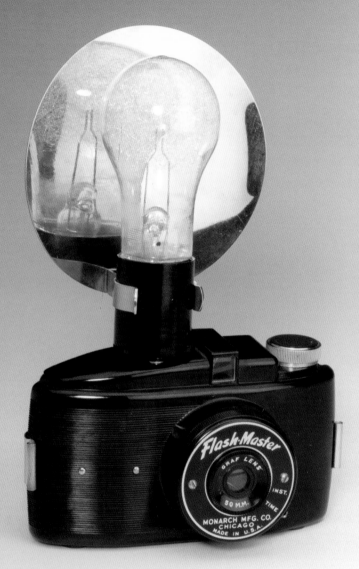

Flashmaster 127
ca. 1939
Monarch Manufacturing Company, Chicago, Illinois. Gift of Eastman Kodak Company. 1991:0977:0005.

Introduced in 1939 by the Monarch Manufacturing Company of Chicago, the Flashmaster camera was one of the many brand names marketed from the West Lake Street facility also used by Falcon and Spartus. The Flashmaster created sixteen half-frame images on No. 127 roll film and was known for its internally synchronized flash attachment, powered by two pen cell batteries. The $4.50 retail price included the reflector and one flash bulb.

SLICES OF LIGHT

IT IS EASY TO OVERLOOK THE IMPORTANCE of flash technology. Demonstrated almost from the start of photography, flash methods and devices did not become practical until the late 1800s—and did not become convenient until the mid-1900s.

Henry Fox Talbot may have been the first to take a flash picture in 1852. A Leyden jar (a glass jar that used metal wires or foil to store electricity) housed a sufficient charge to create a high voltage flash bright enough to freeze objects in motion. Early photographers relied on igniting volatile chemicals to create a controlled explosion of light bright enough to illuminate a given scene. Photographers turned to lime and assorted mixtures of magnesium powders. Placed in specially designed open containers, they were fired by mechanical, chemical, or electrical sparks to create brilliant bursts of light—followed by billows of smoke.

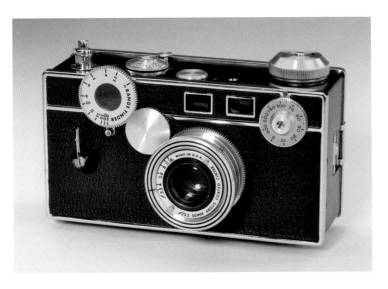

Argus C3
ca. 1939
International Research Corporation, Ann Arbor, Michigan. 1974:00037:2750

Known fondly as "The Brick," the Argus C3 was introduced in 1939 by International Research Corporation of Ann Arbor, Michigan, which changed its name to Argus, Inc. in 1944. The cameras nickname derived from both its shape and the fact that it was reliable and durable. A 35mm coupled rangefinder camera with internal flash synchronization, the C3 was very popular and remained in production until 1966. The retail price, including case and flash, was $69.50 in 1939.

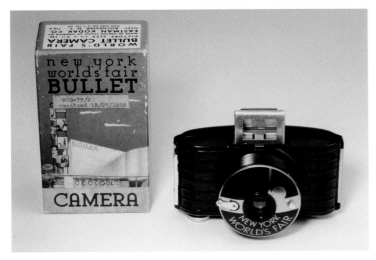

New York World's Fair Bullet
1939
Eastman Kodak Company, Rochester, New York. Gift of Eastman Kodak Company. 1999:1097:0031.

The New York World's Fair Bullet camera was produced in 1939 and 1940 to commemorate the World's Fair of those years. Originally released in 1936, the Eastman Bullet was designed by Walter Dorwin Teague in his characteristic art deco look with heavy horizontal ribs. The commemorative camera was a standard Bullet with the addition of a special metal faceplate—also designed by Teague—and name plate featuring the Fair's Trylon and Perisphere logo. Although not listed in the Kodak catalog, reportedly 10,000 units sold through dealers and at the fair for a retail price of two dollars.

Even when controlled, however, the explosion tended to frighten the subjects and could shower them with a post-flash residue.

Along with the miniaturization of cameras came the miniaturization and simplification of flash devices. In 1925, the Austrian Dr. Paul Vierkötter patented a flash bulb using magnesium foil. By placing a predetermined amount of foil inside a glass bulb, he greatly reduced the danger presented by an open explosion of magnesium powder. A few years later he further refined the flash process by using an oxygen-filled lamp and less explosive aluminum foil.

From this design came the popular flash bulb. The early flash bulbs were about the size of a 75-watt lamp bulb. They controlled and contained the explosion and smoke, making them much safer and more practical.

With the Kalart Flash Synchronizer, Leica, Contax, and Speed Graphic photographers could take their pictures no matter how little light was

Spy Cameras

SURREPTITIOUS PHOTOGRAPHY has its own appeal. Henri Cartier-Bresson used black tape over the shiny chrome to keep people from noticing his Leica. And subminiature cameras can give rise to half-guilty thoughts about how much fun it might be to take pictures when no one is looking. But their portability is intrinsically attractive, too. Because small cameras usually mean small negatives, compromised image quality is inevitable, but the combination of fast, sharp lenses, fast shutter speeds, and fine-grained films greatly reduces that objection.

There is no strict definition of subminiature. Many contend any camera using a film format smaller than 35mm or APS (16.7mm x 30.2mm) would qualify. But we know one the second we see one, such as the 1892 Kombi camera, one of the world's first subminiature models. Its brass body measured 1¾ x 1¾ x 2⅛ inches, and it used special film supplied by George Eastman. It sold well—an interchangeable film back was a useful feature. But it was tricky to operate, there was no adequate viewfinder, and when you armed the shutter you had to keep your finger over the lens. Its 1⅛-inch square format yielded good picture quality. But in 1895 Eastman rolled out the slightly larger Kodak Pocket camera, and the Kombi's days were numbered.

The watch camera concept appealed to people who valued stealth or were engaged in espionage. While appearing to check their pocket watch, they could pilfer the scene before them while the unwitting subject went about his or her business. Such cameras were the first disk models, with names like Photoret, Expo, and Ticka, as well as the Expo Police camera. The rugged Minifex and sleek Coronet Midget cameras suggest what clever engineering and design went into the subminiature cameras from the 1930s. Likewise, the 35mm Compass camera is captivating for its sheer ingenuity in making exposures whether on glass plates or roll film. Japan's Petal camera, made in the 1940s and 1950s, is scarcely larger than a quarter. The 1948 Tone camera resembles what a present-day Gulliver might find trained on him as he woke up in Lilliput. The Russian KGB had a similar model, the F21 Button model. The Tessina camera was made to roughly the same dimensions in Germany. And the French Stylophot was a camera designed to resemble a large fountain pen.

The best-known subminiature camera remains the Minox. The classic spy camera was first produced in Latvia in 1937. With shutter speeds up to 1/1000 second, it was capable of taking excellent pictures and is referenced on the CIA website. A digital Minox—resembling a classic 35mm camera—is now available that can be affixed to a small telescope.

Kombi
ca. 1892
Alfred C. Kemper, Chicago, Illinois. Gift of Walter D. Marshall. 1974:0084:0064.

The photography boom of the 1890s had many manufacturers eager to meet the demand. Simplification and portability were required by amateurs and encouraged Alfred C. Kemper of Chicago to set up production of his tiny Kombi in 1892. An all-metal box camera roughly the size of a modern 35mm film carton, the Kombi was named for its dual purpose, being both camera and viewer. The roll holder for the 1⅛-inch wide film slipped onto the body and was held in place by friction. Film had to be loaded in the dark, requiring familiarity with the holder assembly. The shutter was spring loaded and held with a latch but was not self-capping; a finger had to be kept over the lens while the shutter was cocked. To use the Kombi as a Graphoscope, images were transferred to positive film and a cap on the holder removed. With a positive roll in the holder, the lens was brought to the eye and the film end aimed at a light source, just like a souvenir shop viewer. The Kombi retailed for $3.50, a price that included masks for square and round pictures. Its catalog offered a wide selection of equipment for processing and printing.

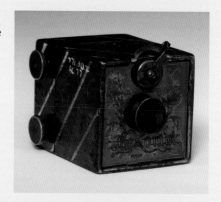

Photoret
ca. 1893
Magic Introduction Company, New York, New York. Gift of Eastman Kodak Company. 1974:0084:0066.

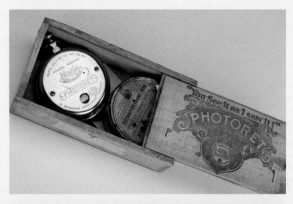

In the 1890s, almost every man carried a pocket watch. No one then would have looked twice at someone with a watch in his hand. In 1893, inventor Herman Casler was granted a patent on his Photoret camera, a nickel-plated metal device shaped like an ordinary timepiece of the day. For $2.50, the buyer received a sliding lid wooden box containing the camera and a tin of six film disks. Similar to that of the Kodak Disc camera, which would appear nearly a century later, the Photoret disk rotated after each exposure until all frames were complete. Film needed to be loaded and unloaded in the dark. Camera operation was simple. Unlike the later Expo and Ticka watch cameras, the Photoret lens was in the watch body, not the stem. Moving the stem sideways brought a fresh film sector into position, with a counter keeping track. The watch was aimed and the stem depressed to trip the shutter. Despite its tiny lens and 12 x 12-mm negatives, the Photoret's images could be enlarged to snapshot size with good sharpness.

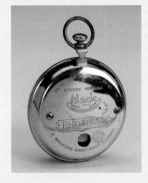

Ticka
ca. 1910
Houghton's Ltd., London, England. Gift of Eastman Kodak Company. 1974:0037:0036.

The 1910 Ticka was a milestone in miniaturization made possible by continuous improvement in the quality of roll films. Introduced by Expo Camera of New York, the pocket watch-shaped camera was also licensed to Houghton's Ltd., in London. The watch's winding stem hid a 30mm f/16 meniscus lens that worked through a simple guillotine shutter; the knob served as a lens cap. The dial and hands looked functional but were just for effect, though the hands were positioned to serve as a viewfinder. Sold in special daylight-loading cassettes, the film dropped right into place when the dial face was removed. A winding key on the back advanced the film to the next of its twenty-five exposures. The Ticka sold for under five dollars at introduction.

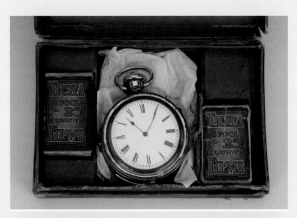

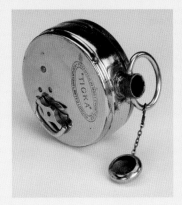

Expo Police Camera

ca. 1911

Expo Camera Corporation, New York, New York.
1974:0037:2068.

Manufactured by the Expo Camera Corporation of
New York City from 1911 to 1924, the Expo Police
Camera is an example of the "detective" cameras
popular at the time. About the size of a box of
kitchen matches, it was an all-metal box camera
with a cloth focal-plane shutter. It produced twelve
¾ x 1 ¹⁄₁₆-inch images on special roll-film cassettes.
Many consider it a milestone subminiature camera,
the precursor of all the "matchbox" cameras. Its
original retail price was five dollars.

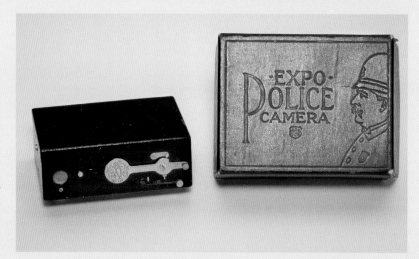

Minifex

ca. 1932

Fotofex-Kameras, Berlin, Germany. 1974:0037:1539.

The subminiature Minifex camera was produced by Fotofex-
Kameras, Berlin, in 1932. It was a palm-sized camera that made
thirty-six exposures on 16mm film. The Compur Rapid, Pronto, or
Vario shutters, normally used on much larger cameras, dwarf the
small camera. In its most expensive form, priced at Mk. 185, it
was equipped with the f/1.8 lens.

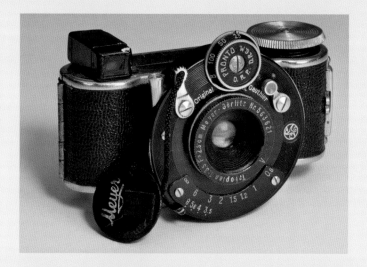

Coronet Midget

ca. 1935

Coronet Camera Company, Birmingham, England.
1974:0028:3052.

The Coronet Midget, manufactured by Coronet Camera Company,
Birmingham, England, in 1935 was advertised as "the world's
smallest camera." Also known as "The Tom Thumb of Cameras,"
it was made of Bakelite in five different colors and weighed just
1¾ ounces. The retail price was $2.50, and a roll of six-exposure
16mm film sold for twenty cents.

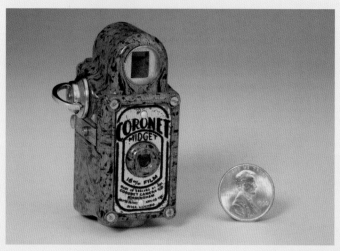

Minox (original model)
ca. 1937
Valsts Electro-Techniska Fabrica, Riga, Latvia. Gift of Eastman Kodak Company. 1974:0084:0130.

The original Minox, designed as a pocket-sized hiking camera, was destined to become the world famous "spy camera" as seen in the movies. It was designed by Walter Zapp and manufactured in 1937 by Valsts Electro-Techniska Fabrika, in Riga, Latvia. The first of many tiny Minox cameras, it was initially made from stainless steel and later changed to lighter aluminum. Though the camera had all the usual controls, its main feature was that it was made instantly ready by merely pulling the sliding inner case out, which simultaneously exposed the viewfinder, advanced the film, and set the shutter. Later versions of the camera kept up with advancing technology by adding innovations such as parallax correction, electronic flash, and auto exposure. The original retail price in 1937 was $79.

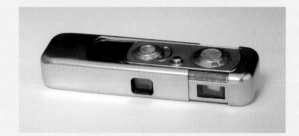

Compass
ca. 1938
Jaeger LeCoultre & Cie, Switzerland. 1974:0028:3309.

The Compass camera was manufactured by Jaeger LeCoultre & Cie, Switzerland, for Compass Cameras Limited, London, in 1937. It had a precision, fully machined aluminum body that produced 24 x 36-mm images on glass plates, sheet film, or 35mm roll film; No. 828 roll film also could be used with an available back. The compact camera possessed advanced features such as a coupled rangefinder, extinction meter, right-angle viewer, ground glass focusing, and interchangeable backs. The retail price in 1937 was £30.

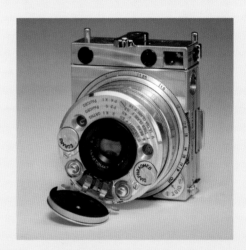

Sakura Petal (octagonal model)
ca. 1948
Sakura Seiki Company, Tokyo, Japan. Gift of C. A. Vander. 1978:0642:0002.

The Sakura Petal, manufactured in 1948 by the Sakura Seiki Company of Japan, was a subminiature camera just over one inch in diameter. It made six exposures, each about 1/8-inch in diameter, on a round piece of film about one inch across. The octagon-shaped body shown here was rarer than the earlier round body.

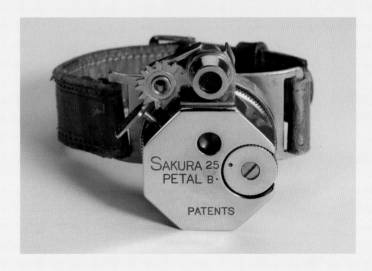

Tone
ca. 1948
Toyo Seiki Kogaku, Tokyo, Japan. Gift of Harry G. Morse. 1981:2297:0033.

Small enough to hide in your hand, the little Tone of 1948 was a cut above the cheap novelty cameras produced in enormous quantities in post-war Japan. Manufactured by Toyo Seiki Kogaku in Tokyo, the Tone used the same "midget" size film for 14 x 14-mm negatives, but it was made of higher quality materials and had features the cheaper cameras lacked, such as both eye-level and waist-level viewfinders. The lens was adjustable for focus, and the shutter could be set at whichever of its three speeds suited the occasion.

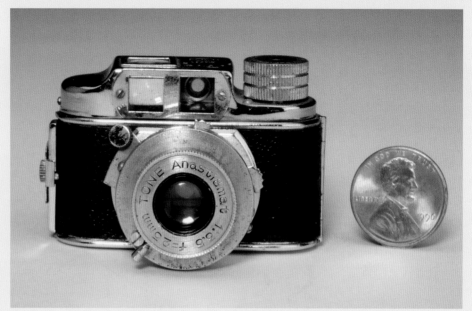

Stylophot
ca. 1955
Secam Corporation, Paris, France. 1974:0028:3311.

The public's fascination with espionage during World War II continued through the Cold War years and undoubtedly boosted sales of subminiature or "spy" cameras. Some, like the Minox, were costly, high-quality instruments, but most were sold as inexpensive trinkets. Secam of Paris offered the Stylophot in 1955, with its bloated fountain-pen shape and $14.95 price tag placing it firmly in the novelty market. The pocket clip did come in handy for carrying the plastic-bodied Stylophot. Special cassettes held perforated 16mm ciné film for eighteen pictures in either *noir* or *couleur* (black-and-white or color). Operation was very simple. The film was advanced and the shutter cocked, then a chrome slide called the "transport plate" was pulled out. The tiny fixed-focus 27mm f/6.3 coated lens fed light to the film through one of the two stops, and a ridged metal thumb tab actuated the 1/50 second shutter for each 10 x 10-mm image.

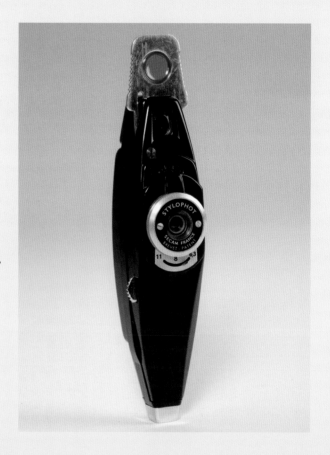

F21 Button Camera
ca. 1960
KMZ, Krasnogorsk, USSR. Gift of Jerry Friedman.
2006:0265:0006.

Made in the Krasnogorsk (KMZ) factory from the 1960s through the 1980s, the F21 Button Camera was used by the Soviet KGB for espionage purposes. In appearance, it resembled a miniature version of Otto Berning's Robot camera, featuring a similar top-wind spring-motor film advance, though no viewfinder. It produced 19 x 24-mm images on 21mm unperforated roll film. In use, the camera was disguised in a jacket with the lens protruding through the buttonhole. The lens was covered by a four-hole button, complete with what appeared to be thread; during exposures, the button split in half, allowing the picture to be made.

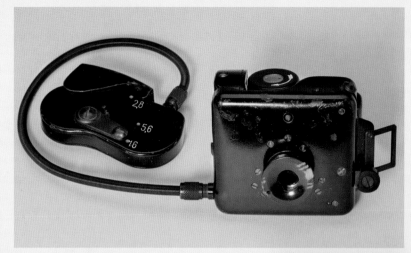

Tessina 35
ca. 1960
Concava SA, Lugano, Switzerland. 1978:0763:0001.

The Tessina 35, introduced in 1960 as the "world's smallest and lightest 35mm camera," is a side-by-side twin-lens reflex 35mm camera about the size of an iPod. The viewing lens reflects up to the waist level, or spy finder, and the taking lens reflects down to the film, which is spring motor-driven across the bottom of the camera. Accessories include a pentaprism finder, high magnification finder, right angle finder, and a wrist strap that allows the camera to be worn like a wristwatch. Despite all the "spy" features, this is not a toy; it's a fine piece of Swiss workmanship, offering all the features of a subminiature with the convenience of 35mm film.

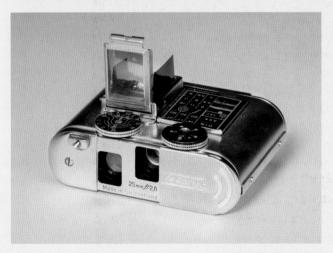

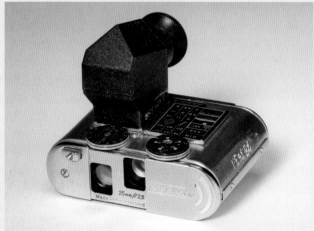

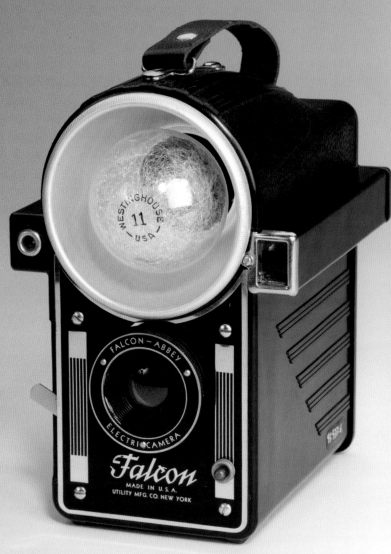

Spartus Press Flash
ca. 1940
Utility Manufacturing Company, Chicago, Illinois.
1974:0037:0140.

Introduced in 1939, the Spartus Press Flash was arguably the first camera with a built-in flash reflector. A Bakelite box camera with art deco design elements on the body and name plate, it had a flash reflector for Edison base bulbs built into the top surface and produced 2¼ x 3¼-inch images on No. 120 roll film. At introduction, the retail price was $5.95.

The Spartus Press Flash was virtually identical to the Falcon Press Flash. Both were manufactured by the Utility Manufacturing Company of Chicago, which had a tangled corporate history. Operating from a building on West Lake Street, the company went through numerous ownership changes and brand names, marketing cameras under the names Falcon, Spartus, Herold, Galter, Regal, Monarch, Monarck, and Spencer, among others.

available in the scene. Introduced in 1935, this early accessory flash unit synchronized the flash with the camera shutter so that the shutter would open when the flash occurred.

Soon flash synchronization was brought inside the camera. Nicknamed "The Brick" for its shape and reliability, the 1939 Argus C3 was a 35mm coupled rangefinder camera with internal flash synchronization. Ann Arbor, Michigan's International Research

Corporation (which later changed its name to Argus, Inc.) sold the camera for $69.50 in 1939 and manufactured it until 1966.

The Spartus Press Flash debuted with another first in the world of flash—a built-in flash reflector. A Bakelite box camera with deco design elements on the body and name plate, it had a flash reflector for Edison base bulbs built into the top surface and produced 2¼ x 3¼ images on No. 120 roll film. The retail price was $5.95 in 1939.

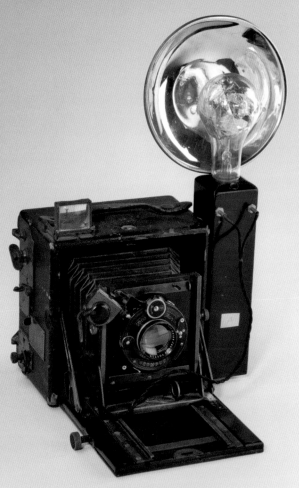

Kalart Flash Synchronizer
1935
Kalart, New York, New York. 1976:0011:0317.

The Kalart Flash Synchronizer, introduced in 1935, was an early accessory flash unit that synchronized the flash with the camera shutter. The unit had a Bakelite battery holder with a chrome-plated reflector and a timing device that plugged into the cable release socket. Compatible with miniature cameras using focal-plane shutters, such as the Leica and the Contax, it was most often used by press photographers with the Speed Graphic camera. It synchronized at all shutter speeds, including 1/500 and 1/1000 second. The retail price in 1935 was $22.50.

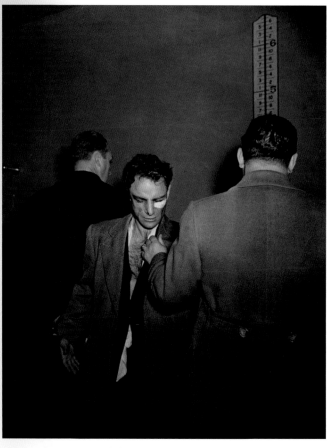

Weegee (Arthur H. Fellig) (American, b. Poland, 1899–1968). *BOOKED ON SUSPICION OF KILLING A POLICEMAN, ANTHONY ESPOSITO, ACCUSED "COP KILLER,"* January 16, 1941. Gelatin silver print. Museum purchase, Intrepid Fund. George Eastman House collections.

WEEGEE AND DR. FLASH

ONE PHOTOGRAPHER, IN PARTICULAR, would become famous for his flash bulb pictures. Weegee was born Usher H. Fellig (1899–1968) in Europe. He came with his family to New York City, where he changed his first name to Arthur. A photojournalist noted for his harsh photos of New York street life, he got his nickname from the Ouija board based on his uncanny ability to show up where the action was— thanks to the police radio in his car. His lurid photos of the living and the dead portrayed a ruthless world of mobsters and victims. Weegee's pictures sold papers.

The convenience and practicality of flash bulbs suited them well for public use. But the relatively long duration of their light (in the range of 1/50 to 1/200 second) meant that they could only slow, not stop, the action. Flash bulbs—later flash cubes—got smaller and

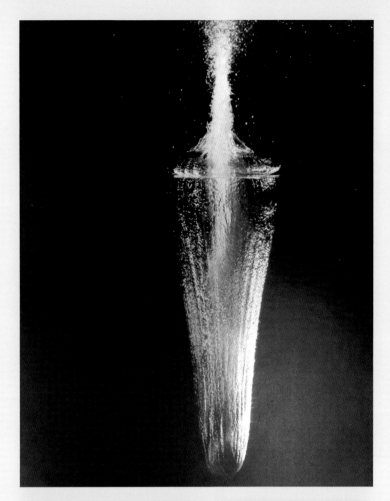

Unidentified photographer. *THIS ULTRA-HIGH-SPEED PHOTO SHOWS THE SPLASH PRODUCED WHEN A 1/8-INCH SPHERE TRAVELING AT 7000 FEET PER SECOND HITS A COPPER WIRE. THE PARTIALLY VAPORIZED COPPER PARTICLES ARE THROWN OFF AT A RATE OF 20,000 FEET PER SECOND. EXTREMELY HIGH SPEED PHOTOGRAPHY IS REQUIRED TO OBTAIN DETAILED PICTURES FOR STUDY OF SUCH PHENOMENA AT THE NAVAL ORDNANCE LABORATORY, WHITE OAK, MARYLAND. OFFICIAL U.S. NAVY PHOTO*, ca. 1950. Gelatin silver print. George Eastman House collections.

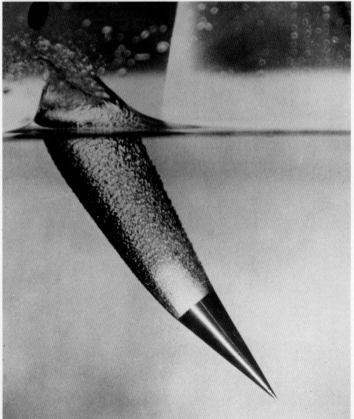

Unidentified photographer. *UNDERWATER HIGH SPEED PHOTO OF A STEEL CONE BEING SHOT INTO THE WATER AT ABOUT SIXTY FEET PER SECOND. A CAVITY WHICH APPEARS LIKE A HUGE ELONGATED BUBBLE IS PRODUCED BY THE CONE AS IT PENETRATES THE WATER. SUCH PHOTOGRAPHS ARE NECESSARY FOR WATER ENTRY STUDIES CARRIED ON AT THE NAVAL ORDNANCE LABORATORY, WHITE OAK, MARYLAND. U.S. NAVY PHOTOGRAPH*, ca. 1950. Gelatin silver print. George Eastman House collections.

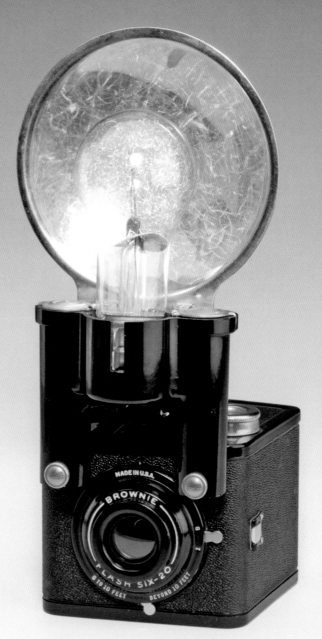

Six-20 Flash Brownie
ca. 1940
Eastman Kodak Company, Rochester, New York. Gift of Eastman Kodak Company. 1974:0037:1181.

Eastman Kodak Company's first internally synchronized flash camera, produced from 1940 to 1954, was known initially as the Six-20 Flash Brownie and later as the Brownie Flash Six-20. It was a trapezoidal metal box camera producing 2¼ x 3¼-inch images on No. 620 roll film. The flash holder used the large General Electric No. 11A (Washbash 00) flash bulb, though an adapter was available for the smaller No. 5 bulb. The retail price was $5.75, with flash holder.

safer well into the 1960s, when most consumer cameras incorporated built-in flash.

In the 1930s at the Massachusetts Institute of Technology (MIT), one man solved the problem. Known fondly as "Dr. Flash," Dr. Harold E. Edgerton (1903–1990) was a Nebraska-born professor of electrical engineering. Edgerton spent his life designing and improving stroboscopes that could produce a brilliant burst of light lasting no longer than a millionth of a second. His stroboscopes fired an electric spark through a gas held in an enclosed tube—the very principle used

even in the twenty-first century in the miniaturized built-in flashes common to nearly every camera.

If Eadweard Muybridge's action photos of the everyday motion of animals and people fascinated his audience of the 1880s, Edgerton's results of some fifty years later proved positively spellbinding: frozen action at its most infinitesimal moment revealing a world not only never before seen, but not even imagined. His work would prove invaluable not only to the scientific community but also to all contemporary and future photographers.

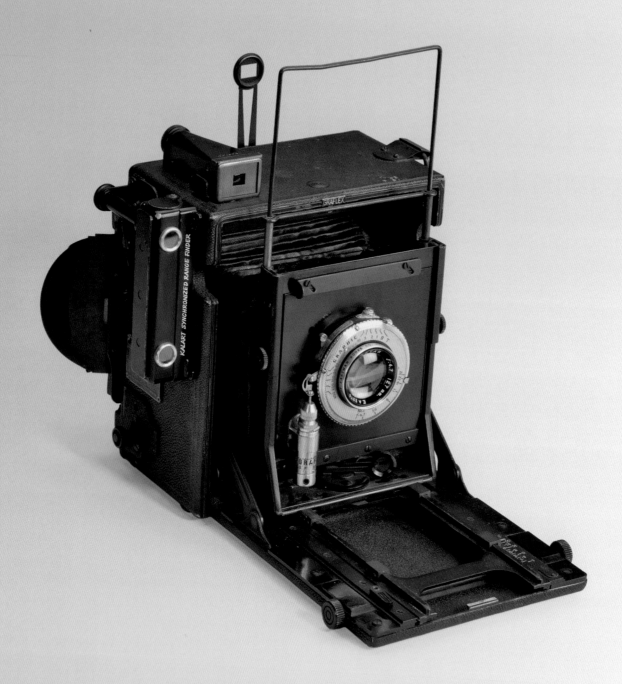

Anniversary Speed Graphic (used by Joe Rosenthal), 1940. See page 264.

XIV

DEPRESSION, WAR

Joe Rosenthal, *OLD GLORY GOES UP ON MT. SURIBACHI, IWO JIMA*, February 23, 1945.
See page 265.

Walker Evans (American, 1903–1975). *[Roadside stand, vicinity Birmingham, Alabama]*, 1936. Gelatin silver contact print, printed ca. 1971 by Jim Dow from original negative. Gift of Jim Dow. George Eastman House collections.

As CAMERA TECHNOLOGY ADVANCED in the 1930s, the Great Depression touched everyone in America. The U.S. government employed tens of thousands of citizens on public work projects such as the Civilian Conservation Corps (CCC) and the Farm Security Administration (FSA).

Roy Stryker (1893–1975), a native of Kansas, sat in the "Historical Section" of the FSA. Now considered a visionary, he recognized the magnitude of the events unfolding around him and knew that pictures could chronicle them more memorably than words. Stryker put together a team of photographers that included notables such as Walker Evans (1903–1975), Arthur Rothstein (1915–1985), Russell Lee (1903–1986), Dorothea Lange (1895–1965), and Marion Post Wolcott (1910–1990). They were later joined by the African American Gordon Parks (1912–2006), whose photographs of Chicago's black ghetto drew Stryker's attention.

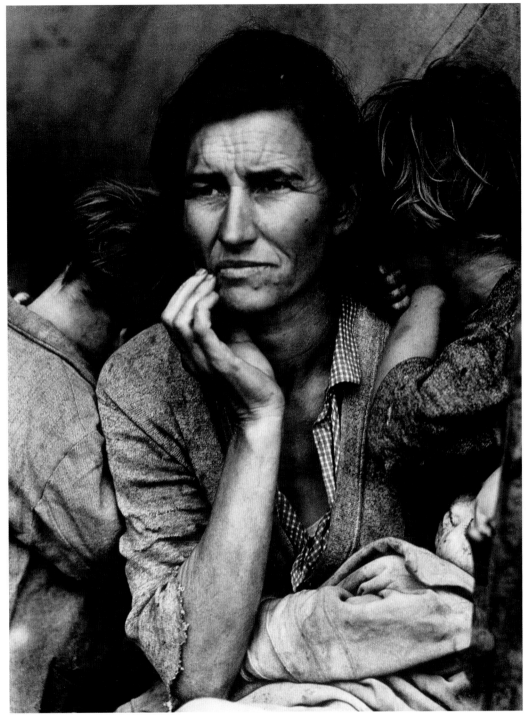

Dorothea Lange (American, 1895–1965). *MIGRANT MOTHER, NIPOMO, CALIFORNIA*, 1936. Gelatin silver print. Gift of Robert Doherty. George Eastman House collections.

Under Stryker's guidance, Lange, Evans, Rothstein, Lee, and others roamed the country photographing hungry people in soup lines, struggling farmers, and destitute parents and children clinging to one another, staring hopelessly from doorways at the cameras pointed their way. Their photographs, all produced with government funds, form one of the great photographic documentary projects of the twentieth century.

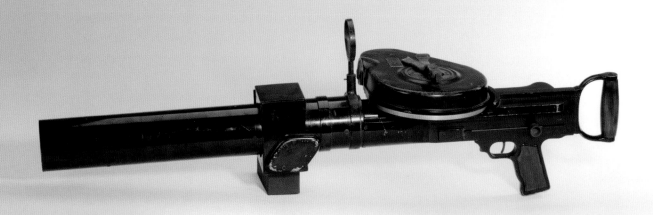

Eastman Gun Camera
ca. 1915
Eastman Kodak Company, Rochester, New York. Gift of Eastman Kodak Company. 1994:1486:0001.

The Eastman Gun Camera, designed by John A. Robertson, was produced from 1915 to 1920 by Eastman Kodak Company, Rochester, New York. A training device, the gun camera was used to practice shooting, though photographs, not bullets. Prior to this invention, army airmen trained with live ammunition, shooting at kites, pennants, or balloons that were towed by other planes, endangering both pilots and planes. The camera, similar in style and weight to the Lewis machine gun that gunners fired in the field, allowed for much safer training. It shot a 4.5 x 6-cm image of the target with a superimposed crosshair of the bullet location (see image) on No. 120 roll film. In effect, it was a forerunner of a training process now done with computer simulation.

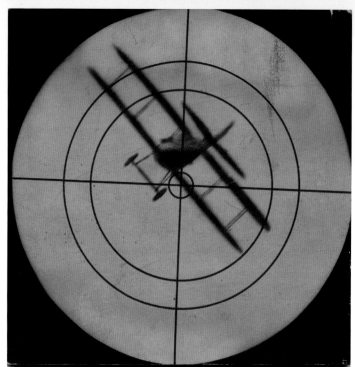

Unidentified photographer. *[Sample image from Eastman Gun camera]*, ca. 1914. George Eastman House Technology Collection.

MILITARILY SPEAKING

To help airplane gunners practice target-shooting without wasting the fuel and ammunition required by live practice, Kodak and the English camera manufacturer Thornton Pickard jointly built a camera "gun" that duplicated the actual armament and actions used by the gunners in a real dogfight. Its pictures revealed how well the gunner performed.

Then came World War II. The need to marshal all resources for the war effort nearly halted the development of cameras for consumers. But the need for greater intelligence about the enemy led ultimately to improved films and specialized cameras. Having shown its value in World War I, aerial photography became a prime tool for battle planners and strategists during World War II.

The Office of Strategic Services (OSS), predecessor to the Central Intelligence Agency, asked Kodak to

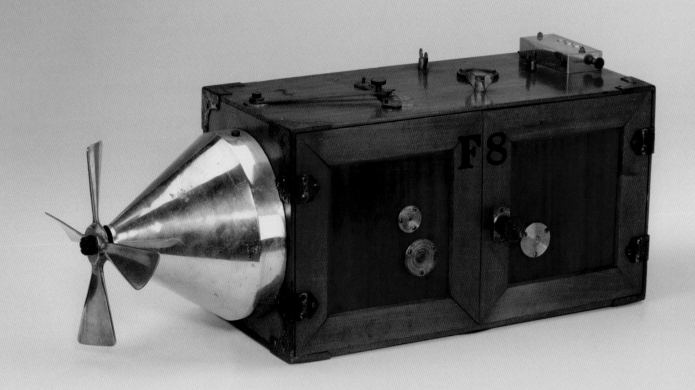

Williamson Aeroplane Camera

ca. 1915

Williamson Manufacturing Company Ltd., London, England. Gift of Eastman Kodak Company. 1992:0140:0001.

Designed for aerial reconnaissance photography around 1915, the Williamson Aeroplane Camera produced 4 x 5-inch images on roll film, exposed in either single or continuous mode. Its cloth curtain shutter, which had to be manually set when loading the film, used different speeds of 1/25, 1/50, and 1/100 second. Power for the shutter and film advance were provided by the aluminum propeller located on the front of the camera. Thumbscrews on the top of the camera were used to connect the camera to the plane.

produce a tiny "spy" camera that their agents in occupied Europe could use to copy enemy war plans and photograph military installations. Kodak created the top-secret Camera X, also known as the Eastman Matchbox camera. Designed to fit inside a standard box of European matches, its lens peered through the side panel. It produced thirty ½-inch square images on 16mm film using special cassettes. The Matchbox also had a stand with close-up lens for document copying.

Kodak shipped 1,000 cameras in 1944 and 1945.

The U.S. military needed cameras in World War II, but ordinary models would hardly survive the grim conditions of combat. The Combat Graphic 45 was introduced in 1942 by Folmer Graflex Corporation of Rochester, New York, for use by American armed forces. The all-wood 4 x 5-format camera, It was offered to qualified members of the public in limited quantities in late 1944 as the Graphic 45 camera.

Eastman Matchbox Camera
1945
Eastman Kodak Company, Rochester, New York.
Gift of Eastman Kodak Company. 2001:0636:0002.

Named for its size, the Eastman Matchbox Camera was small enough that the sleeve of a standard European matchbox could slip over it as a disguise while the lens peered discreetly through a side panel. A true spy camera, it was designed when the American intelligence agency, the OSS (Office of Strategic Services), approached Kodak for a small photographic instrument to be used in occupied Europe by American and European agents and resistance members. The top-secret project shipped 500 units in early 1944, with another 500 in 1945. Using 16mm film in cassettes to produce thirty half-inch square images, the Matchbox also had a stand with close-up lens for document copying. Patented in February 1945, the camera discontinued production with the war's end, just months later.

Leica Reporter Model GG
ca. 1936
Ernst Leitz GmbH, Wetzlar, Germany.
1974:0037:2926.

Many photographic tasks benefit from film rolls longer than the standard twenty-four or thirty-six exposures, especially those that require rapid shooting where time spent reloading can mean the loss of one or more critical shots. The Leica 250, also called Leica Reporter, was designed to accept special cassettes that held ten meters (approximately thirty-three feet) of 35mm film, enough for 250 exposures. Two identical cassettes—one containing the film supply and another to take up the exposed film—eliminated the need to rewind the long film, making the camera especially useful to street photographers, photojournalists, aerial photographers, and audiovisual studios.

There were two basic models. The Model FF, black with nickel knobs and a maximum shutter speed of 1/500 second and based on the Leica III (also called Leica F), was introduced in 1934 at a cost of $178.50 for the body, or $228 with a 50mm Elmar lens. The Model GG, black with chrome knobs and a maximum shutter speed of 1/1000 second and based on the Leica IIIa (also Leica G), was introduced in 1936. In addition to a few chrome-plated models, there was also a version of the Model GG that accepted a special electric Leica Motor. This combination was mounted on the underside of German "Stuka" dive bombers to record the results of their actions during World War II. The camera shown here is a Model GG, serial number 353619, produced in 1942 or 1943.

Robot Luftwaffen Model
ca. 1940
Otto Berning & Company, Düsseldorf, Germany.
Gift of Jacques Bolsey. 1974:0037:0147.

Robot cameras were made by Otto Berning & Company in Düsseldorf, Germany, beginning in 1934. Their main feature was an automatic film advance powered by a spring motor. The Luftwaffen Model was made for the German military during World War II and differed from the civilian Robots in having a taller winding knob and all the metal parts painted black. Early Robots used 35mm film but took one-inch square exposures and required special film cassettes. Robots of the 1950s used standard 35mm film magazines, but most models still took square pictures. The small size and high-quality optics of the camera kept sales going through the 1960s.

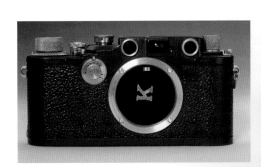

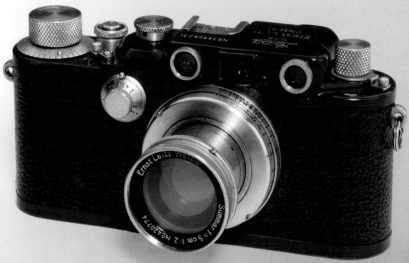

Leica IIIc K version
ca. 1941
Ernst Leitz GmbH, Wetzlar, Germany. 1974:0028:3246.

The Leica IIIc K version was usually distinguished by a "K" suffix to the serial number and/or a white letter "K" stamped on a shutter curtain. This marking identified a "Kugellager" (English translation: ball-bearing) shutter designed to operate reliably in extreme temperatures. Aside from the shutter differences, the camera was identical to the regular production Leica IIIc, with a coupled rangefinder and separate dials for fast and slow shutter speeds. Many "K" cameras had additional military markings, though some were sold to civilian customers. Typically finished in gray paint, others had a satin chrome finish. Not including lens or case, the Leica IIIc sold for $81.

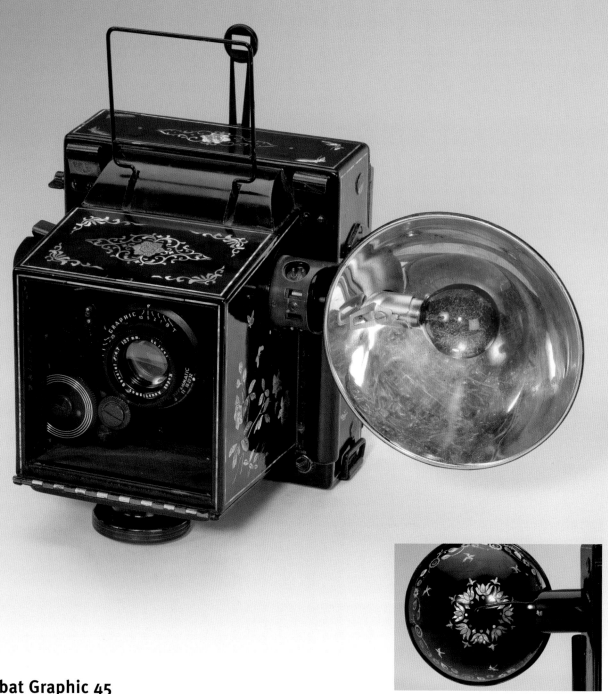

Combat Graphic 45
(with inlaid mother-of-pearl)
ca. 1942

Folmer Graflex Corporation, Rochester, New York. Gift of Graflex, Inc. 1974:0037:2454.

The Combat Graphic 45 was introduced in 1942 by Folmer Graflex Corporation, Rochester, New York, for use by the U.S. armed forces in World War II. It was an all-wood 4 x 5 camera, olive drab in color. Built to afford simplicity and sturdiness, it did not have the customary bellows, instead using a solid cone front construction, and it had a pop-up spring-loaded wire frame as a finder. The traditional focal-plane shutter had a fixed spring tension with only four speeds. The camera was offered to qualified members of the public in limited quantities in late 1944 as the Graphic 45 camera. The retail price of the public version was $174. The camera illustrated here is a one-of-a-kind hand decorated model.

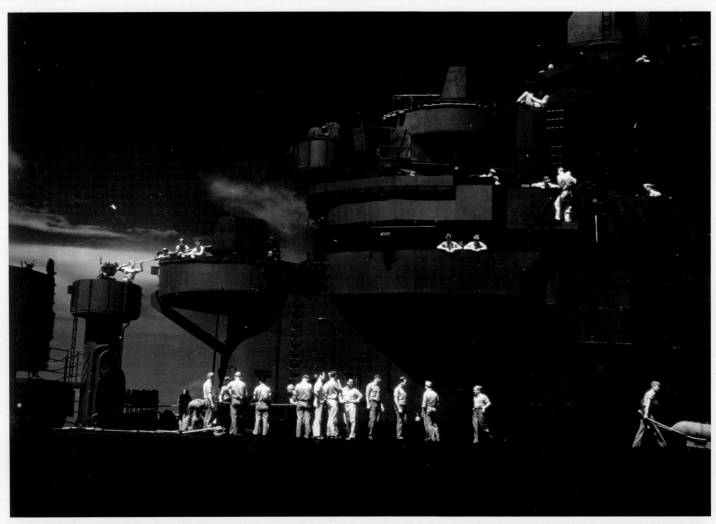

Edward Steichen (American, 1879–1973). *ABOARD THE U.S.S.* LEXINGTON: *PREPARING FOR THE STRIKE ON KWAJALEIN*, 1943. Gelatin silver print. Gift of Joanna Steichen. George Eastman House collections.

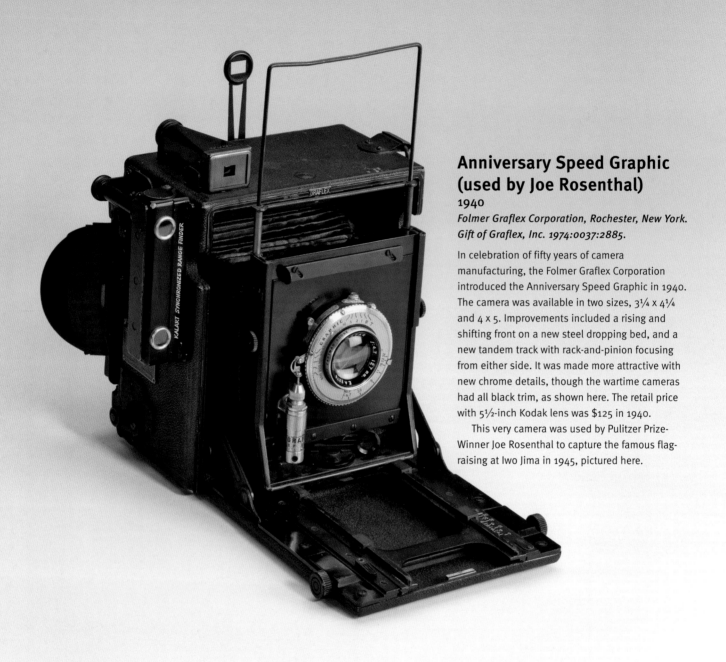

Anniversary Speed Graphic (used by Joe Rosenthal)
1940
Folmer Graflex Corporation, Rochester, New York.
Gift of Graflex, Inc. 1974:0037:2885.

In celebration of fifty years of camera manufacturing, the Folmer Graflex Corporation introduced the Anniversary Speed Graphic in 1940. The camera was available in two sizes, $3\frac{1}{4}$ x $4\frac{1}{4}$ and 4 x 5. Improvements included a rising and shifting front on a new steel dropping bed, and a new tandem track with rack-and-pinion focusing from either side. It was made more attractive with new chrome details, though the wartime cameras had all black trim, as shown here. The retail price with $5\frac{1}{2}$-inch Kodak lens was $125 in 1940.

This very camera was used by Pulitzer Prize-Winner Joe Rosenthal to capture the famous flag-raising at Iwo Jima in 1945, pictured here.

THE WAR PHOTOGRAPHERS

ARMED WITH MANY TYPES OF CAMERAS (Kodak 35, Speed Graphic and Eastman 2D to name a few) and fast films, World War II photojournalists revealed horrors no one had ever seen. Joe Rosenthal (1911–2006), Robert Capa (1913–1954), Margaret Bourke-White (1904–1971), David Douglas Duncan (b. 1916), Lee Miller (1907–1977), and others set a new standard and strongly influenced photographers such as Eddie Adams (1933–2004) and Nick Ut (b.1951) who later came to immortalize on film conflicts such as those in Korea and Vietnam.

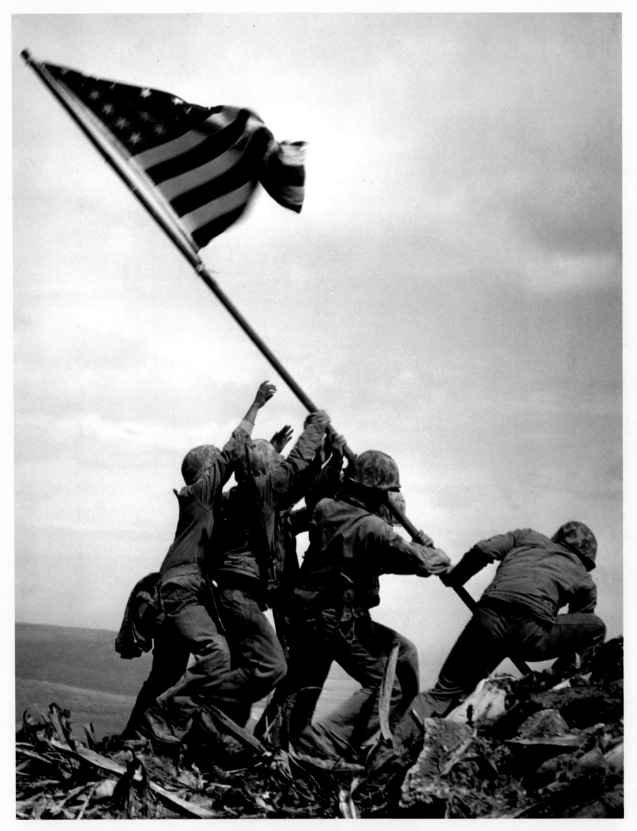

Joe Rosenthal (American, 1911–2006). *OLD GLORY GOES UP ON MT. SURIBACHI, IWO JIMA*, February 23, 1945. Gelatin silver print. Gift of The Associated Press. George Eastman House collections.

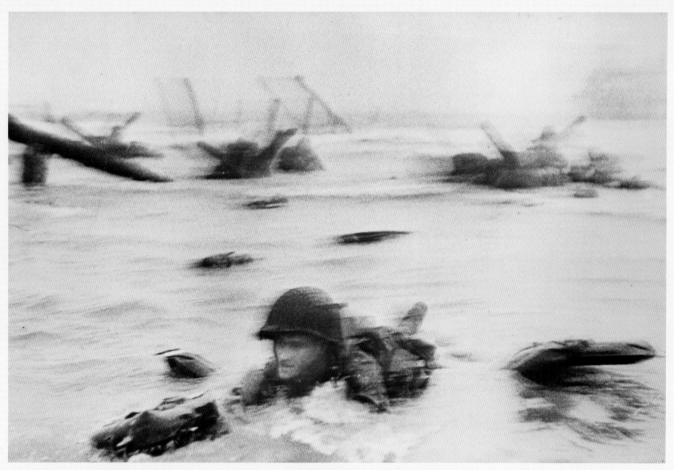

Robert Capa (Andréi Friedmann) (American, b. Hungary, 1913–1954). *D-DAY, OMAHA BEACH*, June 6, 1944. Gelatin silver print, printed later. Gift of Magnum Photos. George Eastman House collections.

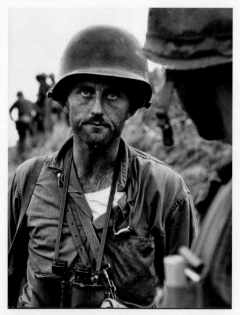

David Douglas Duncan (American, b. 1916). *COMBAT, KOREA*, 1950. Gelatin silver print, printed later. George Eastman House collections.

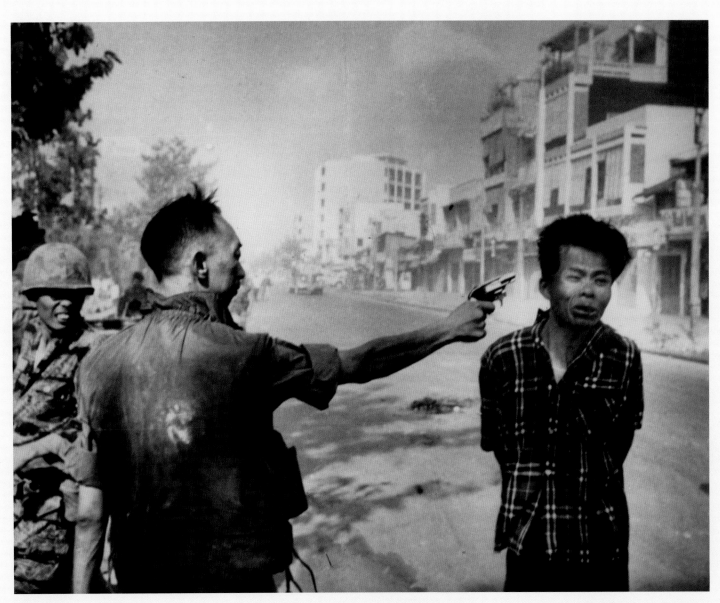

Eddie Adams (American, 1933–2004). *VIETCONG EXECUTED*, February 1, 1968. Gelatin silver print. Museum purchase, Lila Acheson Wallace Fund. George Eastman House collections.

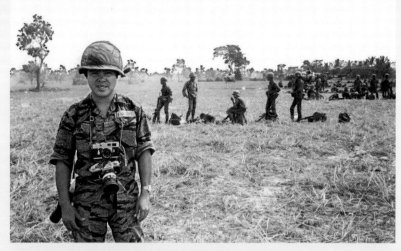

Unidentified photographer. *[Nick Ut in Cambodia during Vietnam War shown with his Leica M2 and Nikon F]*,1970. Gift of Nick Ut. See Nikon F on page 271.

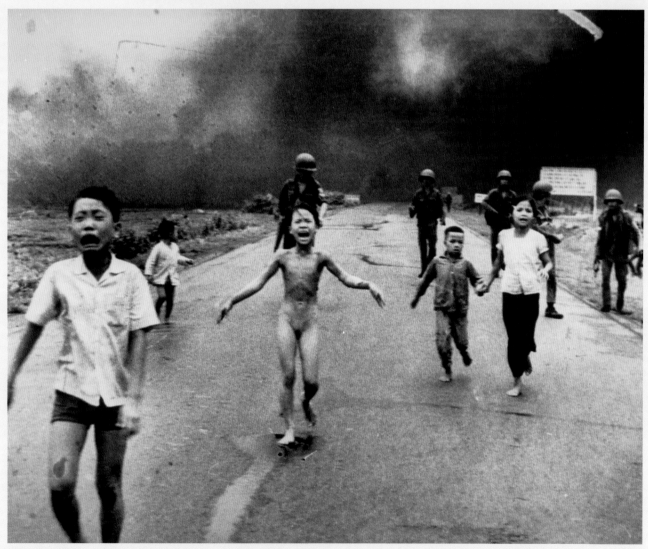

Nick Ut (American, b. 1951). *TERROR OF WAR; SOUTH VIETNAMESE FORCES FOLLOWING TERRIFIED CHILDREN FLEEING DOWN ROUTE 1, NEAR TRANG BANG, SOUTH VIETNAM, JUNE 8, AFTER AN ACCIDENTAL AERIAL NAPALM STRIKE. GIRL AT CENTER HAD RIPPED OFF HER BURNING CLOTHES*, 1972. Gelatin silver print, printed 1988. Gift of The Associated Press. George Eastman House collections.

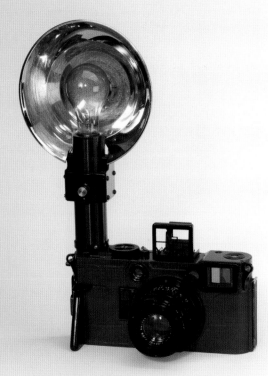

70mm Combat Graphic
ca. 1953
Graflex, Inc., Rochester, New York.
1981:2813:0002.

Introduced in 1953 by Graflex, Inc., of Rochester, New York, the 70mm Combat Graphic fulfilled a long-standing goal of the U.S. Army Signal Corps Lab. Since World War II, the Signal Corps had worked to develop a camera specifically for military needs. After specifications were released to camera manufacturers, Graflex assigned Hubert Nerwin, formerly of Zeiss Ikon, to the task. Following several prototypes, his result was a large, rugged, spring motor-driven rangefinder camera that produced 5.5 x 7-cm images on 70mm roll film and shot ten frames in six seconds. The civilian version, called the Graphic 70, appeared in the 1955 Graflex catalog. Available in a limited quantity, it retailed for $1,850 with an Ektar f/2.8 lens

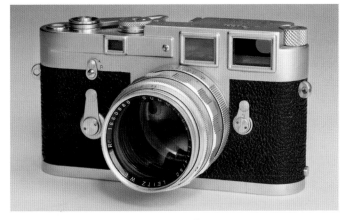

Leica M3 (double stroke)
1954
Ernst Leitz GmbH, Wetzlar, West Germany. Gift of Eastman Kodak Company. 1999:0161:0002.

Introduced at the Photokina trade show in Cologne, West Germany, in 1954, the Leica M3 quickly became a favorite of photojournalists for its nearly silent operation. Many of its features were improvements over previous models: the lens mount changed to bayonet-type; shutter speeds were on a single dial; the viewfinder automatically compensated for aiming errors resulting from the distance between the taking lens and the viewer (parallax); the film was advanced and the shutter cocked by means of a lever that required two quick strokes; and a hinged door on the camera's back simplified film loading. Costing $288 for the body alone, adding a faster lens like the 50mm f/1.5 Summarit brought the total to $469.

Although manufacturers of nearly all consumer products found themselves reconfiguring their factories to produce military supplies, some found a way to continue making a portion of their normal products. Thus a few new cameras entered the market during the war.

Made in the 1940s, Folmer Graflex's Little Bertha camera (see page 208) was a custom-built, modified version of a 4 x 5 RB Graflex Super D camera. What made the Little Bertha unique was the cumbersome appendage attached to it: a thirty-inch, forty-pound, f/8 super telephoto lens. Photographers interested in catching the fast action of baseball, for example, needed a fast-focusing lens. This need was met by a chain-drive system with three adjustable focus points; for baseball, conveniently enough, the lens could be pre-focused on first, second, and third bases.

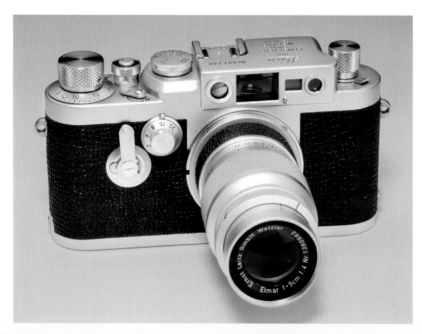

Leica IIIg
ca. 1956
Ernst Leitz GmbH, Wetzlar, West Germany.
1974:0028:3020.

The Leica IIIg, introduced in 1956, was the firm's last rangefinder camera to use screw-mount lenses. An improved viewfinder system had one eyepiece for both viewing and focusing and included framing for 50mm and 90mm lenses. The sequence of shutter speeds was revised to match the geometric progression of the aperture scales, making exposure settings more convenient. The IIIg also featured a self-timer, a diopter adjustment for the viewfinder, and a film reminder dial on the back of the camera body. At introduction, it sold for $244.50, including an Elmar 50mm f/3.5 lens. This example is shown with the 90mm f/4 Elmar lens.

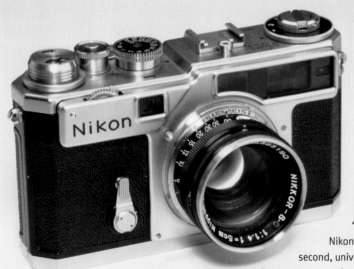

Nikon SP
ca. 1957
Nippon Kogaku K. K., Tokyo, Japan. Gift of
Nippon Kogaku. 1974:0037:0112.

Manufactured between 1957 and 1964, the Nikon SP was the company's third generation rangefinder camera. It is easily identified by the placement of "Nikon" directly below the focusing wheel on the camera's front and a serial number with "62" as the first two digits of seven. The camera features include Nikon's rubberized cloth focal-plane shutter, with speeds to 1/1000 second, universal viewfinder with color-coded bright frame lines for 5cm, 8.5cm, 10.5cm, and 13.5cm lenses, and an auxiliary finder next to the viewfinder for 2.8cm and 3.5cm lenses. With slight modifications, the SP could be fitted with a battery-powered motor drive. Some of the later cameras were supplied with a titanium foil shutter, also used on the Nikon F reflex camera.

The quality build of the SP made it a favorite among photojournalists, with some considering it the best rangefinder camera ever made. Produced in fairly small numbers, with only about 23,000 made during the seven year run, it most certainly set the table for Nikon professional cameras to come.

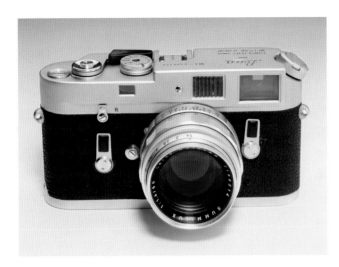

Leica M4
ca. 1967
Ernst Leitz GmbH, Wetzlar, West Germany.
Gift of Elizabeth L. Warner. 1992:0677:0035.

Ernst Leitz of Wetzlar, West Germany, continued the evolution of Leica's M-series rangefinder camera with the M4, introduced in 1967. The most visible improvement is the angled rewind knob. However, the camera sports a shopping list of advancements over the earlier M3 and M2 cameras, including an easy loading film take-up system; a bright frame viewfinder for 35mm, 50mm, 90mm, and 135mm lenses; standard PC flash socket; and a more ergonomic plastic-tipped film advance lever. The M4 list price was $288 without lens; adding the 50mm f/1.4 Summilux lens brought the price to $501. This example has a satin chrome finish; black paint and black chrome versions were also available.

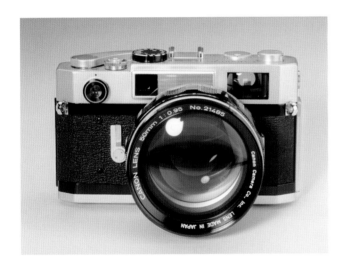

Canon 7S
ca. 1964
Canon K. K., Tokyo, Japan. 1977:0138:0001.

The 35mm rangefinder has been a popular camera design since the 1930s. Canon of Tokyo, Japan, made their reputation with the coupled rangefinder featuring interchangeable lenses. The cameras of the Canon 7 series had threads for screw-mount lenses but also a breech-lock bayonet mount for the huge 50mm f/0.95 unit billed as the "World's Fastest Lens." A focal-plane shutter with a maximum speed of 1/1000 second allowed for full use of the massive lens. Selling for almost $500 in 1964, the 7S added an improved battery-operated CDS light meter and a top-mounted accessory shoe to its earlier sibling model, the Canon 7. The last rangefinder Canon camera, it had available lenses in focal lengths from 19mm to 1000mm.

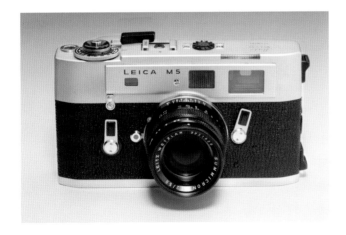

Leica M5
ca. 1971
Ernst Leitz GmbH, Wetzlar, West Germany. Gift of
Elizabeth L. Warner. 1992:0677:0026.

The Leica M5, introduced in 1971, was the first Leica rangefinder camera to offer through-the-lens exposure metering. An exposure sensor mounted to an arm swung into the space between the lens and film, exactly measuring the light reaching the film; it retracted just before the actual exposure. The body styling was a significant departure from the prior M-series models. This earlier example has only two strap lugs (both on one end of the camera), while later versions offered three lugs. The M5 body alone cost $627, and with the Summicron 50mm f/2 lens shown here, cost $849.

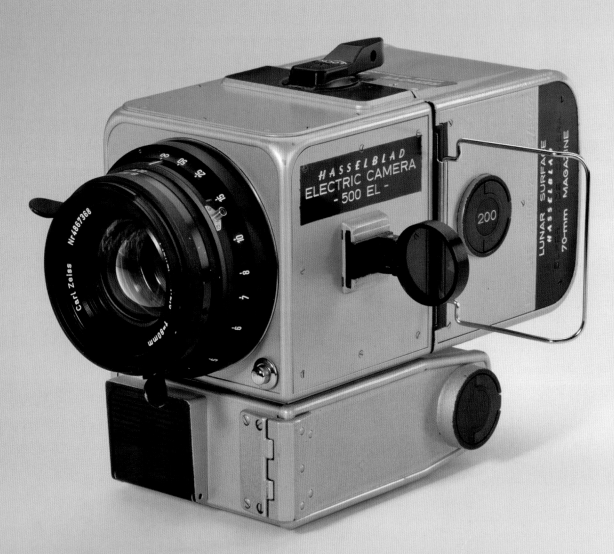

Hasselblad Electric Camera (HEC), ca. 1969. See page 295.

XV

CANON, NIKON, HASSELBLAD

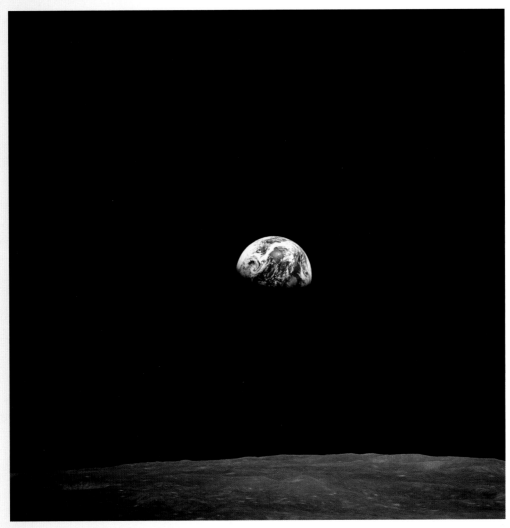

William Anders, *[Earth rise over the moon]*, December 24, 1968. See page 295.

Canon S
ca. 1938

*Seiki Kogaku Kenkyusho, Tokyo, Japan. Gift of
Harry G. Morse. 1981:2297:0029.*

Working from a single room in a Tokyo apartment in
November 1933, motion picture camera repairman Goro
Yoshida, together with his brother-in-law Saburo
Uchida and Takeo Maeda, founded Seiki Kogaku
Kenkyusho (Precision Optical Instruments Laboratory),
later known as the Canon Camera Company. These men
were determined to build a 35mm rangefinder camera comparable in
design to the Leica II, introduced in Germany in 1932, but with a price more
accessible to the Japanese public. With funding from a friend, Dr. Takeshi Mitarai, they embarked on a research project that resulted in the
camera prototype Kwanon, named after the thousand-armed Kwannon, the Buddhist goddess of mercy. As early as June 1934, the company
publicized its new camera in print advertisements, seeking to drum up public support. However, the Kwanon camera and subsequent design
variants never reached the production stage for want of quality optical elements.

Instead, in February 1936 Seiki Kogaku Kenkyusho introduced the Hansa Canon camera, built in cooperation with Nippon Kogaku Kogyo (the Nikon
Corporation predecessor). With lenses, viewfinder, and rangefinder systems supplied by Nippon Kogaku, the Hansa Canon realized the company
founders' aspiration for a more affordable, high-quality camera. The design success of the Hansa Canon not only won immediate public admiration
but also irrevocably changed the Japanese camera industry. The younger sibling Canon S, shown here, was released in 1938. It retained the original
camera's pop-up finder but moved the frame counter to the top of the camera's frame, under the advance knob, as found in Leica cameras.

ONE DAY IN THE 1930S, a Japanese motion-picture
camera repairman, Goro Yoshida, was wondering
why the price of a Leica camera equaled six months of
a salary for a banker fresh out of the best university. So
he took a Leica apart:

> I just disassembled the camera without any spe-
> cific plan, but simply to take a look at each part. I
> found there were no special items like diamonds
> inside the camera. The parts were made from
> brass, aluminum, iron and rubber. I was surprised
> that when these inexpensive materials were put
> together into a camera, it demanded an exorbitant
> price. This made me angry.

In the June 1934 issue of the *Asahi Camera* magazine,
Yoshida ran this ad:

> "The best submarine is the Igo.
> The best airplane is the Model 92.
> The best camera is the Kwanon.
> They are all the best in the world."

The Kwanon was so named because Yoshida was
devoted to Kwannon, the Buddhist goddess of mercy.
The prototype 35mm rangefinder camera was never
produced because Yoshida had trouble finding lenses,
but its second iteration, the first Canon camera,
marked an inflection point in the arc of photographic
history and triggered the rise of the Japanese camera
industry, culminating in the 1959 introduction of the
Nikon F system.

In February 1936, Seiki Kogaku Kenkyusho intro-
duced the Hansa Canon camera, built in cooperation
with Nippon Kogaku Kogyo, the predecessor of Nikon
Corporation. The Hansa Canon realized the company
founders' aspiration for a more affordable, high-quality
camera, winning public acclaim and changing forever
the Japanese camera industry. The popular Canon S,
shown here, was released in 1938.

The growth, of course, came well after World War II.
Camera manufacturing equipment such as lathes, sheet
metal stamping presses, and lens grinding machinery had
been confiscated because it was thought useful for making
weapons. Restrictions and anti-Japanese sentiment,

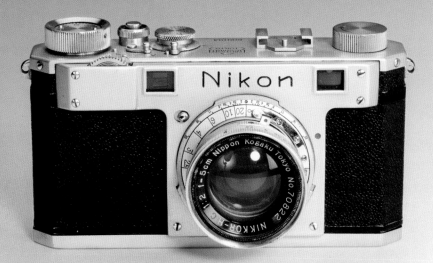

Nikon

1947

Nippon Kogaku K. K., Tokyo, Japan. Gift of Eastman Kodak Company. 1990:0128:0005.

Taking the best features of Leica and Contax rangefinder cameras as its starting point, the original Nikon (usually referred to as the Nikon I by collectors), the first production camera from Nippon Kogaku, sought to improve upon both. Introduced in 1948, it combined a horizontal cloth focal-plane shutter and a rangefinder similar to the Leica with a body shape, focusing controls, and bayonet lens mount derived from the Contax.

Nippon Kogaku was new to camera manufacturing but had been a leading producer of optics since 1917. Accordingly, the Nikkor lenses supplied for its new camera were already in use on Canon and other cameras of the time. The Nikon came with either an f/3.5 or f/2 collapsible 5cm lens. Additional Nikkors with focal lengths of 3.5cm, 8.5cm, and 13.5cm were also available. As with all Japanese products intended for export in the years immediately following World War II, the camera and lenses were engraved "Made in Occupied Japan."

The 24 x 32-mm image size used by the Nikon allowed forty exposures on a standard roll of 35mm film. Unfortunately, this size was incompatible with U.S. standard Kodachrome mounts, a problem quickly recognized by the Overseas Finance and Trading Company (OFITRA), the first American importer of the Nikon, as a severe limitation to U.S. market acceptance of the camera. Ultimately, only several hundred cameras were manufactured before the format increased to a still non-standard 24 x 34 mm with the introduction of the Nikon M in 1949. The Nikon S, introduced in 1951, became the first camera from Nippon Kogaku to use the standard 24 x 36-mm format.

primarily in the United States, impeded the growth of the camera industry. In spite of this, the Japanese designed and produced new cameras for export markets, overseen by the General Headquarters of the Occupation Forces, the organization managing Japan's post-war economy.

THE SEEDS

UPON ITS INTRODUCTION IN 1948, the first Nikon gave no hint that it would one day become a brand synonymous with high-quality consumer and professional cameras, especially SLRs. By the same token, the pre-war Canon camera gave no indication that it would become Nikon's most aggressive competitor in the fight for dominance over the 35mm SLR niche in the post-World War II camera marketplace.

Taking the best features of Leica and Contax rangefinder cameras as its starting point, the Nikon I, the first production camera from Tokyo-based Nippon Kogaku, sought to improve upon both. The Nikon combined a horizontal cloth focal-plane shutter and a rangefinder similar to that of the Leica with a body shape and focusing controls derived from the Contax. The lens mount was a bayonet-type like that of the Contax. The collapsible 50mm lenses were available in f/3.5 and f/2 versions.

The image size of 24 x 32 mm allowed forty exposures on a standard roll of 35mm film. Known as Nippon format in Japan, it was promoted by the Japanese government as a more efficient size for 35mm film; 24 x 32 mm creates an 8 x 10-inch enlargement with almost no waste of film. Unfortunately, it was incompatible with 24 x 36 mm standard Kodachrome mounts and, although

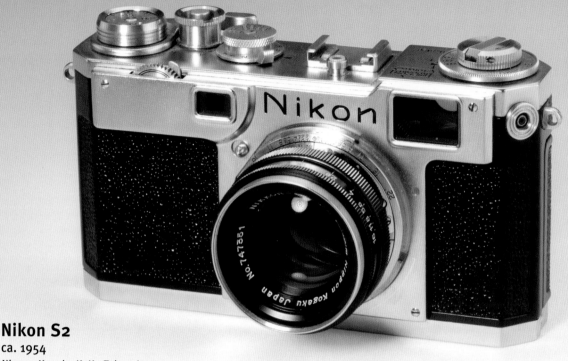

Nikon S2
ca. 1954
Nippon Kogaku K. K., Tokyo, Japan. 1974:0028:3048.

The Nikon S2, manufactured from 1954 through 1958, is identified by a serial number with "61" as the first two digits of seven. The second generation Nikon rangefinder camera was designed to fix the shortcomings of the earlier I, M, and S models. After consulting with a select group of end-users, Nippon Kogaku added a number of features to the S2 that made it a viable competitor to the Leica M3: an increased top shutter speed of 1/1000 second; rapid film advance lever; folding rewind crank; and a larger viewfinder window permitting ninety percent image viewing. There are two versions of the S2, the original (shown here) featuring chrome shutter speed and flash sync dials, and a later version with black-painted shutter speed and flash sync dials.

originally intended for export, it was not sold outside Japan. To suit the camera for export, a slight modification was made to the gate and film advance that allowed for a 24 x 34 mm image size, which would fit slide mounts. These cameras were known as the Nikon M. The film advance system would be completely redesigned for standard 24 x 36 mm and sold as the Nikon S.

With the 35mm format gaining widespread acceptance among serious photographers, manufacturers around the world aggressively went after the market. Zeiss Ikon of Dresden, East Germany, sought an edge by providing a camera with an improved viewing system. The Contax S of 1949 was the first 35mm single-lens reflex camera to use a pentaprism, which gave the photographer a right-side-up view of the subject.

The pentaprism sat atop the camera in a pyramid-shaped housing. A mirror behind the lens redirected image-forming light coming from the lens to the prism. Light hitting the prism was redirected again, through three of the prism's five faces, an action that correctly oriented the image to the photographer's eye. The design is common to all SLRs today, including digital models. With a screw mount lens and a knob for film advance, the Contax S also had a shutter release button on the front that angled outward to meet the user's fingertip.

The Contax S was superseded by improved models and continued in production until the 1960s, although the name was changed to Pentacon in the 1950s, due to disputes with the West German Zeiss Ikon firm in Stuttgart.

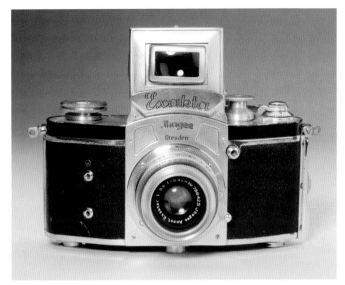

Kine Exakta I (rectangular magnifier)
ca. 1937
Ihagee Kamerawerk, Dresden, Germany. 1974:0037:1597.

The Ihagee Kamerawerk in Dresden, Germany, introduced a single-lens reflex design in 1933 they named Exakta. This wedge-shaped camera took size 127 roll film and had a folding viewfinder hood and a mirror that allowed the photographer to compose and focus through the same lens used for making the exposure. Though not a new idea, Exakta utilized it in a very small body. In 1936 Ihagee built the Kine Exakta I, which used the 35mm film magazine, making it the world's first 35mm SLR camera. It had a cloth focal-plane shutter with a maximum speed of 1/1000 second and interchangeable lenses. The film advance lever and shutter release were on the left side. Lens choices included Ihagee's own Exaktar 5.4cm f/3.5 and various Zeiss Ikon and Schneider units. The Kine Exakta remained on the market for about ten years and sold for up to $275 with a Zeiss Biotar f/2 lens.

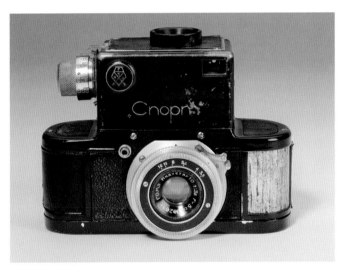

Спорт (Sport)
1935
GOMZ, Leningrad, USSR. Gift of Eastman Kodak Company. 1990:0128:0004.

The Спорт (English translation: Sport) camera, manufactured by GOMZ in Leningrad, USSR, in 1935, is reputed to be the second-ever 35mm SLR, the Ihagee Kine Exakta being introduced about a month earlier. Capable of producing fifty images, 24 x 36 mm, on 35mm film in special cassettes, it had a large boxy housing on top, containing the reflex viewing hood and an optical eye level finder. The GOMZ company later changed its name to "Leningrad" and in 1965, to the current "Lomo."

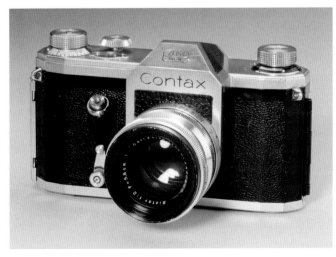

Contax S
ca. 1949
Zeiss Ikon, Dresden, East Germany. Gift of Eastman Kodak Company. 1974:0037:0076.

The first 35mm single-lens reflex camera to use a pentaprism to give the photographer a right-side-up view of the subject, the Contax S was introduced in 1949 by Zeiss Ikon of Dresden, East Germany. It originated the form that defined the 35mm single-lens reflex and continues in the twenty-first-century digital SLR. With a screw mount lens and a knob for film advance, the camera also had a shutter release button on the front that angled outward to place it right at the user's fingertip. The Contax S was superseded by improved models and continued in production until the 1960s, although the name was changed to Pentacon in the 1950s due to disputes with the West German Zeiss Ikon firm in Stuttgart.

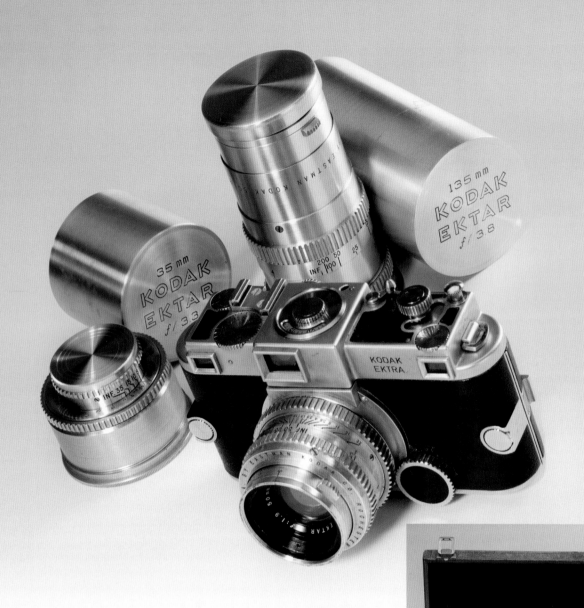

Ektra (35mm)
ca. 1941
Eastman Kodak Company, Rochester, New York. Gift of Ruth Yuster. 1991:0274:1–6.

In the late 1930s, Eastman Kodak Company felt it had the ability and technology to design the globe's best camera, and they set out to do so. The result was introduced in 1941 as the "world's most distinguished camera." The Kodak Ektra was a high-quality, precision camera system using 35mm film and interchangeable lenses that were considered among the best. A number of features were firsts for 35mm rangefinder cameras. They included six coated lenses, ranging in focal length from 35mm to 153mm, interchangeable backs, parallax-compensated finder, built-in optical zoom finder, lever film advance, film rewind lever, and a very long based coupled rangefinder. Such a marvelous camera came with a high price. The camera and 50mm f/1.9 lens retailed for $300 in 1941. All five accessory lenses cost an additional $493.

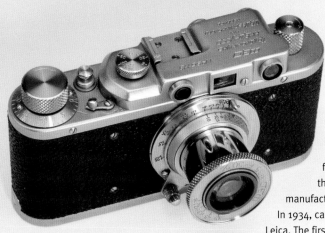

ФЗД (FED)
ca. 1938
Dzerzhinsky Commune, Kharkov, Ukraine 2004:0919:0001

Organized in 1927, the F. E. Dzerzhinsky commune was a rehabilitation colony for 150 orphaned boys and girls, thirteen to seventeen years of age. Named for Felix Edmundovich Dzerzhinsky, the founder of the Soviet secret police who died in 1926, the community initially produced craft goods, such as clothing and furniture, to serve its needs. Later, the communards began taking orders for their products from outside the colony. Funds accumulated from the sale of these goods, along with a loan from the state, allowed the commune to expand its manufacturing facility, and in 1932 an electric hand drill was added to the inventory.

In 1934, camera production began with the fabrication of ten prototype copies of the famous Leica. The first 35mm camera made in the USSR, this knockoff of the popular and versatile handheld German camera was named FED, also in honor of Dzerzhinsky. By June 1941, when Germany invaded the Soviet Union, 175,000 FED cameras had been manufactured. Production of the camera was discontinued during World War II, as manufacturing facilities were relocated to Bersk and retooled to make airplane parts for the Soviet Air Force. After the war, FED production resumed, first at the Bersk factory and, starting in 1946, also at a new Kharkov plant. By the end of its run in 1970, nearly two million FED cameras been produced. Illustrated is a FED 1c, ca. 1938.

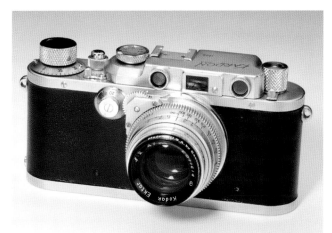

Kardon 35
ca. 1945
Premier Instrument Company, New York, New York. Gift of Harry G. Troxell. 1987:1515:0001.

Manufactured in 1945 by Premier Instrument Company of New York, the Kardon 35 was sold to the U.S. Army Signal Corps as well as civilians. Proclaimed by its maker as the "world's finest 35mm camera," it was very similar to the Leica IIIa. In fact, Premier's sales literature claimed that lenses and most accessories were interchangeable between the two cameras. The retail price, including a coated Kodak Ektar f/2 lens, was $306.25.

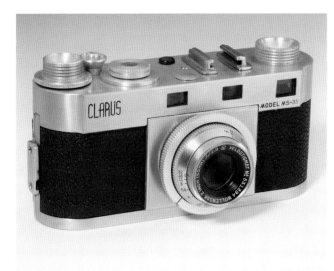

MS-35
ca. 1946
Clarus Camera Manufacturing Company, Minneapolis, Minnesota. Gift of J. Shean. 1974:0028:3141.

At first glance, the Clarus MS-35 seems to be an American Leica. It has many of the same features as the German camera, such as coupled rangefinder, 1/1000 second focal-plane shutter, and the style of a precision photographic instrument. The Wollensak Velostigmat 50mm f/2.8 lens added to its élan. Introduced by the Clarus Camera Manufacturing Company of Minneapolis in 1946, the MS-35 had been designed before World War II. Heavy and awkward to hold, it was also mechanically unreliable. Many of the cameras failed shortly after purchase and were returned for repair or a refund of the $116.25 purchase price. The firm's owners finally ironed out the kinks, but by then a wary buying public chose competitors' products over Clarus, and the inevitable financial problems brought the story to an end.

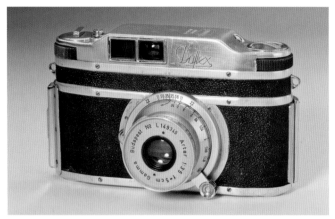

Duflex
ca. 1947
Gamma Works for Precision Engineering & Optics, Ltd.,
Budapest, Hungary. 1978:0686:0007.

Made by the Gamma Works in Budapest, Hungary, the Duflex was
created from patents granted in 1943. However, World War II
delayed the camera's introduction until late 1947, around the time
the factory became state-owned. Production stopped in 1949, after
only about 600 to 1,000 units. The Duflex was the first 35mm SLR
to have a metal focal-plane shutter, instant return mirror, automatic
stop down diaphragm, and a viewfinder with an image-correcting
prism. It is also one of the few non-Japanese cameras to use the
24 x 32 mm Nippon image format.

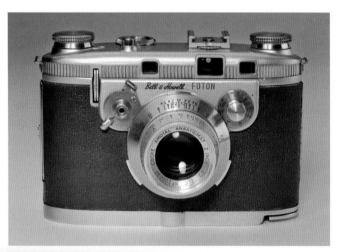

Foton
ca. 1948
Bell & Howell Company, Chicago, Illinois. 1981:1296:0009.

Introduced in 1948, the Bell & Howell Foton was a high-quality,
attractively styled 35mm camera. It had a die-cast body, coupled
rangefinder, and a unique spring motor drive that allowed for
bursts of six frames per second. A feature-rich product, the Foton
debuted at a retail price of $700. However, even after a price
reduction to $500, it didn't find enough buyers and was
discontinued in 1950.

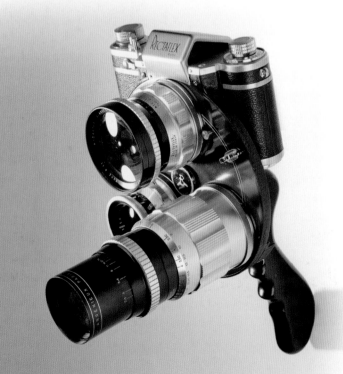

Rectaflex Rotor
ca. 1952
Rectaflex, Rome, Italy. 1974:0037:2536.

The 1952 Rectaflex Rotor was a 35mm SLR camera made in Rome,
Italy, with a rotating three-lens turret, a successful feature on
movie cameras since the 1920s. In the days before zoom lenses,
the idea was to make lens swapping easier. The Rectaflex's
pistol-grip handle had a trigger linked to the shutter actuator. Its
rotor lock release was an easy-to-press thumb button and
allowed the photographer to select a normal, wide-angle, or
telephoto lens, all while keeping the subject framed in the
finder. Designed with many features desirable to the serious
shooter, the camera's weight wasn't among them.

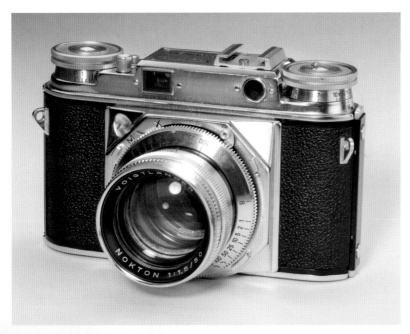

Prominent (35mm)
ca. 1952
Voigtländer & Sohn AG, Braunschweig,
West Germany. Gift of Myron Bernhardt.
1989:1162:0010.

Voigtländer has been manufacturing cameras in Braunschweig, Germany (West Germany, 1946–1990), since 1840, and through the years has made every style and type. The Prominent was a coupled rangefinder 35mm with interchangeable lenses and flash synchronized Synchro-Compur leaf shutter with speeds to 1/500 second. An unusual feature was the top-mounted focus knob on the left side, instead of the usual knurled ring on the lens. Several lenses were available for the camera, from 35mm wide-angle to 150mm telephoto. Voigtländer made the Prominent from 1951 until 1960.

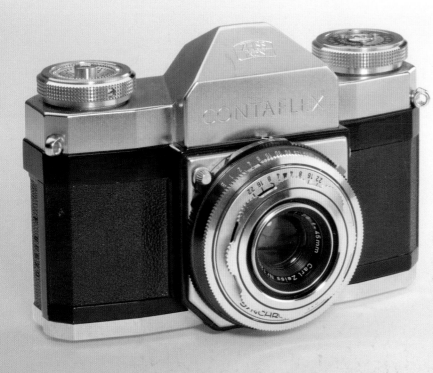

Contaflex I (861/24)
ca. 1953
Zeiss Ikon AG, Stuttgart, West Germany.
1974:0037:2974.

Introduced in 1953 by Zeiss Ikon AG of Stuttgart, West Germany, the compact Contaflex incorporated an inter-lens shutter instead of the traditional cloth focal-plane shutter found in other SLRs. With the introduction of the Contaflex II the following year, the original was renamed Contaflex I. The Contaflex III brought interchangeable front lens elements to the line. The retail price of the original Contaflex was $153.

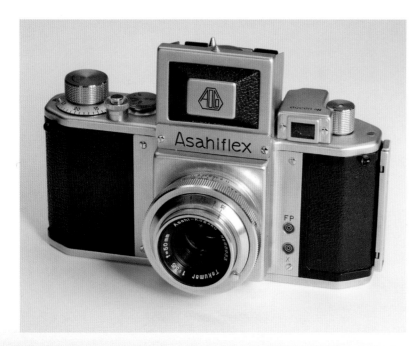

Asahiflex IIB
1954
Asahi Optical Company, Ltd., Tokyo, Japan. Gift of Asahi Optical Company. 1981:1296:0025.

Introduced in 1954 by Asahi Optical Company, Tokyo, the Asahiflex IIB was Japan's first 35mm SLR that appeared in 1952. The Asahiflex IIB was the first Japanese 35mm SLR to use an instant return mirror, which became the world standard. By 1957, the Asahi camera line was known as Asahi Pentax cameras, although in the U.S. they were labeled Honeywell Pentax for the American corporation that imported them into the 1970s. Since then, the name on the plate has been simply Pentax. In June 2007, after an earlier attempt at a merger failed, Hoya Corporation announced a buyout of Pentax Corporation that would make it a wholly owned subsidiary, while retaining its brand name.

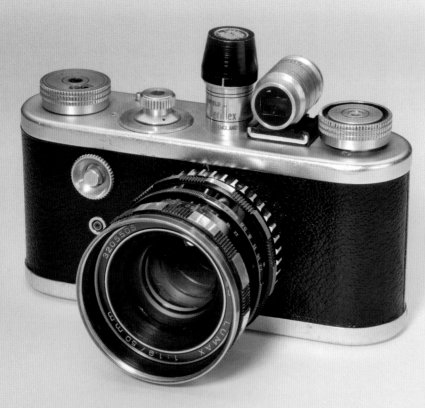

Periflex 1
1955
K. G. Corfield Ltd., Wolverhampton, England. 1974:0037:2803.

The Periflex was the product of Sir Kenneth Corfield's pursuit of an economically priced, high-quality 35mm camera body with a focal-plane shutter and a Leica lens mount. His goal was a camera that Leica owners could purchase for use as a second body. To reduce the bulk of a conventional camera, the Periflex uniquely eliminated the rangefinder and incorporated a periscope that was lowered behind the lens for focusing. The photographer then used the conventional viewfinder to compose the picture. The original model was released in 1953 by K. G. Corfield Ltd. of Wolverhampton, England, and sold for £29 with lens. Shown here is the Periflex 1 (silver) of 1955.

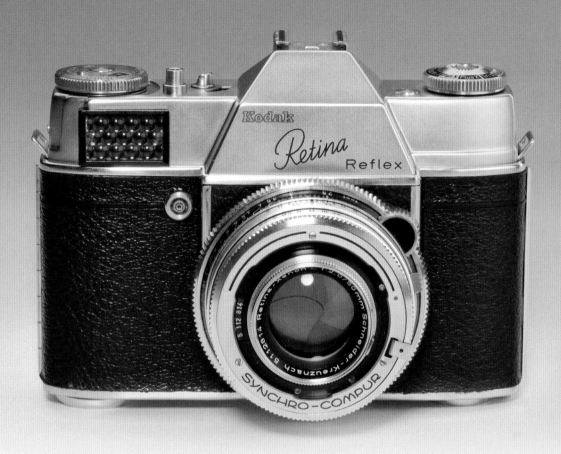

Retina Reflex (type 025)
ca. 1956
Kodak AG, Stuttgart, West Germany. 1974:0037:2917.

The Retina Reflex type 025, the first single-lens reflex Retina camera, was manufactured by Kodak AG, the German subsidiary of Eastman Kodak Company in Stuttgart, West Germany. Shown at Photokina in 1956, the prototype 025/0 was soon followed by the production model, the type 025. In addition to the reflex finder, it featured a split image rangefinder and was the first Retina with an integral exposure meter. The retail price was $215.

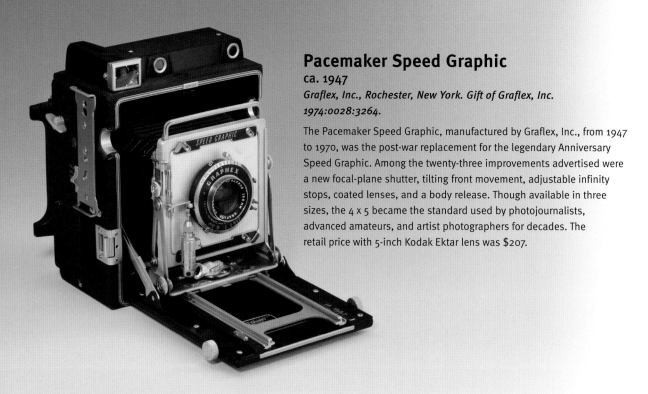

Pacemaker Speed Graphic

ca. 1947

Graflex, Inc., Rochester, New York. Gift of Graflex, Inc.
1974:0028:3264.

The Pacemaker Speed Graphic, manufactured by Graflex, Inc., from 1947 to 1970, was the post-war replacement for the legendary Anniversary Speed Graphic. Among the twenty-three improvements advertised were a new focal-plane shutter, tilting front movement, adjustable infinity stops, coated lenses, and a body release. Though available in three sizes, the 4 x 5 became the standard used by photojournalists, advanced amateurs, and artist photographers for decades. The retail price with 5-inch Kodak Ektar lens was $207.

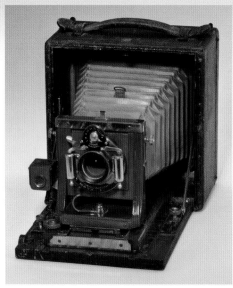

RB Cycle Graphic (4 x 5)

ca. 1900

Folmer & Schwing Manufacturing Company, New York, New York. Gift of Graflex, Inc.
1974:0037:1722.

Designed to collapse down to the smallest possible package, cycle cameras proved a popular carry-along with bicyclists. The RB Cycle Graphic, introduced in 1900 by Folmer & Schwing Manufacturing Company of New York, was the "embodiment of all that is perfect in a camera of cycle size." For viewers of old black-and-white movies, this may seem a vaguely familiar camera. Picture it with an added rangefinder and a wire-frame finder protruding above the front lens board and you have the Speed Graphic, the legendary press camera and offspring of the Cycle Graphic.

Widely believed to have surpassed all other cycle cameras in terms of workmanship and materials, the RB Cycle Graphic featured extra strong wood panels, heavier gauge brass fittings, and red Russia leather bellows. The reversible back (RB) could be removed and repositioned for vertical or horizontal images. This 4 x 5-inch model, with a Graphic RR lens, sold for $40. Substituting a Goerz or Bausch & Lomb lens would more than double the price. The camera was also available in 5 x 7-, 6½ x 8½-, and 8 x 10-inch sizes.

SMALL, MEDIUM, LARGE

DESPITE THE INCREASING POPULARITY of the small 35mm format cameras, not all photographers were happy with them. Bigger negatives always meant better quality prints. The Speed Graphic, introduced in 1912, still reigned in the minds of photojournalists and serious amateurs. In 1947, in an effort to maintain such an exalted position in a world increasingly taken with 35mm photography, Graflex, Inc. advertised the new Pacemaker Speed Graphic. It emphasized twenty-three improvements, including a new focal-plane shutter, tilting front movement, adjustable infinity stops, coated lenses, and a body release.

Spido Pliant Gaumont Type Tropical

ca. 1925

L. Gaumont & Cie, Paris, France. 1974:0028:3132.

French cameras of the early 1900s, especially those from Gaumont of Paris, often had a particularly industrial appearance, yet less in a modern sense than in a back-to-the-future, Jules Verne kind of way. Their designs hark back to the days when engineering marvels were iron works, like the Eiffel Tower, instead of moving toward the curvy, streamlined look of speed that we now associate with the twentieth century. Even with its teakwood body, a material more readily associated with handcraft than machine work, the Spido Tropical had the feel of a one-off prototype. The Tropical was part of Gaumont's Spido series of pliant (folding) cameras popular with press photographers. The vertical focal plane shutter could freeze sports action with its 1/2000 second maximum speed. A Newton finder with pendulum sight folded down when not in use. The mounting

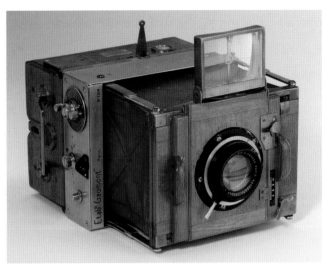

board for the Zeiss Krauss Tessar 13.5cm f/4.5 lens had rise and shift movements for perspective corrections. The teak and brass magazine held a dozen 9 x 12-cm film plates that could be quickly changed by pulling the magazine out by its handle and pushing it back in place. Loading and unloading the plates was a darkroom job.

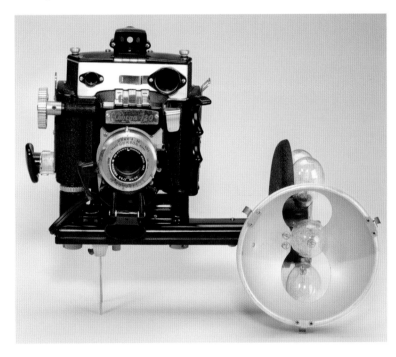

Omega 120

ca. 1954

Simmon Brothers, Inc., Long Island City, New York.
Gift of Simmon Brothers, Inc. 1974:0037:0088.

Better known for their Simmon Omega enlargers, Simmon Brothers, Inc., of Long Island City, New York, also made the Omega 120 medium-format professional camera, which produced 2¼ x 2¾-inch images on No. 120 roll film. Its novel feature was an automatic film advance that, with the single action of pulling out and pushing back a lever, advanced the film, counted the exposure, set the shutter, and even changed the bulb in the Repeater-Action flash holder. The retail price in 1954 was $239.50, and with a flash unit was an additional $49.50.

Nevertheless, the advantages of the 35mm SLR camera were enormous. Only its small image size seemed a drawback. To make 8 x 10-inch or 11 x 14-inch prints for magazine or portrait applications, the negative had to be enlarged ten times or more. Such pictures showed the grainy, sand-like texture inherent in all films. Most professionals used larger cameras and—

despite the alluring benefits of high-end digital cameras—some still do.

But the pull of the SLR system and its interchangeable lenses was powerful. One man thought he could deliver the best features of each.

On the eve of World War II, Victor Hasselblad(1906–1978) founded his company Victor Hasselblad Aktiebolag

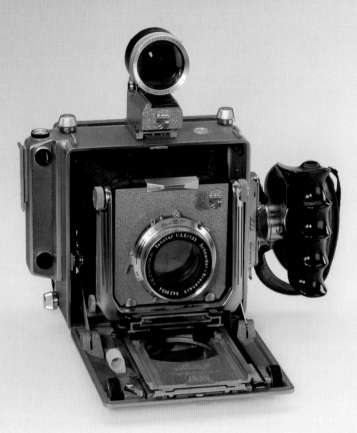

Super Technika IV
ca. 1956
Linhof Präzisions Kamera Werke GmbH, Munich, West Germany.
Gift of James Sibley Watson Jr. 1981:0790:0046.

Another iconic camera of the twentieth century is the Linhof Super Technika IV. Manufactured by Linhof Präzisions Kamera Werke GmbH of Munich, West Germany, and introduced in 1956, the latest model in a line that began in 1936 was fitted with a larger lens board to accommodate larger modern lenses and shutters, an improved front standard design that allowed for tilt as well as swing, and a revolving back. Suitable as either a press or field camera, the Super Technika IV had nearly the same perspective control capability as many monorail view cameras, making it also popular for use in the studio. Neither lightweight nor cheap, the 4 x 5-inch model weighed about eight and a half pounds and listed for $499.50, without lens, at introduction.

Sinar p2
ca. 1990
Sinar AG, Schaffhausen, Switzerland. Gift of Sinar Bron. 1989:0012:0001.

Commercial photographers routinely deal with demanding customers and impossible deadlines. Any equipment that helps the professional satisfy the fussiest clients is welcomed in the studio. Sinar AG of Schaffhausen, Switzerland, designed the p2 view camera using the same monorail concept as its first cameras from 1951. The standards are mounted on a tube or bar and connected with a bellows. This allows for fast adjustments and a wider range of movements than a baseboard camera. The p2's self-locking movements are micrometer gear-driven for fast, precise adjustment and asymmetrical for clear focus even during extreme movement. This 4 x 5-inch model, like most Sinars, is of modular design. The price at its 1990 introduction was $6,390, including the metering back. Despite the cost, Sinar cameras are among the most widely used in the commercial photography business.

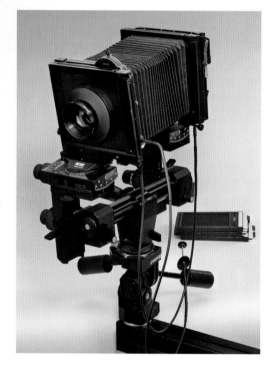

in Göteborg, Sweden, with contracts from the Swedish Air Force for aerial cameras. Hasselblad was convinced that he could produce the "ideal camera" for the professional photographer. The Hasselblad family had become involved in photographic products shortly after Eastman introduced dry plates. They became Eastman's Swedish distributor.

Many professionals concur that the Hasselblad 1600F, introduced in 1948, was the first in a series of nearly ideal cameras. Along with the Rolleiflex camera, it established what was to become a new class of professional cameras known as medium-format models that used square negatives measuring 2½ x 2½ inches (6 x 6 cm).

Rolleiflex I
ca. 1929
Franke & Heidecke, Braunschweig, Germany. 1974:0084:0121.

Introduced in 1929 by Franke & Heidecke of Braunschweig, Germany, the Rolleiflex was an instant classic. Rollei's compact twin-lens reflex design was constantly improved and manufactured well into the 1990s and was copied by many companies throughout the world. What made it popular was that the 6 x 6-cm format, being more than four times larger, made sharper enlargements than 35mm film. The large reflex finder screen, although it gave a mirror image of the subject, was bright and made it easy to focus the 7.7cm f/3.8 Carl Zeiss Jena Tessar lens. The Compur shutter with rim-set controls had a maximum speed of 1/300 second. Rolleiflexes were favorites of professionals and serious amateurs alike, prized for their superior optics, durable all-metal construction, and extensive catalog of accessories. The Rolleiflex I cost $75 in 1929.

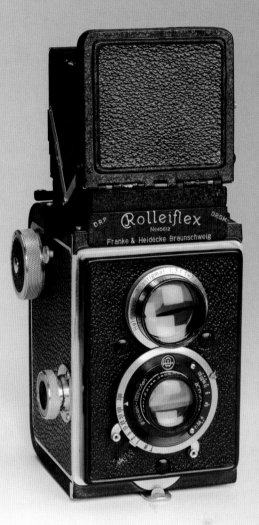

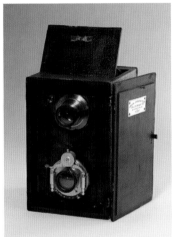 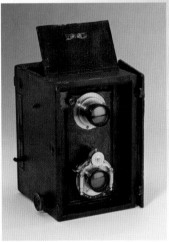

Magazine Twin-Lens "Artist" Camera
ca. 1899
London Stereoscopic and Photographic Company, Ltd., London, England. 1974:0037:0028.

Twin-lens reflex cameras were in quantity production long before the Rolleiflex appeared and defined the breed. One example was the Magazine Twin-Lens "Artist" Camera sold by London Stereoscopic and Photographic Company, Ltd., in 1899. Conceptually very similar to the later German product, the Magazine Twin-Lens had two lenses in an over-and-under mounting on a moveable panel. Light from the upper lens was reflected by a mirror to the underside of a ground glass. A door atop the box-shaped camera opened to reveal the viewing screen. The photos were taken by the bottom lens, the firm's own Black Band rapid rectilinear six-inch f/7.5 working through a Unicum shutter from Bausch & Lomb in Rochester, New York. The lens board was focused by turning a brass knob on the lower right side, which adjusted the distance using a rack-and-pinion drive. A rear door opened to access the magazine for the 3¼ x 4¼-inch plates or sheets and a lever on the side transferred the exposed plates and brought fresh ones in place.

Ikoflex (850/16)
ca. 1934
Zeiss Ikon AG, Stuttgart, Germany. 1974:0084:0126.

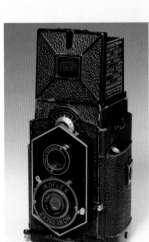

The first twin-lens reflex made by Zeiss Ikon AG was the Ikoflex, introduced in 1934. A very sturdy camera, it had a cast magnesium body that in early versions (as shown here) was a painted leather texture. Features included a rapid film advance lever on the lower front. Unique in running the film horizontally, rather than vertically, the Ikoflex produced 2¼ x 2¼-inch images on No. 120 roll film. It retailed for $36 in 1934.

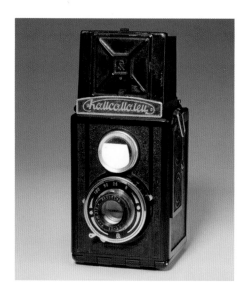

Комсомолец ("Communist Youth")
ca. 1946
GOMZ, Leningrad, USSR. 2005:0279:0001.

An exact copy of the popular 1930s German Voigtländer Brilliant, the **Комсомолец** or Komsomolet ("Communist Youth") was intended for young Soviets with limited experience in photography. The twin-lens reflex design made twelve 6 x 6-cm images on a roll of 120 film. Manufacture began in 1946 at the GOMZ factory in Leningrad, which was the only Russian manufacturer of twin-lens reflex cameras. This camera was succeeded by several improved versions that sold in the millions under the Lubitel name.

Anscoflex
ca. 1954
Ansco, Binghamton, New York. Gift of GAF Corporation. 1985:1250:0040.

The Anscoflex was introduced in 1954 by Ansco, of Binghamton, New York. It was a very sturdy, attractive, twin-lens reflex camera, a style very popular at the time. The unique feature was a sliding combination lens cover and viewfinder sunshade that had the appearance of a tambour door, which in operation slides vertically to uncap the lens and becomes the front part of the viewfinder shade. The camera, constructed in a gray and silver metal case, was styled by the renowned Raymond Loewy and retailed for $15.95.

Automatic Reflex
ca. 1947
Ansco, Binghamton, New York. Gift of Philip G. Maples. 1987:1604:0002.

After World War II, many photographic manufacturers wanted to take advantage of the twin-lens reflex camera's popularity. Ansco of Binghamton, New York, entered the 2¼ x 2¼ TLR market in a big way with the 1947 Automatic Reflex. Advertised as "America's Finest" TLR, the Automatic came with a sturdy aluminum body and coated 83mm f/3.5 lenses. Like the Rollei, it had the focus knob on the side, but also a ridged wheel on either side of the lens panel for fingertip focusing. The large shutter set-and-release levers were also located near the top lens. A side-mounted crank lever handled the job of film advance. This was a well-made premium camera with a price to match at $225 post-war dollars. Poor sales led to big price reductions in the 1950s, but foreign competitors dominated the medium-format field and Ansco abandoned the model soon after.

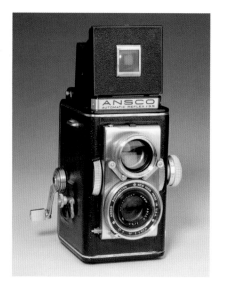

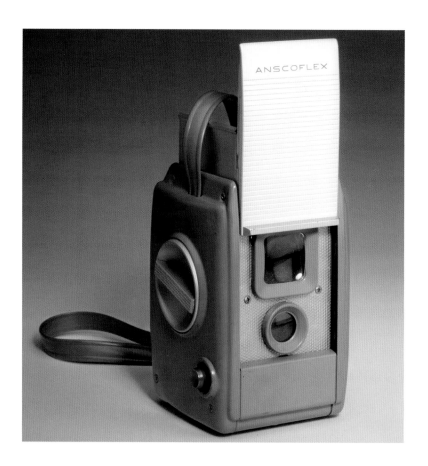

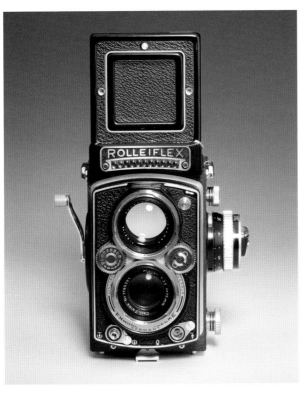

Rolleiflex 3.5E
1956
Franke & Heidecke, Braunschweig, West Germany. Gift of Rollei Corporation of America. 1978:0766:0001.

The Rollei name is best known for the twin-lens reflex roll-film cameras made by Franke & Heidecke in Braunschweig, Germany (West Germany, 1946–1990), since 1929. After World War II, many other camera manufacturers introduced TLRs, which only made the design more popular. In 1956, the E-series made its way into the TLR market as the first Rolleiflex with a built-in meter. The 3.5E was fitted with either Carl Zeiss Planar or Schneider-Kreuznach Xenotar 75mm lenses. The meter on the 3.5E wasn't coupled to the shutter-speed knob, so it took two steps for the photographer to adjust for light conditions. The F-series, which replaced the E in the Rolleiflex lineup in 1960, rectified this shortcoming.

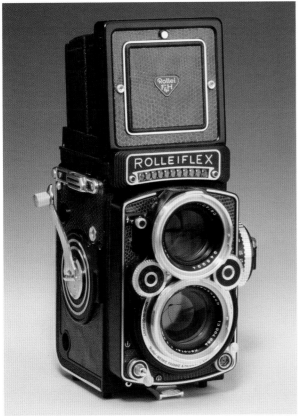

Rolleiflex 2.8F Aurum
ca. 1983
Franke & Heidecke, Braunschweig, West Germany. Gift of Berkey Marketing Companies, Inc. 1983:0694:0001.

The Rolleiflex 2.8F Aurum of 1983 descended from a long, distinguished line of twin-lens reflex cameras dating back to the pioneer 1929 Rolleiflex made by Franke & Heidecke in Braunschweig, Germany. The Aurum (Latin for "gold") was finished in black with alligator leather and gold-plated metal parts. Other than the finish and trim, it was a standard 2.8F model, long regarded by professionals and serious amateurs alike as one of the finest cameras produced anywhere. The Rolleiflex 2.8F took twelve 6 x 6-cm images on a roll of 120 film, or twice as many on 220, for cameras so equipped. The 80mm f/2.8 lenses, Compur shutter, bright focus screen, and coupled meter made it a favorite medium-format tool, especially for location shots where the Rolleiflex's ruggedness and reliability were important. Rolleiflex 2.8Fs were mounted with either Zeiss Planar or Schneider-Kreuznach Xenotar lenses.

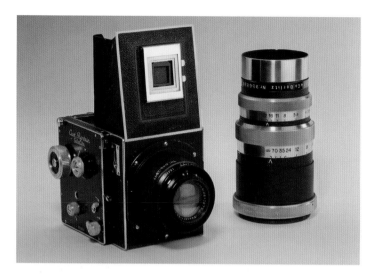

Primarflex
ca. 1936
Curt Bentzin, Görlitz, Germany. Gift of Philip Condax.
1974:0028:3347.

The Primarflex, manufactured by Curt Bentzin
in Görlitz, Germany, was introduced in 1935. It
was a high-quality 6 x 6-cm SLR anticipating the Hasselblad,
which was introduced a dozen years later. There is some
reason to believe that the young Victor Hasselblad became
familiar with the Curt Bentzin company early in his career,
having been sent to Dresden to learn the photo business. Like
the Hasselblad, the Primarflex had a compact square box
shape and used No. 120 roll film. The retail price with standard
lens was $145 in 1937.

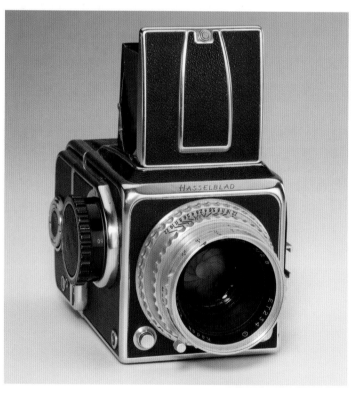

Hasselblad 1600F
1948
*Victor Hasselblad AB, Göteborg, Sweden. Gift of Eastman
Kodak Company. 1974:0037:0072.*

The introduction of the Hasselblad 1600F in 1948 was the result
of the successful effort of Swedish inventor Victor Hasselblad to
produce the "ideal camera" for the professional photographer.
There was little about the Hasselblad 1600F that was not
perfection, from its unique single-lens reflex design—the first
modular camera concept—to the interchangeability of film
magazines, viewing systems, and lenses. Measuring less than
four inches square and six inches long, the camera boasted a
fast 1/1600 second shutter speed and a thin, lightweight,
stainless steel foil focal-plane shutter.

Hasselblad's innovative camera designs evidenced
his twin passions for science and photography. A
serious birdwatcher, he was always on the lookout
for better ways to photograph birds in their natural
habitats. The Hasselblad 1600F was named for its
1/1600 second shutter speed that stopped fluttering
wings in motion.

The Hasselblad 1600F and successive designs were
embraced by professional photographers the world over,
including otherworldly photographers like NASA astro-
nauts Edward White and Walter Schirra. NASA even
contracted with Hasselblad and Nippon Kogaku (Nikon)
to supply special cameras for manned space flights—that
later recorded these missions with stunning results.

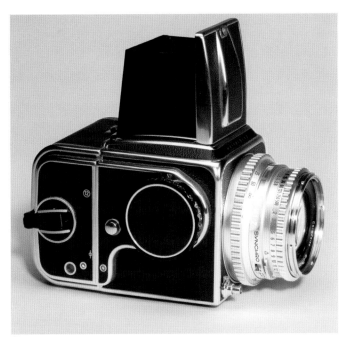

Hasselblad 500C
ca. 1957
Victor Hasselblad AB, Göteborg, Sweden. Gift of Eastman Kodak Company. 1999:0163:0001.

Introduced in 1957, the Hasselblad 500C was destined to become an instant classic. Built by Victor Hasselblad AB, Göteborg, Sweden, it succeeded the 1600F and later 1000F cameras, both of which used focal-plane shutters. The new 500C was still basically the same 2¼-inch square reflex medium-format SLR, but with the new Synchro-Compur leaf shutter built into every lens. It offered full aperture viewing, automatic diaphragm, and flash synchronization at all shutter speeds. As with previous Hasselblad cameras, interchangeable film magazines allowed for an easy mid-roll change from one film type or format to another. In 1970, the 500C was modified slightly and became the 500C/M, which had a quick change viewing screen. In 1962, astronaut Walter Schirra bought a Hasselblad 500C. NASA removed the leatherette covering, painting it black to minimize reflections. In October 1962, he took it up into space—making it the first Hasselblad camera used in space.

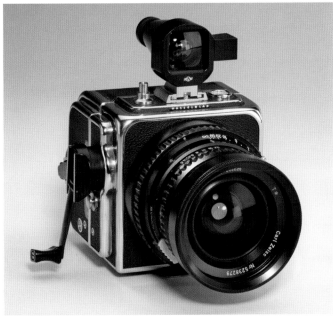

Hasselblad SWC
ca. 1969
Victor Hasselblad AB, Göteborg, Sweden. Gift of Victor Hasselblad AB. 1974:0028:3079.

Manufactured by Victor Hasselblad AB of Sweden, the Hasselblad SWC is a wide-angle version of the venerable Hasselblad 500C. A short non-reflex viewing body immediately identifies it as a "Super Wide," a line that began with the SWA. Second in the series, the SWC of 1959 incorporated the film advance and shutter cocking in a single crank and moved the shutter release to the top of the body. The example shown here has a black anodized Biogon lens barrel that indicates a manufacture date of post-1969. The retail price, with 38mm Biogon lens and viewer, was $700.

Victor Hasselblad's approach to camera design was so successful that competitors such as Kowa (in 1968), Pentax (in 1969), and Mamiya (in 1970) created their own medium-format models.

Hasselblad's legacy continues today with the Edna and Victor Hasselblad Foundation, established after Hasselblad's death in 1978. Headquartered in Sweden, the foundation promotes research and teaching in the natural sciences and photography. Its annual major achievement award to a photographer carries an aura recalling the Nobel Prize. Past winners have included Ansel Adams, Sebastião Salgado, Richard Avedon, Henri Cartier-Bresson, Robert Frank, Irving Penn, and Graciela Iturbide.

Space Cameras

PHOTOGRAPHY IS A VITAL ELEMENT in the study of the heavens, an important tool in both astronomy and space exploration. In the more than half century of its existence, NASA has used many different camera systems and sub-systems, progressing from off-the-shelf consumer products to custom-built equipment. The millions of images taken of the universe have added greatly to our knowledge of distant and hostile places.

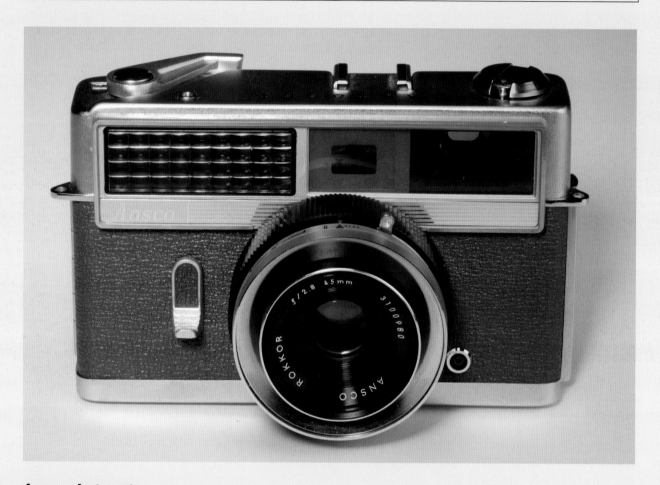

Ansco Autoset
ca. 1961
Ansco, Binghamton, New York. Gift of Eastman Kodak Company. 2008:0301:0001.

Manufactured by Minolta for Ansco, the Autoset is best known as the hand camera used by John Glenn on Friendship 7, the first U.S. manned space flight to orbit the earth. To produce an apparatus suitable for outer space, NASA purchased several cameras from a local drugstore and made numerous modifications, including milled components for reduced payload weight and a coat of black paint. Now oriented upside down for left hand operation (Glenn's right hand was needed to fly the spacecraft), the customized camera was fitted with an auxiliary viewfinder, as well as a large film advance lever and a pistol grip that accommodated access by space-gloved hands. For a few years after the successful flight, Ansco advertised the Autoset as the "First handheld camera used in outer space by an astronaut." Later U.S. manned space missions used special cameras supplied by Hasselblad and Nippon Kogaku (Nikon).

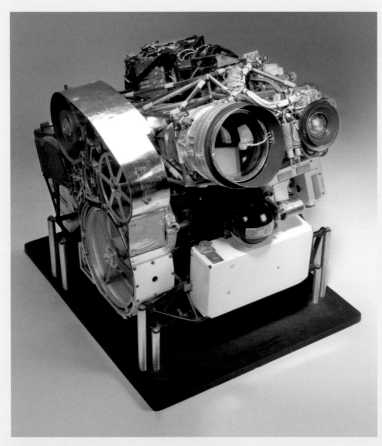

Lunar Orbiter camera payload
1967
Eastman Kodak Company, Rochester, New York. Gift of Frank Marussich. 1981:0795:0001.

In the early 1960s, NASA began to develop a Lunar Orbiter Program that would photographically map the entire surface of the moon to aid in site selection for the planned manned lunar landings of the Apollo space program. After compiling specifications, the agency solicited design proposals from aerospace firms, ultimately awarding the contract to Boeing, with Eastman Kodak Company and RCA being major subcontractors. While Boeing built the mission vehicle, Kodak's contribution to the project was a photographic subsystem that included a 65mm film media for image capture, two lenses, onboard film processing that used the Kodak Bimat process to eliminate the use of "wet" chemicals in the development, and a scanner and video system.

Once the photographs were taken, the film was developed and electronically scanned, and the negative images were transmitted as analog video to ground receiving stations back on Earth. They were then written back to film and shipped to Kodak in Rochester, New York, for final reconstruction. A total of eight subsystems were built by Kodak, five of which made one-way trips aboard Orbiter spacecraft in 1966 and 1967. During the five missions, the many images made provided a wealth of knowledge to NASA scientists. Another photograph made was perhaps less scientifically useful, but certainly more cosmically appealing—the first shot of the Earth taken from the vicinity of the Moon.

The apparatus shown here was originally unfinished, as it wasn't needed for the program. It was acquired at government auction by Rochester's Genesee Tool and Die Corporation, completed, and donated to George Eastman House.

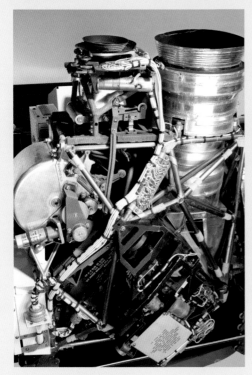

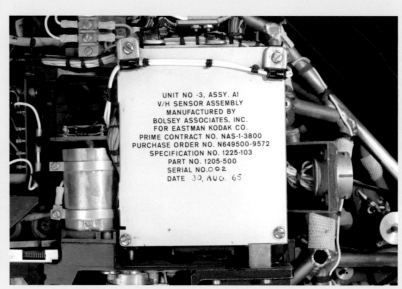

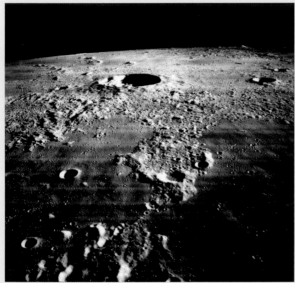

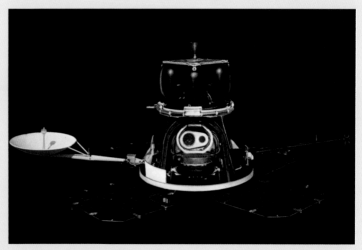

Unidentified artist. *[Rendering of Lunar Orbiter spacecraft in flight configuration]*, 1966. Courtesy NASA

LUNAR ORBITER III. 80mm LENS MEDIUM RESOLUTION PHOTOGRAPHY OF SITE S-26 (KI-3049); CRATER KEPLER AND VICINITY; ORBITER ALTITUDE 36 STATUTE MILES, DISTANCE TO CRATER, 80 STATUTE MILES, February 15–23, 1967. Gelatin silver print. Gift of William Vaughn. George Eastman House collections.

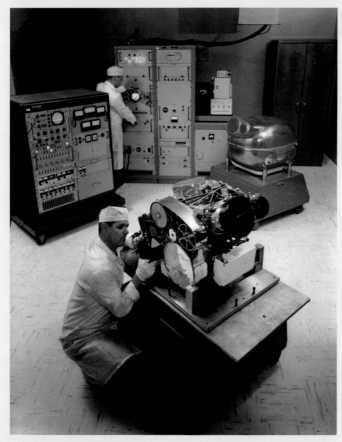

Unidentified photographer. *[Eastman Kodak Company technicians working on Lunar Orbiter]*, 1966. Kodacolor print from C-41 negative. Gift of Eastman Kodak Company. George Eastman House collections.

Hasselblad Electric Camera (HEC)
ca. 1969

Victor Hasselblad AB, Göteborg, Sweden. Gift of Victor Hasselblad. 1974:0028:3081.

The first Hasselblad camera used in space was a 500C carried onboard Mercury Sigma 7, which flew October 3, 1962. A standard off-the-shelf model, it was purchased at a Houston camera store by astronaut Walter Schirra (1923–2007) and modified slightly by NASA, with the leather panels removed and the camera body painted black to reduce reflections. That mission's high-quality photographs prompted NASA to contract Hasselblad to build special models for the space program. Since then, Hasselblad cameras have served on virtually all NASA manned flights.

The Hasselblad Electric Camera (HEC), a modified version of the Hasselblad EL/70, first flew on Apollo 8 in December 1968 and was used for the remainder of the Apollo program, including the moon landing missions, as well as the Skylab and space shuttle missions of the early 1980s. Interestingly, all the cameras used on moon landings were left there. Due to weight concerns at the lunar takeoff, only the film magazines came down to Earth.

The example shown here did not travel into space—it was donated personally by Dr. Victor Hasselblad to the George Eastman House Technology Collection in March 1972.

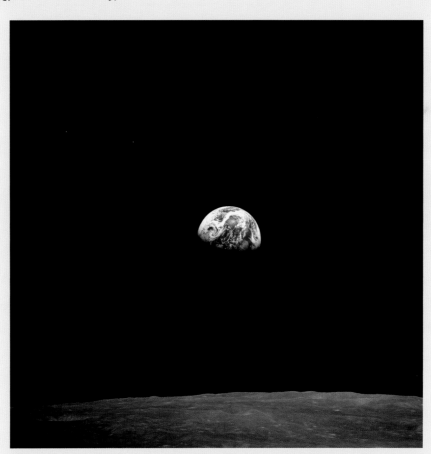

William Anders (American, b. 1933). *[Earth rise over the moon]*, December 24, 1968. Ektachrome transparency. Courtesy NASA.

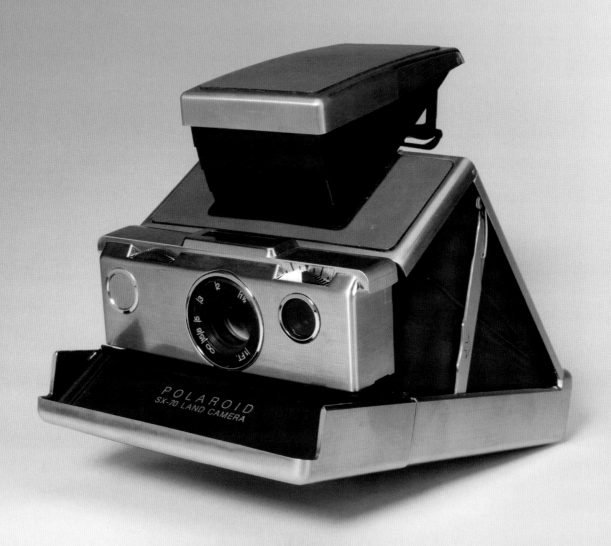

SX-70 Land Camera, ca. 1972. See page 307.

XVI

EVER EASIER: INSTAMATIC AND POLAROID

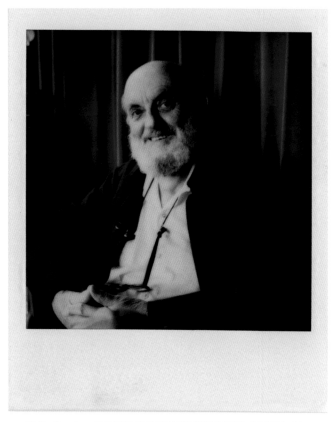

Philip Condax, *PORTRAIT OF THE PHOTOGRAPHER, CARMEL, CA [Ansel Adams]*, 1974. See page 307.

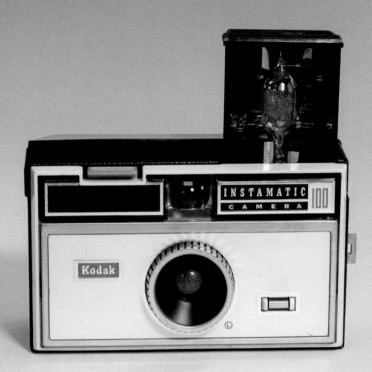

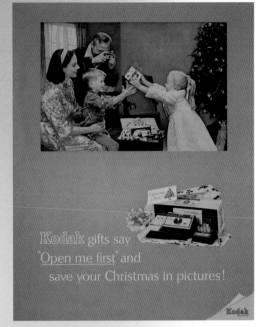

Advertisement promoting Kodak cameras for Christmas pictures, 1963. Gift of Eastman Kodak Company. George Eastman Legacy Collection.

Instamatic 100
1963
Eastman Kodak Company, Rochester, New York. Gift of Eastman Kodak Company. 1974:0037:0246.

The Kodak Instamatic 100 camera was introduced in 1963. In various forms, the Instamatic line would stay in production for more than twenty years. The 100 was a simple little plastic box camera with fixed-focus, a pop-up flash gun, and rapid lever wind. Its use of a drop-in cartridge was not novel; attempts to utilize cartridge loading began in the 1890s. None were as successful as the Kodak No. 126 cartridge, which revolutionized the snapshot industry. The Instamatic 100 outfit retailed for $16 in 1963.

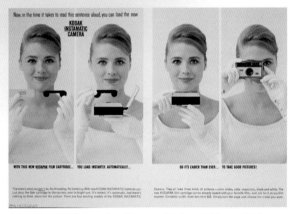

Advertisement featuring the new Kodapak film cartridge, 1963. Gift of Eastman Kodak Company. George Eastman Legacy Collection.

THE SIXTIES WERE AN ERA OF initials and nicknames: JFK. LBJ. LSD. SDS. Stones. Dead. Janis. Pot. Nam.

Most Americans alive in the 1960s recall and respond to those codes. And the memory flashes on the pictures—mostly stills, many in black-and-white.

Two words defined photography in the sixties: Instamatic and Polaroid.

The Kodak Instamatic 100 camera was introduced in 1963—a camera built around a cartridge. Before then even the simplest camera had to be loaded with film, a task that required hooking sprocket holes onto little gears, closing the camera, then advancing the film two or three times while making sure the film was spooling through. This did not inspire the very highest confidence. People would come into stores and timidly ask clerks to do it for them. Even professionals would fumble now and then.

The new system came about as a result of "Project 13," a top-secret R&D program begun at Kodak in the late 1950s. It was a small plastic box camera with fixed-focus tack-sharp 43mm f/11 lens, a pop-up flash, and film

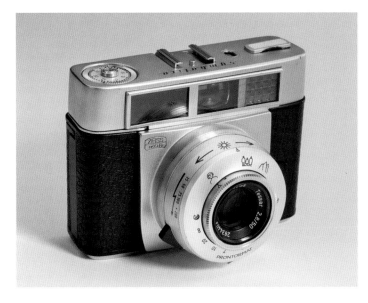

Symbolica (10.6035)
ca. 1959
Zeiss Ikon AG, Stuttgart, West Germany. Gift of Eastman Kodak Company. 1991:0540:0005.

Zeiss Ikon of Stuttgart, West Germany, built some modestly priced 35mm focusing cameras that lacked rangefinders, thus requiring the photographer to estimate distances. In 1959 they sought to cut cost and complexity while still providing accurate focusing. The Symbolica II replaced the rangefinder with a set of pictographs on the lens focus ring, showing settings for a single person close-up, a group, and a mountain range. Detents at each zone symbol set the 50mm f/2.8 Tessar lens for the corresponding situation, although it was a sometimes a compromise. A numerical scale was still provided for those with a good eye for distances. These symbols have since been adopted by other manufacturers for their own zone-focus models. The Symbolica II had a coupled meter visible in the viewfinder and fingertip knobs on the aperture control ring that the user rotated until the meter needle was centered.

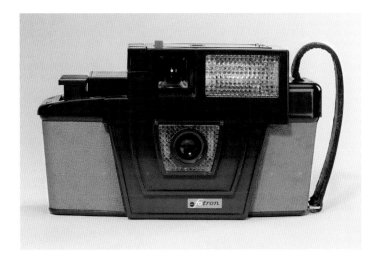

Fotron
ca. 1960
Traid Corporation, Encino, California. Gift of Charles Benton. 1989:0904:0001.

The Traid Fotron camera, introduced in the early to mid-1960s, had several new technology features, including auto exposure, motorized film advance, built-in electronic flash, built-in battery charger, and "Snap Load" cartridge film. It produced ten square images on No. 828 film, which was processed via mailer by Traid, a "pioneer in America's space and defense systems." The cameras were marketed exclusively through door-to-door sales, selling at up to $415.

advance lever that needed to be cranked only once. It used a film format, 126. (The film was about 26 mm square, and Kodak inserted a "1" before the specification.) The Instamatic 100 outfit retailed for $16 in 1963.

As Douglas Collins wrote in *The Story of Kodak*, removing the intimidating barrier of correctly loading roll film into a camera led to "probably the best judged marketing coup in commercial photographic history." Over the twenty-year life of the trademark, an estimated ten million cameras were sold.

Meanwhile, 35mm cameras were evolving, often in response to problems. For instance, the underwater photographer Jacques-Yves Cousteau (1910–1997) found his photographic equipment inadequate. In an effort to meet the needs of the most famous aquatic scientist of the time, France's Spirotechnique, of Levallois-Perret, produced the Calypso in 1960. The Calypso (named after Cousteau's ship) was a watertight 35mm scale-focusing model that needed no external housing. The

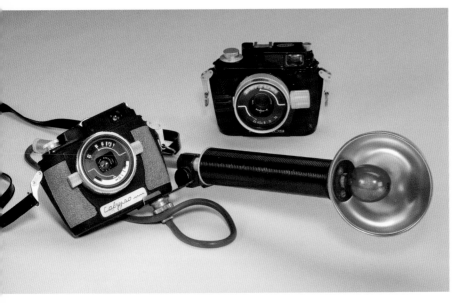

Calypso
ca. 1960
Spirotechnique, Levallois-Perret, France. Gift of John and
Zarnaz Arlia. 2006:0251:0001–2.

Nikonos
ca. 1963
Nippon Kogaku K. K., Tokyo, Japan. Gift of Ehrenreich
Photo-Optical Industries (EPOI), Inc. 1974:0028:3164.

The first commercial camera produced specifically for amphibious photography, the Calypso was designed for Jacques-Yves Cousteau and manufactured by Spirotechnique of Levallois-Perret, France, in 1960. Its O-ring-sealed body was watertight without need of an external housing, yet the same size as a normal 35mm camera. Tested to 200 feet, it was also tropicalized and protected against corrosion, sand, and mud. The covering is a gray imitation sealskin. The design was later sold to Nikon and evolved into the Nikonos line of cameras.

Nikonos IV-A
ca. 1980
Nippon Kogaku K. K., Tokyo, Japan. Gift of Nikon, Inc.
1981:3208:0027.

The Nikonos IV-A of 1980, manufactured by Nippon Kogaku of Tokyo, was the first updated version of the amphibious line of cameras originally designed by Spirotechnique as the Calypso camera for Jacques-Yves Cousteau. The Nikonos IV-A featured an automatic aperture priority exposure system with an electronic shutter, a hinged film back, and O-ring seals, waterproof to 160 feet. Its new die-cast body was more rugged-looking and used a textured rubber covering and featured a hinged back for ease of loading. The series's final model appeared in 1984 as the Nikonos V, with a new bright orange covering on the body.

design was later sold to Nippon Kogaku and evolved into the Nikonos line of underwater cameras.

The 1960s saw the ongoing evolution of themes that had long intrigued—and inspired—camera manufacturers: the need to simplify cameras with automation, to make them smaller, to lower cost by streamlining manufacturing. Better plastics, batteries, and electronics were evolving independently and added value.

A big step forward in electronic automation was taken by Tokyo's Asahi Optical Company in 1964. The Pentax Spotmatic camera (its official name was Asahi Pentax SP) was the world's first SLR to offer what would soon become standard on all SLRs: through-the-lens metering (TTL). It was based on a 1960 prototype. In the U.S., the camera was imported by Honeywell and carried the distributor's name on the camera's pentaprism. A simple, manually controlled camera of relatively low cost, it soon became a favorite choice of photography students.

Exposure meters were moving inside the cameras. Exposure was important to all serious photographers but especially critical to those using slide films. Both

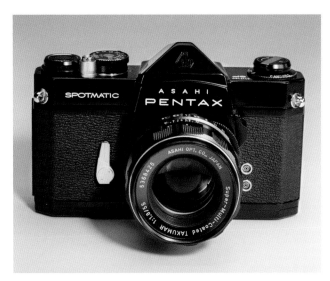

Spotmatic
ca. 1964
Asahi Optical Company, Ltd., Tokyo, Japan. Gift of Asahi Optical Company. 1981:1296:0027.

The Asahi Pentax SP, introduced in 1964, was manufactured by Asahi Optical Company, Ltd., of Tokyo. Commonly referred to as the Spotmatic, it was the production model of their 1960 Spotmatic prototype, the world's first SLR with through-the-lens metering (TTL). In the U.S., the camera was imported by Honeywell and carried their name on the pentaprism. The SP body eventually became the K-1000, a favorite of the high school and college photography student due to its relatively modest cost, simplicity, and all-manual controls generally required by photography instructors.

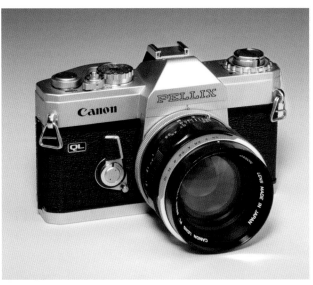

Canon Pellix
ca. 1965
Canon K. K., Tokyo, Japan. 1974:0028:3054.

The Canon Pellix 35mm SLR camera, introduced in 1965, was a unique design employing a "pellicle" semi-silvered mirror. The semi-silvering allowed seventy percent of the light to pass through to the film and the remaining thirty percent to reflect up to the finder, eliminating the usual moving mirror. There was a resulting drop in brightness in the finder and on the image, estimated to be about one-third of a stop, offset somewhat by a fast f/1.4 lens. The stationary mirror had the advantage of not blocking the shot at the moment of exposure, but it also required a metal focal-plane shutter to prevent the burn-through a cloth shutter would suffer from bright sunlight. The retail price in 1966 was $299.95.

black-and-white and color negative films had a wide "latitude." Under- and overexposed negatives could be printed in ways that compensated for their defects. Slide films (also called reversal films) were unforgiving. Either the exposure was right, or it wasn't and you threw the slide away.

Early photographers had relied on exposure tables that correlated aperture and shutter settings with film speed and lighting. Handheld exposure meters became common by the 1930s. Many studio and other professional photographers rely on them still.

But for most users, cameras with built-in meters or entirely automatic exposure controls eliminated the problem. Automatic exposure controls work because the metering and exposure controls (aperture/shutter/speed settings) recommend or set the correct exposure. Such progress was made possible because of miniaturized electronics: sophisticated sensors, exposure programs, and so on. Many recent cameras have become virtual computers with lenses, laden (some say larded) with features and options few people cared about before they were introduced.

Land Camera Model 95
ca. 1948
Polaroid Corporation, Cambridge, Massachusetts. 1974:0028:3137.

In February 1947, inventor Dr. Edwin H. Land demonstrated the Polaroid Land Camera, the world's first instant camera. It went into production in 1948 and became an immediate success. The first Polaroid camera, the model 95, used roll film and produced finished 3¼ x 4¼-inch prints in just sixty seconds. After exposure, pulling a tab caused the roll of negative film to join with print paper as they were drawn through rollers. At the same time the rollers spread developer evenly across the interface surface to process the print.

Over time, film improvements meant that a film pack replaced the roll film and allowed for the print to develop outside the camera, letting the user take another picture immediately. Faster film required only ten seconds to the finished black-and-white print, and color film was added. Camera advances included sonar auto focusing, and a later model, the SX-70, was a folding SLR. The retail price at introduction was $89.75.

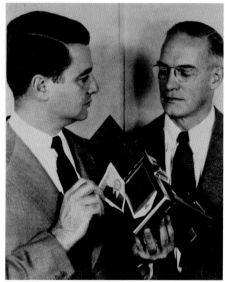

Unidentified photographer. [Dr. Land showing an MIT professor how the Polaroid camera works], ca. 1948. Gelatin silver print. George Eastman House Technology Collection.

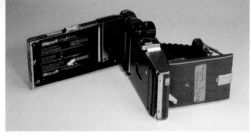

EDWIN LAND: THE MAGICIAN

Edwin Land (1909–1991) had much in common with George Eastman. He was an inventor and a businessman. He coined a memorable name. He invented a new camera/film system. It flourished without competition.

Land went to Harvard but did not pursue a degree he would never need. On the basis of his first inventions—inexpensive polarizing filters—he formed Polaroid Corporation in 1937, in Cambridge, Massachusetts.

The problem defined itself when he was photographing his young daughter, Jennifer, and promising the pictures. "Why can't I see them now?" she demanded. A doting father, Land went to work.

In February 1947, he demonstrated his principal invention. The Polaroid Land camera went into production the next year.

It was an immediate success. The first camera, the model 95, used roll film made by Kodak for Polaroid and delivered finished 3¼ x 4¼-inch prints in just sixty seconds.

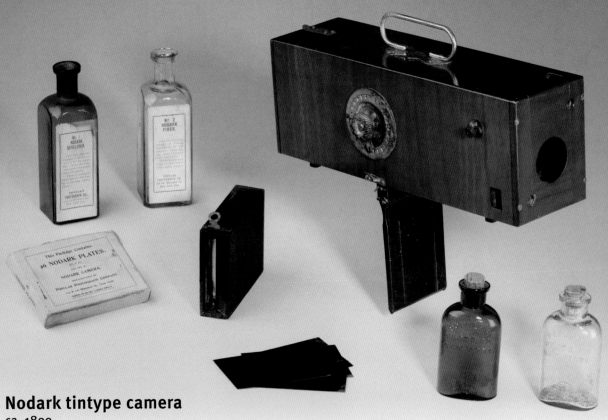

Nodark tintype camera

ca. 1899

Popular Photograph Company, New York, New York. 1974:0037:1762.

The magazine ads boasted "A Finished Picture in a Minute," but this wasn't the 1948 Polaroid introduction. It was 1899 and the camera was called Nodark, a hardwood-bodied box built to use metal dry plates, popularly known as tintypes. Nodark outfits were sold by Popular Photograph Company in New York for six dollars, delivered. What you got for your money was a camera with a meniscus 5-inch f/10 lens, two finders, and a non-automatic shutter. The slow media of the day required exposures too long for a simple snap shutter. The tintypist had to keep both camera and subject still while the shutter was open. Inside the box was a darkroom-loaded wooden magazine with twenty-six 2½ x 3½-inch plates in individual slots. A bright, plated knob on the side turned to advance the next fresh plate into position as a knob pointer tracked the remaining plates. When the narrow dark slide was pulled out, the exposed tintype dropped from the magazine into a developing tank or storage box slipped on the bottom side. Chemicals included in the outfit developed the plates individually or in batches.

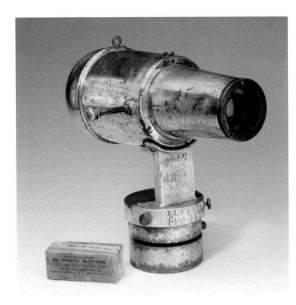

Wonder Automatic Cannon Photo Button Machine

ca. 1910

Chicago Ferrotype Company, Chicago, Illinois. 2000:0413:0001.

Earning a living as a portrait photographer usually involved a considerable investment for equipment, supplies, and studio. Additional money had to be spent on advertising your services. In 1910, Chicago Ferrotype Company offered an alternative. For $30, they would deliver the Wonder Automatic Cannon Photo Button Machine and enough supplies for you to start business immediately. The idea was to set up the four-pound Wonder Cannon in busy public areas and offer passers-by a metal button with their picture on it for five cents. A hundred one-inch diameter sensitized blanks could be loaded into the nickel-plated brass cannon's breech in daylight. When the subject was centered in the sights, a squeeze of the rubber bulb operated the shutter. The exposed buttons didn't have to be removed for developing. A quick push-pull of the "bolt" dropped the button into a tank of developer, and thirty seconds later it could be removed, rinsed, and popped into a pinback frame. All this for a nickel.

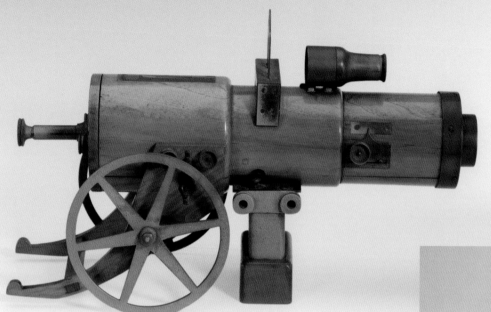

Räderkanone

ca. 1912

Romain Talbot, GmbH, Berlin, Germany. Gift of Kodak Pathé. 1988:0099:0001.

A button portrait camera was a familiar sight at tourist attractions, carnivals, and other gatherings where souvenirs were sold. The Räderkanone of 1912 was made by Romain Talbot GmbH of Berlin for concessionaire use and could deliver your portrait on a one-inch-diameter metal button in a minute. Made mostly of polished hardwood, it was styled like a field gun, right down to its brass wheels. More than fifteen inches in length, the camera was loaded from the rear with a tube full of tintype blanks. Using the scope atop the barrel, the vendor centered the customer's face in the circle. A spring-loaded plunger moved the blanks forward to be exposed by the f/4 lens when the shutter at the muzzle end was tripped. A push of the transfer plate dropped the exposed button into the tank of developer beneath the barrel. When the photographer retrieved the developed button and finished washing it, the customer handed over a five-cent piece and walked away happy.

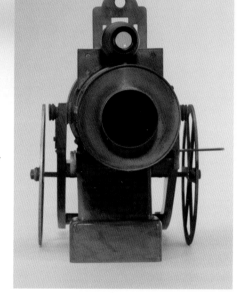

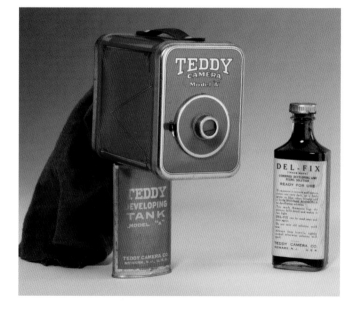

Teddy Camera

ca. 1924

Teddy Camera Company, Newark, New Jersey. Gift of Eastman Kodak Company. 1990:0458:0007.

Long before Edwin Land's 1947 Polaroid camera made it look so easy, there were many attempts at cameras that processed their own prints after exposures were made. In 1924, the Teddy Camera Company of Newark, New Jersey, added their two-dollar answer to that list. Tin-can technology made the low price possible, but like most tries at "instant" cameras, this one required extra work both before and after the shot. The Teddy Model "A" didn't use film. Exposures were made on a sensitized card that was transferred to the developing tank hanging from the underside. To do this in darkness, the user had to slip a hand through the flannel sleeve on the back cover. Teddy sold a combined developing and fixing solution, Del-Fix, that was poured into the removal tank. Handheld photos were seldom possible with a Teddy because of the long exposure times needed for the direct-positive prints.

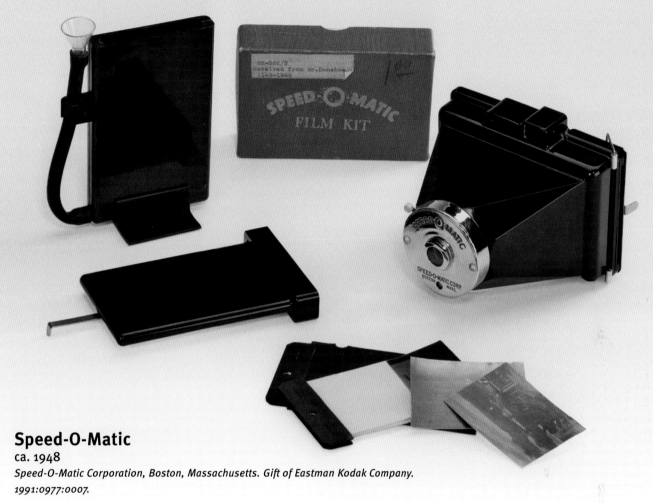

Speed-O-Matic
ca. 1948

Speed-O-Matic Corporation, Boston, Massachusetts. Gift of Eastman Kodak Company.
1991:0977:0007.

The Speed-O-Matic camera was introduced in 1948 by the Speed-O-Matic Corporation of Boston, Massachusetts. It was an interesting, if not successful, "instant" camera producing 2 x 3-inch images on direct positive paper. The black Bakelite body had an extinction meter that allowed the photographer to select one of five apertures. A sliding rod on the back transferred the exposed image to a holder that was mounted to the developing tank, where a mono-bath developed the images. In 1950 the camera was redesigned by the Dover Film Corporation to use traditional No. 620 film.

Instant cameras enchanted consumers. But just as important, they found demand in any business where pictures on the spot saved time and money. ID cards and passports. Insurance documents. Crime scenes. Medical and dental applications. Advertising and fashion photographers (who spent tens of thousands of dollars on models and setups) used instant photography to verify that compositions looked good, that lights were placed properly.

Land's camera was easy to use. The photographer would load a roll of picture paper through a slot in the top of the camera and thread its leader between two rollers and out through a slot at the bottom of the camera. He then loaded the negative paper in the bottom slot. After taking a picture, the photographer would pull the leader, sandwiching the paper and negatives together as it drew them through the rollers. The squeezing rollers would break a chemical pod at the front of the paper strip and spread its processing chemicals across the negative film. Sixty seconds later, the photographer opened a flap in the back of the camera and peeled the finished print away from the film to see a fully developed sepia-color image.

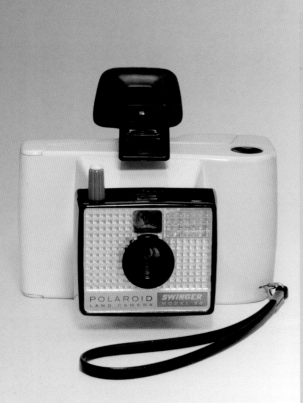

Swinger Model 20 Land Camera
ca. 1965
Polaroid Corporation, Cambridge, Massachusetts.
Gift of Eastman Kodak Company. 1996:0473:0001.

Polaroid's Swinger, introduced with great fanfare in 1965, was heavily advertised on television. Aimed at the teen market, the all-plastic Swinger was Polaroid's entry-level instant camera. Pinching the shutter button let the user know whether there was enough available light. If "YES" appeared in the viewfinder, you were ready. "NO" meant you had to pop in a flash bulb first. Once the button was pressed, all you had to do was pull a tab to start the developing process—which took place outside the camera—wait sixty seconds, and peel the finished picture free.

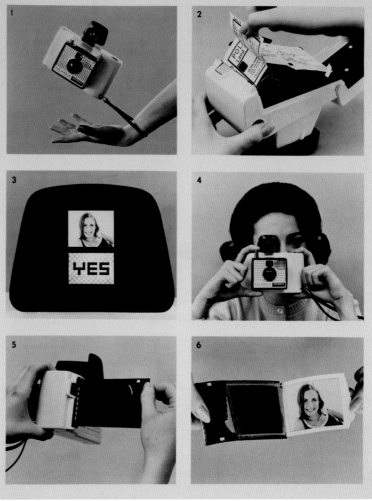

Advertisement for Polaroid Swinger camera, 1965. George Eastman House Technology Collection.

A word here about plastic. Any purchase weighs value received in light of quality, convenience, and cost. Whenever plastic replaces a more expensive material, it lowers manufacturing cost, which lets companies lower price. Consider the Polaroid Swinger, introduced with great television advertising fanfare in 1965.

The all-plastic model was designed to lure teenagers into Polaroid photography. With a simple pinch of the shutter button, the user could determine the amount of light available for the exposure. "YES" or "NO" signals in the viewfinder told a person whether or not a flash bulb would be necessary. After taking the picture, the photographer only had to pull

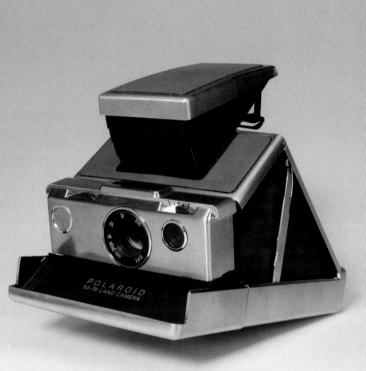

Philip Condax (American, b. 1934). *PORTRAIT OF THE PHO-TOGRAPHER, CARMEL, CA [Ansel Adams]*, 1974. Color print, internal dye diffusion-transfer (Polaroid SX-70) process. Gift of the photographer. George Eastman House collections.

SX-70 Land Camera
ca. 1972
Polaroid Corporation, Cambridge, Massachusetts. Gift of Eastman Kodak Company. 1999:0140:0001.

Polaroid's SX-70 Land Camera made its spectacular debut in 1972, even showing up on the cover of *Life* magazine. The futuristic look and fresh technology was a startling break from any previous Polaroid product. When opened, it resembled no other camera, and when folded for carrying, didn't look like a camera at all. The film itself was an extraordinary piece of design. You simply unwrapped the flat pack and slipped it into the camera base. Each pack had its own battery that powered the print eject motor, electronics, and flashbar. The viewfinder was large and bright, making it easy to focus down to 10½ inches.

The real fun began when you pressed the shutter button. Almost immediately, the distinctive SX-70 song heralded the arrival of an exposed print from the front of the camera. An image began to appear on the blank white sheet and a minute later was fully developed, whether you held it in the light or put it in your pocket. Photographers had no peel-off waste or chemical goop to deal with because everything was contained in the print and activated when the whirring motor squeezed it through a pair of rollers on its way out. All this was available for a list price of $180. Later versions of the camera had sonar autofocus. The SX-70's technology migrated to new lower-priced Polaroids as well as into some non-photographic products.

a tab, wait sixty seconds, then peel the finished picture free. The Swinger's huge success was spurred by the jingle on its clever TV commercial: "It's more than a camera, it's almost alive, it's only nineteen dollars and ninety-five."

Soon an integral film pack (no chemical mess) allowed prints to develop outside the camera as the photographer continued taking pictures. Faster film cut development time from sixty seconds to ten seconds. Instant color pictures became available in 1963.

But it was the SX-70, a folding, motorized SLR unlike any camera ever seen, that shocked the world in 1972, when "the most amazing camera ever produced" appeared on the cover of *Life* magazine.

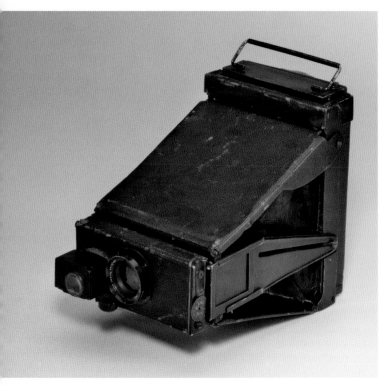
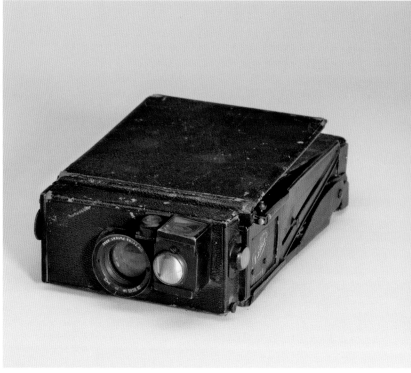

Nattia
ca. 1905
Adams & Company Ltd., London, England. Gift of Graflex, Inc. 1974:0037:2313.

Photography, like all human endeavors, is an evolutionary process. Making it easy and convenient for amateurs kept many camera designers busy after George Eastman's extraordinary success with the Kodak. At introduction, the Polaroid SX-70 was described as a camera like no other. However, earlier portable cameras may have influenced its designers, including the Adams Nattia. Unveiled nearly seventy years before the SX-70, the Nattia featured a similar pocket-sized folding system, albeit without reflex focusing. The goal for companies such as Adams was to offer a sturdy, capable camera that could be carried in a coat pocket or purse. In 1905, the engineers at Adams's London works created what they called "The Best" pocket camera available. The Nattia could use dry plates, cut film, or roll film, simply by changing from one holder to another. Focusing was easy with the rack and pinion with distance scale, and a bright finder made for fast framing of subjects. The shutter behind the Ross 9-inch f/6.3 Zeiss Patent Protar lens was set with a push-pull rod and tripped with a button at the exact location of the user's index finger. Being an Adams camera, the Nattia had the features of larger cameras, such as rising front and bubble levels. Best of all, the nineteen ounce Nattia folded into a tight, tidy package that could be toted along and be ready for action in seconds. It was priced under £17.

Its design seemed bizarre, un-camera-like. It looked like an elegant leather case when closed. The user simply unwrapped the flat film pack and slipped it into the camera base. Each ten-exposure film pack had its own battery that powered the print eject motor, electronics, and flashbar. A quiet whir followed the shutter click, and the camera pushed out the picture, which began to develop under your eyes. It focused as close as 10½ inches. Its list price was $180. The line flourished at first, as new models came along, including one with Sonar focus in 1978.

As Polaroid's success grew, so did the interest of competitors. In 1952, Leningrad-based Gomz introduced the

Kodak Handle Instant Camera
ca. 1977
Eastman Kodak Company, Rochester, New York. Gift of Eastman Kodak Company. 1981:2812:0006.

Introduced in 1977, the Kodak Handle Instant Camera was a solid body, direct light path, inexpensive instant camera, named for the large handle molded into its body. Instead of folding bellows or mirrors, it used a long snout for direct path imaging. It also used a folding crank handle for picture ejection. A popular premium version of the Handle was manufactured for Coca-Cola as the Happy Times camera. The Handle retailed for $39.95 at introduction.

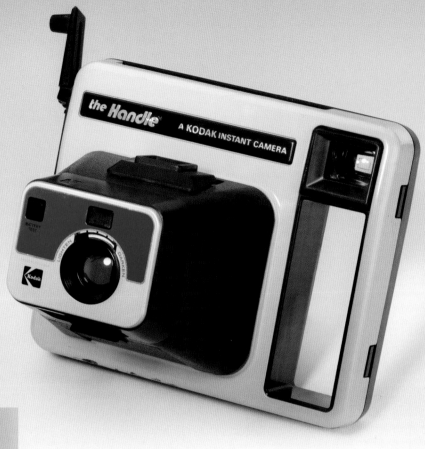

Момент (Moment)
ca. 1952
GOMZ, Leningrad, USSR. 2005:0277:0001.

Introduced in 1952 by GOMZ in Leningrad, USSR, the Момент (Moment) camera was a copy of the Polaroid 95. Though an impressive-looking camera, with metal body covered in brown leather with bright trim, the instant film of GOMZ's own manufacture was a persistent problem. Production halted after a few thousand units.

Момент (Moment) camera—a copy of the Polaroid 95. It was an impressive-looking camera, but problems with the manufacturer's own instant film were persistent enough to halt production after a few thousand units.

Other competitors introduced cameras similar to the Polaroid, including Kodak. Its 1976 Kodamatic system used a different process, but Kodak lost a patent suit to Polaroid and had to pay $909.4 million in 1985 (a figure far below the $12 billion Polaroid asked).

Polaroid technology could not withstand the arrival of digital photography, however, and in February 2008, it announced it would cease making instant film.

Nikon FM2, ca. 1982. See page 317.

INNOVATION EVERYWHERE

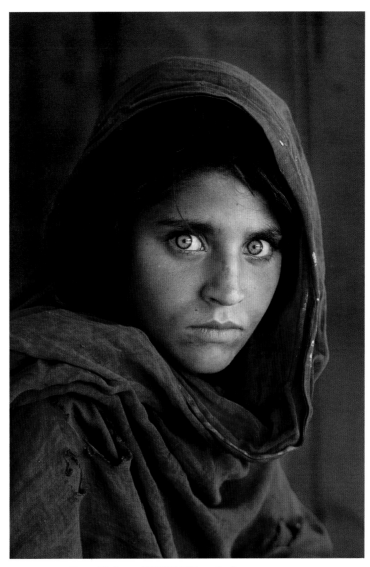

Steve McCurry, *AFGHAN GIRL*, 1985. See page 317.

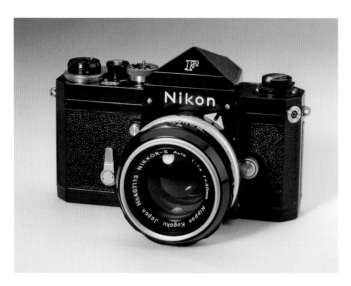

Nikon F

1959

Nippon Kogaku K. K., Tokyo, Japan. Gift of Ralph Alexander. 1977:0051:0001.

Perhaps no camera better represents photojournalism in the 1960s than the Nikon F, an omnipresent image-maker that seemingly covered every event of the period. At the time, many professional photographers already saw the 35mm rangefinder as a bit old-fashioned, and the Nikon entry into the field crystallized the clear advantages of the more advanced SLR. Not that the Nikon F was the first from Japan—most other Japanese camera manufacturers already had one on the market—but it quickly became "the" 35mm SLR. A number of features would recommend the Nikon F, but what sold it was its renown for quality and durability that may have almost single-handedly repositioned the Japanese photographic industry, upending a post-war reputation for shoddy production. In describing the F's robust construction, famed camera repairman Marty Forcher called it "a hockey puck."

Introduced in 1959, at the list price of $329.50 (Nikon Fs were many things, but cheap wasn't one of them), the F was Nippon Kogaku's first 35mm single-lens reflex camera. Intended as the centerpiece of the Nikon System, it was sold alongside the rangefinder Nikon SP, an older sibling that shared about forty percent of its parts. But the Nikon System was about more than just cameras. It was a complete integration of compatible components that would eventually include a plethora of accessories: lenses from 6mm to 2000mm in focal length; motor drives; interchangeable viewfinders and viewing screens; close-focusing bellows; flash units; and, when necessary for a specialized job, custom-built items. All were made to accommodate the needs of the professional photographer. The flow of new accessories was so constant that a 1971 Nikon F ad declared, "There has never been an up-to-date photograph made of the Nikon System."

Nikon F2

ca. 1971

Nippon Kogaku K. K., Tokyo, Japan. Gift of Ehrenreich Photo-Optical Industries (EPOI), Inc. 1981:1036:0001.

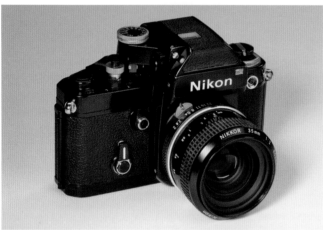

The Nikon F2, introduced in 1971, was manufactured by Nippon Kogaku of Tokyo. Billed as an "Evolutionary System" that advanced the venerable F of 1959, the F2 carried over the appearance and legendary reliability of its predecessor. Knowing its base of professionals, Nikon continued to stress the system concept. All prior Nikkor lenses fit the new camera, and accessories allowed the photographer to meet specific needs. The many featured improvements included a higher shutter speed of 1/2000 second, larger mirror for full image view, interchangeable film back, flash-ready light, short stroke advance lever, repositioned shutter release, meter on indicator, rapid rewind crank, and others. The F2 with the 50mm f/1.4 Nikkor lens carried a list price of $550.

THE JAPANESE HAD RULED advanced 35mm photography from the 1960s onward, cascading one improvement after another. It all started with the equivalent of the Big Bang: the Nikon F. Introduced as a professional camera in March 1959 (for $359.50), it was the first SLR to compete with the superior German cameras that dominated the professional 35mm market. It overcame all the problems previously associated with SLRs—mirrors that hung up, manual diaphragms, limited lens options. It offered a selection of nine lenses (from 21mm to 1000mm) plus a four frames-per-second motor drive. It offered interchangeable focusing screens and a 250-exposure film pack. Its viewfinder provoked one professional to say "it was the first camera I ever had I could really see through." It was as rugged, as one camera repairman put it, "as a hockey puck."

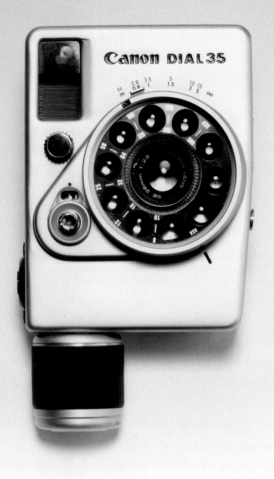

Canon Dial 35
ca. 1963
Canon K. K., Tokyo, Japan. Gift of K. Donald Fosnaught.
1984:0167:0001.

The Canon Dial 35 was introduced in 1963 as a half-frame 35mm camera. Its unusual style incorporated a vertical format body, which worked well with the shape of the half-frame image. The similarity to a telephone dial of the circular light meter surrounding the lens actually suggested the name. It had a spring-wind film advance motor extending beneath the camera, which also served as a handle and mimicked the style of the then-popular movie cameras.

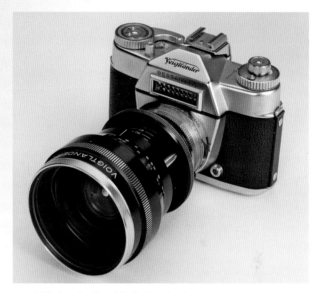

Zoomar lens
ca. 1959
Zoomar, Inc., Glen Cove, New York. Gift of Eastman Kodak Company.
1991:2644:1–2.

Introduced in 1959 by Zoomar, Inc., of Glen Cove, New York, the Zoomar lens was billed as the "world's first and only zoom lens for single-lens reflex cameras." The first version issued was the 36mm to 82mm f/2.8 and used with the Voigtländer Bessamatic—one of the first 35mm SLR cameras with a coupled light meter—offered fully automatic, pre-set operation. As became standard with most lenses, the focusing was done with the lens wide open, then automatically stopped down to the pre-set aperture when the shutter was tripped.

In 1959 the retail price for the Zoomar lens was $298 for the Voigtländer version and $318 for a version to fit other SLR cameras with focal-plane shutters. That same year, the Voigtländer Bessamatic sold for $220.

The Nikon F (and its earlier rangefinder sibling, the Nikon SP) was the first signal that Japan could introduce products of compelling superiority. Like Sony televisions, Seiko watches, and later automobiles, it forced American and European companies to play catch-up, a position they had never been in before. Later, Korean companies such as Samsung, Hyundai, and LG Electronics began to assert similar superiority in world markets.

Canon, Minolta, and other Japanese camera companies benefited from Nikon's reputation as they added similar features to their own models. Olympus of Tokyo was a latecomer to the crowded 35mm full-frame single-lens reflex market. After arriving on the international photography scene with an inconspicuous Olympus FTL camera in 1971, Olympus redeemed itself with the release of the OM-1 in 1973.

Questar 3½-inch CAT (catadioptric) lens

ca. 1962

Questar Corporation, New Hope, Pennsylvania. Gift of Questar Corporation. 1978:1525:0001.

The 1954 introduction of the Questar Astronomical telescope was the culmination of an eight-year project to apply Soviet optical engineer Dmitri Maksutov's catadioptric design to a commercial product. The result was a 3½-inch telescope of seven-foot focal length reduced to an eight-inch-long tube. For amateur astronomers who didn't have room to set up a telescope or wanted to pack one along to get away from city lights, the Questar was a wish granted. For $995, delivered from the New Hope, Pennsylvania, plant, the stargazer received a handmade, fitted leather case with the Questar 'scope and everything needed to explore the night skies, including a synchronous clock drive. Questar chose Nikon cameras for telescopic photography because of their smooth working shutters and interchangeable finders, then added a mirror lock-up to eliminate a source of vibration. The Questar Nikon body was priced at $250. The camera-telescope combination also could be used for earthbound photography. Wildlife close-ups and other extreme long-distance shots were now possible. With extension tubes and two Barlow lenses, effective focal length was 450 inches.

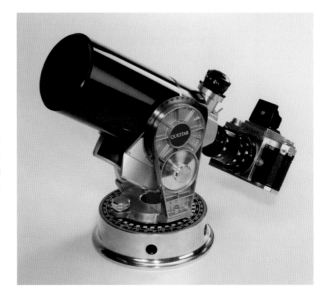

Olympus OM-1

ca. 1973

Olympus Optical Company, Ltd., Tokyo, Japan. Gift of Robert A. Sobieszek. 1985:1247:0001.

Olympus of Tokyo, Japan, was a latecomer to the crowded 35mm full-frame single-lens reflex arena. After joining the game with a rather ordinary entry in 1971, Olympus hit a home run with the OM-1 in 1973. Almost overnight, the OM-1 became the star of the entire industry. Olympus applied what they learned from their successful half-frame 35mm Pen SLR to their new design. Much smaller and lighter than its competition, the OM-1 had a brighter viewfinder with easily changed focusing screens, plus an extremely quiet focal-plane shutter with a 1/1000 second maximum speed. Olympus introduced the OM-1 as a full system with dozens of Zuiko lenses (from an 8mm f/2.8 fisheye to a 1200mm f/14 telephoto), motordrives, 250-exposure magazine, and every sort of adapter and accessory for any application. Later OM models featured improvements like fully automatic exposure and even more accessories.

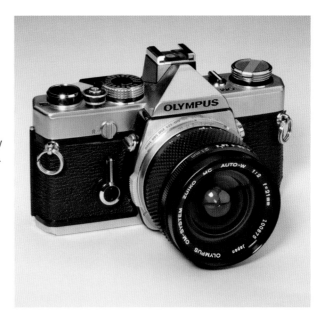

The OM-1 was a superb model of efficiency and miniaturization that fast became the star of the camera industry. Olympus successfully applied lessons learned from their half-frame 35mm SLR—the Pen F, introduced in 1963—to its design. Much smaller and lighter than models from Asahi, Canon, Minolta, and Nikon, the OM-1 had a brighter viewfinder with changeable focusing screens and a quiet focal-plane 1/1000 second shutter. Olympus rolled out the OM-1 as a full system with dozens of Zuiko lenses, motordrives, a 250-exposure magazine, and adapters and accessories for any application.

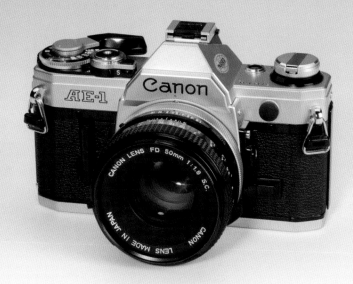

Canon AE-1
ca. 1976
Canon, Inc., Tokyo, Japan. Gift of Canon USA, Inc. 1985:0966:0003.

Introduced in 1976, the Canon AE-1 was a shutter-preferred, auto-exposure camera and the first 35mm SLR to use a central processing unit (CPU). The CPU regulated operations like exposure memory (known then as exposure lock) as well as aperture value control and the self-timer. The rest of the camera's circuitry, which controlled functions such as shutter speeds and the exposure counter, was traditional analog. An aggressive advertising campaign and automated modular construction techniques that lowered production costs resulted in sales of five million units, making the AE-1 the best-selling 35mm SLR of its day and Canon the top Japanese camera manufacturer.

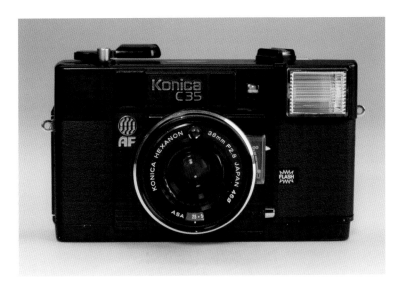

Konica C35AF
ca. 1977
Konishiroku Photo Industry Company, Ltd., Tokyo, Japan. Gift of Berkey Marketing Companies, Inc. 1978:0915:0001.

Konishiroku Photo Industry Company, Ltd. of Tokyo introduced the Konica C35AF in late 1977. The world's first production autofocus camera, it used the Visitronic AF system, a passive system developed and produced by the American firm of Honeywell. Other features were a programmed automatic exposure and a built-in electronic flash.

In 1976, the Canon AE-1 became the first SLR to use a central processing unit (CPU), practically speaking, a brain. The shutter-preferred, auto-exposure camera relied on the CPU to regulate exposure memory, aperture value control, and the self-timer. At five million units, the AE-1 became the best-selling 35mm SLR of its day.

Konishiroku Photo Industry Company, Ltd., of Tokyo introduced the Konica C35AF (for autofocus) model in late 1977. It employed a "passive" system that used scene contrast to determine best focus and was often inaccurate under low light. In 1979, Canon countered with its own autofocus model, the

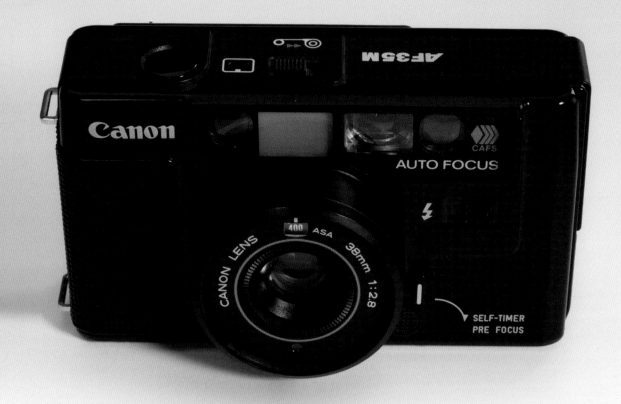

Canon Sure Shot AF35M
ca. 1979
Canon, Inc., Tokyo, Japan. Gift of Canon USA, Inc. 1983:0577:0001.

The Canon AF35M, introduced in 1979 by Canon, Inc., of Tokyo, was called "Sure Shot" in the U.S. and "Auto Boy" in Japan. It was the first camera to employ infrared focusing, which is an active autofocusing system. Sure Shot's system provided its own light source that sent out an infrared signal and received the reflected light to measure distance. The signal was limited to twenty-seven feet, at which point the camera selected infinity focus. Canon's strategy of giving the camera a name instead of a model number started an industry-wide naming trend.

Canon AF35M. Called "Sure Shot" in the United States and "Auto Boy" in Japan, it was the first camera to use an "active" infrared autofocusing system, firing an infrared beam in the direction of its subject. to determine the subject's distance and the proper focus. Canon's decision to give the camera a personalized name rather than a meaningless model number revived a dormant industry practice. As Sure Shot sales climbed above a million units in North America alone, others saw a memorable name as a marketing tool. Rebels, Styluses, Speedlights, Coolpixs, and others began to show up in ads often aimed at youth.

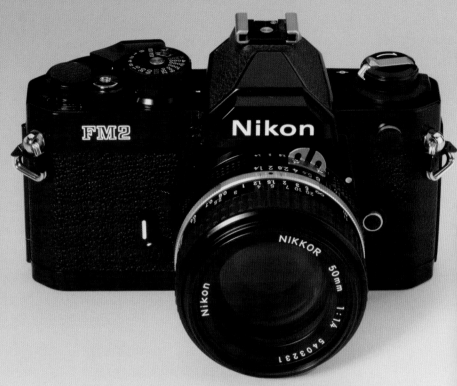

Nikon FM2
ca. 1982
Nippon Kogaku K. K., Tokyo, Japan. Gift of Nikon, Inc. 1983:0583:0001.

The Nikon FM2, introduced in 1982 by Nippon Kogaku of Tokyo, was the last all-manual mechanical Nikon SLR. Recognizing that a portion of its customer base was still uncomfortable with auto-anything, the company billed the camera as "The Perfectionist's Nikon," while the brochure stated "Automation is fine, but you want to be in control." Two significant improvements were X flash synchronization to 1/200 second and a shutter speed of 1/4000 second, both the world's fastest. The shutter speed was made possible by the development of a new titanium focal-plane shutter with a honeycomb pattern that reduced the thickness of the blades and thus the weight of the moving parts by fifty-eight percent. The retail price of the FM2, body only, in black was $313.50. With the 50mm f/1.4 AI Nikkor lens shown here, the price was $614.50.

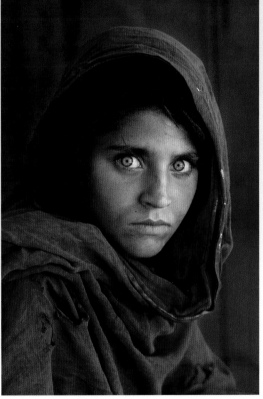

Steve McCurry (American, b. 1950). *AFGHAN GIRL*,1985. Kodachrome C-print. © Steve McCurry. Courtesy of the artist.

Professional photographers saw advances, too. A formidable studio workhorse was getting ready to make its appearance in 1970.

The medium-format Mamiya RB 67 Pro S from the Mamiya Camera Company of Tokyo used 120 film, but offered an alternative to the square 6 x 6-cm format of the Hasselblad and Rolleiflex. The "RB" in the name referred to the camera's revolving back: it could be spun to either vertical or horizontal perspective.

Many thought its 6 x 7-cm dimension the ideal format because it yielded 8 x 10-inch enlargements.

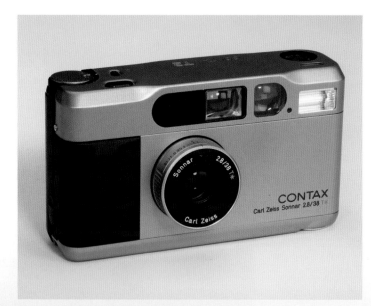

Contax T2
ca. 1991

Kyocera Corporation, Tokyo, Japan. Gift of Yashica, Inc.
1991:2829:0002.

Although Zeiss Ikon AG stopped producing Contax cameras in 1961, the revered brand was revived in 1975 by a joint venture with Yashica of Tokyo. In 1990 this successful collaboration produced the Contax T2, a titanium-bodied compact with all the features that made point-and-shoot 35mms so popular. A lithium battery fueled the T2, from the power winder to the retractable Carl Zeiss 38mm f/2.8 Sonnar T* lens and the metal slide that covered the lens when the camera was switched off. Automatic exposure and flash were expected on cameras of this type, but the T2 also provided manual control. The focus knob could be locked at ∞ (infinity) or adjusted until the finder gave the green light signaling correct focus for the subject. A ring on the lens adjusted the aperture, if desired, and turned off the automatic flash. The finder displayed the shutter speed selected by the camera program. A premium-priced camera at $550, the Contax T2 used some exotic materials at wear points. The pressure plate was made of hard ceramic, and the viewfinder elements were scratchproof sapphire glass. Even the shutter button was built for long life, using polished synthetic sapphire.

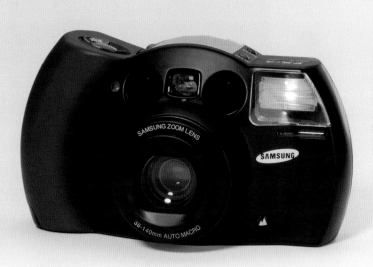

Instruction manual for Samsung Aerospace Industries' FX-4, ca. 1994. Gift of Samsung Aerospace Industries. George Eastman House Technology Collection.

FX-4
ca. 1994

Samsung Aerospace Industries, Tokyo, Japan. Gift of Samsung Aerospace Industries. 1994:1478:0001.

The Samsung FX-4 35mm camera featured a distinctive design by F. A. Porsche meant for maximum ergonomic comfort and user friendliness. A large zoom lens (snout), curved grip (ears), and symmetrical autofocus (eyes) led the company to poke fun at itself in the user's manual. Printed in Korean, the meaning can be derived from the extensive illustrations in which the camera was represented as a cartoon elephant. The camera was well featured with a 38mm to 140mm zoom lens and numerous user-selectable exposure, flash, and focus modes. Samsung introduced it at PMA, the American trade fair of the Photo Marketing Association, in the fall of 1994—ten years after producing its first independent camera design.

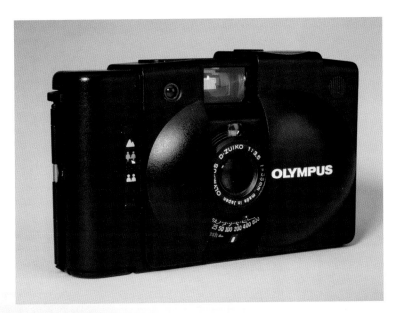

Olympus XA2
ca. 1980
Olympus Optical Company, Ltd., Tokyo, Japan. Gift of Olympus Camera Corporation. 1981:1296:0021.

The Olympus XA series of ultra-compact 35mm cameras, produced by Olympus Optical Company, Ltd., of Tokyo, debuted in 1979. The XA had a coupled rangefinder for focus, automatic exposure, and an f/2.8 Zuiko lens. The XA2 had a zone-focus system and programmed shutter, instead of rangefinder and aperture-priority, and an f/3.5 lens. The XA1 was simpler yet, with a fixed-focus f/4 lens. All the XA cameras had the same sliding cover that functioned as the lens protection and on-off switch. A detachable flash kept the body as small as possible. Film advance was handled by a ridged thumbwheel on the right side. The XA cameras stayed in production until the mid-1980s, when autofocus cameras with power winders began to dominate the sales charts.

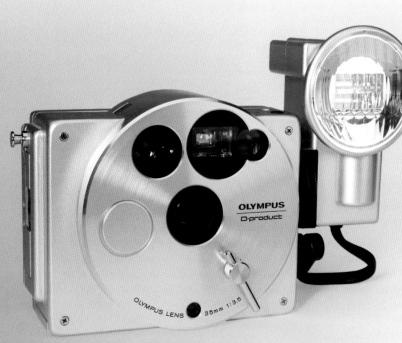

Olympus O-Product
ca. 1988
Olympus Optical Company, Ltd., Tokyo, Japan. Gift of Mr. and Mrs. Robert L. Freudenheim. 2003:1101:0002.

The O-Product, despite its unusual styling, was a point-and-shoot 35mm camera with features and specifications similar to the Olympus Stylus 35. Made in limited quantities by Olympus Optical Company of Tokyo, the 1988 camera had an aluminum body with a unique round-peg-in-a-square-hole shape. The lens cover opened and closed via a chrome lever resembling an alarm clock key, and the shutter release was a dime-sized button flush with the front panel. The detachable flash was plastic painted the same silver as the body. Automatic exposure, autofocus, and power wind/rewind helped the O-Product live up to the motto revealed when the film door was opened: "Functional imperatives molded to artistic form."

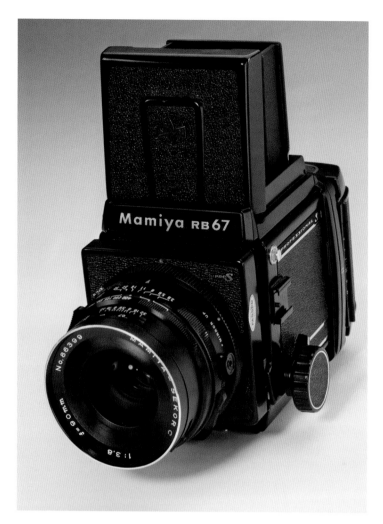

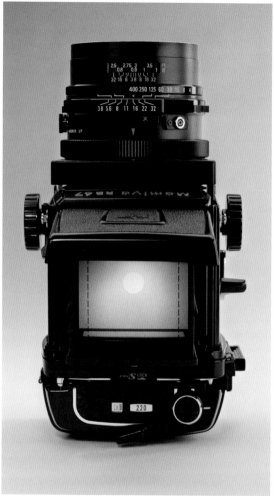

Mamiya RB 67 Pro S
ca. 1970
Mamiya Camera Company, Tokyo, Japan. Gift of Bell & Howell Mamiya Company. 1978:0692:0001.

Introduced in 1970 by the Mamiya Camera Company, Tokyo, the Mamiya RB 67 Pro S appeared similar to, but was larger than, conventional medium-format SLRs in the 6 x 6-cm square format. Its 6 x 7-cm format used No. 120 roll film and was often referred to as "the ideal format" because it had the correct proportions to be wholly enlarged to 8 x 10 inches. In appearance, the RB 67 differed from the other 6 x 7-cm camera of the time, a Pentax, which resembled a very large 35mm camera. The "RB" designation means the camera had a revolving back and could be easily used in either a vertical or horizontal orientation. Some consider the RB 67 the Japanese version of the legendary Graflex SLR.

Even with the Japanese firms vigorously ramping up their production of 35mm cameras, Kodak continued to place its bet on smaller-format cameras. It was a bet that Kodak would make two more times on two new small formats (disc and APS), as the company became increasingly aware that competitors were benefiting enormously from their investments in 35mm cameras.

Kodak thought the biggest profits would come from driving consumers to take more pictures, and the key to

Pocket Instamatic 20

ca. 1972

Eastman Kodak Company, Rochester, New York. Gift of Eastman Kodak Company. 1974:0028:3049.

In 1972, Eastman Kodak Company of Rochester, New York, introduced a new film format and a line of cameras to use it. The film was the 110 size, using 16mm roll film with paper backing in a drop-in cartridge, similar to the 126 cartridge. The new cameras were small enough to slip into a shirt pocket and were named Pocket Instamatic 20, 30, 40, 50, and 60. Available films included black-and-white, a new finer grain color print emulsion, and two color slide films. The retail price of the Pocket 20 was $27.95.

Ektralite 10

ca. 1978

Eastman Kodak Company, Rochester, New York. Gift of Eastman Kodak Company. 2003:1111:0019.

Eastman Kodak Company introduced the subminiature Pocket Instamatic camera line in 1972, with the easy-loading 110 film cartridge design adapted from the original 126 Instamatics. To add to the versatility of the line, Kodak offered the Ektralite 10, which had a built-in electronic strobe flash. Powered by a pair of AA-size batteries, the flash had to be switched on by the user whenever there was insufficient illumination for available light photography. A simple fixed-focus 25mm f/25 lens was protected by a sliding cover interlocked with the shutter button. A complete Ektralite 10 outfit, boxed with camera, booklet, strap, a roll of Kodacolor VR 200, and even batteries, listed for $39.95 in 1978.

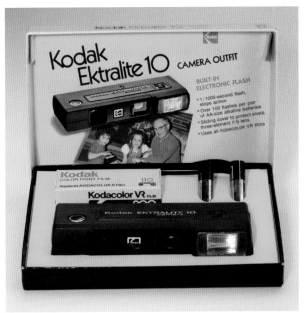

that was simplicity and ease of use. The company's next subminiature camera was the line of Kodak Pocket Instamatic models.

The Pocket Instamatic 20, 30, 40, 50, and 60 were introduced in March 1972; the 20 carried a list price of $27.95. Its small drop-in loading 110 film cartridges were derived from the original 126 Instamatic concept. To add to the versatility of the line, Kodak offered the Ektralite 10, with a built-in electronic strobe flash.

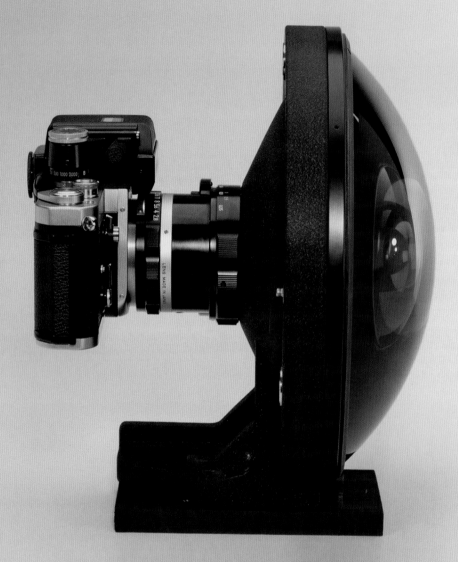

Fisheye-Nikkor 6mm f/2.8 lens, ca. 1975. See page 324.

XVIII

——✦——

1975 AND BEYOND

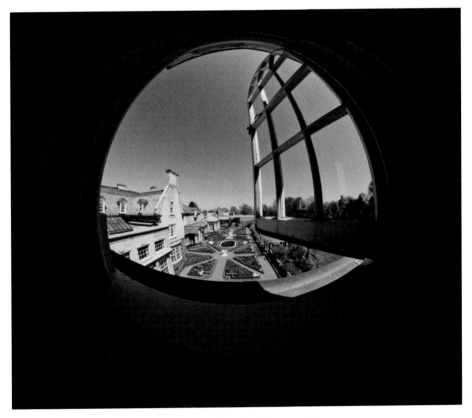

Sample image made with a Nikon F camera. See page 325.

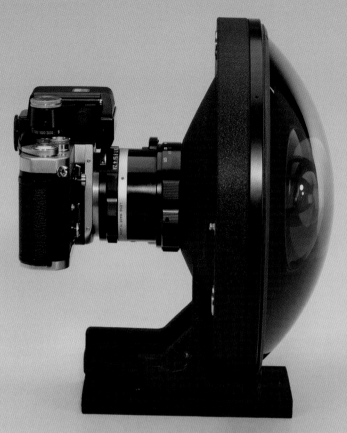

Fisheye-Nikkor 6mm f/2.8 lens

ca. 1975

Nippon Kogaku K. K., Tokyo, Japan. Gift of Ehrenreich Photo-Optical Industries (EPOI), Inc. 1981:1037:0001.

Introduced in 1972, the 6mm f/2.8 fisheye Nikkor lens was intended for meteorological and astronomical research. A 220-degree picture angle also made it ideal for use in industrial photography to shoot images of objects in tight spaces, such as the interior of pipes or cylinder walls. Weighing in at eleven and a half pounds and measuring nearly ten inches in diameter, the lens was by no means a small one. It produced a round, 23-mm diameter image in the center of a standard 35mm roll film. The dramatic fisheye effect—an extreme wide angle with enormous depth of field— was adopted by advertising and commercial photographers to create attention-grabbing images.

THE YEAR 1975 COULD BE CONSIDERED the year it all got started. Steve Sasson went to work for Kodak (see page 336).

In January, *Popular Electronics* magazine featured the Altair 8800 computer kit on its cover. A young man named Paul Allen showed it to his friend Bill Gates. They wrote some code and started a company called Microsoft.

In 1976, on April Fool's Day, Steve Wozniak and Steve Jobs started a company called Apple. They announced the first single circuit-board computer, the Apple I, with a video interface, 8K of RAM, and a keyboard.

In 1977, Radio Shack announced the TRS-80, made for them by their parent company, Tandy Corporation. It sold 10,000 units in the first month. Commodore followed.

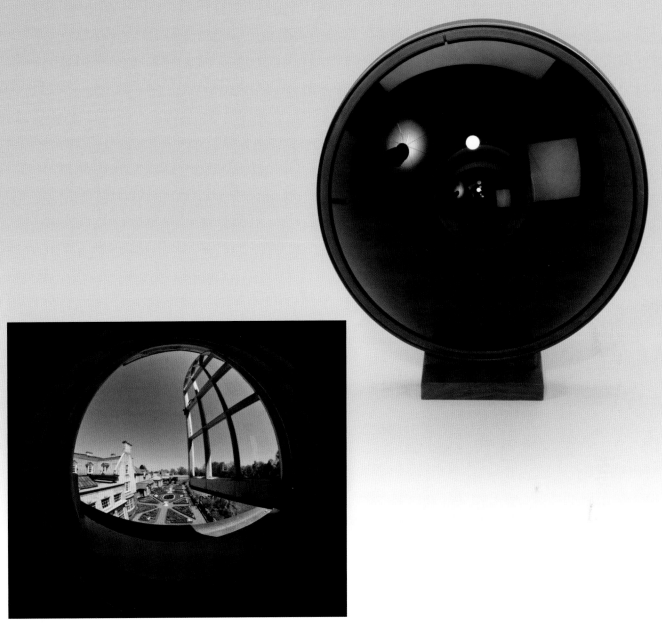

Sample image made with a Nikon F camera fitted with a 6mm f/2.8 Nikkor Fisheye lens, May 2003.

Cameras had become smaller, lighter, cheaper, easier, faster. In a word, cameras had become smarter. There were, seemingly, no limits to what the camera could do. Just as the decades immediately following World War II had brought with them heightened prosperity and an enduring appreciation for liberation, the last quarter century would bring technological developments to surpass anything that even the most creative photographers could have imagined.

For example, the Nikon F series had long been the 35mm camera of choice for working professionals, especially photojournalists. In 1980, Nikon announced the F3, a completely new camera from the base-plate up.

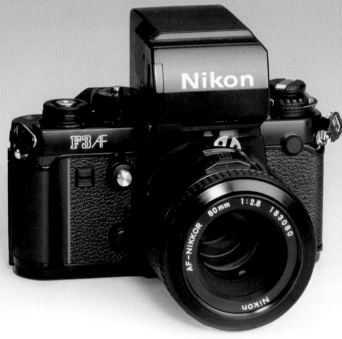

Nikon F3
ca. 1980
Nikon, Inc., Tokyo, Japan. Gift of Nikon, Inc. 1981:3208:0001.

The F3 shared the best features of its predecessors, but it had more automatic features, such as an electronically controlled shutter, battery-saving built-in LCD meter, and automatic exposure control. Famed Italian auto designer Giorgetto Giugiaro consulted on the camera's exterior design, creating an appealing look for the camera. An autofocus model, the F3AF, was introduced in 1983. Eastman Kodak Company chose the F3 as the basis for its Kodak DCS 100 professional digital camera in 1991.

At introduction, the F3 retailed for $1,174.90, with the 50mm f/1.4 lens. It remained in production for more than twenty years, with three sequential models concluding with the final F6. Although the F3 no doubt proved its mustard in the field, it never really gained the iconic status held by its older mechanical siblings.

NASA selected the F3 for the space shuttle program, continuing a streak that placed a Nikon F on every manned U.S. space mission since Apollo 15. Nikon's ad copy declared "Performance so extraordinary it was selected to make history aboard the U.S. Space Shuttle."

An autofocus model, the F3AF, was introduced in 1983 and sold for $1,746 with the 50mm f/1.4 lens.

Although the mechanical Nikon F had achieved legendary status, the electronic F3 series never did.

Minolta upped the electronic ante in 1985 with the Maxxum 35mm single-lens reflex system. It rocked the SLR market. With a gleaming black polycarbonate body, the Maxxum glowed with technological allure. It included programmed exposure, autofocus, and power winding into a normal-sized body for true point-and-shoot operation.

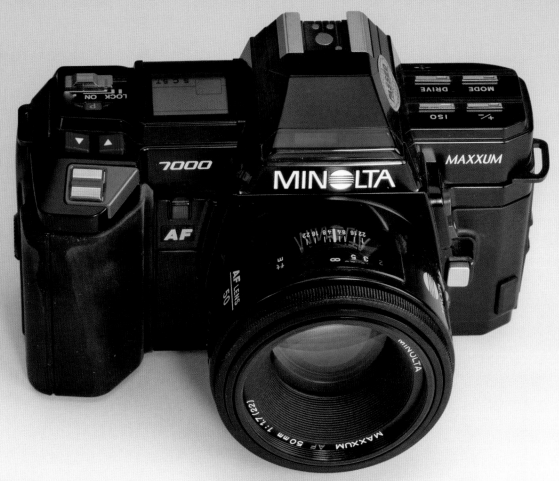

Maxxum
ca. 1985
Minolta Camera Company, Ltd., Osaka, Japan. Gift of Minolta Company, Ltd. 1985:0961:0005

When Minolta Camera Company, Ltd., of Osaka, Japan, announced the Maxxum 35mm single-lens reflex system in 1985, the market for SLR thirty-fives was jolted from its doldrums. It sold for $596 with a 50mm f/1.4 lens. With a body molded of tough polycarbonate, the Maxxum was both attractive and dent-resistant. A technological leap, it packed features like programmed exposure, autofocus, and power winding into a normal-sized body for true point-and-shoot operation. Autofocus lenses for 35mm SLRs weren't new, but previously they were bulky, slow, and expensive. The Maxxum design moved the focus drive motor inside the camera, so its lenses were no larger than conventional designs. Minolta's focus system was remarkably fast, no matter which of the eighteen AF lenses was mounted. Customers wanting to do their own exposure settings and focus could set the camera for full manual control. The Maxxum became an almost immediate target for the competition, and most eventually caught up, but Minolta's technology set standards still in place in the digital age.

While Canon, Konica, Minolta, Nikon, Pentax, and Olympus were competing for the 35mm market, Kodak planned major systems introductions. New cameras (analogous to razors) requiring new film sizes (blades) stimulated the market like nothing else, leaving competitors with years to tool up if they hoped to catch up.

The 1982 Disc System turned camera design on its ear. The format was unlike anything sold by the competition. A glitzy introduction resulted in front-page coverage in the *New York Times*.

Kodak Disc cameras were designed to make photography shirt-pocket portable, easy, and foolproof. Everything on the camera was automatic: exposure, flash settings, and film advance. A lithium battery with a ten-year life supplied power. The fifteen-exposure disc film cassette made the thin body feasible.

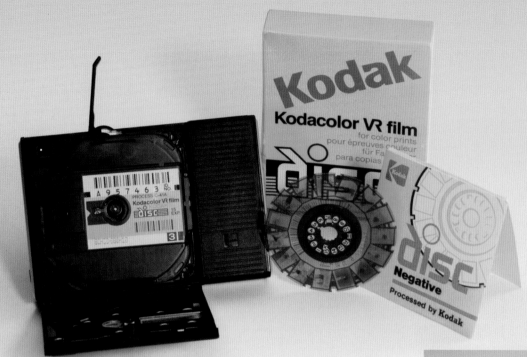

Kodak Disc 4000
ca. 1982
Eastman Kodak Company, Rochester, New York. Gift of Eastman Kodak Company. 1982:1002:0001.

The Kodak Disc camera was designed to replace the enormously popular and profitable Instamatic designs that had been Eastman Kodak Company's mainstay for twenty years. Foolproof photography had made Kodak the world's largest photographic company, and the engineering teams were determined to retain its top position. Everything on the camera was automatic; exposure, flash settings, and film advance required no input from the user and were powered by a ten-year lithium battery. The fifteen-exposure disc film cassette made the thin, pocket-size body possible but also presented many manufacturing challenges. New film and precision-ground glass lenses were necessary to produce good snapshots from a negative about one-third the size of the Pocket Instamatic images. The entire system of cameras, film, and processing/printing machinery, plus the facilities to successfully produce them, could only have been accomplished by Kodak, but in less than five years Disc camera production was halted in the wake of the compact point-and-shoot 35mm cameras the public preferred.

The creation of the entire system of cameras, film and processing/printing machinery, as well as the facilities to successfully produce them, could have been accomplished only by Kodak.

The Kodak Disc was an ingenious camera, a technically amazing system. But there was one problem: picture quality. The 8.2 x 10.6-mm negative size compromised enlargement, especially in sizes above 5 x 7 inches. Even standard prints were often too grainy, especially those pictures taken in low light.

More than twenty-five million disc cameras were sold in less than five years. But popular compact point-and-shoot 35mm cameras were continuously being improved. The disc program was discontinued when Kodak stopped producing disc film on the last day of the twentieth century.

Less than five years after the disc was announced, what seemed to be the least sophisticated camera ever made appeared. The most popular camera of all time—at least in terms of sales—presented itself, much like the Brownie, almost as a toy.

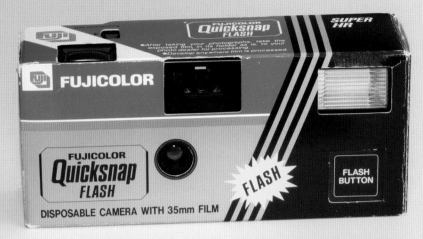

Fuji one-time-use camera
ca. 1990
Fuji Photo Film Company, Ltd., Tokyo, Japan.
1990:0238:0001.

Although Fuji Photo Film of Tokyo didn't invent the one-time-use camera, they can take credit for being first on the market with a modern version you could take to any one-hour photofinisher for prints. Previous one-time-use cameras required you to mail them back to the manufacturer to get your pictures processed. Loaded with standard Fujicolor ISO-100 film in the 110 size, Fuji's HR100 was used without removing the paper carton dressed to match Fujicolor film packages. Cutouts in the carton for the lens, finder, shutter, advance wheel, and exposure counter added up to what Fuji called the "Film with lens."

The success of this camera soon attracted Eastman Kodak Company and others to the market. The 110 format was joined, and then replaced, by 35mm versions like the Quicksnap Flash with built-in electronic strobe. One-time-use cameras specialized for close-up, telephoto, and panoramic photography were soon sold everywhere, often in a choice of film speeds. Initially, Fuji labeled the Quicksnaps as "disposable," but that word soon disappeared and the discarded plastic parts were retrieved for recycling.

Fuji Photo Film announced the first one-time-use camera (OTUC) in 1986. Named the Utsurun-Desu ("It takes pictures") in Japan and the QuickSnap in the U.S., it used 35mm film. Before the 1970s, cameras had been quite expensive in Japan and were commonly used during special occasions by the male of the household. Cheap, lightweight cameras started a cultural shift. Both parents and children got in on the act, creating the "snap happy" stereotype that still persists. Konica soon produced its own model.

Companies offered OTUCs for panoramic and underwater photography. Some models had a virtual zoom feature that worked by shifting two lenses in front of the shutter.

The Fling, Kodak's first OTUC, was a simple plastic camera sold pre-loaded with 110-size film. After exposure, the whole camera was returned to the photofinisher, who opened it to remove the film. Kodak soon replaced the 110 Fling with the Fling 35 to keep up with competitors' 35mm offerings.

Fling 110
ca. 1987
Eastman Kodak Company, Rochester, New York. Gift of Eastman Kodak Company. 1992:0258:0001.

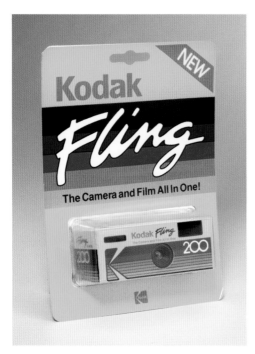

The one-time-use or "disposable" camera concept had been tried many times prior to the introduction of the Kodak Fling in 1987. Flings were simple plastic cameras sold pre-loaded with 110-size film. After exposure, camera and all were returned to the photofinisher, who cracked it open to remove the film. The size of a 110 film box, the Fling had a simple finder and a ridged thumbwheel advance. Kodak soon replaced the 110 Fling with the Fling 35 to keep up with competitors' one-time-use 35mms that made much better pictures. The "Fling" name didn't last long either. Criticized for a product with a name that suggested it was destined for landfills, Kodak redesigned the cameras for disassembly and recycled most parts into new cameras.

In 1995, Kodak OTUCs carried list prices between $6.95 for a 110 Fling model to $19.95 for a 35mm model with a portrait lens. Processing costs varied widely from lab to lab but were consistent with the same charges for equivalent lengths and sizes.

Kodak Stretch 35
ca. 1989
Eastman Kodak Company, Rochester, New York. Gift of Eastman Kodak Company. 1992:0255:0001.

As a follow-up to the successful Fling, the first Kodak one-time-use camera, Eastman Kodak Company introduced the Kodak Stretch 35 in 1989. With its fixed-focus, 25mm wide-angle lens and masked film plane, the Stretch 35 was designed to take panoramic photographs as the user saw a scene through the viewfinder. Instead of cropping the pictures during the printing process, the editing was done in-camera, with just a little more than fifty percent of the vertical coverage of the film utilized. The resulting prints were 3½ x 10 inches. The Stretch 35 retailed for $12.95.

Kodak followed the Fling with the Kodak Stretch 35 camera in 1989. The Stretch 35 was designed to take panoramic photographs as the user saw the scene through the viewfinder. Instead of cropping during the printing process, the editing was done in-camera, with final prints measuring 3½ x 10 inches. The Stretch 35, which retailed for $12.95, proved to be very popular. In fact, in 1989, the camera was a *Popular Science* selection for a "Best of What's New" award in the category of science and technology. Both the Fling and Stretch 35 were later renamed "Fun Saver" cameras, as a complement to Kodak's ever-expanding OTUC line.

D-Day 50th Anniversary Camera
ca. 1994
Kodak Pathé, Paris, France. Gift of Nicholas M. Graver.
1995:0882:0001.

In 1994, to commemorate the fiftieth anniversary of the start of Operation Overlord, popularly known as the Normandy Invasion, on June 6, 1944, the D-Day camera was produced by Kodak Pathé, the French subsidiary of Eastman Kodak Company. A one-time-use 35mm camera, it had a cardboard wrapper printed in seven European languages, including German, and featured images of Eisenhower, Churchill, and de Gaulle, along with the U.S., British, French, and Canadian flags.

Asti Cinzano one-time-use camera
1999
Unidentified manufacturer, Hong Kong, China. Gift of Todd Gustavson. 1999:0141:0001.

Shortly after the introduction of one-time-use cameras like the Fuji QuickSnap of 1987, manufacturers of these cameras began to utilize the printable outer wrap for promotional offerings. One such use was an Asti Cinzano-wrapped one-time-use camera, made in China by an unknown manufacturer. The 1997 promotion included the camera and a 750-ml bottle of Asti Cinzano Sparkling Wine in a star-studded cellophane bag with gold elastic tie.

As still cameras were getting easier to use, so were video cameras.

Drawing on advances in plastics molding techniques, Canon's Photura was a radical departure from traditional still camera design. Most contemporary zoom cameras were clearly designed as cameras first, with large, awkward lenses extending from the front. However, Photura, introduced in 1990 and known as "Epoca" in Europe and "Autoboy Jet" in Japan, was designed around the lens, with a small camera at the back.

Still cameras have long been preferred over motion ones, in part because few people can stand to

Canon Photura

ca. 1990

Canon, Inc., Tokyo, Japan. Gift of Canon USA, Inc. 1991:2785:0001.

Although probably the only 35mm camera that could be said to resemble a beer stein, the Canon Photura actually looked and functioned more like a video camcorder than a still camera. When the hinged lens cap swung open, the camera turned on, as the inside of the cap, which now faced the photographer's subject, held the flash unit. The handle provided a grasp similar to camcorders of the time, which allowed for one-handed operation. As a point-and-shoot with autofocus and built-in zoom lens, the camera was designed for everything to be done with the right hand. With the hand inside the strap, the thumb supported the camera while a single finger controlled the zoom and shutter. Perhaps this novel form and grip prompted Photura's slogan: "Hold the future of photography in your hand." Other features included dual viewfinders, for shooting at eye or waist level, and a date back with five pre-programmed messages like "Happy Birthday" and "Congratulations." No wonder that Canon proclaimed the Photura as "Daring to be different."

Sample image made with Sony Mavica, December 2008.

Sony Mavica MVC-5000

ca. 1989

Sony Corporation Ltd., Tokyo, Japan. Gift of Rochester Institute of Technology. 2006:0113:0001.

Photojournalism has always been driven by pressure to decrease the time lag of getting images to press. Generally, any new technology that helps to cut the gap is put to good use. Yet, in some parts of the world, the latest technology may not be the way to go. A current example is the use of video phone cameras in reporting from remote areas of Afghanistan. Sony began experimenting with Mavica (magnetic video camera) in the early 1980s and eventually produced the MVC-5000 still video camera in 1989. By that time, its two-chip 500 raster-line TV resolution was far from the cutting edge. Still, when used in conjunction with the Sony DIH 2000 (digital image handler), the Mavica MVC-5000 could transmit analog still color images over telephone lines. Shortly after the camera's introduction, the television network CNN used a Mavica to avoid Chinese censors and deliver images of the Tiananmen Square student protests.

watch unedited video for more than three minutes. But a market persists, and the technology to gratify its demands keeps improving. Before there was digital recording, other technologies captured motion relatively well.

Sony began experimenting with Mavica (magnetic video camera) in the early 1980s and produced the

MVC-5000 still video camera in 1989. Its two-chip 500 raster-line TV resolution, when used in conjunction with the Sony DIH 2000 (digital image handler), meant the Mavica MVC-5000 could transmit analog still color images over telephone lines.

As the Zapruder movie of the JFK assassination proved, the news value of an important event matters

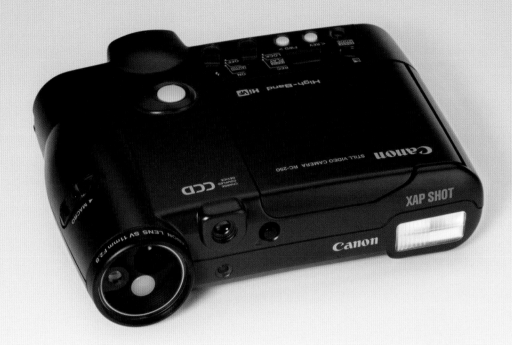

Canon Xap Shot
ca. 1990
Canon, Inc., Tokyo, Japan. Gift of
Canon USA, Inc. 1989:1161:0001.

The Canon Xap Shot of 1990, manufactured by Canon, Inc., of Tokyo, is best thought of as a video camera that used small discs instead of videotape. Before the advent of digital photography, this analog still video camera was capable of storing fifty individually erasable images on removable 2 x 2-inch video discs. Images were viewed by connecting an AC coupling device from the camera's video output to a television's video input. As with any NTSC video image, Xap Shot photos could be digitized and imported into a PC via a video capture device. Image quality, while adequate for some applications, was not equal to that produced by modern digital cameras.

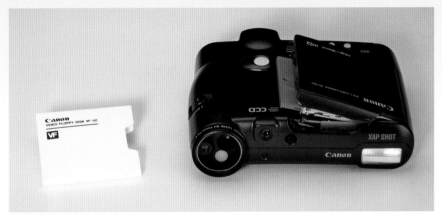

more than the technical quality of the images. Soon after the Mavica's introduction, CNN used one to transmit pictures of the Tiananmen Square student protests.

The enormously significant news value of the subject matter more than compensated for the poor technical quality of the actual images produced by the Mavica and Chinese censors were successfully avoided.

The Canon Xap Shot of 1990 was an analog still video camera capable of storing fifty erasable images on the same small disks as the Mavica. However, although the image quality was adequate for some applications, it remained inferior to that produced by later digital cameras.

Looking back, it is easy to see how all this was, in effect, a preparation.

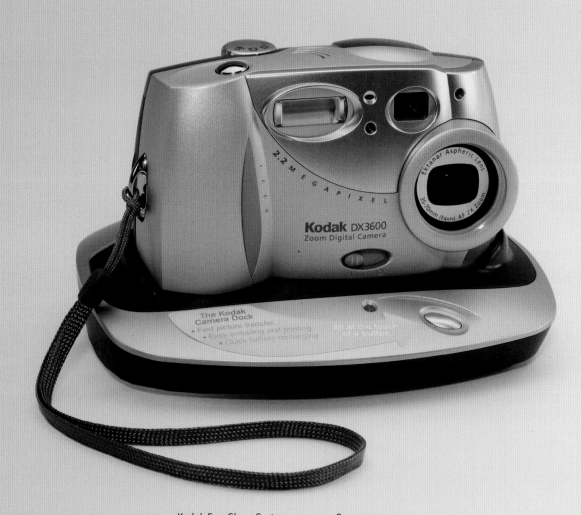

Kodak EasyShare System, ca. 2001. See page 344.

XIX

SETTING THE DIGITAL STAGE

Sample image made with a Kodak EasyShare One, August 2006. See page 349.

Sasson digital camera
1975
Eastman Kodak Company, Rochester, New York.
Gift of Eastman Kodak Company. 2008:0303:0001.

In a 1977 report titled "A Hand Held Electronic Still Camera and Its Playback Unit," Eastman Kodak Company electrical engineer Steven J. Sasson predicted new digital technologies might "substantially impact the way pictures will be taken in the future." How right he was! Sasson was the first Kodak employee assigned to the momentous task of building a complete camera using an electronic sensor, known as a charge-coupled device or CCD, to capture optical information and digitally store the captured images. Primitive by today's standards, the CCD provided to Sasson by Fairchild Semiconductor realized .01 megapixels and black-and-white optical information. Undaunted, Sasson incorporated the CCD with Kodak movie camera parts, other commercially available components, and circuitry of his own design to create the world's original digital camera in 1975. His resulting camera weighed more than eight pounds and measured the size of a toaster. The unwieldy camera required twenty-three seconds to record an image to a cassette tape and another twenty-three seconds for the image to be read from the tape to a stand-alone playback unit for display on a TV screen. With this groundbreaking innovation, Sasson helped to introduce digital technology in camera and photography systems and claim for Eastman Kodak Company its first digital camera patent in 1978.

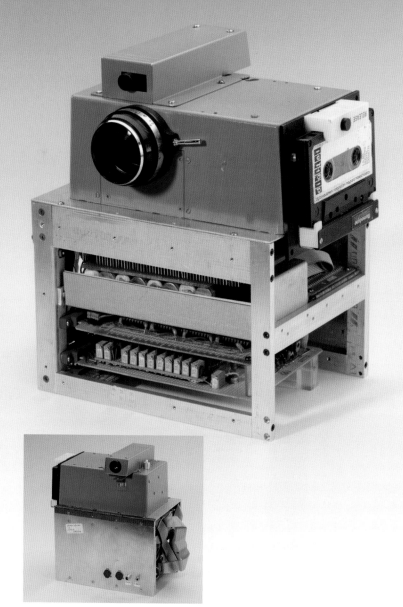

As mentioned, in 1975, Steven J. Sasson was twenty-five years old and had just gone to work for the Kodak Research Laboratories. He was one among a worldwide Kodak workforce of more than 100,000 employees. Unsure of what to do with a new hire, his supervisors suggested that he take a look at a new electronic component called a charge-coupled device (CCD) and see if it had any potential.

He looked, and thought, and talked with other Kodak engineers. At first the CCD could capture only black-and-white optical information, and not very well at that. At 0.1 megapixels (100 pixels x 100 pixels), its resolution was a mere 1/1000 that of a modern digital camera. Sasson incorporated into the CCD parts from a Kodak movie camera, then added some other components and circuitry of his own design. He and his colleagues had invented the digital camera.

In 1977, he handed in his report, "A Handheld Electronic Still Camera and Its Playback Unit." It predicted that new digital technologies might "substantially impact the way pictures will be taken in the future."

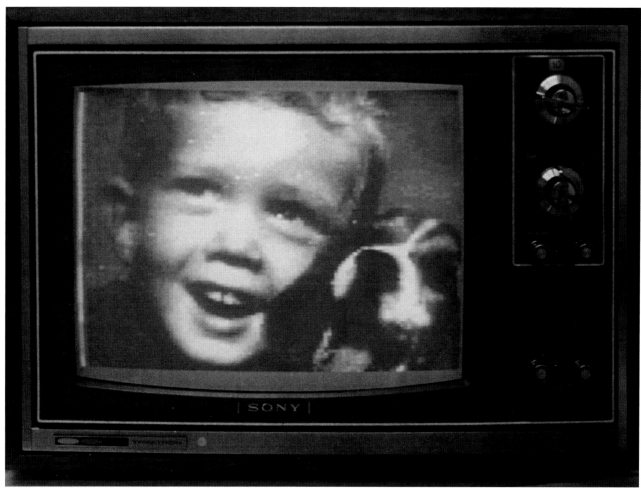

Sample image made with the Sasson digital camera, 1977. Courtesy Eastman Kodak Company.

Sasson's 1978 Kodak patent signaled future digital developments in camera and photography systems. Kodak prudently did not publicize the fact for some twenty-five years. During that time, personal computers would evolve. The Internet would come to involve the world. And digital photography, or "imaging," would present itself as a disruptive technology, causing much hullabaloo over "the death of film."

With digital images beginning to appear, software applications to manipulate them would become essential.

The story goes that in 1987, a University of Michigan Ph.D. candidate wrote a program on his Macintosh Plus computer to display grayscale pictures on a black-and-white TV screen. Thomas Knoll called his program "Display." He showed it to his brother John, who worked for Industrial Light & Magic, the special effects movie company founded by *Star Wars* creator George Lucas. John suggested to Thomas that he turn his idea into a program that would allow users to adjust their color pictures. Together they came up with a program renamed ImagePro, soon renamed once more. He called it Photoshop.

1975 Kodak Prototype Digital Camera

—Steven J. Sasson

IN DECEMBER 1975, after about a year of piecing together a bunch of new technology in a back lab at the Eastman Kodak Company Apparatus Division research lab in Rochester, New York, a team of one engineer and two technicians was ready to try taking pictures with an odd-looking contraption that didn't use film.

We called it a "handheld electronic still camera." However, this moniker didn't accurately reflect what we had. First, it was really a stretch to call the toaster-sized, 8½-pound box of circuits "handheld." It was electronic, but it might be more accurately described today as a digital camera because the prototype design used an entirely digital approach. Finally, the pictures taken with this "camera" were black-and-white and were made up of only 10,000 pixels (each digitized to four bits) so they would never be confused with the consumer 110-film images prevalent at the time. But we did carry it around and take pictures with it, and in doing so began a dialog about a possible future direction for photography.

The camera that captured those images resulted from a small investigation of one of the first area array charge-coupled device (CCD) imaging devices commercially available at the time. In Kodak's applied research lab, it was not uncommon, as part of ongoing efforts in research and development, to have general investigations into all kinds of technologies regarding their possible impact on imaging. Since this was such a small project, to be carried out by junior staffers in the lab, there was not much attention from management on the activity at all. This was fortunate—with no one "watching" it was easier to talk ourselves into the rather impractical task of using this new CCD imager in constructing an all-digital camera for taking still pictures.

We chose a digital approach because it allowed us to store the individual pixel output signals of the CCD imager without any mechanical storage mechanism. It also enabled us to consider storing the image as a digital file on a removable storage medium (cassette tape), much like how exposed images are stored on a roll of film that is removed from the camera for processing and printing. In our case, since our captured image was already in electronic form, we could avoid the complexity of printing an electronic image (not easy to do in 1975) by utilizing an electronic display device, namely a conventional television set, to view the images. This would require a second major effort for the project: the development of a playback system that would read the image from the cassette and produce an NTSC television signal representing the still image that was captured.

As luck would have it, our laboratory was actively working with the newly emerging microprocessor technology, and the team could justify the expenditure of several thousand dollars (the biggest single expense of the project) for the purchase of a microprocessor development system. Since this system could be leveraged to other projects in the lab, this rather crazy activity was not its sole justification. The tabletop system could serve as the platform to which we would add custom circuitry to create the playback unit.

It should be noted that "back-lab" projects with little managerial oversight lack significant budgets, and that was the case here. The only significant specific external expenditures made for the camera prototype were for the CCD device itself and a small digital cassette recorder for recording the images. All the other parts used in the camera came from laboratory stock parts or "borrowed" components from existing products being made downstairs in the factory. In summary, our plan was unrealistic, no one was paying attention, our budget small, and few knew where we were working. In other words, our situation was just about perfect.

Our task proceeded in small steps, first getting together the CCD, the electronics to drive it, and the imaging optics assembly (from a used parts bin on the XL movie camera production line). Then we adapted a digital conversion technique used in digital voltmeters in which light-dependent pulses from the imager were converted into four-bit digital words. Since our exposure time for an image was about fifty milliseconds, the entire image had to be stored into an in-camera digital storage array made of twelve of the densest DRAM memory chips available at the time, 4096-bit chips. The digital control circuits were then built that would read the stored digital image and send it to the digital cassette recorder for permanent storage (which took twenty-three seconds). In addition, all the support circuitry, batteries (16 NiCad AA), and power conversion circuits were built as needed for the finished prototype. Success at each step was measured by voltage measurements and oscilloscope traces.

During the year it took to build the camera, the fact that most of it was experimental and thus had to be modified and analyzed further compounded the challenge of putting everything in a portable package. The team built the prototype using a series of circuit boards that were on hinges, which allowed any part of the camera to be accessible while still in operation. The camera could also be folded up again for portable use. Needless to say, the apparatus spent most of its time that year with the circuit boards unfolded.

There were no images to be seen until the playback device was constructed. To the microprocessor development system was added a cassette reader and a custom internally designed image frame-store circuit board. After the custom frame-store received the data from the tape, the microprocessor (Motorola Mc 6800) was programmed to interpolate the hundred lines of captured data into four hundred lines for television display. The frame-store board then generated a standard NTSC video signal from the stored data, which was sent to a television set.

This prototype represented a concept initially called "film-less" photography at many internal demonstrations held around the company during 1976. We took images of attendees at each briefing and showed the results to them immediately on the playback system in the back of the conference room. This prototype generated a great deal of interest and also a number of questions, which unsurprisingly we were in no position to answer at the time. When would such a concept be viable for the consumer? Why would someone want to view his or her images on a television set? How would you save your images? What would an electronic photo album be like?

The view at the time was that this concept was fifteen to twenty years away from consumer reality, based on a crude application of Moore's law and an expected consumer-acceptable resolution of approximately two megapixels. It is interesting to note that Kodak introduced its first consumer digital camera under the name of the Apple QuickTake 100 eighteen years later in 1994.

Not considered at the time of our 1976 projection was the impending impact of the yet-to-be-widely introduced personal computer, the Internet, wide-bandwidth connections, and personal desktop ink-jet printing. Based on the success of the groundbreaking prototype, researchers at Kodak began a number of projects to look at the development of critical technologies and possible market applications in anticipation of a digital future for picture-making.

The result of our team's back-room experiment was a patent filed in 1977 (U.S. Patent 4,131,919), the first patent to document and introduce the advent of digital capture systems. Beyond this patent filing, there was no public disclosure of the prototype camera and playback system until 2001.

Steven J. Sasson is the retired Director of Project Management and Competitive Intelligence IP Transactions and Standards for Eastman Kodak Company.

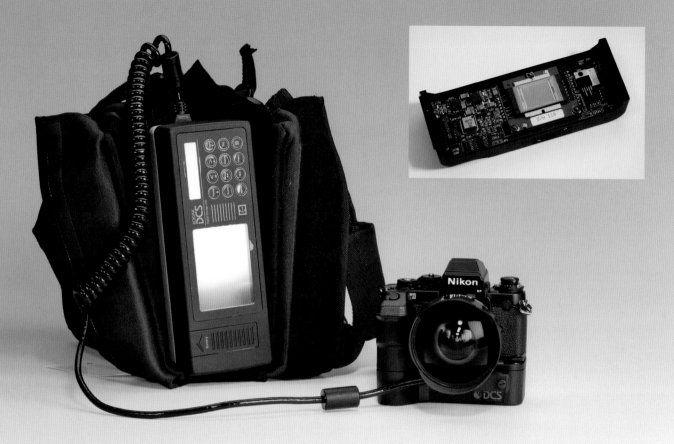

Kodak DCS

ca. 1991

Eastman Kodak Company, Rochester, New York. Gift of Eastman Kodak Company. 2001:0106:1–3.

Introduced by Eastman Kodak Company in 1991, the Digital Camera System was the earliest commercially available professional system of its kind. The first model was the DCS, which consisted of a camera and separate digital storage unit (DSU). A standard Nikon F3 body with a Kodak-designed charge-coupled device (CCD) back and a power winder, the camera was the first digital SLR (DSLR). In operation, light reaching the CCD was converted to charge packets, which were then electronically measured and converted into numeric values. These digital values were exported from the camera body via a connecting cable to the DSU, a battery-powered, 200-megabyte recorder that stored about 150 uncompressed or 600 compressed images. Virtually all of today's digital cameras work in this manner.

Adobe decided to purchase the license, and Photoshop 1.0 was released in 1990. At first it was for Macintosh exclusively. Photoshop software would quickly become the standard image-editing software for professional and advanced amateur photographers.

THE DIGITAL WAVE

EASTMAN KODAK COMPANY offered professional photographers the first digital single-lens reflex (DSLR) camera in 1991. The Kodak DCS (digital camera system) consisted of a standard Nikon F3 body fitted with a module containing a Kodak-designed charged coupled device (CCD), a power winder, and a separate digital storage unit (DSU). The DCS was intended for deadline-pressed photojournalists for whom rapid image dissemination meant everything. News organizations realized the competitive advantage a one-megapixel camera could confer. A $20,000 camera seemed a prudent expenditure.

Knowing that most consumers were waiting for better prices on digital cameras, Kodak marketed its early digital cameras to businesses with an interest in

Kodak DC40
ca. 1995
Eastman Kodak Company, Rochester, New York.
Gift of Eastman Kodak Company. 1998:1440:0003.

In 1995, Eastman Kodak Company introduced the Kodak DC40 digital camera, their branded version of the Apple QuickTake 100, which Kodak had manufactured for Apple Computer the previous year. Although both cameras used the same Kodak sensor (model KAF-0400), they differed in detail. The Apple produced images of 640 x 480 pixels with one megabyte of internal storage memory, while the Kodak produced images of 512 x 768 pixels with four megabytes of internal storage memory. Removable storage cards and LCD viewing screens were still in the future, but these cameras produced color images and retailed for just under $1,000, a milestone at the time. Both cameras were significant to the new digital photography industry.

Sample image made with a Kodak DC40, February 2004.

digital technology. People in insurance and law enforcement agencies knew well how digital documents would save them money by slashing storage costs and speeding document retrieval.

Until the end of the 1990s, Kodak had the SLR professional digital camera market largely to itself. It responded by producing a series of digital cameras with high megapixel sensors on both Nikon and Canon SLR bodies. Prices for professional cameras inspired sticker shock. In 1995, Kodak sold the six-megapixel DCS 460 digital camera for more than $25,000. The company continued to direct these models at photojournalists

and military photographers, for whom returns justified the expense—and who were accustomed to the Nikon and Canon platforms.

Nikon and Canon shied away from the professional contingent until both the technology and market matured. However, when they did enter the competition for professional dollars at the close of the twentieth century, the two companies quickly took digital SLR customers away from Kodak by offering significant price and system advantages on their own models.

But nobody held back from the lucrative mass consumer market. The Dycam Model I, introduced in 1991,

Dycam Model 1
ca. 1991
Dycam Inc., Chatsworth, California. Gift of Rochester Institute of Technology. 2006:0106:0001.

The Dycam Model 1 is considered the world's first completely digital consumer camera; prior "digital camera" offerings were, in fact, still video cameras. Introduced in 1991, the Dycam could connect to a PC or Macintosh and produced black-and-white photos at 320 x 240 resolution; thirty-two compressed images could be stored on a 1 MB RAM. It worked similarly to the Canon Xap Shot except that the digitizing hardware was in the camera itself. Also marketed as the Logitech FotoMan, the Dycam Model 1 retailed at $995.

is considered the world's first truly digital consumer camera. The Kodak DC210, out in 1997, was the consumer market's first one-megapixel digital camera, producing 4 x 6-inch images with quality equal to those from film snapshot cameras. And Minolta's 2002 Dimage X was the first of the small digital cameras, following the same concept as the shirt-pocket cameras of the past.

With the growing demand for all things digital, the technical expertise resided not with camera companies but with electronics manufacturers. Sony, Hewlett-Packard, Casio, and others soon offered cameras. Since the mid-1990s onward, new models with unexpected features and lower prices have been tumbling into the marketplace, creating both enthusiasm and steep learning curves for those who can't quite figure out what all those buttons are for.

To make matters even more interesting, a new device promised to take the camera into fresh communications

Kodak DC210
1997
Eastman Kodak Company, Rochester, New York. Gift of Eastman Kodak Company. 2004:0720:0002.

Introduced in late 1997, the Kodak DC210 was a pioneering one-megapixel digital camera with the popular characteristics of a snapshot camera. Its attractive body design boasted the reliability and ease of handling of a traditional point-and-shoot camera, and its picture quality rivaled that of traditional analog snapshot cameras. The DC210 incorporated features now familiar in manufactured digital cameras: a color LCD image viewing screen, first introduced with the 1995 Casio QV-10; easy-to-use operator interface controls, including a thumbwheel for selecting operational modes; and a removable memory card image storage system.

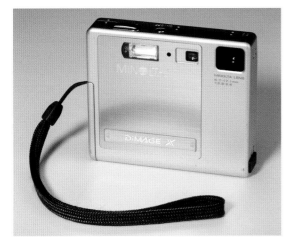

Dimage X
ca. 2002
Minolta Company Ltd., Osaka, Japan. 2004:0297:0001.

The digital camera market follows the same rules that have governed the photographic hardware arena since the Brownie's day: for a product to stand out and attract paying customers, it must have fresh design and new features. Minolta of Osaka, Japan, met the challenge in 2002 with their Dimage X, a two-megapixel mite measuring $3\frac{1}{4}$ x $2\frac{3}{4}$ x $\frac{3}{4}$ inches and featuring a 3X optical zoom lens. Minolta accomplished this feat by placing a ninety-degree prism behind the front element and mounting the seven-element power zoom assembly vertically. The result was a shirt-pocket camera without the usual body thickness required for a zoom. The Dimage X had the usual built-in flash, LCD screen, and video recorder found in most digitals, but its rugged metal body and ultra-compact size set the $399 camera apart from the crowd, at least for a while.

realms. Made by Finland's Nokia Corporation, the Nokia 7650 cell phone/digital camera sold for around $600 when first released to the American public in 2002. Cameras are now available as "throw-ins" on most phones and even computers.

Offering convenience and entertainment, cell phone cameras did not significantly affect digital camera sales. On the contrary, hybrid devices often stimulate interest in what fully featured digital cameras now deliver.

One full-fledged digital model was the Kodak DX6490 zoom digital camera, which made its debut in 2003. The camera is packaged with the popular EasyShare system designed to make it easy to store, retrieve, and send pictures. The camera is stored on its charging dock, which connects to the PC (or Mac) with a USB cable. This "dock-and-go" system made it easier for people to get pictures out of a camera and was ideal for sharing files or making prints.

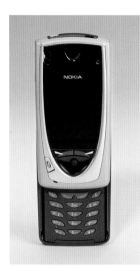
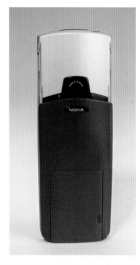

Nokia camera phone
ca. 2003
Nokia, Helsinki, Finland. Gift of Nokia. 2004:0811:0001.

What today seems a commonplace accessory, especially among teens and twenty-somethings, was revolutionary only a half dozen years ago. Introduced in 2002, the Nokia 7650 was one of the first commercial cell phones with an integrated digital camera available in the U.S. It was billed as the "mobile phone that lets you show what you mean." As of this writing, today's multi-interface devices can include not only a wireless phone and camera with up to 10 MP of resolution, but text messaging, web browsing, and support for viewing e-mail attachments, watching videos, and listening to downloadable music—a menu of options that will undoubtedly be outdated before publication. By comparison, this Nokia 7650 produced an image of just 300 kilopixels (.3 MP) using an onboard memory of 1 MB to store up to fifty-five basic-level images.

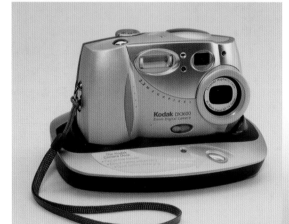

Kodak EasyShare System
ca. 2001
Eastman Kodak Company, Rochester, New York. Gift of Eastman Kodak Company. 2006:0344:0018.

In a bid to simplify digital photography, in 2001 Eastman Kodak Company introduced its EasyShare System, a combination of the DX3600 digital camera and Kodak Camera Dock. Prior to EasyShare, digital photography often was seen as for only the computer-savvy, not an entirely unrealistic perception since the setup required an end-user to install software and add peripherals—the sort of things that instill dread in many non-techies. EasyShare was meant to be the new Brownie, a system that removed all complexities from digital photography. The photographer only had to connect the dock to a computer via USB cable. After that, the system was ready to print and share images. Once the camera was placed in the dock, picture transfer was handled by simply pressing the dock's only button, located at the end of a large yellow arrow. With that button, George Eastman's more than century-old advertising slogan entered the digital age: "You press the button, we do the rest."

Kodak mc³
ca. 2001
Eastman Kodak Company, Rochester, New York. Gift of Eastman Kodak Company. 2006:0344:0023.

To appeal to the youth market, in 2001 Eastman Kodak Company introduced the mc³, a portable, multifunction digital appliance. A sort of digital Swiss Army knife, it consisted of still and video cameras, MP3 player, and Digital Juke Box software package, and it was just the ticket to share images, music, and videos with your Internet friends.

On the tech-side, it was the first camera to incorporate Kodak's CMOS battery-saving image sensor. The mc³ listed for $299, including the 64 MB compact flash memory card. An additional $24.95 bought the USB dock, which connected to a PC or Mac and made sharing even easier.

Imaging Evolves

ALWAYS A MUTABLE MEDIUM, photography experienced momentous change in its use, appearance, distribution and meaning in the closing decade of the twentieth century. Digital imaging and its related technologies exerted an ever-increasing influence, leading to an oscillating mixture of older (analog) and newer (digital) practices. While many image-makers were drawn to the expansive sphere of the digital, with its interactive and virtual media properties, others began to revive so-called antique photographic processes, such as collodion, gum bichromate, platinum, and photogravure printing. The photo-based team of Robert and Shana ParkeHarrison engaged historical processes in the early years of their collaborative career. In *The Exchange* (1999), photographs from large-scale paper negatives were combined to create a seemingly seamless and convincing view of an ecologically exhausted planet Earth. Although not new in the history of photography—the medium experienced a similar rekindling of interest in antique processes in the 1970s—the recent resurgence of older techniques once again attempted to assert the uniqueness of the photographic image by touting the hand-made as opposed to the mechanical, the one-of-a-kind physical object as an alternative to the multiple or the virtual. Attentiveness to both older and newer imaging practices characterizes the wide-ranging and innovative creative expressions of today's post-photographic age.

Robert and Shana, ParkeHarrison, (American, b. 1968, 1964). *The Exchange*,1999. From series: *Earth Elegies*. Gelatin silver print and mixed media on panel. Gift of Shana and Robert ParkeHarrison. George Eastman House collections.

Kodak EasyShare DX6490
ca. 2004
Eastman Kodak Company, Rochester, New York.
Gift of Eastman Kodak Company. 2004:0296:0001.

When Eastman Kodak Company introduced the DX6490 zoom digital camera in 2003, their goal was to provide professional quality features in a four-megapixel consumer digital camera with a high-quality optical zoom lens, advanced photographic controls, and an SLR-like body. The DX6490 was the first to unite a professional quality Schneider-Kreuznach Variogon 10X optical zoom lens with an f/2.8 to f/3.7 maximum aperture; a new Kodak Color Science image processing sensor; and low-light precision autofocusing, all packaged with the popular EasyShare system. With a press of the camera's red "Share" button, the user could immediately select printing, e-mailing, and marking as favorite options for each picture. On-camera sharing was made simple with a 2.2-inch LCD screen. The retail price for the camera was $499.

Kodak Pro 14n
ca. 2004
Eastman Kodak Company, Rochester, New York.
Gift of Eastman Kodak Company. 2004:0300:0001.

The Kodak Pro 14n digital camera was the world's first Nikon mount digital camera to use a full-frame 35mm (24 x 36 mm) CMOS sensor, producing 13.89 megapixel resolution. Announced at Photokina in September 2002, its high resolution and low price took the world by surprise. Though assumed to have been built on a production Nikon N80 camera, it actually had a body made especially for Kodak in a magnesium alloy with a unique vertical format shutter release. The release price was $4,995.

In 2004, the same camera was upgraded with a new imager and improvements in power management and noise performance. This improved model was called the DCS Pro SLR/n; an upgrade package for the 14n was offered at $1,495.

As of 2009, digital cameras had been commonly available for more than a decade. The first few years defined a fixed feature set. The notable changes in the early digital cameras included removable memory cards, a liquid crystal display that allowed users to review pictures immediately, and the incorporation of video capability for taking movies with still digital cameras.

Although contemporary manufacturers would seek to make cameras easier to use and to provide customers more ways to print their digital pictures (e.g., online printing services, snapshot printers), it was through artful presentation of features that they tried to entice customers. From the late 1990s, manufacturers repeatedly boosted the image sensor size, or megapixel count, of cameras—from two to three to four, five, six, seven, eight, and twelve. Just as horsepower once was the hallmark of cars, so has the number of megapixels seemed to lead the way in camera marketing.

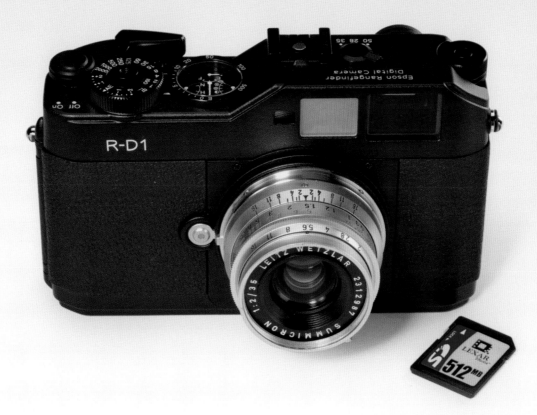

Epson R-D1

2004

Seiko Epson Corporation, Tokyo, Japan. Gift of Seiko Epson Corporation.
2006:0415:0001.

Introduced at Photokina 2004, the biennial trade fair held in Cologne, Germany, the Epson R-D1 is the world's first digital rangefinder camera. In terms of styling and handling, it is a traditional camera, suggestive of the classic Leica M cameras introduced in 1954. It accepts most M-mount Leica lenses and uses analog controls for focus, shutter speed, and lens aperture. On the camera's top plate is a status gauge that somewhat resembles a chronograph watch and displays information about the current image settings, such as image quality, number of remaining exposures, available battery power, and white balance setting.

Still, a superb snapshot requires no more than three or four megapixels, and a good 8 x 10-inch enlargement could be accomplished with five or six megapixels. Since large files take up space on one's hard drive, the added capacity offers some consumers more burden than benefit.

Cell phone cameras—with their plastic lenses and low resolution—are convenient and fun, if often lacking in image quality, at least for those sold in the U.S.

market. A user can instantly upload pictures or send them to other cell phone users, sharing their adventures and lives in the next best thing to real time.

Sharing is the key word here. The Kodak EasyShare One camera was introduced in 2005 as the world's first wireless consumer digital camera. Users could send and receive images via e-mail directly into and out of the camera, without the previously necessary computer connection.

Kodak EasyShare One
2006
Eastman Kodak Company, Rochester, New York. Gift of Eastman Kodak Company. 2006:0344:0020.

The Kodak EasyShare One was introduced in 2005 as the world's first wireless consumer digital camera with the ability to send and receive images directly from the camera. In addition to WiFi capability, it had an articulated three-inch LCD display screen and 3X optical zoom, and it allowed online browsing of photo albums at the Kodak EasyShare Gallery. Initially offered with 4 MP of resolution at $599, it was soon joined by a 6 MP version.

Sample image made with a Kodak EasyShare One, August 2006.

Leica M8

2007

Leica Camera AG, Solms, Germany. Gift of Leica Camera AG. 2007:0351:0001.

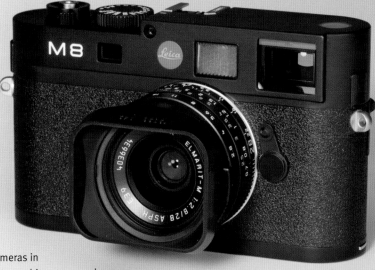

In 2007, the Leica M8 was awarded "Camera of the Year" by the editors of *American Photo* magazine. Introduced in 2006 at Photokina, the camera world's largest trade fair in Cologne, Germany, the M8 advanced Leica's fortunes in a crowded digital photography market. Drawing its incomparable design from the company's celebrated M-series rangefinders, the gold standard for professional and amateur photographers alike, the ten-megapixel camera uses the Eastman Kodak Company KAK-10500 image sensor, designed especially for Leica.

Company founder Ernst Leitz began manufacturing high-quality and high-performance 35mm handheld cameras in 1925. Their impact on the development of aspiring photographic genres such as photojournalism and fine art photography was monumental. In 1954, the company introduced the now legendary M3, a camera still considered the benchmark of 35mm rangefinders. Its descendents, the M6 and M7, longtime favorites and immediate antecedents to the digital M8, remain in production today.

In 1998, the Leica Camera Group embarked on digital camera production with the award-winning S1, its first high-end, scanning back digital camera. The M8 is the manufacturer's latest in a line of triumphs in the digital camera field. Now known as Leica Camera AG, the company's success in the rapidly evolving and highly competitive field of digital camera technology is owed to Dr. Andreas Kaufmann, who became sole owner in 2006. Kaufmann's energy and vision have propelled Leica to new heights in both innovative production and the marketplace.

NEWTON'S HEIRS?

THE CAMERA ARRIVED AT A TIME when science and engineering had been set free. Historians credit Isaac Newton for beginning it. Newton believed in numbers. His 1687 book on the principles of mathematics is considered the most influential work in the history of science, establishing the basic laws of motion, mechanics, and gravity. He invented the reflecting telescope. He developed a theory of light based on the spectrum cast by a prism. Newton also (contemporaneously with Gottfried Leibniz) invented the calculus.

It is hard not to imagine that the people who made the discoveries chronicled here would be honored to consider themselves Newton's intellectual heirs, and credit the scientific method for their discoveries and inventions. But the one thing that sticks out when looking at the progress of the camera is just how much intuition, accident, ingenuity, tenacity, and pure luck are at the root of one eureka moment after another.

The Future of Image Capture

—Alexis Gerard

Where to next, in the long road that's led us from the camera obscura to the full-frame sensor DSLR and the camera-phone? Bear in mind two key facts. First, the number of image-capture devices in use is exploding. By the end of 2010, it will be ten times above levels that had, until now, remained fairly stable in the modern era. Second, that trend is already driving unprecedented levels of investment in imaging research and development. As a result, in the coming years we'll see image-capture devices go through their most profound evolution since the invention of light-sensitive materials. This reinvention will center around two key concepts: the synthetic eye and connected imaging. The good news is that these changes will make our cameras much more valuable to all of us—whether we make our living behind them or use them to record the moments of our lives.

The Synthetic Eye

Recently a twenty-something asked me why his digital camera produced blurred images in low light. I looked at his pictures and pointed out they were superior to what he would have obtained with a film camera. Then the irrelevancy of my statement dawned on me. This kid wasn't comparing his digital camera to film—he had probably never even used film. He was grading his experience against the standard that made sense to him, the only standard that makes sense for customers today: their eye.

The eye, the human visual system, is the performance benchmark that digital camera designers will have in their sights for the immediate future. Technologies are already appearing that promise to exceed it, but there's a lot of work still to be done just to equal it. The most recent PMA show featured a flurry of product announcements aimed squarely at my young friend's complaint: high sensitivity, anti-shake, blur correction, and noise reduction. Clearly the industry is moving in the right direction, albeit with some distance yet to cover in order to match human performance.

Furthermore, even our best cameras do not have our ability to see fine detail or to hold information at both ends of high-contrast scenes. They don't equal even our limited ability to see in color in low light. They also fail to match human vision in less immediately obvious ways. Cameras don't have peripheral vision. They don't perceive and record depth and dimension information. They treat "still" and "motion" as different modes. And they don't record anywhere near as much "metadata" (information about the picture) as we associate with our visual memories.

Rising to the level of these capabilities is a huge challenge for engineers and product designers. But ultimately we expect nothing less from our cameras than to equal what we see with our eyes. We won't be satisfied until we get it, and we'll vote with our wallets in favor of those who give it to us.

Connected Imaging

Pure image capture capabilities, however, are only the beginning of what imaging companies hope we'll open our wallets for. Remarkable as it is, the human visual system is designed to enable

us to function and survive in the natural world. Its blueprint doesn't factor in computing devices, the Internet, televisions—all the artifacts and infrastructures of a technological society. In fact, it doesn't assume any society at all. But the ways we use—and the new ways we will want to use—the images we capture are highly influenced by and dependent on all of these. They relate to the emerging world of "connected imaging"—imaging products and services that, partly by virtue of being themselves connected through always-on access to a global network, can play a key role in helping people connect more effectively with each other.

From the industry's viewpoint, the rise of connected imaging is an opportunity to develop products that think ahead in order to optimize not just the capture experience itself but the downstream uses of images as well. Doing so requires addressing both system constraints and customer intent.

System constraints: Will the picture be displayed on a sixty-inch high-definition TV, or on a cell phone? If the latter, not only would it be wise to create a low-resolution version that will transmit efficiently, it might also be advisable to zoom and crop so that the key elements are clearly visible on a small screen. Perhaps a dynamic file that automatically pans and zooms across the image to highlight specific features is what's needed.

Customer intent: What are the customers trying to communicate through their images? Will that be best served by a single frame or by a short motion sequence? How can composition, focus, and lighting be optimized for that? These skills, which we at Future Image call "visual eloquence," are currently the domain of professional photographers, but that barrier too is about to fall thanks to technology. In the same way, achieving accurate exposure was beyond the skill set of the average user until the advent of automatic cameras, and, even before that, the entire realm of photography was accessible only to a small minority of science and chemistry buffs until the advent of roll film and develop/print services.

Today, anyone can operate a point-and-shoot camera with satisfactory results. Expect coming generations of capture devices, particularly those aimed at mass-market consumers, to incorporate intelligent "assistants" that will collect and analyze information about the user's intent and system constraints, and help them capture images accordingly.

The broader picture is that the place of images in our society is changing profoundly. Going are the days when most people took pictures only twice a year, at Christmas and on vacation. We'll use images routinely to communicate more effectively in all aspects of our daily lives—personal, work, community—and the imaging industry is working feverishly to bring us the tools we need to do so. Those tools will enable average consumers to, among other things, "shoot like pros." They will also enable both pros and amateurs to shoot like no one has ever shot before.

Alexis Gerard is co-author of Going Visual: Using Images to Enhance Productivity, Decision-Making, and Profits; *founder of Future Image Inc., the leading independent center of expertise focused on the convergence of imaging, technology, and business; and chair of the 6Sight™ and Mobile Imaging Executive conferences.*

American daguerreotypes:

6½ x 8½ inches Whole plate

4¼ x 5½ inches Half plate

3¼ x 4¼ inches Quarter plate

2¾ x 3¼ inches Sixth plate

2 x 2½ inches Ninth plate

1⅜ x 1⅝ inches
Sixteenth plate

**dry plate, sheet/
cut film sizes:**

2¼ x 3¼ inches

3¼ x 4¼ inches

4 x 5 inches

5 x 7 inches

8 x 10 inches

7 x 11 inches

11 x 14 inches

4.5 x 6 cm

6 x 6 cm

6 x 9 cm

6.5 x 9 cm

9 x 12 cm

10 x 15 cm

13 x 18 cm

Whole plate	6½ x 8½ inches	Sixth plate	2¾ x 3¼ inches
Half plate	4¼ x 5½ inches	Ninth plate	2 x 2½ inches
Quarter plate	3¼ x 4¼ inches	Sixteenth plate	1⅜ x 1⅝ inches

Roll film sizes

The table below gives the Kodak roll film sizes in the order they were introduced, with the first camera in which they were used; the film numbers were not allocated until 1913.

Number	Dates	Camera	Picture size (inches)
101	1895–Jul. 1956	2 Bullet	3½ x 3½
102	1895–Sept. 1933	Pocket Kodak	1½ x 2
103	1897–Mar. 1949	4 Bullet	4 x 5
104	1897–Mar. 1949	4 Cartridge Kodak	5 x 4
105	1897–Mar. 1949	Folding Pocket Kodak	2¼ x 3¼
106	1898–1924	2 Eureka	3½ x 3½
107	1898–1924	Rollholder	3½ x 4¼
108	1898–Oct. 1929	Rollholder	4¼ x 3¼
109	1898–1924	Rollholder	4 x 5
110	1898–Oct. 1929	Rollholder	5 x 4
111	1898–no date listed	Rollholder	6¼ x 4¾
112	1898–1924	Rollholder	7 x 5
113	1898–no date listed	Rollholder	9 x 12 cm
114	1898–no date listed	Rollholder	12 x 9 cm
115	1898–Mar. 1949	5 Cartridge Kodak	7 x 5
116	1899–1984	1A Folding Pocket Kodak	2½ x 4¼
117	1900–Mar. 1949	1st Brownie	2¼ x 2¼
118	1900–Aug. 1961	3 Folding Pocket Kodak	3¼ x 4¼
119	1900–Jul. 1940	3 Cartridge Kodak	3¼ x 4¼
120	1901–	2 Brownie	2¼ x 3¼
121	1902–Nov. 1941	0 Folding Pocket Kodak	1⅝ x 2½
122	1903–Apr. 1971	3A Folding Pocket Kodak	3¼ x 5½
123	1904–Mar. 1949	4 Screen Focus Kodak	4 x 5
124	1905–Aug. 1961	3 Folding Brownie	3¼ x 4¼
125	1905–Mar. 1949	2 Stereo Brownie	3¼ x 5½
126	1906–Mar. 1949	4A Folding Kodak	4¼ x 6½
127	1912–Jul. 1995	Vest Pocket Kodak	1⅝ x 2½
128	1913–Nov. 1941	1 Ensignette	2¼ x 1½
129	1913–Jan. 1951	2 Ensignette	3 x 2
130	1916–Aug. 1961	2C Autographic Kodak	2⅞ x 4⅞
616	1931–May 1984	Kodak Six-16	2½ x 4¼
620	1931–Jul. 1995	Kodak Six-20	2¼ x 3¼
135	1934–	Kodak Retina	24 x 36 mm
828	1935–May 1984	Kodak Bantam	28 x 40 mm
No. 35	1916–Jan. 1933	00 Cartridge Premo	32 x 44 mm

(This special roll film for the smallest Premo camera used unperforated 35mm film)

Number	Dates	Camera	Picture size (inches)
126	1963–Dec. 1999	Instamatic 100	28 x 28 mm
110	1972–	Pocket Instamatic 20	13 x 17 mm
Disc	1982–1999	Disc 4000	8 x 10 mm
APS	1996–	Advantix 2000	16.7 x 30.2 mm

Autographic films

The special films for Kodak Autographic cameras were made in the following sizes: A116, A118, A120, A122, A123, A126, A127, A130. They were identical to the standard films of those sizes except for the special construction. Standard films could be used in the Autographic cameras, although of course not giving the facility for writing on the film.

Film packs

The film packs used in the Premo cameras and in film pack adaptors were also given a number sequence in 1913; the name was changed from Premo Film Packs to Kodak Film Packs in June 1922, and the 300 series numbers were changed to a 500 series.

Premo no.	Kodak no.	Dates	Picture size (inches)	Picture size (cm)
300	500	1911–1948	1¾ x 2⅜	4.5 x 6
		1921–1948	1⅝ x 2⁷⁄₁₆	4.5 x 6
315	515	1905–1955	5 x 7	13 x 18
316	516	1909–1955	2½ x 4¼	6.5 x 11
318	518	1903–1976	3¼ x 4¼	8 x 10.5
320	520	1906–1976	2¼ x 3¼	6 x 9
322	522	1904–1955	3¼ x 5½	8 x 14
323	523	1904–	4 x 5	10 x 12.5
326	526	1920–1941	4¾ x 6½	12 x 16.5
	531	1926–1941	2⁹⁄₃₂ x 5¹¹⁄₁₂	6 x 13
340	540	1920–1941	1¾ x 4¼	4.5 x 10.7
341	541	1920–1963	3½ x 4¾	9 x 12
342	542	1911–1948	3 x 5¼	7.5 x 13.5
343	543	1920–1948	3¾ x 5½	10 x 15

Agfa/Ansco to Kodak roll films

Agfa/Ansco	Kodak
A8	127
FA8	127
B1	117
B2	120
FB2	120
PB20	620
D6	116
PD16	616
M6	130
E6	118
F6	124
G6	122

Kodak film manufacturing facilities "dot code" key:

Dot positioned high between letters:
- between K and O: Rochester
- between O and D: Canada
- between D and A: United Kingdom
- between A and K: France
- after K: Indonesia

Dot positioned low between letters:
- between K and O: Australia
- between O and D: Mexico
- between D and A: Colorado
- between A and K: Brazil
- after K: India

Dedication / Acknowledgments

This book is dedicated to those who have chaired the George Eastman House Technology Collection Acquisitions Committee since its inception: Colby H. Chandler; the late Thurman F. Naylor; Harris H. Rusitzky; and Mark A. Schneider.

A BOOK OF THIS TYPE OBVIOUSLY is not possible without an expansive collection. The Technology Collection at George Eastman House would not exist without support from the numerous corporations and individuals who have donated generously to the museum from its inception. The photographic world is richer for their assistance in the creation and maintenance of this collection.

Many colleagues and friends assisted in the preparation of this book; I offer my sincerest appreciation to all of them. Specifically, I would like to thank:

Alexis Gerard and Steven J. Sasson for writing thoughtful essays on digital photography.

Frank Calandra, Joseph Constantino, Rolf Fricke, Timothy J. Fuss, and Therese Mulligan for contributing to the research and writing of the camera captions.

Derek Doeffinger and Michael More for transforming my random thoughts into an entertaining narrative of photographic history from the camera's point of view.

Kathy Connor, David Gibson, Bill Krauss, Mark Osterman, Martin L. Scott, and Robert Shanebrook for keeping the facts in order.

Greg Drake and Robyn Rime for making intellectual and grammatical sense of it all.

Barbara Puorro Galasso for creatively photographing all the cameras and providing the digital scans of everything else, and Laura Smith for shuttling the collection from vault to studio and back.

Jamie M. Allen, Alison Nordström, Joe R. Struble, and David Soures Wooters for assisting with the historic image selection and captions.

Leica Camera AG, Steve McCurry, Robert and Shana ParkeHarrison, and Nick Ut for the use of their photographs.

Anthony Bannon for his support of this project.

The folks from Sterling Publishing, especially Pam Horn and Cindy Katz, for making this book possible.

—Todd Gustavson

PHOTO CREDITS

INDEX